Jacopo Sansovino

Architecture and Patronage in

Renaissance Venice

JACOPO SANSOVINO

Architecture and Patronage in Renaissance Venice

DEBORAH HOWARD

Yale University Press

New Haven and London

1975

Library of Congress catalog card number: 75-8441

International standard book number: 0-300-01891-6

Designed by John Nicoll and set in Monophoto Bembo.

Filmset and printed in Great Britain by
BAS Printers Limited, Wallop, Hampshire

Published in Great Britain, Europe, and Africa by
Yale University Press, Ltd., London.
Distributed in Latin America by Kaiman & Polon, Inc., New York City;
in India by UBS Publishers' Distributors Pvt., Ltd., Delhi;
in Japan by John Weatherhill, Inc., Tokyo.

Preface

MOST of the material for this book was collected during a two-year stay in Italy in 1970–72. I am grateful to the Department of Education and Science and the Leverhulme Research Foundation, who generously sponsored the work: thanks to them I was able to hold a three-year State Studentship, a Leverhulme European Studentship, and a Leverhulme Research Fellowship at Clare Hall, Cambridge. Some of the information in the second and third chapters has been drawn from my Ph.D. thesis 'Studies in Jacopo Sansovino's Venetian Architecture', Courtauld Institute of Art, London University (1973), a detailed discussion of Sansovino's career as *proto* to the Procurators of St. Mark's and his work in Piazza San Marco.

So many friends (and strangers) have helped me during the preparation of this book that I cannot thank each one in person, but I owe them all my warmest thanks. My greatest debt is to Howard Burns, for his inspiration, help and encouragement, and for his expert criticisms of the manuscript of this book. I am deeply grateful, too, to David Rosand, who read the whole text and made numerous most enlightening suggestions. His interest in my work has always been tremendously stimulating.

Others who have shared their knowledge or given practical help include Bruce Boucher, Hans Brill, Humfrey Butters, Suzie Butters, Susan Connell, Clare Coope, Jane Glover, Professor John Hale, Charles Hope, Professor Frederick Lane, Douglas and Carolyn Lewis, Lester Libby, Oliver Logan, Professor Ulrich Middeldorf, Reinhold Mueller, Nicholas Penny, Marilyn Perry, Graham Pollard, Giles Richards, Guido Ruggiero, Philip Rylands, Professor Juergen Schulz, Anne Schulz, Frank Tirrho, and Wolfgang Wolters.

It would be hard to exaggerate the exceptional kindness and co-operation of the directors and staff of the Venetian archives and libraries. In particular I must thank Dottore Giorgio Ferrari, former director of the Biblioteca Marciana, for his tireless assistance and lively interest. Giulia Musumeci showed me the Loggetta restorations in progress on several occasions; I am most grateful both to her and to Sir Ashley Clarke who authorised these visits.

Finally, I must thank all my friends in Venice for helping to make my stays there so happy and invigorating.

Contents

LIST OF PLATES

All photos are by the author unless otherwise stated,
except Plates 4, 6, 12, 13, 21, 26, 31, 45, 50, 68 and 69
which were photographed by the various museums
concerned.

showing site of the Palazzo Moro. Photo Courtauld Institute.

109. Palazzo Moro, corner tower and view towards lagoon.

110. Filarete: Venetian palace façade, from his treatise on architecture. Photo Courtauld Institute.

LIST OF FIGURES

All plans of individual buildings are drawn to a scale of approximately 1/800. They were re-drawn by the author from various sources, including eighteenth and nineteenth-century versions. Some simplification and inaccuracy has therefore been unavoidable.

NOTE ON THE DOCUMENTARY SOURCES
AND ABBREVIATIONS

Unless otherwise stated, all archival sources are to be found in the Venetian State Archives (the Archivio di Stato di Venezia).

Venetian dates (m.v. = *more veneta*) have been given in addition to the orthodox dating system in the notes. The Venetian year began on 1 March.

Documents have been quoted as accurately as possible, with minor alterations to modernise spelling and punctuation for the sake of clarity (e.g. changing 'u' to 'v'), and expanding most of the abbreviations.

The original rather than revised page numbers have been given wherever possible.

c. = *carta* (sheet number)
t. = *tergo* (reverse side of sheet)
b. = *busta* (box file)
reg. = *registro* (bound volume)
f. = *filza* (collection of loose documents, sometimes bound later)
fasc. = *fascicolo* (booklet)
proc. = *processo* (series)
PS = Procuratia de Supra
ASV = Archivio di Stato di Venezia
q. = *quondam* (deceased)
D. = *Dominus*

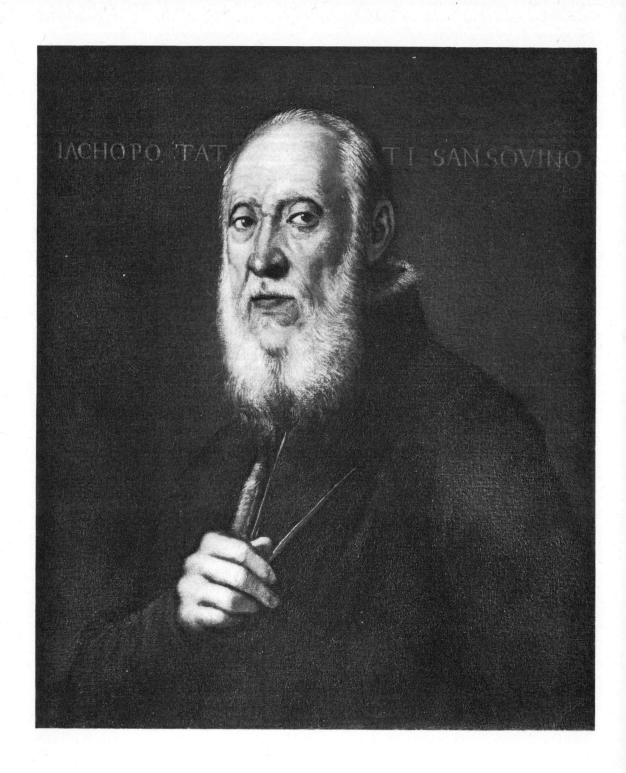

1. Jacopo Tintoretto: *Jacopo Sansovino, c.*1566.

I. Jacopo Sansovino and his Venetian Patrons

To the reader of Vasari's graphic description, Jacopo Sansovino seems as real as a character on the stage:

As for his appearance Jacopo was of average height, not at all fat, and he carried himself well. He had a pale complexion and a red beard, and in his youth was extremely beautiful and charming, which led a number of ladies of some importance to become rather fond of him. Later, in his old age, he had a venerable presence, with a fine white beard and the gait of a young man. Even at the age of 93 he was still extremely vigorous and healthy, and could see the tiniest thing at any distance without spectacles; and he held his head up when writing, instead of leaning over as others do. He enjoyed dressing elegantly and was very well-groomed; and he took pleasure in women right up to the end of his life . . .[1]

The entry of this attractive personality (Plate 1) into a scene no less captivating —the colourful, cosmopolitan world of sixteenth-century Venice—was to launch the already mature artist on a new phase in his career, and leave a deep impression on the appearance of the city itself. Sansovino arrived in Venice in 1527 at the age of 41, initially to take refuge from the atrocities of the Sack of Rome.[2] He intended to return to Rome as soon as the troubles had subsided, but his unfinished commissions there were left abandoned.[3] He was invited to France to work for King Francis I, but he never reached the French court either.[4] Even the King of England, Henry VIII, pressed on him a commission worth 75,000 ducats, but he never took up the offer, so far as we know.[5] For the rest of his long life Jacopo Sansovino remained in Venice, dying there in 1570 at the age of 84.[6] Such was the respect for longevity in Venice, that in later life, like his close friend Titian, he was reputed to be even older than his true age. Kings, princes, popes and emperors tried in vain to seduce the refugee artist away from Venice, but he apparently left the Veneto only once more, to make a quick business trip to Florence in 1540.[7]

A Florentine by birth, Jacopo Tatti adopted the name of his master, the sculptor Andrea Sansovino. He spent his early career in Florence and Rome, in close contact with the great artists of the High Renaissance—he knew Bramante, Raphael, Michelangelo, Andrea del Sarto and many more.[8] Having been trained as a sculptor, he had relatively little architectural experience before his flight to Venice. In Florence he designed a temporary façade for the Duomo and other pieces of architectural scenery for the entry of Pope Leo X into the city in 1515, and while in Rome he began the churches of San Marcello al Corso and San Giovanni dei Fiorentini and built a fine palace for his friend,

the banker Giovanni Gaddi. Other traces of his Roman architectural activities (according to Vasari he also built a beautiful loggia on the via Flaminia and a house for one Luigi Leoni, and began a large building for Cardinal Antonio di Monte in his vineyard outside Rome) have now disappeared.[9] It must have been his reputation as a sculptor rather than as an architect which led Lorenzo Lotto to refer to Sansovino, in a letter announcing his arrival in Venice, as 'second only to Michelangelo'.[10]

Jacopo came to Venice at a particularly fortuitous moment. At the instigation of Doge Andrea Gritti, an enthusiastic patron of the arts who welcomed non-Venetian artists to the city, he was immediately given the task of restoring the domes of the Basilica of St. Mark, which were then in an alarmingly precarious state.[11] The competence with which he handled this assignment did not go unnoticed. Two years later, when the death occurred of Bartolommeo Buon, architect to the Procurators of St. Mark's, Jacopo Sansovino was appointed to succeed him.[12] And thus he became the 'proto' to the Procuratia de Supra, provided with a reasonable salary, a house on Piazza San Marco, and a busy, challenging professional life.[13]

The Venetian Republic was about to embark on a new period of prosperity and political self-confidence. The traumatic shock of the League of Cambrai in 1508, when the Papacy, France and the Holy Roman Empire formed an alliance and declared war on Venice, and the undermining effects of the years of wartime which followed, in which the Republic only just managed to hold on to its mainland possessions, had threatened the existence of Venice as an independent state and badly drained her economic resources. The plague and famines of the late 1520s only added to the city's distress. At last, in 1529, the Peace of Bologna was concluded, marking the beginning of a long interlude of tranquillity. Apart from the brief war against the Turks in 1537–40, Venice was to remain at peace until after Sansovino's death in 1570.[14]

In this atmosphere of security and well-being, architectural enterprises proliferated. None but the most urgent or well-endowed projects—like the rebuilding of the Procuratie Vecchie damaged by fire in 1512, the reconstruction of the Rialto market after the great fire of 1514, or the building of the Scuola and church of San Rocco—had been undertaken during the two decades following the League of Cambrai. Now, with the return of a sense of political and economic stability, Venetians again turned their attention to outward appearances—to pomp and display, to comfort and commodity, to beauty and innovation. It was the plentiful supply of commissions, both sculptural and architectural, which enabled Jacopo Sansovino to settle in the city and supported him there for over forty years.

The emergence of an ambitious and varied patronage in the thirties provided ideal conditions for the infiltration of new ideas and standards into Venetian architecture. In a city eager to establish itself as the 'new Rome', the pretentions and aspirations of employers encouraged architects to flaunt their knowledge of Vitruvian grammar and classical motifs—still a novelty in Venice.[15] Giovanni Maria Falconetto had already begun to prepare the ground in the Veneto, demonstrating in his buildings his competent handling of the orders and his thorough familiarity with the antiquities of Rome. His Loggia and Odeo Cornaro in Padua are fine specimens of Renaissance architecture by any

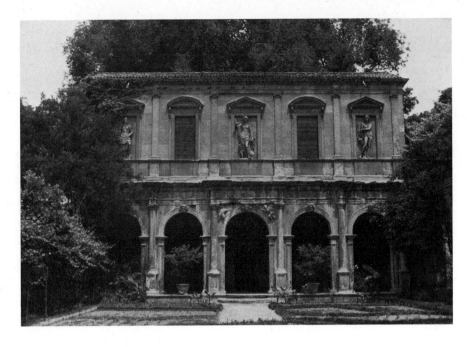

2. Falconetto: Loggia
Cornaro, Padua, 1524.

standards (Plate 2).[16] However, none of the early pioneers of the *all'antica* style
in Venice itself—such as the Lombardi, Mauro Coducci and Bartolommeo
Buon—appears to have visited Rome. Their view of antiquity was based on
local classical and Early Christian monuments such as those of Verona and
Ravenna. The first true glimmer of enlightenment in the city was kindled by
the publication there in 1511 of Fra Giocondo's famous illustrated edition of
Vitruvius (Plate 14), in the midst of the Cambrai Wars, but the real impact of
Vitruvian doctrine on Venetian architecture was delayed until the return of
peace and prosperity some twenty years later.[17]

Sansovino's Roman experiences—his intensive studies of ancient ruins, and
his knowledge of the works of Bramante and his successors—had provided
him with the necessary equipment to propagate the new style in Venice. Yet
Vasari's assertion that it was he who taught the Venetians how to build
correctly and how to apply the principles of Vitruvius is misleading.[18]
Sansovino was not the only innovator. Peruzzi's pupil, Sebastiano Serlio, also
arrived in Venice at the time of the Sack of Rome, and soon began to publish
prints illustrating the classical orders and the buildings of Antiquity (Plate 3).[19]
Although only nine of his initial series were engraved, Serlio's ideas began to
develop further, and by 1537 the first volume of his illustrated architectural
treatise, Book IV, on the orders, was published in Venice.[20] The next volume,
Book III, dealing with the chief monuments of Antiquity, appeared in 1540,
the year in which Serlio left Venice for France.[21] He himself built almost
nothing in the city, but his contribution to the local architectural vocabulary
was immense, and his emphasis on the importance of adapting the appearance
of a building to its particular function, as well as on scenic effects and variety
in architecture, had a deep and wide-ranging impact in Venice. Sansovino, who
knew Serlio personally and shared his familiarity with Roman antiquities, was

3

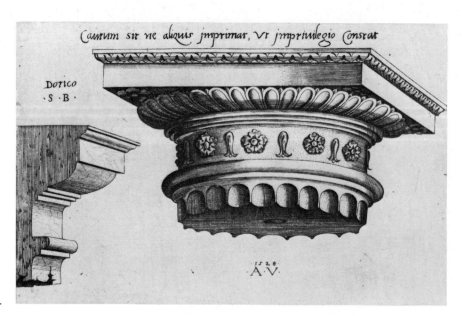

3. Serlio: The Doric order, from Book IV of his treatise, first published in Venice 1537.

himself profoundly affected by these concepts.[22] The Veronese architect, Michele Sanmicheli, who likewise returned to the Veneto from central Italy in the late 1520s, also played a major part in the influx of new ideas into Venetian architecture. Although he worked mainly in Verona, he was appointed military architect to the Venetian Republic in 1535, and built the imposing fortress of Sant'Andrea on the Lido. In Venice itself he designed two magnificent palaces, the Palazzo Grimani at San Luca, and the Palazzo Corner at San Polo.[23] Even long-established local architects such as Antonio Scarpagnino were to some extent influenced in their own works by these new developments. Vasari's comment in his Life of Falconetto, implying that Sansovino and Sanmicheli together brought the true classical style of architecture to the Veneto after Falconetto had paved their way, is a more perceptive assessment of the situation than his assertion that Sansovino alone was responsible.[24]

In the introduction to Book IV of his treatise, published in 1537, Sebastiano Serlio underlined the significance of Doge Andrea Gritti's contribution to the revival of Venetian architecture in the preceding ten years.[25] We know from Vasari's Life of Sansovino that Gritti (Plate 4) became one of Jacopo's closest friends and most loyal supporters; and an early biography of the Doge confirms his interest in embellishing the city.[26] It was Gritti who, in 1527, persuaded the Procurators of St. Mark's to employ the newly-arrived Flemish musician and composer Adriano Willaert as choirmaster of the Basilica.[27] Willaert, like Sansovino, chose to settle in Venice and spent the rest of his life in the service of the Procurators; and in this capacity he revolutionised Venetian music and set the scene for the great musicians to come, notably the Gabrieli and Monteverdi. Gritti was no less welcoming to literary figures, to judge from the gratitude expressed in a letter to the Doge by the poet Pietro Aretino, who was one of Sansovino's closest friends.[28] Aretino, too, came to Venice at the time of the Sack of Rome, and remained in the city until his

4

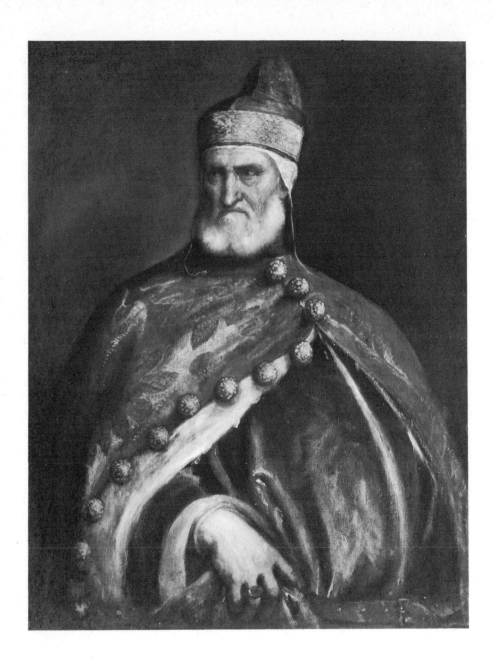

4. Titian: *Doge Andrea Gritti* (1523–38).

death in 1556. The reign of this enlightened Doge, coinciding with a phase of economic and political recovery, provided the ideal background for artistic ventures; and this stimulating atmosphere pervaded every type of creative activity.

Such happy circumstances did not persist throughout Sansovino's stay in Venice. The death of Doge Gritti in 1538 deprived the artist of one of his principal promoters, while the exhilaration which followed the Peace of Bologna was dampened by the outbreak of war against the Turks in 1537. As the middle of the century approached, hopes of prolonged prosperity began to fade too. In the period of rapid inflation which followed, it became more and more difficult to bring architectural projects to completion, and new commissions were fewer and less ambitious.[29] Through the exploration of Sansovino's own career, this study will try to show how both architects and patrons had to adjust to changing conditions during the course of the century.

The focus on the activities of a single architect will provide us with a structure for our investigation. During his four decades in Venice Sansovino experienced almost every type of architectural patronage which the city could offer. Besides his permanent post as *proto* to the Procurators of St. Mark's, he was employed by the state, the Church, charitable institutions, and private individuals (both nobles and citizens). In each case he encountered a different system of organisation, both in decision-making and budgeting. In each case the building had to serve a particular purpose determined by the very nature of Venetian society, for which traditional, indigenous building-types had already been evolved. In each case the project was affected by a range of peculiar physical conditions imposed by the geographical environment—the shortage of land and materials, the instability of the terrain, and problems of lighting and drainage. In each case the progress of the building work and the relationship between the architect and his patrons followed an individual course.

As a non-Venetian Sansovino responded to this new context relatively objectively, even self-consciously, but comparable circumstances would have affected any architect, whether native or not, then working in Venice. The wide range of commissions which he undertook makes Sansovino's career an especially useful vehicle for the examination of Venetian architectural patronage of the time. This book makes no attempt to provide a complete survey of Sansovino's Venetian architecture, but rather to explore his main buildings in detail, using these examples to throw light on some of the fortunes and misfortunes which would have confronted an architect in sixteenth-century Venice. Nor does it aim to take the place of Manfredo Tafuri's recent monograph, *Jacopo Sansovino e l'architettura del '500 a Venezia*, but instead to illustrate with historical material the relationship between the architect and his society —a concept which Tafuri launched with all the energy of his Marxist convictions but expressed in more abstract terms.[30]

It is all too easy to analyse architecture in two dimensions—to content oneself with the discussion of façades alone, based on purely aesthetic or stylistic criteria. The use of photography only increases this temptation. Even the most careful selection of photographs cannot act as a substitute for the experience of actually entering and exploring a building in its real surroundings. The tracing

6

of precedents and prototypes has no value unless the reasons for the choice of a particular motif are taken into consideration. The analysis of proportion and window disposition is wasted unless some account is taken of the arrangement of the interior. We should never allow ourselves to treat a building like a painting, or the backcloth of a stage. It must be seen as a complex product of a particular society, intended to serve a specific function (almost never a purely visual one), reflecting the needs and tastes of the patron as well as the aesthetic ideals of the architect. Considerable cost is involved in the execution, so that experimentation has to be largely confined to the drawing-board. Surviving drawings and models can help to illuminate the creative processes of an architect, but in the case of Sansovino, whose entire corpus of architectural drawings has been lost, such an approach is clearly excluded.[31] An assessment of his development and achievement can only form the end-point of a thorough examination of the historical background to each commission—the previous buildings on the site, the purpose of the new structure, the existence of a local building type which conditioned the expectations of the patron, the means of financing the project, and the progress of the construction work.

Jacopo Sansovino was not only a master of classical doctrine who brought to Venice his knowledge of ancient and modern Rome. His contribution to Venetian architecture is a far more complex subject. He seems to have been more than a little shrewd in his dealings with his patrons—as Vasari pointed out, he had a remarkable capacity for expressing his own opinions lucidly and eloquently, and he also had an unusual grasp of economic situations[32]—which adds an extra dimension of interest to the study of his patronage. Above all, Vasari reports, he sought to adapt each building to its site and function, and it is for this reason in particular that his Venetian architectural career deserves attention.[33] He did not merely transplant Roman High Renaissance architecture on to Venetian soil. He was acutely aware of the merits of the local architectural tradition which, through many centuries of evolution, had adjusted itself to the city's peculiar physical environment and the special needs of the society. It would be difficult to envisage Sansovino's Venetian buildings in any other city, so subtly do they harmonise with the setting. Just as in Venice he combined the medieval role of superintendent of buildings with that of the Renaissance court artist, so he translated the indigenous building conventions into his own language, using Roman vocabulary and syntax. The following chapters will try to show how this process operated.

II. The Procurators of St. Mark's

OF Sansovino's various Venetian patrons, the most important were the Procurators of St. Mark's, whom he served as *proto* (that is, architect and superintendent of buildings) from the time of his appointment on 7 April 1529 until his death in 1570. In this position he was permanently employed by the Procuracy on a full-time basis, with the result that none of his other architectural patrons had the benefit of such dedicated service or close attention. His decision to become a permanent resident in Venice is a reflection of his satisfaction with the professional and financial security which the job offered him. The special relationship which developed between Sansovino and the Procurators was, in many respects, the ideal patronage situation. In the course of his career he established close friendships with several of the individual Procurators, who often succeeded in swaying the decisions of their colleagues. And he was especially lucky that this powerful institution had the means to implement some of his most ambitious artistic ideas. It was the Procuracy which sponsored Sansovino's radical scheme for modernising and improving Piazza San Marco, and commissioned the Library and the Loggetta, two of his most prominent and highly rated architectural works.

The office of Procurator of St. Mark was originally established to take charge of the church which housed the saint's body.[1] Since the time of the first known Procurator, Otto Basilius, who was recorded in 1152, the institution had grown in size and importance to become the main political and financial link between the state and the Church. The position of Procurator was second in prestige only to that of the Doge (apart from the post of Grand Chancellor which was occupied by a citizen, not by a patrician), and it was the only other office which could be held for life. Every ambitious Venetian noble, working his way up the political ladder, hoped eventually to be elected to the Procuracy.[2] The duties of the Procurators had always involved handling large amounts of both public and private money, and it was this financial role which gave the office its supreme importance. As the wealth of the Basilica grew, swelled by bequests and tithes, its treasurers, the Procurators, began to take on the additional duty of administering private estates and trusts. By the later fifteenth century there were nine Procurators in all, split into three divisions. Two of these, the Procuratia de Citra and the Procuratia de Ultra, handled the private estates on either side of the Grand Canal. The third division, the Procuratia de Supra (the one which was to employ Sansovino), had special responsibility for the church itself, and for church property in and around

Piazza San Marco.[3] In the sixteenth century the office became somewhat less exclusive. The Procurators were normally elected by a ballot of the Great Council; but after the League of Cambrai, the Venetian Republic, finding itself in desperate financial straits, began to raise large amounts of capital from the richest noble families by the sale of extra Procuratorships. By the end of Gritti's reign there were as many as twenty-three Procurators. Nevertheless, they must all have felt a certain dedication to public service, for the office offered little scope for personal gain or individual power. The salary was negligible for such a distinguished position—in the sixteenth century it was only 60 ducats a year, lower than the salaries paid to many of the Procuracy's employees.[4]

The property in the Piazza administered by the Procuratia de Supra had been bequeathed to the church of St. Mark by Doge Sebastiano Ziani, who died in 1178, together with the nucleus of the famous treasure.[5] Unlike the two other Procuracies, this division administered few private trusts. Its income was derived chiefly from rents paid on the property in the centre of the city—inns, shops, apartments, workshops, banking tables and market stalls—and from church investments. It is important to remember that the Procuracy was strictly a secular institution. The Basilica was not the seat of the Patriarchs of Venice, but the private chapel of the Doge. Until the nineteenth century the cathedral church was San Pietro di Castello, situated in one of the remotest corners of the city—perhaps a comment on the Venetian government's eagerness to exclude ecclesiastical interests from public affairs.

On his appointment as *proto* in 1529, Sansovino was awarded a yearly salary of 80 ducats and the use of an apartment on Piazza San Marco, near the Clock Tower. He quickly impressed the Procurators with his 'diligence, industry, competence and dedication', and his salary was raised twice in the following year, first to 120 ducats and then to 180 ducats.[6] There can be no doubt that he worked hard to earn this remuneration. Vasari makes much of Sansovino's selfless dedication to his employers:

. . . he was always more than ready to serve the particular needs of each of these *signori Procuratori*. They in turn, taking advantage of him both in Venice and elsewhere, and never doing anything without his help or advice, employed him continuously, not only for themselves but also for their friends and relations, without any payment. And he was prepared to suffer any discomfort and trouble to satisfy them.

(We must, of course, bear in mind that Vasari's source must have been either Sansovino himself or his son Francesco!)[7]

The *proto* was not merely an architect. He was also responsible for the upkeep of all the buildings administered by the Procuratia de Supra, that is to say the Basilica and the other properties in the Piazza, charity housing and hospitals, the private estates in other parts of the city, and various possessions on the *terraferma*.[8] The word *proto*, meaning 'first' in Greek, is short for *protomaestro*, the Venetian equivalent of the Tuscan term *capomaestro*.[9] For every repair— even the mending of broken roof-tiles, window-panes or floorboards—he had to inspect the building concerned, prepare an estimate, award the contract to a suitable *maestro*, and organise the supply of materials. In 1532 Sansovino was

also made responsible for supervising all the workers employed on these jobs.[10] In addition to such time-consuming chores, he had to attend meetings of the Procurators to submit his estimates for approval and to witness other administrative decisions.[11] At the time of his appointment no more than two ducats could be spent on a repair without the formal approval of the Procurators.[12] For the Basilica he produced major works of sculpture—including the bronze reliefs for the singing galleries and the sacristy door—as well as designs for mosaics, tapestries and choir-stalls.[13] Meanwhile, as we shall see, he began to accept major architectural commissions from other patrons in different parts of the city. And despite all these commitments he still managed to maintain a steady output from his sculpture workshop. As far as one can tell, he carried out his architectural work relatively independently, his only recorded assistants being sculptors.[14] Jacopo Sansovino must have been a man of prodigious energy.

PIAZZA SAN MARCO

Piazza San Marco had evolved as two interconnecting open spaces—the Piazza itself, facing the Basilica, and the smaller area in front of the Doge's Palace known as the Piazzetta (Figure i). The main Piazza was the scene of the great public processions on religious feast-days, while the Piazzetta was more strictly political in character, its arcades buzzing with political intrigue and propaganda. Most of the Piazza had been arcaded since the twelfth century, when the space was enlarged by Doge Ziani, although some of the porticoes were obscured by lean-to shops and stalls.[15] The Piazza and the Piazzetta at the end of the fifteenth century are vividly illustrated in Gentile Bellini's famous painting of the *Corpus Domini Procession in Piazza San Marco* (Plate 5), and in a view of the Piazzetta attributed to Lazzaro Bastiani (Plate 6).[16] Jacopo de' Barbari's detailed bird's-eye view of Venice also records the appearance of the city centre at the turn of the century (Plate 7).[17] Little had changed by the time of Sansovino's arrival in 1527, except for the rebuilding of the north side of the Piazza by his predecessor, Bartolommeo Buon, after a disastrous fire in 1512.[18]

5. Gentile Bellini: *Corpus Domini Procession in Piazza San Marco*, 1496.

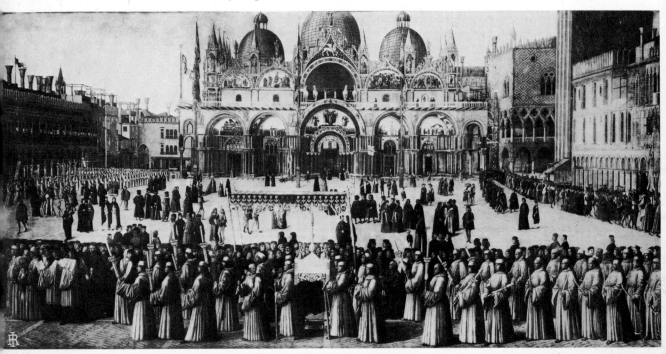

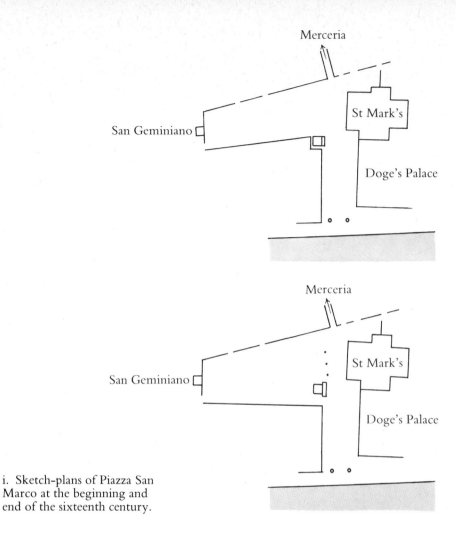

i. Sketch-plans of Piazza San Marco at the beginning and end of the sixteenth century.

This wing, now known as the Procuratie Vecchie (Plate 8), was let out by the Procuracy as shops and apartments. Meanwhile the Procurators themselves still lived, rent-free, in the ancient houses on the opposite side of the Piazza (a valuable subsidy to their modest allowances).[19]

Vasari records that Sansovino was the first *proto* to try to improve the appearance of Piazza San Marco. Both Vasari and Francesco Sansovino describe how, in the year of his appointment as *proto*, with Doge Gritti's support, he organised the removal of the sordid wooden stalls around the two great columns at the lagoon end of the Piazzetta.[20] In the early sixteenth century the centre of Venice was cluttered with temporary shacks and stalls—both legal and illegal. Money-changing booths stood at the base of the Campanile, and bakers' shops occupied some lean-to huts nearby. Meat and vegetable stalls and even latrines surrounded the great columns, at the very place where the most distinguished visitors were welcomed to the city. Five rather dubious hostelries, as well as the meat market, were housed in the decrepit buildings in the Piazzetta, facing the Doge's Palace. And there was a row of cheese-and-salami shops along the lagoon side of the Mint.[21]

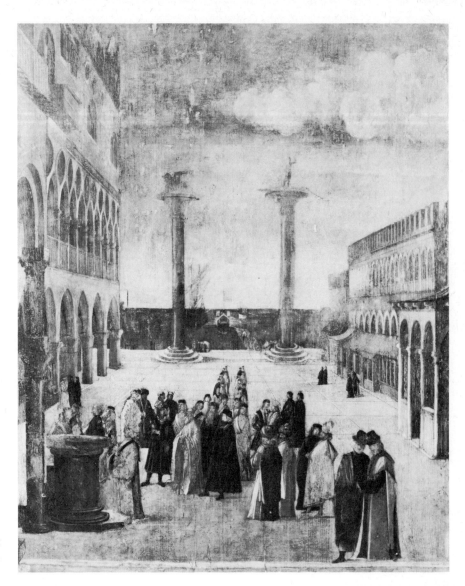

6. Lazzaro Bastiani (attrib.):
View of the Piazzetta, Venice,
*c.*1487.

Clearing such eyesores from the city centre was not a simple matter, for their very existence was perpetuated by strong economic pressures. To the Procuracy the rent from the shops and stalls was a substantial source of revenue. The tenants of these properties were in turn dependent on the custom of the crowds who frequented the Piazza. Foreign visitors, since the time of the Crusades, had needed guest-houses and taverns, as well as money-changing facilities. Tenants of shops and hostelries often held long-standing rights to premises in the Piazza. Only if the Procuracy offered suitable accommodation elsewhere could such tenants be evicted. And since empty sites in the centre of Venice were almost non-existent by the sixteenth century, moving one tenant probably involved further evictions, and the provision of yet more alternative premises.

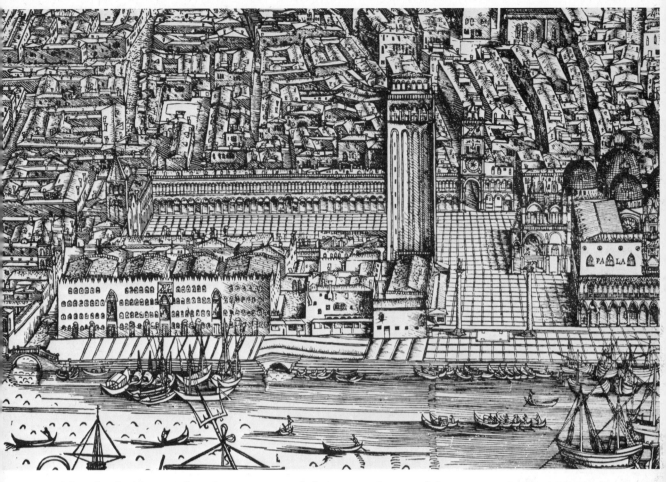

After the decision to clear the space around the great columns, eight new stalls on the waterfront beyond the Mint were erected for the displaced greengrocers.[22] The Procuratia de Supra's radical programme of general reforms, formulated in 1531, included a bolder resolution, almost certainly suggested by Sansovino himself, to keep the whole Piazza absolutely free of stalls and other obstructions, except during the annual trade fair at the Festa della Sensa.[23] Throughout Sansovino's career as *proto*, attempts were made by the Procuracy to shift commercial activities away from the political centre of the city, but they were constantly thwarted, either by the shortage of space, or by blatant disregard of the Procurators' orders. During the great rebuilding schemes which Sansovino launched in the Piazza, shops which were displaced when the sites were cleared were, of necessity, moved temporarily to the foot of the great columns, in spite of the resolutions to keep that part of the Piazza clear.[24] Illegal stall-holders—selling goods such as poultry, eggs, fruit and vegetables —were a continual problem. Many of them found trade so profitable that they were undeterred by the penalty of a 25 *lire* fine and the confiscation of their wares.[25] In 1551 the Procurators threatened offenders with 15-day prison sentences in addition to the usual punishments.[26] A year later the fine was

7. Jacopo de' Barbari: Perspective-view map of Venice, detail showing Piazza San Marco, 1500.

13

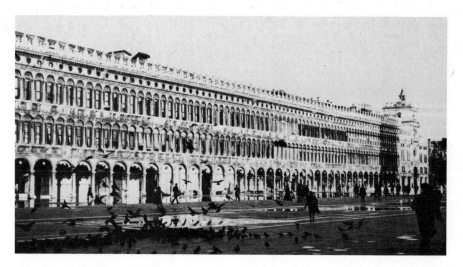

8. Bartolommeo Buon:
Procuratie Vecchie, Venice,
begun 1513.

raised to 50 *lire*, but still obstinate traders disobeyed the regulations.[27] Eventually, in 1569, the year before Sansovino's death, the Council of Ten had to intervene with a decree banning stalls and counters from the great columns and the arcades of the Doge's Palace.[28]

Of course, the separation of commercial and political activity in the city centre was not a concept invented by Sansovino. It was an ancient tradition in Italian urban planning, given new life by Quattrocento architectural theorists such as Alberti and Filarete.[29] Indeed such a division already existed in Venice itself. The commercial centre had always been in the part of the city known as the Rialto on the other side of the Grand Canal, linked to Piazza San Marco by the street called the Merceria. Nevertheless, as we shall see in the following chapter, the distinction was not clearly defined—some political activity took place at the Rialto, and some commercial business in Piazza San Marco. To Sansovino we must give credit for trying to clarify the contrasting functions of the two centres. It was thanks to his initiative that the Procurators persistently tried to play down the commercial aspects of life in the Piazza.

Sansovino's greatest contribution to the appearance of Piazza San Marco was not, however, the redistribution of food stalls, but his far more significant plan to replace all the more dilapidated buildings with new ones. At the time of his arrival in Venice, many of the existing structures in the Piazza were nearing the end of their useful life, and the fact that this coincided with a phase of economic and political recovery in the Republic gave him the opportunity to initiate one of the most ambitious programmes of urban renewal in sixteenth-century Italy.[30] As the paintings of Bellini and Bastiani indicate (Plates 5 & 6), the south side of the main Piazza and the west side of the Piazzetta still preserved their ancient Veneto-Byzantine buildings. Now that the whole of the north wing of the Piazza had been reconstructed, the shoddy state of the old buildings would have been even more obvious.[31] Since the Procurators themselves lived in this part of the Piazza, they were constantly reminded of the urgency of the problem. The cost of maintaining their antiquated houses was steadily rising, and parts of them periodically threatened to collapse completely.[32] Faced with such strong incentives, the Procuracy decided to remedy the situation. On 14

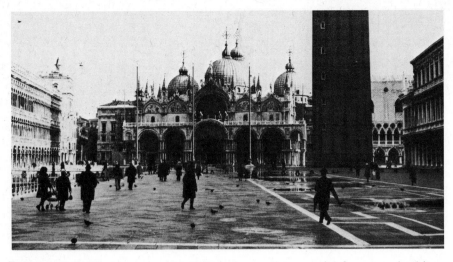

9. View of Piazza San Marco with the Basilica.

July 1536, Sansovino was commissioned to make a model for a new building on the site of their old houses (extending as far as the church of San Geminiano), with two storeys of apartments for Procurators' dwellings above the ground floor, like the recently-built wing by Buon on the other side (Plate 8).[33]

What transpired in the Procuracy in the months which followed this decision has not been recorded, but the project must have been discussed verbally, for it underwent a radical transformation. In the event, for unspecified reasons, construction was begun not on the south side of the Piazza as first proposed, but in the Piazzetta opposite the Doge's Palace. On 6 March 1537 it was recorded that work had just started on the site of the bakers' shops near the Campanile, using a model prepared by Sansovino. It was on that day that the Procurators resolved to house in the new building (originally intended for their own dwellings) the magnificent collection of Greek and Latin manuscripts bequeathed to the Venetian Republic by Cardinal Bessarion in 1468.[34] This was a momentous decision, for the Library of St. Mark's was to become Sansovino's best-known work.

As Francesco Sansovino pointed out in his guide of 1581, his father proposed to continue the elevation of the Library around the whole of the south side of the main Piazza, as far as the church of San Geminiano.[35] It must have been Sansovino who suggested widening the main Piazza, making it trapeze-shaped instead of rhomboidal, so that the Basilica became the centrel feature at the east end (Plate 9 and Figure i). This plan drew attention to the Campanile, which emerged as a separate monument in its own right, and allowed the arcade to run unbroken around the corner between the Piazza and the Piazzetta.[36] Sansovino even planned to continue the porticoes of the Piazza along the front of the little church of San Basso near the Clock Tower.[37] After Sansovino's death it was left to Scamozzi to complete the whole scheme;[38] but the later architect did not simply continue the two-order elevation of the Library, as Francesco Sansovino suggests was his father's intention, but built two storeys above the ground floor to comply with the original commission for that part of the Piazza (Plate 10). What Sansovino himself would have done is unclear. If he really intended to extend the two-order elevation around the

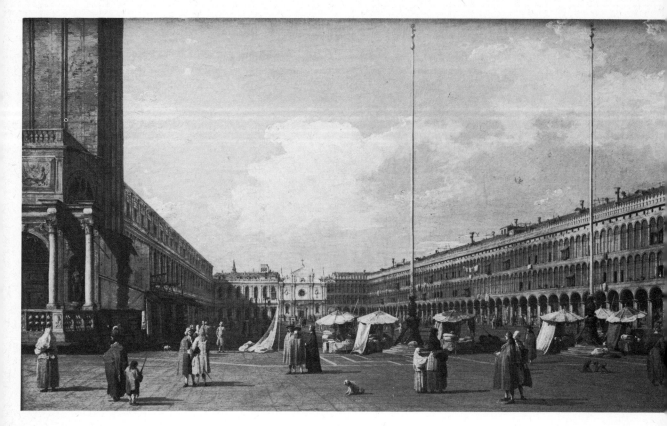

10. Canaletto: *View of Piazza San Marco with the church of San Geminiano*, 1730–31.

main Piazza, then Scamozzi altered the delicate balance between the heights of the two sides, and lost something of the effect of a huge open-air room with the ceiling removed. However, it is highly unlikely that either architect would have been able to resist the Procurators' demands for space in their new residences.

Sansovino was not the first architect in Renaissance Italy to undertake such a radical renewal of an urban complex. The effectiveness of arranging the various buildings of the city centre in a single unified scheme had already been demonstrated in the fifteenth century in the new town of Pienza, designed by Bernardo Rossellino. In emphasising the continuity of the portico Sansovino was following in the wake of more recent schemes for transforming town centres by the construction of new arcaded buildings—as at Vigevano and Loreto. Parallel to his activities in Piazza San Marco were Michelangelo's plans to give a new face to the Capitol, the centre of Ancient Rome.[39] Yet Sansovino's own achievement can scarcely be underestimated. His deep understanding of the complex economic and human problems involved, his capacity to conceive ideas on a huge yet realistic scale, and his intimate relationship with his distinguished patrons, allowed him to transform the appearance of the centre of Venice—giving it dignity, coherence and harmony—even if he never lived to see the final result.

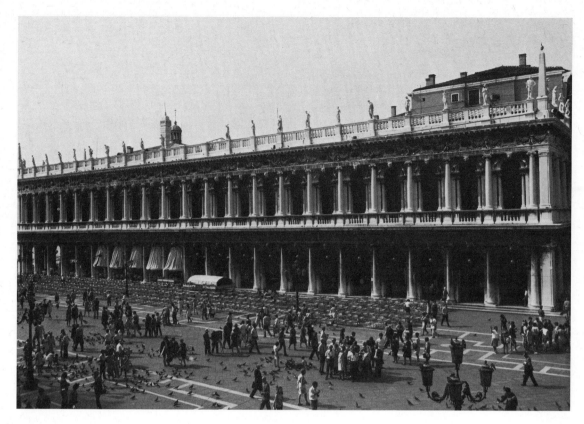

11. Jacopo Sansovino: The Library of St. Mark's, Venice, begun 1537.

THE LIBRARY

The Library of St. Mark's lies along the west side of the Piazzetta, facing the Doge's Palace on the opposite side. It is one of the most striking buildings in Venice (Plate 11). The elaborately carved Istrian-stone façade is twenty-one bays long, with a Doric order on the ground floor surmounted by an Ionic *piano nobile* and finally a crowning balustrade carrying a row of skyline statues. On the west side it adjoins the State Mint, which Sansovino was also to rebuild during the same period. (This commission, awarded not by the Procuracy but by the government, will be discussed in the next chapter.) The façade of the Library exudes a richness appropriate both to the distinguished site and to the eminence of the Procuracy which commissioned it. What were the circumstances which led such a notable monument to be conceived and constructed?

The choice of the Piazzetta site for the Library in 1537 was made after over half a century of indecision and vacillation.[40] It was no small scandal that Bessarion's bequest had been neglected for so long. It included one of the richest collections of Greek manuscripts then in existence—some 500 in all.[41] And the fact that Venice was a major centre of Greek studies made this state of affairs even more disgraceful. The conditions of the bequest had stipulated that the Procurators should provide suitable premises for the Library in or near the Basilica.[42] At first the books were stored in a room near the Doge's Palace, but

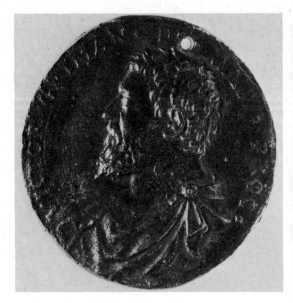

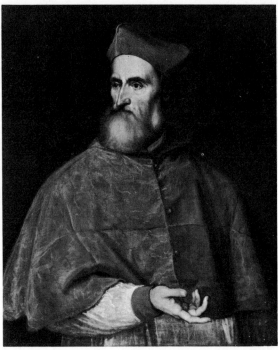

12. Medal with portrait of the Procurator Vettor Grimani.

13. Titian: *Cardinal Pietro Bembo, c.*1540.

they took up valuable space, and at one point the Senate even considered handing them over to the monastery of Santi Giovanni e Paolo.[43] In 1515 another proposal, to house the Library in Buon's new wing in the Piazza, was revoked because of the shortage of public funds in the aftermath of the League of Cambrai.[44] Eventually, in 1531, the precious books, still in their original crates, were moved out of the Doge's Palace into an upper room in the Basilica.[45]

However, this makeshift solution did not satisfy everyone. By this time some of the books had been damaged, and others lost. The two people who made the greatest efforts to persuade the Procuracy to carry out Bessarion's wishes and to give the books a suitably distinguished home were the Procurator Vettor Grimani (Plate 12) and the new librarian, Cardinal Pietro Bembo (Plate 13). Vettor Grimani, as Vasari tells us, was one of Sansovino's closest friends, and a loyal supporter of the architect.[46] He was the grandson of the previous Doge, and nephew of Cardinal Domenico Grimani who had employed Sansovino in Rome. In April 1532 Vettor urged his colleagues to give first priority in their building programme to the provision of a new library, before they used up any funds on the reconstruction of their own houses.[47] A few weeks later, Bembo, who was also a friend of Sansovino's, reminded Doge Gritti of the need to find a permanent home for Bessarion's bequest, and the Doge called the Procurators to discuss the matter.[48] Since his appointment as librarian and official historian in 1530, Bembo had been trying to recover 'borrowed' books and to restrict lending, and he also took trouble

to make provisions for visitors to consult the codices, and for manuscripts to be printed or copied. He was a most assiduous librarian—stimulated by his fervent enthusiasm for classical studies—and he must have felt a deep sense of shame at the sad state of Bessarion's priceless bequest.[49] His intellectual curiosity also embraced a keen interest in architecture, and it was this combination which made him a particularly powerful promoter of the new Library.[50]

As we have seen, there is no evidence to suggest when the initial commission, issued in 1536 for a three-storey building in the Piazza, was amended. Whether the new function of the Piazzetta building as a library called for a completely revised model, or indeed whether a three-storey design was ever produced, cannot be ascertained.[51] Construction work had begun in the Piazzetta in February 1537, only a month or so before the decision to put Bessarion's library there. Thus the building had clearly not progressed very far by the time the change was made.[52] The purchase of materials and monthly payments to workers continued for the next three years without interruption, although during this initial burst of activity no more than a small section near the Campanile was under way.[53] The date 1538 appears in one of the arches at this end of the building. Of the five hostelries on the site, only part of the first of these, the Pellegrin, had so far been demolished, together with the bankers' shops in front of it.[54]

It would have been inconceivable to clear the whole of such a valuable site at the very beginning. Hostelry rents were considerably higher than those of ordinary houses and shops. Since the Procuratia de Supra depended on rents as its main source of income, piecemeal demolition was the only sensible procedure. Besides, the Procurators were legally obliged to keep at least three inns in Piazza San Marco, and it was not easy to find alternative sites for the demolished hostelries.[55] Provision for moving the Pellegrin was not made until 1544 when it was decided to pull down the rest of the inn. A group of houses near the Piazza, in the street known as the Spadaria, was selected and converted for the purpose. Sansovino's scheme for this hostelry provided for several new shops as well, a useful supplement to the Procuracy's rent income.[56] This was one of the projects mentioned by Vasari which earned for Sansovino the favour of his employers by increasing the revenue accruing from their properties.[57] In order to carry through such a major building programme as the new Library, he shrewdly realised that he had to convince them of his awareness of the need to economise in other ways. Vasari's account of Sansovino's career as *proto* emphasises how he was a financial boon to the Procurators, for which 'he fully deserved their love and affection'.[58]

The basic model for the Library, described in one of Aretino's letters in 1537, consisted of a two-storey elevation, Doric below and Ionic above.[59] However, it can have been no more than a repeatable bay-system, for a design for the corner had still not been supplied in 1539. In that year Sansovino carried off a remarkable publicity stunt by appealing to architects from all over Italy for suggestions. The problem he posed was how to comply with Vitruvius's recommendation that half a metope should fall at the end of a Doric frieze (Plate 14). (Since the triglyphs must be placed above the columns, there is normally no space for a full semi-metope beyond the final corner column.) In

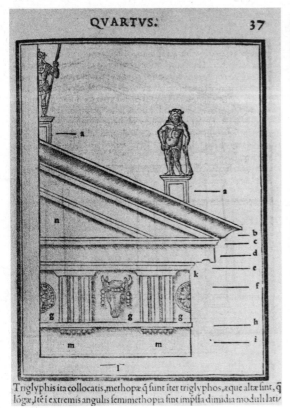

Triglyphis ita collocatis, methopæ q̃ sunt iter triglyphos, æque altæ sint, q̃
lõgæ. Itẽ í extremis angulis semimethopia sint impłła dimidia moduli lat̃

14. Vitruvius: The Doric frieze, from Fra
Giocondo's edition of the *Ten Books on Architecture*,
1511.

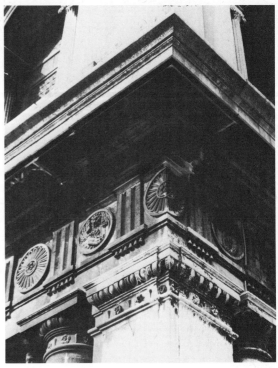

15. The Library, detail showing corner.

the meantime, as his son Francesco recounts, he had secretly solved the problem
himself, and at the last moment he suddenly revealed his ingenious solution.
This involved lengthening the end of the frieze by superimposing the final
pilaster on a wider pier behind, so that the last metope was wide enough for a
full semi-circle instead of a small segment (Plate 15). Thus the desire for
Vitruvian orthodoxy was satisfied, and the corner of Sansovino's Library has
been admired ever since.[60]

Alas, this initial display of virtuosity was followed by a disaster which
seriously undermined the confidence of his patrons—at least temporarily. On
the night of 18–19 December 1545, the vault of the first bay of the great *salone*
of the Library collapsed, noiselessly and unpredictably. That same night
Sansovino was actually thrown into gaol, and although he was soon released
his career suffered a serious setback. Even with the support of such illustrious
friends as Titian, Aretino and the Spanish ambassador Mendoza, he was harshly
treated by the Procurators. His salary was suspended, and he was ordered to
repair the damage at his own expense.[61] Only the faithful Vettor Grimani
disassociated himself from the Procurators' decision.[62]

The first reactions to the disaster seem, in fact, to have been out of proportion
to the actual degree of destruction. As Sansovino wrote to Bembo in the
following year, 'The whole thing was not as great as it had seemed at first—

only one window fell, together with the vault above it.'[63] Sansovino estimated the cost of repairing the damage at 800–1,000 ducats, a mere fraction of the amount already spent on the building. He blamed the collapse chiefly on the effects of frost, the vibrations caused by artillery fire from a galley, and the premature removal of the props by ignorant workmen. But he was forced to admit that his employers' preference for a wooden ceiling—voiced some time before by the Procurator Antonio Capello—was probably wise.[64] Sansovino's experiences in the circles of Bramante and Raphael in Rome had left him with a high regard for great vaulted spaces, but in Venice he was forced to compromise with the more conservative wishes of his patrons, who were aware of the potential instability of the terrain in the city.[65] As we shall see, this was not the only occasion on which Sansovino was persuaded by Venetian clients to use wooden beams, which had the advantage of greater elasticity, rather than a vault.

Less than a year after the disaster the building was inspected and found to be 'stronger, safer and more durable than before the collapse'.[66] Yet a proposal to grant him an interim payment of 100 ducats as a means of livelihood was turned down because of the opposition of one Procurator, Piero Grimani, and the absence of two others.[67] His salary was not restored until more than two years after the calamity;[68] and the sum of 1,000 ducats which he owed for the repairs was not finally discharged until twenty years afterwards when it was set against payments for various sculptural commissions.[69] The submissive way in which Sansovino accepted his fate is a measure of his respect for his employers and his acknowledgment of their absolute authority over him. Indeed he commented wistfully to Bembo in his letter of 1546, 'May God forgive the one who wished it to be done in that way.'[70]

In the same letter to the librarian, Sansovino claimed that the Library was now usable. He was a little over-optimistic, considering that the roof had not yet been built, but this was soon remedied. At the end of 1546, the Procurators borrowed 300 ducats from their trust funds to pay for the roof, so that the first five shops in the arcade could be let to bring in some revenue.[71] By the early fifties the first seven bays—the very ones which contained the Library reading-room on the *piano nobile*—had been completed.[72]

The next stage in the demolition of the hostelries began smoothly. In 1550 the tenants of three houses in Campo Rusulo, a little square near Piazza San Marco, were evicted so that their homes could be converted for the Osteria del Cavaletto.[73] Rehousing the last of the hostelries in the row, the Lion, turned out to be the most complicated undertaking. Two possible sites were considered—one in the Merceria, and one at Santa Maria in Broglio—but each turned out to be unsuitable. The former was a cramped site, exposed to a serious fire-risk, which needed an expensive conversion. The latter was occupied by a stubborn tenant who steadfastly resisted every attempt to evict him.[74] Eventually, in 1556, another site was chosen, and the Lion was rehoused in Campo Rusulo near the new Cavaletto.[75] According to Vasari, the moving of these hostelries increased the Procuracy's rent income by as much as 400 ducats a year, an estimate supported by the evidence of surviving inventories.[76] The Procurators had now fulfilled their obligation to retain three hostelries in or near the Piazza. In consequence, the replacement of the two other demol-

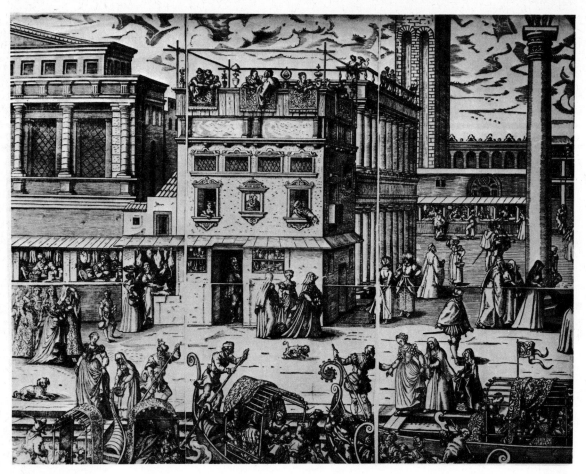

16. Jost Amman:
*The Procession for the
Doge's Marriage with
the Sea*, woodcut,
detail showing the
unfinished Library,
mid-sixteenth
century.

ished hostelries, the Luna and the Rizza, was less pressing, and these were not
reopened in new premises until the 1570s.[77] The whole of the main hostelry
block had now been demolished. Only a smaller building at the far end of the
site, beyond the entrance to the Mint, was still standing.

The storm which had broken over the collapse of just one bay of the
Library is a symptom of the enormous importance which was attached to the
project. It was the prestige element which encouraged the Procurators to make
a special effort to press on with the building work in the 1550s, despite the fact
that the boom conditions of the thirties had now been superseded by a more
problematic situation of high inflation. The prospect of additional rent income
from the new shops in the arcade was an extra incentive. In 1551 they decided
to elect one of their number every year to take special responsibility for the
scheme.[78] The incomplete state of such a conspicuous monument was a source
of shame and embarrassment to the Procuracy. As they explained in a long
motion in 1552, they felt a duty to their ancestors, who had spared no expense
in embellishing the city, to complete the building 'for the honour and dignity
of our Republic, and for the benefit of the church'.[79] The odd appearance of
the partly-finished Library is clear from two engravings dating from the
mid-sixteenth century (Plates 16 and 31). In the drive to complete the project,
attempts were made to keep strict control over the building expenses.[80] But

22

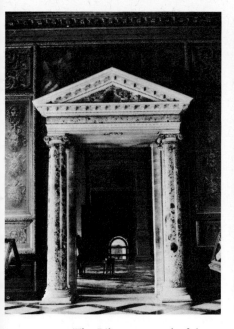
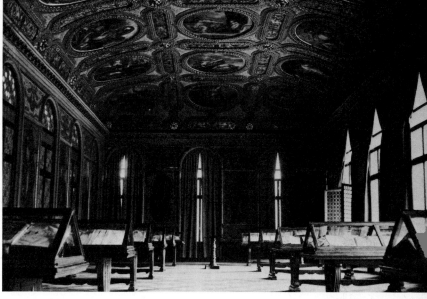

17. The Library, portal of the reading-room, 1553.

18. The Library, reading-room.

this alone was not enough. In the early fifties the Procuracy resorted to various extra fund-raising measures to augment the usual annual grant of 1,200 ducats set aside for the building. Money was drawn from a variety of sources—from the recovery of unpaid rents, the sale of unprofitable *terraferma* holdings, income from government bonds held by the Procuracy, the rent on two priories near Bergamo, and even loans from the kitty which financed the day-to-day running of the Procuracy.[81] Thanks to these exceptional provisions, work proceeded at an unprecedented rate. During the three-year period 1551–54 exactly twice as much of the building was constructed as in the previous fourteen years. By 1554 fourteen bays had been finished, and two years later the Library was sixteen bays long.[82]

The later 1550s were devoted chiefly to the decoration of the interior, so that the Library could finally be opened. The first stage was the execution of the grand marble portal of the reading-room, begun in 1553 (Plate 17).[83] The painted decoration of the ceiling of the *salone* also took high priority (Plate 18). Contracts were awarded to seven different painters for the twenty-one ceiling roundels in 1556.[84] The books were probably moved from the Basilica to the new Library soon after the completion of the ceiling, and they were certainly in their new home by 1564—almost a century after Bessarion's bequest.[85]

The decoration of the vestibule and the staircase, a less urgent matter, was begun somewhat later, in 1559.[86] Sansovino treated these two components as separate elements in his design (Figure ii)—in contrast to the other famous library then under construction in Italy, Michelangelo's Laurentian Library in Florence, in which the vestibule actually contained the staircase leading up to the reading-room. In Sansovino's Library the vestibule had a specific function

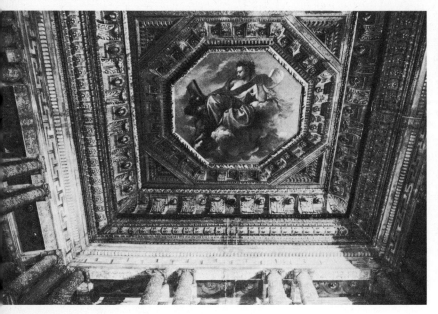

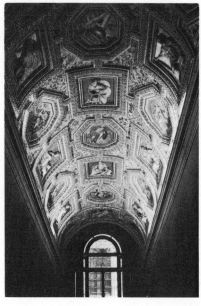

19. Titian: *Allegorical figure (Wisdom?)*, after 1560, with perspective surround by Cristoforo Rosa, Library, vestibule ceiling.

20. The Library, staircase, ceiling decoration, begun *c.*1559.

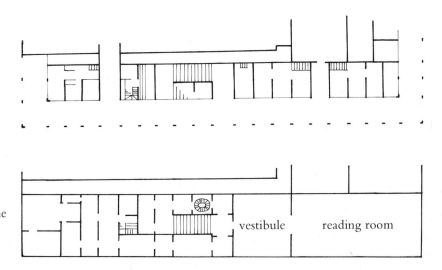

ii. Jacopo Sansovino: The Library, Venice, begun 1537, plans of ground floor and *piano nobile*.

vestibule reading room

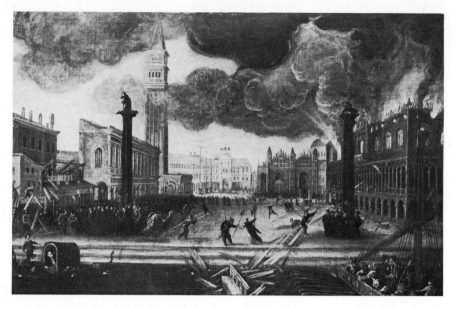

21. Pozzoserrato: *Fire in the Doge's Palace*, 1577.

of its own, to house the public school previously held near the Campanile. In this school two lecturers were employed by the State to give classes to young nobles in humanistic studies. The fact that the range of the curriculum—Greek and Latin philosophy, law, history and literature—mirrored the contents of Bessarion's library made the vestibule a most appropriate setting.[87] Just as the iconography of the reading-room ceiling, extolling the pleasure and satisfaction afforded by learning, encouraged the library-users in their quest for knowledge, so Titian's allegorical painting on the ceiling of the vestibule (Plate 19), thought to represent Wisdom (or possibly History), aimed to inspire the young patricians to study diligently. Work on the wall-decoration and the wooden furniture of both the vestibule and the reading-room dragged on into the 1560s and beyond, but apart from these finishing touches both rooms were virtually finished by the time of Sansovino's death in 1570. The vestibule was converted into a museum for the Grimani collection of antique sculpture in 1591–96, and apart from the ceiling the original decoration and furnishings were removed.[88] However, the staircase still preserves its rich *all'antica* stucco and painted ceiling decoration (Plate 20).

Unfortunately the architect never lived to see the remaining five bays of the building erected. The Library now extended as far as the entrance to the Mint (Plate 21).[89] It still remained to demolish the last building on the site, which contained a meat market on the ground floor. The five bays yet to be built were to contain the Procurators' offices on the *piano nobile*. The original intention had been to incorporate the meat market into the lagoon end of the new building, but it was now becoming apparent that, because of the space taken up by the portico, there would not be enough room left for the butchers' stalls. In 1563 Sansovino surveyed three possible alternative sites, but the discussions which followed in the Procuracy made it clear that none of these was ideal. Yet the need to remove the meat market from the Piazzetta was now fully recognised—it was after all hardly appropriate for such a distinguished

25

site. Its transfer would be a natural sequel to Sansovino's earlier attempts to separate commercial and political activities in the city centre. Eventually, in 1565, the Collegio decided on the site preferred by Sansovino himself, at Santa Maria in Broglio, but after this the matter seems to have been dropped. In the past the Procurators had been prepared to take extraordinary trouble over their greatest showpiece. Now, however, the Library's chief promoter in the Procuracy, Vettor Grimani, was dead; and the aged Sansovino seems no longer to have had the energy or influence to overcome such difficulties. The meat market was not moved until 1580, and the last five bays were finally erected under Vincenzo Scamozzi between 1588 and 1591.[90]

It is sad that Sansovino never saw the work which is generally considered his masterpiece in its finished state. According to Vasari, widely travelled connoisseurs judged it to be without parallel anywhere.[91] This was also the building which Palladio called the richest and most ornate since Antiquity.[92]. It was the *all'antica* character of the Library which most impressed contemporary critics. Aretino wrote in a letter to Sansovino, 'You are the man who knows how to be Vitruvius.'[93] Sansovino's vast knowledge of the antiquities of Rome and his thorough familiarity with Vitruvian doctrine were welcomed in Venice, the city which hungered for opportunities to rival the great civilisations of Antiquity.[94] As the Senate pointed out in their decree of 1515, the whole notion of building a splendid public library was a conscious attempt to emulate the Ancients.[95] Few libraries since Antiquity had been open to the public—in the Middle Ages most of them were attached to princely courts or monasteries, and used only by certain privileged scholars.[96] Bessarion's stipulation, in the conditions of his bequest, that his library should be accessible to any reader thus offered a great chance to re-create an aspect of ancient civilisation.[97]

Both Vitruvius and Alberti had expressed admiration for the libraries of Antiquity in their treatises, but neither gave any indication of the appearance of the buildings they occupied.[98] Classical literary sources were a little more informative. For instance, Pausanias in his guide to Greece described the library built by Hadrian in his temple in Athens as 'the hundred columns of Phrygian marble, with walls built just like the columns, and pavilions with gilded roofwork and alabaster, decorated with statues and paintings. Books are kept in them.'[99] The remarkable series of resemblances between Sansovino's Library and these fragmentary records of ancient prototypes—the vicinity to the Basilica (or temple), the adjoining vestibule and school, the surrounding colonnade, the fine precious marble columns, the gilded ceiling, and the rich painted and sculptural decoration—can hardly be fortuitous.[100] After all, the humanistic emphasis in the contents of Bessarion's bequest called for a classicising setting. To an even greater extent than in Michelangelo's Laurentian Library (which was, in fact, part of the monastery of San Lorenzo), little survived in Sansovino's project of the ascetic atmosphere of medieval libraries.[101] Even the choice of the Piazzetta site for the Library had a classical justification, for it complied with Vitruvius's recommendation that libraries (like bedrooms) should face the east—to admit morning light and to protect the books from decay.[102] Vitruvius's treatise, published in Venice in 1511 in Fra Giocondo's famous edition, was well known in the city (a fact which

accounts for the amazing impact of Sansovino's corner solution).[103]

Despite Vasari's claim that the Library first demonstrated to the Venetians how to apply Vitruvian discipline in architecture, Sansovino did not adopt strictly Vitruvian proportions for the orders of the Library, treating the 'grammar' with a freedom more typical of ancient Roman architecture in reality than Vitruvius's codification would suggest.[104] But unlike the other architects who contributed the fruits of their Roman experience to the local building tradition, Sansovino had the rare opportunity of embarking on a building project on the prodigious scale of the ancients, the Library being conceived to extend around the whole of the south side of the main Piazza to the church of San Geminiano. Thus its *all'antica* character not only reflects the contents of Bessarion's bequest, but also expresses the grandeur of the city's political centre as a whole, the classical reminiscences gratifying the yearning of the Serenissima to emulate ancient civilisations.[105]

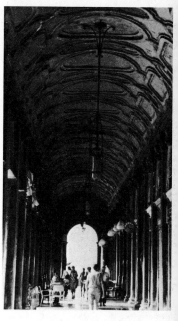

22. The Library, arcade.

To Venetians it was naturally the unfamiliar classical elements in the Library which made the strongest impression. To an outsider, on the other hand, the peculiarly Venetian character of Sansovino's design would have been equally striking. It is difficult to imagine the Library in any setting other than Venice. The degree to which Sansovino managed to assimilate the indigenous architectural tradition, even in his first Venetian works, is remarkable. The Library reproduces the basic arrangement of the previous building on the site —the two-storey elevation with a ground-floor arcade and balconies on the *piano nobile* (Plate 6)—which would have been foremost in the minds of his employers when they commissioned the new building. Sansovino replaced the Veneto-Byzantine crenellations with a more up-to-date balustrade (recalling Raphael's Palazzo dell'Aquila in Rome), and crowned it with a row of skyline figures, complementing the statues on top of the Basilica. Florid skylines are a distinctive feature of the Venetian townscape.

Furthermore, the use of local materials gives the Library a strong Venetian flavour. Istrian stone, transported cheaply to Venice by sea, is exceptionally easy to carve, and the fall of morning light on the brilliant white stone brings out the richness of the carving and emphasises the deep shadows of the portico. The façade of the Library in fact plays no structural role, but is simply a veneer superimposed on a brick skeleton beneath. In Venice, elaborate Istrian-stone façades were a feature of the more ostentatious buildings, such as the Scuola Grande di San Rocco (Plate 74), begun two decades before the Library. Similarly, plentiful supplies of glass in the city allowed Sansovino to eliminate the wall-surface as an expressive element in the design. Air seems to circulate freely through the building—through the crowning balustrade, around the paired columns framing the first-floor windows, and along the portico below (Plate 22).

Not only do juxtapositions of light and shade enliven the façade. The effect of richness and variety is conveyed, too, by contrasts between horizontal and vertical forces, mobile and static elements, and rounded and angular forms. The strong horizontal stress exerted by the continuous heavy projecting cornices (reminiscent of Coducci's Palazzo Vendramin) on a façade of this length was a bold gesture on Sansovino's part, especially considering that the elevation was to be continued around the whole south side of the main Piazza.

27

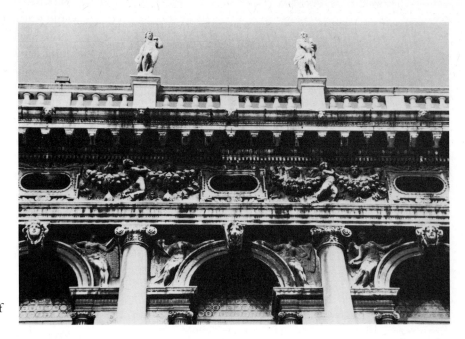

23. The Library, detail of upper order.

The architect achieved the compensating vertical emphasis needed by clearly indicating the continuous upright structural axes. As the eye follows these axes upwards, the forms become progressively lighter and more mobile. In the *putti* in the upper frieze, the downward vertical force finally breaks into movement, so that the skyline figures above appear to be released from the building and to soar into the sky (Plate 23). Such tensions between movement and stability are attenuated by the combination of lively sculptural decoration with the solid, grid-like framework of the façade. Juxtapositions of rounded and angular forms are exploited repeatedly to give variety to the long elevation —the triglyphs and metopes of the Doric frieze, the round half-columns and square corner piers, the skyline obelisks and statues, and the cubic blocks in the balusters of the balconies. Sansovino fully exploited his unique opportunity to work with an exceptionally generous budget, and it is no wonder that this splendid showpiece should be considered his *capolavoro*.

THE LOGGETTA
Until Sansovino's scheme for the transformation of Piazza San Marco was put into effect, the Campanile of the Basilica stood hemmed in by buildings on two sides (Figure i). Only narrow alleys separated the tower from the neighbouring structures. By realigning the buildings on the south side of the main Piazza, Sansovino planned to isolate the Campanile as a free-standing monument. The Piazza and the Piazzetta would thus be intervisible, and the uninterrupted arcade around the corner of the new building would emphasise the continuity between these two spaces. In consequence, the Campanile would become a far more prominent feature of the whole complex (Plate 9). As soon as this plan was formulated, it must have been obvious that the shabby little loggia at the base of the bell-tower would also have to be replaced.

28

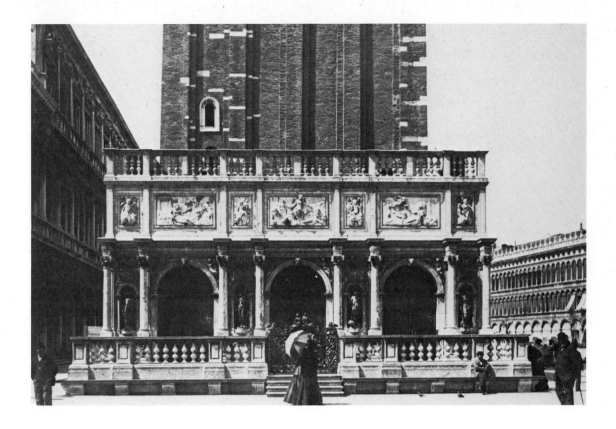

The old Loggetta, as Bastiani's view of the Piazzetta indicates, was a simple lean-to shelter with a triple arcade supported on four stone columns. It was used by the nobility as a meeting-place when they came to the Piazza on government business. The site at the foot of the Campanile was a particularly hazardous one—whenever the tower was struck by lightning the Loggetta was liable to be hit by falling masonry, and it was also badly damaged in the earthquake of 1511.[106] Although it was repaired on each occasion, it could hardly be expected to hold its own aesthetically amid the magnificent complex of buildings, free from stalls and other eyesores, which Sansovino envisaged for the centre of Venice.

Like the Basilica and most of the rest of the buildings in the Piazza, the Campanile and the little loggia below it were administered by the Procuratia de Supra. They must have decided to commission a new Loggetta before November 1537, when Aretino mentioned the project in his famous letter of admiration to Sansovino.[107] Early in the following year the caretaker of the Loggetta, who was also the sacristan of the Basilica, was awarded a salary increase because of the extra work caused by the rebuilding.[108] From the Procurators' account-book for this period, it appears that most of the main structure was erected between 1538 and 1540. The sculptural decoration was applied afterwards—the first purchases of red and white marble date from early in 1540.[109] Sansovino's four bronze figures were ready in 1545, by which time the building seems to have been more or less completed.[110]

24. Jacopo Sansovino: The Loggetta, Venice, begun 1537.

25. Giacomo Franco: *The Loggetta*,
engraving published 1610.

26. Jan Grevembroch: *The
Loggetta with the Guardia Regia*,
early eighteenth century.

The patricians probably began to use their new meeting-place as soon as possible—maybe even before the final touches were added to the decoration. The Loggetta was open every morning until noon, and then again in the evenings (lit by oil lamps in winter).[111] However, it seems that the new building was not such a welcoming spot as the old one—perhaps the small flight of steps in front of Sansovino's Loggetta discouraged the nobles from wandering in casually, as they had before. By 1581, when Francesco Sansovino published his guide to Venice, the habit had already died out.[112] The Loggetta was now usually kept closed, except on Sundays during the assemblies of the Great Council, when it was occupied by three of the Procurators, attended by fifty guards supplied by the Arsenal as fire-watchers.[113] The Procurators themselves sometimes held meetings in the Loggetta.[114] At last, in 1734 it acquired what was arguably its most successful function, as the headquarters of the Public Lottery.[115]

The Loggetta is a small pavilion faced in red and white marble attached to the base of the Campanile (Plate 24). The three-bay façade is articulated by pairs of free-standing Composite columns in various different types of Oriental marble. Four bronze statues occupy the niches between them, and all the available surfaces are sumptuously decorated with relief sculpture. The building as we know it today has undergone several changes. A spirited engraving by Giacomo Franco, published in 1610, shows the appearance of the Loggetta in its original state (Plate 25). In the seventeenth century the side windows of the façade were converted into doorways, and iron grills were installed in the lunettes. The red marble benches in front were replaced by a

wide terrace surrounded by a marble balustrade (Plate 26). In the eighteenth century a bronze gate was placed across the entrance to this terrace; and the attic storey—believed at that time to have been left incomplete—was extended across the whole width of the façade. The Loggetta was totally crushed when the Campanile collapsed in 1902, but it was rebuilt as before, with the addition of a marble facing on the brick walls at the sides.[116] The latest restoration had revealed the vivid and varied colour of the marble, but nevertheless the architect would have been more than a little surprised to see the building in its altered form.[117]

The fact that the Loggetta was extremely small in scale compared with the other buildings in the Piazza was a major influence on the design. If it was to stand up to its distinguished setting, it had to be sufficiently eye-catching to compensate for its diminutive proportions. The basic construction costs were correspondingly small, so that the Procurators were not forced to economise too strictly. Whereas more than 28,000 ducats were spent on the first sixteen bays of the Library, the Loggetta cost only 4,258 ducats and 14 grossi.[118] Yet even this relatively modest sum was an extravagant price to pay for what was, after all, only a small shelter. As in the case of the Library, the main structure was built in brick; but the lavish materials used and the copious sculptural decoration of the outer coating show that the Procurators were more interested in display than in utility (Plate 27).

No expense was spared in the acquisition of stone. Red Verona marble, most of it supplied by a cousin of Michele Sanmicheli in Verona, forms the framing elements in the architecture—the cornices, the crowning balustrade, the panelling inside the niches, and the frames of the upper reliefs. The pilasters behind the columns and the convex frieze of the main entablature are made of white Carrara marble veined with grey; and this stone was also adopted for the capitals and the crowns of the arches. Sansovino's great friend, Marc'-Antonio Giustiniani, whom he had met in Rome, provided much of the white marble, which was not easy to obtain in Venice.[119] A dark green marble, known as verde antica, forms the vertical strips between the niches and the main pilasters. The reliefs are of Istrian stone, which is easier to carve than marble. Rare Oriental marbles were used for the eight projecting columns, increasing in richness of colour and texture towards the centre. In spite of the variety of materials used, the effect is by no means gaudy, but is carefully contrived to tone in with the surroundings. The dominant colours, red and white, were not a casual choice. The colour scheme of the Loggetta echoes the warm red of the brick Campanile above; and at that time the Piazza, too, was paved in red brick. Red and white are also the colours of the façades of the Doge's Palace.

Although it was so small, the Loggetta had an important role to play in the sixteenth-century transformation of the Piazza. Sansovino was certainly aware of the scenographic arrangement of the Piazzetta, especially when seen from the lagoon. The Clock Tower acts as the focal point in this prospect, while the Loggetta and the Basilica project forward in front of it on either side like the wings of a stage. Hence the rich colours of the Loggetta are designed to balance the polychromatic exterior of the Basilica opposite. Not only did the Loggetta serve as part of the 'scenery' of the Piazzetta, it also acted as the focal point in the view from the Scala dei Giganti (Plate 28) (so-called on account of the

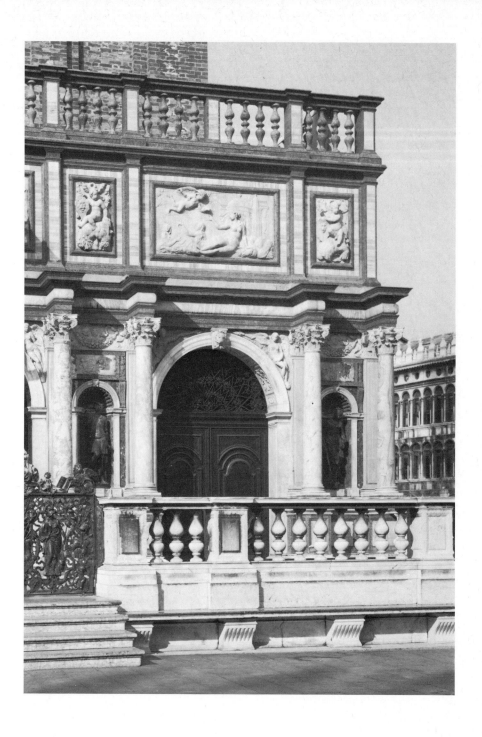

27. The Loggetta, detail, since latest restoration.

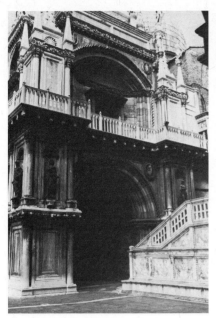

28. The Doge's Palace, Venice,
view of the courtyard with the
Scala dei Giganti and the Arco
Foscari, fifteenth century.

29. View of the Loggetta through the
Arco Foscari from the Scala dei Giganti.

great statues of Mars and Neptune added by Sansovino towards the end of his
life). This splendid staircase in the courtyard of the Doge's Palace was the
setting for Ducal coronations and was used by all important visitors entering
or leaving the palace.[120] The Venetians had long been sensitive to scenographic
effects unfolding along significant axes. It can hardly be accidental that from
the top of the Scala dei Giganti the upper edge of the main door of the palace,
seen through the Arco Foscari, blocks out the Loggetta at the level of the main
cornice; while from the landing half-way down, the door cuts the façade at the
upper cornice, above the attic reliefs (Plate 29). The width of the Loggetta is
revealed bay by bay as the spectator approaches.

Like the Library, Sansovino's Loggetta combined ideas from his Central
Italian experiences with features of the local architectural tradition. Here, too,
the use of locally available materials gave the building a peculiarly Venetian
feeling. Verona marble was not expensive in the city, and rare Oriental marbles
could be brought by sea from the eastern Mediterranean. (Yet even in Venice
such rich materials were used only for relatively small buildings such as the Ca'
d'Oro and the church of the Miracoli.) Again in this case the Loggetta repro-
duces the basic components of the previous building on the site—that is, a
triple arcade with a central entrance (Plate 6). The niche figures and the red and
white marble echo the Arco Foscari in the Doge's Palace, which frames the
view of the Loggetta from the Scala dei Giganti (Plate 28). Projecting columns
were not uncommon in Venice—appearing for example on the façade of the
Scuola di San Rocco (Plate 74)—but their use in the Loggetta is also reminis-

33

cent of the similar feature on the left side of Raphael's fresco of the *Fire in the Borgo* in the Vatican, which has a theatrical layout not unlike the Piazzetta. The variety of precious materials, the bronze statues in niches, and the garlands hung between the capitals again look back to Raphael, this time recalling the Chigi Chapel in Santa Maria del Popolo. The façade of the Loggetta is adapted from early triumphal arches—an early drawing by Francesco da Ollanda actually omits the Campanile and portrays the Loggetta itself as a triumphal arch.[121] Vasari's description of Sansovino's temporary façade for the Duomo in Florence, erected for the entry of Leo X in 1515, suggests that in many respects this early project foreshadowed his design for the Loggetta, a link which underlines his conception of the Loggetta almost as a piece of scenery.[122]

Like the decorations in honour of Leo X, the Loggetta was a forceful vehicle of political propaganda. Commissioned at the end of the illustrious reign of Doge Andrea Gritti, it was an expression of the self-confidence and optimism of the Venetian Republic at that time—reflected not only in the flamboyant character of the design, but also in the specific content of the iconography. According to Francesco Sansovino the Loggetta was proposed and promoted by the Procurator Antonio Capello, who possibly invented, or at least commissioned the iconographic programme.[123] Francesco records his father's explanation of the significance of the Loggetta sculptures—the four bronze figures stressing the superiority of the Venetian government, and the upper reliefs representing the Republic's power on land and sea. The four statues are identified as Pallas, Apollo, Mercury and Peace. Pallas on the far left signifies the supreme wisdom of the Venetian patriciate. The second figure, Apollo, represents the sun—the one and only sun—to demonstrate the uniqueness of the Venetian Republic; and he is also the God of Music, a reference to the exceptional harmony of the government. The statue of Mercury on the right of the entrance extols eloquence as a means of translating ideals into action. And finally, Peace is a reminder of the value of the pacific policies of the Venetian state. The subjects of the attic reliefs are identical to those of the three bronze standard bases set up in front of the Basilica in 1505 (another high point in Venetian morale). In the central panel the figure of Justice is enthroned between two river-gods representing the *terraferma* empire. The two reliefs on either side symbolise the Venetian possessions in the Mediterranean—Jupiter, former King of Crete, is portrayed on the left, and Venus, Queen and Goddess of Cyprus, on the right. Pietro Bembo's nephew claimed to have found the tomb of Venus while on military service in Cyprus, and according to a report quoted by Francesco Sansovino the supposed tomb of Jupiter had long been on the island of Crete.[124] (Venice in fact lost the possession of Cyprus to the Turks in 1571, the year after Sansovino's death.)

The Loggetta is the most complete surviving visual representation of the 'myth of Venice'—that is, the Venetian view of their own state as the perfect republic. While this concept coloured the political writings of the time,[125] the great fires in the Doge's Palace in 1574 and 1577 destroyed virtually every other artistic interpretation dating from before the loss of Cyprus (Plate 21). The Loggetta served not only to impress on foreign visitors the supremacy of the Venetian state, but also to remind Venetians themselves of the myth. The use of classical allegory and mythology, prompted by the current fashion for

all'antica allusion, would have added another dimension to the almost narcissistic iconography. From Sansovino's point of view, the Loggetta, like the Library, was in effect a public if not a state commission. Despite the fact that the Procurators were discouraged from taking an active part in the government, they occupied an extremely distinguished position in the political hierarchy. They were not strictly a public body, yet they were certainly fully briefed by the Doge and his group of advisors, the Collegio. They naturally recognised that Piazza San Marco was the centre of the Venetian government and that its buildings should be appropriate to the setting. The Loggetta may be small, but it is by no means overshadowed by the imposing monuments which surround it. With its dignified façade modelled on classical triumphal arches and adorned with precious materials and rich sculptural decoration, it fully lives up to its distinguished situation. Perhaps it should be regarded not so much as an architectural work on a small scale, but rather as a great piece of sculpture.

Vasari's contention that Sansovino was continually thinking of ways to improve the financial state of the Procuracy is reinforced by documentary evidence, especially during the first fifteen years of his career as *proto*. The resiting of the Piazzetta hostelries has already been mentioned. Another obvious way to increase the revenue of the Procuracy was to provide extra shop premises. For instance, in 1531 it was decided to convert three shops on the bridge between the Mint and the Granaries (Plate 7) into five narrower ones.

35

For the new shops, Sansovino designed a simple five-bay Doric façade in white Istrian stone, which still exists today, adjoining Sansovino's Mint (Plate 30). (This was his first independent architectural work in Venice—a demonstration piece in the purest style of the Roman High Renaissance—yet, curiously, it has long been forgotten.)[126] Similarly, two years later it was resolved to evacuate all the shops at the foot of the Campanile and rebuild them in greater number.[127] But the fruits of such minor economy measures were trifling beside the cost of the radical rebuilding programme. Throughout Sansovino's career as *proto* attempts were made to control the expense on repairs to the old buildings, but in the more extreme cases of disrepair total rebuilding often seemed a wiser policy than costly restoration.

During the last decade of Sansovino's life the Procuracy's expenditure on repairs reached an exorbitant level. In 1556 they had been granted freedom by the Great Council to manage their own budgeting without Ducal interference;[128] but this liberty was curtailed in 1569 when a body known as the Revisori sopra i Procuratori was appointed to investigate their finances. An inquiry was held into the fact that more than half their total outlay for the years 1559–69 had been spent on repairs to their properties, and especially on work on their own residences. The Procurators defended themselves with eloquent descriptions of the precarious state of their own houses, but the fact remained that they now owed considerable sums of money.[129] From 1570 onwards they were forced to repay their debts at the rate of 6,000 ducats a year, until by 1588 most of the amount had been repaid; and it was only then that they were able to resume building work on the Library.[130]

However, we cannot blame Sansovino for the disastrous state of the Procuratorial finances at the time of his death. The scheme for remodelling Piazza San Marco, begun during a period of relative prosperity in the 1530s, had become a serious drain on the resources of the Procuracy during the harder economic conditions of subsequent decades. Such a comprehensive building project could hardly have been financed easily. The greatest periods of artistic patronage often ended in economic chaos—compare, for example, the state of the papal finances after the death of Leo X in 1521. Besides, even a less imaginative *proto* in sixteenth-century Venice would have been forced to spend heavily on the maintenance of the ancient structures. Sansovino was certainly aware of the need to economise; and the charm and powers of verbal expression which Vasari attributes to him must have been useful vehicles for setting his far-sighted artistic ideas in motion.[131]

The Procurators of St. Mark's were no ordinary patrons. They were the only Venetian institution or public body in which the members were elected for life. This led to an unusually consistent attitude from the group as a whole, whereas in other situations regular changes in the office-holders resulted in less predictable policies. Naturally some of the Procurators were more enthusiastic than others—Vettor Grimani, as we have seen, took a special interest in the Library, and Antonio Capello was responsible for the Loggetta commission; while Piero Grimani, for example, was often hostile to Sansovino's ideas. But even so, their corporate approach towards long-term building projects changed relatively slowly. This stable situation was a great asset to Sansovino, and he took full advantage of it. The Procuracy, like the Scuole Grandi which

we shall investigate in a later chapter, was essentially a charitable institution which nevertheless felt the need to draw attention to its distinguished position in the society through the medium of blatantly extravagant buildings and works of art.

III. The State

ALTHOUGH the position of *proto* to the Procuratia de Supra was undoubtedly the most exalted which the city could offer to an architect, Sansovino himself was never the true state architect of Venice. His chief employers, the Procurators of St. Mark's, owed their powerful position to financial rather than political importance, taking no part in the machinery of government. The magistracy which financed most government building projects, including work in the Doge's Palace, was not the Procuracy of St. Mark's, but the Salt Office, using the revenue from the tax on salt. During Sansovino's years in Venice the post of *proto* to the Salt Office was held at first by the local architect Antonio Scarpagnino, until his death in 1549, and then by a series of lesser-known builders.[1] The other major sector of state building patronage was the defence of the city. In 1535 the fortifications were entrusted to Sansovino's Veronese contemporary Michele Sanmicheli. As military architect Sanmicheli worked for the Waterways Board until 1542 when a special magistracy called the Proveditori alle Fortezze was instituted.[2] However, the state did employ Sansovino in a freelance capacity for two major architectural commissions. One was the rebuilding of the Venetian Mint, his only state commission in Piazza San Marco, and the other a warehouse in the Rialto market, now known as the Fabbriche Nuove di Rialto.

THE MINT
The Mint was administered by a magistracy known as the Proveditori di Zecca who were under the authority of the Council of Ten, the Council responsible for the most crucial matters of state security and finance. The magistracy consisted of two nobles, each elected for a one-year period to supervise the running of the Mint and the administration of capital deposited there. The minting of coins was an important manifestation of the autonomy and prosperity of the state. Venice had been producing her own coins since she first acquired independent trading rights in the mid-ninth century. A century later two new mints were established in Piazza San Marco for the production of gold and silver coins. Copper currency was still manufactured in the older premises at Santi Giovanni e Paolo.[3] The siting of the mint near the seat of government was a long-established tradition in Italy, having obvious administrative advantages.[4] In Venice, while the Rialto was the setting for trade banking transactions, Piazza San Marco became the centre for depositing both state and private capital on a more long-term basis.

The rebuilding of the old Mint or 'Zecca' was to be one of the chief expressions of the recovery of the Venetian economy after the setbacks of the first quarter of the sixteenth century. The decision to replace the old structure (Plate 7) was not merely an outward show of self-confidence—it had also become a practical necessity. In the early 1530s the boom conditions were putting a great strain on the facilities of the old Mint. To cope with the situation, new furnaces were built, a deputy was appointed to assist the supervisor with the growing burden of work, and in 1532 the Council of Ten decided that because of the frenzied activity the Proveditori di Zecca should be re-elected every six months, instead of annually as before.[5] The danger of fire and the lack of security in the old structure also caused concern. In 1533 Doge Andrea Gritti paid an official visit to the Mint, so that he could see for himself the urgent need for a new building.[6]

The decision to rebuild the old Zecca was taken by the Council of Ten late in 1535. It was proposed to commission models from three architects and to start work on the best project without delay.[7] No record has survived of the other two models, but it was Sansovino's which was admired by the Proveditori and the other officials of the Zecca, as well as the artisans employed there. Doubtless with the encouragement of Sansovino's faithful supporter, Doge Gritti, the Council of Ten approved his model in 1536.[8] To avoid putting extra pressure on the finances of the Zecca, the Council of Ten conceived a highly original method of fund-raising. They estimated that on the island of Cyprus, then a Venetian possession, there were as many as 23,000–24,000 slaves, descended from the Barbarian invaders who had been conquered by the Byzantine Empire. In view of this obvious superfluity, it was resolved to order the Cyprus Regiment to raise the sum of 5,000 ducats needed for the construction of the Mint by freeing slaves at 50 ducats a head.[9]

The commission was a rare opportunity for Sansovino. Since minting was absolutely indispensable to the Republic, every effort had to be made to complete the building quickly and to provide the necessary funds. Furthermore, because of the risk of fire caused by the high proportion of wood in the old Mint, the commission specified that the whole structure should be vaulted.[10] As a rule, Sansovino's enthusiasm for vaults was continually frustrated by the Venetian preference for wooden beamed ceilings, which were flexible enough to resist the effects of the shifting subsoil. In the Library, as well as in the Scuola della Misericordia and the church of San Francesco della Vigna, he was obliged to omit great vaults from his designs. But in the case of the Mint, resistance to fire was a more important consideration, because of the great heat generated by the refining and minting processes. Although in order to stand up to the potential instability of the terrain none of the individual rooms was very large, he must have welcomed this unusual stipulation.

In other respects the commission made taxing demands on Sansovino's ingenuity. The site was restricted on all four sides. A canal flowed along the west side, and property owned by the Procuratia de Supra enclosed the other three sides—the Orseolo Hospital to the north, the Piazzetta hostelries (soon to be replaced by the Library) on the east, and a row of cheese-and-salami shops along the south side, facing the lagoon. Yet, although there was no possibility of enlarging the site, Sansovino still had to make provision for the expanding

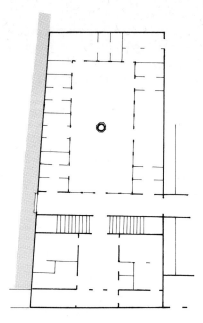

iii. Jacopo Sansovino: The Mint, Venice, begun 1536, plan.

activity of the Mint. To avoid a serious interruption in the production of coins, work had to proceed in gradual stages.[11] This piecemeal replacement must have forced him to adhere closely to the layout of the existing building. The way in which he proposed to distribute the various minting processes is explained in his detailed description of the new Zecca, submitted with his model in 1536 (see Figure iii).[12] The part facing the lagoon, separated from the rest of the building by the entrance hall and staircase, contained the gold and silver foundries. Silver was to be refined on the ground floor, and gold on the *piano nobile* which was both more distinguished and more secure. The rear section consisted of a quadrangular courtyard surrounded by workshops to produce coins from the refined metals. (Again the gold coins were manufactured on the upper floor.) Although he must have had the chance to observe the old Mint in operation and to discuss the project with Mint officials, Sansovino tactfully left the details of his design fairly flexible. The Proveditori di Zecca were to have the final word over the distribution of the workshops. The sizes and forms of the doors and windows would be chosen later, aiming for the maximum efficiency and security.

Building work began quickly, no doubt with some temporary supply of ready cash until the first funds arrived from Cyprus.[13] In 1537 Sansovino was appointed 'proto all fabbricha della cecha' at a salary of 50 ducats a year.[14] In this capacity he drew up contracts to be awarded to the various *maestri*, but he did not supervise the work on a day-to-day basis as he did the Procuracy's building projects. The responsibility for buying materials and supervising the craftsmen fell on the deputy supervisor, not on the *proto*.[15] Sansovino was, of course, responsible for all matters of design. In 1537 the Council of Ten approved his proposal that the Mint should be roofed with lead instead of tiles as planned, for a lead roof, though more costly, would conform with the other major public buildings in the city centre.[16]

40

A major step towards integrating the Zecca into Sansovino's overall plan for Piazza San Marco was taken in 1539. In that year the architect persuaded one of the Proveditori di Zecca, Hieronimo Querini, to negotiate with the Procuratia de Supra for permission to rebuild their cheese-and-salami shops on the lagoon side of the Mint. The façade of the new Zecca would be moved forward to incorporate these shops into the lower part, thus providing more space in the upper rooms of the refineries.[17] For hundreds of years the guild of cheese-and-salami sellers had occupied two rows of shops—one at the Rialto and one in front of the Zecca. Indeed their statutes forbade them to sell cheese in any other part of the city.[18] This was the type of problem which Sansovino constantly had to face in his projects in the centre of Venice. The concept of accommodating cheese-sellers into the new Mint would not have seemed at all surprising at that time. After all, most of the Procuracy's buildings in Piazza San Marco had shops in the ground-floor arcades. Querini apparently had some difficulty in persuading the Procurators to agree to the proposal, although the reasons for their reluctance are not clear. It was Sansovino's friend Vettor Grimani who finally persuaded his colleagues to consent to the agreement.[19] In recognition of their ancient trading rights, the cheese-sellers were temporarily allowed to trade at the feet of the great columns until their new shops were ready for occupation in 1543.[20]

Meanwhile the cost of the new Mint rose steadily. In 1539 the Council of Ten ordered the Cyprus Regiment to raise a further 5,000 ducats from the freeing of slaves, in addition to the sum of 5,000 ducats already requested.[21] By 1543, just over 2,200 ducats of the amount had not yet arrived; and in the meantime, rather than delay the building work the Zecca was amassing huge debts. In that year a further 6,000 ducats were demanded from Cyprus, but even this was not enough.[22] In 1544 yet another instalment of 5,000 ducats was ordered, making a total of 21,000 ducats in all.[23] By 1547, thanks to this extraordinary means of raising capital, the building had finally been brought to completion, and Sansovino was dismissed from his position as *proto*.[24]

During the next decade, heated differences arose between the Proveditori di Zecca and the Procuratia de Supra over the ownership of the nine cheese-shops in the new Mint. In 1554 the Proveditori di Zecca ordered the tenants to pay their rents to the Mint rather than to the Procuracy, who until then had always been the landlords of the shops, encouraging them to co-operate by asking considerably lower rents than those laid down by the Procuracy twelve years earlier.[25] This controversy must have affected the position of Sansovino who, as *proto* to the Procurators, but no longer an employee of the Zecca, had a definite affiliation to one party. The dispute was finally settled in 1558 by an independent tribunal set up by the Council of Ten, which concluded that the Procuracy were indeed the rightful owners of the cheese-shops.[26]

The significance of this dispute lies in the light it casts on Sansovino's precarious position as an employee of a government magistracy. In the course of the hearing, the Proveditori di Zecca objected to Sansovino's evidence on the grounds that he was an employee of the Procuracy and therefore biased in their favour.[27] It is clear that the Proveditori di Zecca in office at that time felt no allegiance towards Sansovino, although he had served their predecessors so recently. This kind of instability was a hazard inherent in state patronage.

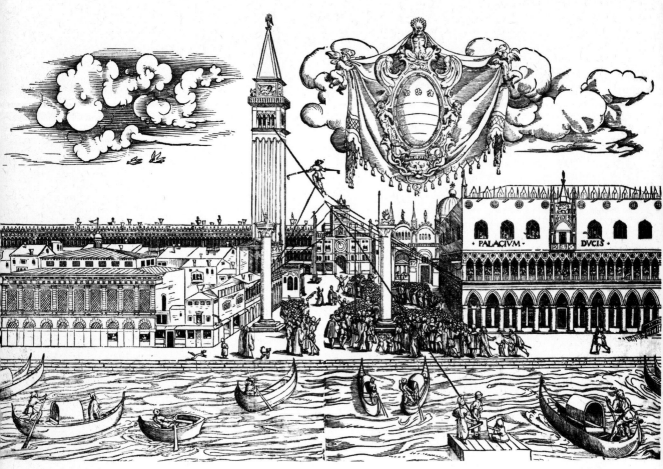

31. *Il Volo del Turco,*
anonymous woodcut, with
arms of Doge Francesco
Donato (1545–53).

In the very same year, 1558, the Council of Ten authorised the Proveditori di Zecca to add an extra floor to Sansovino's two-storey building. The uppermost storey, then a low attic lit by small rectangular windows (Plates 16 & 31), was unusable in summer because of the intolerable heat from the combined effect of the sun and the furnaces.[28] The model for the third storey, presented to the Collegio by the Proveditori di Zecca, was approved on 13 July 1558, the very day on which the Council of Ten confirmed the setting up of the tribunal to resolve the dispute over the cheese-shops.[29] This was at the height of the controversy between the Proveditori di Zecca and Sansovino's regular employers, the Procuratia de Supra. No architect was named at any stage, although the Proveditori were recommended to 'follow the advice of experts'. In view of the current state of tension, it is impossible to assume that Sansovino himself was automatically responsible for the third storey, although he was probably one of the experts consulted.[30]

The third storey was financed with the remainder of the 'slave-money' from Cyprus. By 1558 28,879 ducats had already been spent on the new Zecca, and a further 1,790 ducats were yet to arrive.[31] The uppermost floor must have been built as economically as possible, for only a fraction of the total budget was still available. It was probably completed by 1566 at the latest, for it

42

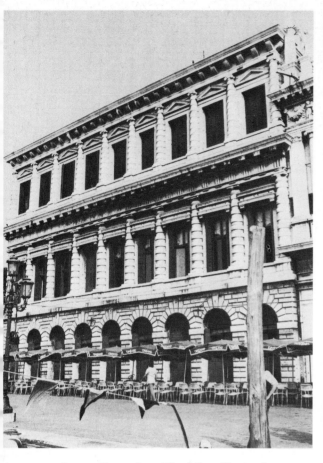

32. Jacopo Sansovino: The Mint, Venice, begun 1536.

33. The Mint, courtyard before conversion into reading-room.

appears in Bolognino Zalterii's map published in that year (though map-makers often take the liberty of showing unfinished buildings as complete). The total cost of the Zecca, including the extra storey, was roughly equivalent to the amount spent on the new Library during Sansovino's lifetime. Both were regarded as significant status symbols, and virtually no expense was spared on either project.

In its present state the Mint no longer serves the function for which it was destined. As early as 1588 the Senate ordered the closing of the nine shops along the lagoon side for security reasons, amid waves of protests from the cheese-sellers.[32] More recently, at the beginning of this century the whole building was converted into the new home of the Marciana Library, which had by then expanded beyond the capacity of Sansovino's Library next door. The court-yard was roofed over to serve as a huge reading-room, and the well-head in the centre was moved to Palazzo Pesaro. Nevertheless the Mint has not ceased to play its visual role in the context of Piazza San Marco as a whole. Its form-idable rusticated façade, on the waterfront next to the Library, is an impressive feature of the prospect which greets the visitor arriving at the Piazza by boat.

43

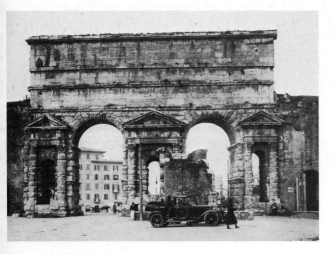

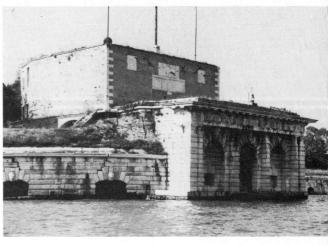

34. Porta Maggiore, Rome, A.D. 52.

35. Michele Sanmicheli: Fortress of Sant'Andrea, Venice, begun 1543.

As in the case of the Library, the Zecca is completely faced in white Istrian stone, which conceals a brick structure behind. With its southern aspect, the façade is even more brilliantly lit than the Library. The strong midday sun heightens the whiteness of the stone, casting deep shadows which emphasise the bold rustication. Both the façade and the courtyard have three orders—a rusticated basement, surmounted by a Doric *piano nobile*, and then the third Ionic storey which was added later; but whereas the façade is entirely rusticated, including the columns of both orders, the courtyard is less imposing and more urbane, with its rustication confined to the ground-floor.

Like the Library the Mint caused a sensation when it was first built, although this effect was achieved in a totally different way. Having seen the model, Aretino wrote in 1537: 'Who is not struck dumb by the rusticated and Doric building of the Zecca?'[33] Vasari described the Mint as 'entirely in the most beautiful rusticated order which, never having been seen in the city before, considerably amazed the inhabitants'.[34] Certainly the Venetians found the building visually pleasing. Francesco Sansovino in his 1581 guide referred to the façade as 'enjoyable to look at, and in accordance with the rules of Vitruvius' (a comment which might just as well have applied to the Library).[35] The Mint was admired, too, for the total absence of wood, as both Vasari and Francesco Sansovino point out, despite the fact that in the more frugal uppermost storey a considerable amount of wood was used.[36] But spectators also found the building psychologically forbidding, and this was surely the very reaction which Jacopo intended. In Francesco Sansovino's earlier guide of 1561, which takes the form of a dialogue between a Venetian and a stranger, the latter likens the Zecca to a fortress, and calls it a 'worthy prison for the precious gold'.[37] Rustication was not in fact unknown in Venice. Every Venetian would have seen the conspicuous rusticated foundations of the Ca' del Duca on the Grand Canal, begun in the mid-fifteenth century but never completed.[38] Even the rustication of the orders had already been introduced to the city by Coducci, if in a more muted form, in the Palazzo Corner-Spinelli

44

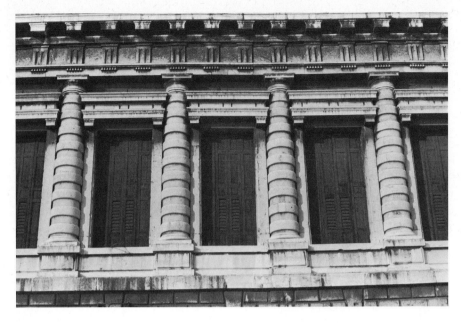

36. The Mint, detail of Doric order.

and the façade of San Michele in Isola.[39] But the use of rustication to suggest impregnability was a newer concept. Serlio wrote in Book IV of his treatise, published in Venice in 1537: 'It occurred to the Ancient Romans to mix the rustic order not only with the Doric, but also with the Ionic and the Corinthian . . . This mixture, in my opinion, is very attractive to look at, and represents great strength. Thus I would consider it more suitable for a fortress than for anything else.'[40]

The Ancient Romans had indeed mixed rustication with the orders, particularly in monuments of the reign of Claudius, such as the Porta Maggiore (Plate 34).[41] But in the early sixteenth century the juxtaposition of clean-cut capitals and bases with crudely rusticated columns or pilasters was still regarded as somewhat unorthodox, intriguing, and even daring. Giulio Romano, at first in Rome and afterwards in Mantua, made frequent use of this contrast of rough and smooth elements, and Sansovino undoubtedly knew his buildings. For Giulio the mixture was a sophisticated Mannerist trait intended, above all, to enhance the visual fascination of his designs. The notion expressed by Serlio that the rusticated orders also conveyed impregnability was exploited in Northern Italy chiefly by Michele Sanmicheli in his military architecture. His Porta Nuova in Verona, begun in 1530–31, and the Fortezza di Sant'Andrea on the Venetian Lido (Plate 35), commissioned in 1535 but not begun until 1543, both of them rusticated Doric structures, may well have influenced Sansovino in his designs for the Zecca.[42]

However, the Mint is by no means purely derivative. The most original feature of the façade is the Doric order (Plate 36), with its large windows (once protected by heavy iron grilles) squeezed tightly between the hefty columns, and the massive protruding lintels above clenched threateningly as if ready to drop on any imprudent intruder. The relatively innocuous rusticated basement was utterly appropriate for so mundane a purpose as a row of cheese-shops.

45

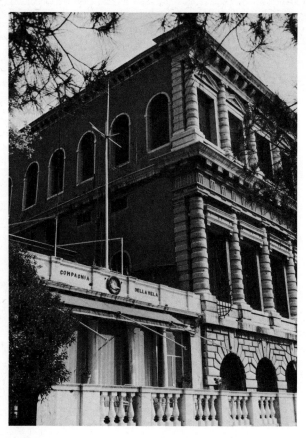

37. The Mint and the Ponte della Pescaria.

The Ionic storey has none of the tension or interest of the Doric order—it could have been built by any competent builder with a knowledge of Vitruvian theory and a familiarity with Sansovino's idiom.

Apart from the completion of Buon's Procuratie Vecchie, the Mint was Sansovino's first major public commission in the city centre. Although the building was patronised by a different body from the rest of Sansovino's buildings in the Piazza, it must obviously be considered as part of the same over-all scheme. It is significant that the elevation of the Zecca closely re-sembles a building in the left background of Peruzzi's fresco of the *Presentation of the Virgin in the Temple* in Santa Maria della Pace in Rome, painted in 1523–26. The parallel is so close that it can scarcely be fortuitous especially in the case of one of the preparatory drawings for this fresco.[43] The painting has a rather theatrical urban setting with a great variety of contrasting buildings, like the illustrations for stage-sets by Serlio, Peruzzi's pupil; and it is indicative of Sansovino's approach to his Piazza San Marco assignment that he turned to such a source for ideas. Some of his devices to relate the Zecca to the surround-ing buildings are fairly obvious—for example the string-course above the rusticated basement falls at the same height as the cornice of the adjoining row of shops on the Ponte della Pescaria which he had remodelled in 1531 (Plate 37), and the window-sills of the Doric order above continue the roofline of these shops. On the other side the relationship with the Library seems more

46

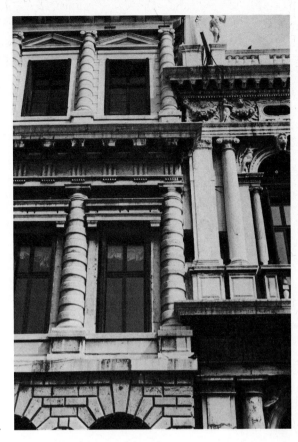

38. The junction of the Mint and the Library.

haphazard, not to say capricious (Plate 38). Scamozzi was dismayed by the bizarre juxtaposition between the Mint and the end bays of the Library which he executed after Sansovino's death.[44] However, since it can be demonstrated that Sansovino himself intended these two façades to be aligned along the waterfront, he must have anticipated this visual conflict. In fact, it seems that he deliberately contrived the jarring effect to emphasise the sharp contrast between the functions of the two buildings: while the Library is both welcoming and erudite, the Zecca beside it appears brutal and daunting.[45] Just as the courtyard of the Mint, with its plain, clean-cut articulation, conveys a sense of mechanical precision and efficiency, reflecting the function of the workshops which surround it, so its fortress-like exterior suggests a solidity and strength, intended not only to deter marauders but also to reassure the Venetians of the security of their wealth.

THE FABBRICHE NUOVE DI RIALTO

Two decades after he began his major projects for Piazza San Marco, Sansovino was employed to design a building for the Rialto market. His contribution to the commercial centre of the city, the block of shops and warehouses, commissioned in 1554, which became known as the Fabbriche Nuove di Rialto, was just one stage in the rebuilding of the greater part of the Rialto area during the

47

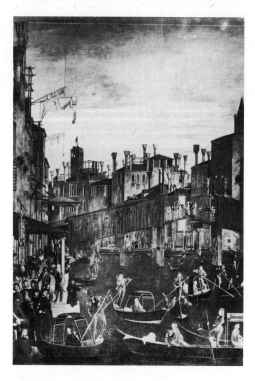

39. Carpaccio: *Miracle of the True Cross*, detail showing the old Rialto bridge, 1494.

sixteenth century, and must therefore be considered in the context of this whole process of renewal.

A stranger in Renaissance Venice had only to follow the flow of the crowd, reported an English visitor, to find himself either in Piazza San Marco or at the Rialto.[46] One might say that these were the two vital organs of the city— Piazza San Marco the brain, and the Rialto the heart. If the Piazza served as a magnificent expression of the wisdom and political power of the Venetian Republic, the Rialto was the source of the life-blood of the city—its prosperity. Venetians and foreigners alike were aware of the enormous significance of the commercial centre. Sanudo referred to the Rialto as 'the principal place in Venice and the richest', while to Vasari it seemed 'almost like the treasury of the city'.[47] The Venetian economy was founded on trade, and it was here that most of the trading and banking transactions took place.

The Rialto had been the site of the earliest settlement on the Venetian archipelago. As its name, *rivo alto*, or high bank, records, it was the highest and thus the driest of the marshy islands.[48] Its development was favoured by two crucial geographical factors: it was both the lowest bridging point on the Grand Canal and the highest point to which seafaring ships could navigate. Large ocean-going vessels were moored in the lagoon and their goods transferred to smaller boats for the last part of the voyage along the Grand Canal, while the ships serving the lagoon and the *terraferma* waterways were small enough to unload their cargoes at the Rialto itself.[49] The original pontoon bridge was replaced by a permanent wooden structure at the end of the fourteenth century. After collapsing under the weight of crowds watching the

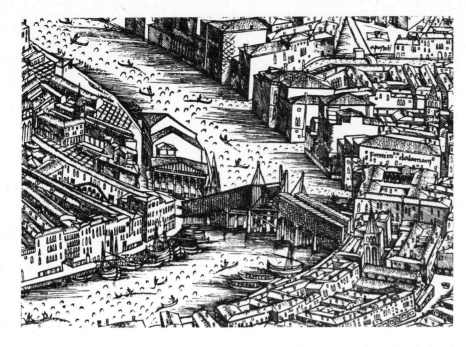

40. Jacopo de' Barbari: Map of Venice, detail showing the Rialto, 1500.

arrival of Emperor Frederick III in 1450, the bridge was widened and fitted with shops.[50] It was this Ponte di Rialto (immortalised in Carpaccio's painting, Plate 39), then the only bridge across the Grand Canal, which Sansovino would have known in Venice.

Linked to Piazza San Marco by the main street of the city, the Merceria, the Rialto was in close contact with the Piazza. The geographical division between political and commercial activities was by no means clearly defined. Many government magistracies, especially those concerned with trade and finance, such as the tax office, the customs headquarters and the salt office, were located not in Piazza San Marco but at the Rialto. The principal food markets—selling meat, oil, fish, cheese, bread, fruit and vegetables, and flour—existed in duplicate, one in each centre. Public philosophy lectures were held in both places, and government proclamations were always read at the Rialto as well as in the Piazza. Not only were most noble families actively involved in both trade and politics, but the government even intervened directly in many facets of the commerce of the city, for instance, organising convoys for the protection of galley-fleets, making special provisions for food supplies in times of shortage, and weighing flour to check that it was not mixed with worthless substitutes such as ash and lime.[51]

The hub of the fifteenth-century market was the square arcaded *campo* in front of the ancient church of San Giacomo, said to be the oldest church in Venice (Plate 40). Here dense crowds of Venetians and foreign merchants assembled every morning and evening to carry out business transactions. Most purchases were paid by cheque, the square being surrounded with bankers' stalls. The nobles, who tended to keep aloof from the rest of the mob, gathered in an ornate little marble and wooden loggia at the foot of the bridge. It was their custom to meet at the Rialto in the morning and at Piazza San Marco in

49

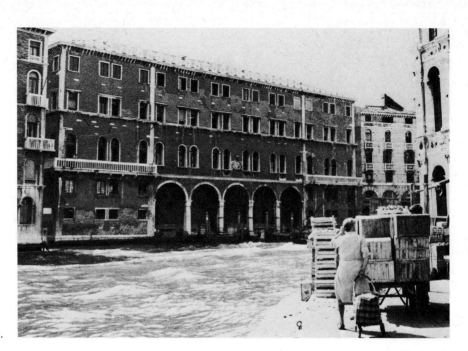

41. G. Spavento and A. Scarpagnino: Fondaco dei Tedeschi, Venice, 1505–08.

the evening, since government assemblies were usually afternoon affairs.[52] Besides its trade in staple foodstuffs the Rialto was an important centre for entrepôt commerce. Goods from the Mediterranean and the Far East, especially spices, silks and cotton, were exchanged for commodities such as metals and wool. Imported raw materials also supplied a variety of local manufacturing industries—including textiles, glass, jewellery, shipbuilding and printing. Since the whole livelihood of the city depended on the success of these mercantile enterprises, Venetians regarded commerce with an almost religious reverence. In his description of the city published in 1500 Sabellico marvelled at the restrained behaviour of the crowds at the Rialto. No noise, no slanders, quarrels, accusations or contentions punctuated the negotiations. Business deals were carried out in hushed voices, proving to Sabellico the assertion that men need few words to communicate through trade.[53]

In the first two decades of the sixteenth century the Rialto suffered two disastrous fires, both of them hard blows to the commercial life of the city. In 1505 a fire destroyed the Fondaco dei Tedeschi, the headquarters of the German merchant colony, situated opposite the market on the other side of the Rialto bridge. After the fire the building was quickly rebuilt at the expense of the Venetian state, with twenty-two shops around the outside to yield extra revenue. The centre was an important source of income to the Republic, for the Germans not only paid a high rent for their premises but also contributed considerable sums in customs duties. German merchants played a major role in Venetian trade, especially in the exchange of gold, silver and copper from Northern Europe for spices imported from the Levant.[55]

The second conflagration was an altogether more traumatic experience for the city. In January 1514, during a spell of intense cold, fire broke out one night in a textile merchant's shop. Rapidly it spread through the whole market

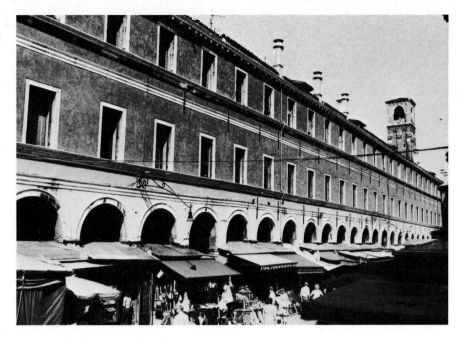

42. Antonio Scarpagnino: Fabbriche Vecchie di Rialto, Venice, begun 1514.

area, fanned by the fierce gales. The dramatic description in Sanudo's diaries gives a vivid picture of the panic and terror which followed.[56] Crowds rushed to the scene to salvage or steal merchandise, and to rescue archives and money from the offices. But despite the efforts of the parish priests of the three local churches who solemnly carried the Eucharist around the market, no one made any serious attempt to halt the blaze. The wells had dried up and the canals were iced over as a result of the appalling cold, only adding to the helplessness of the spectators. The fire burned for twenty-four hours, and when it finally died down little remained of the Rialto market. Only the palace of the Camerlenghi, the loggia at the foot of the bridge, and the little church of San Giacomo nearby survived, save the part around the meat market in the far corner. Sanudo declared that no fire could ever have been so horrible.

The disaster struck at a particularly unfortunate moment. The Venetian Republic was immersed in the wars of the League of Cambrai, which had shattered the economic stability of the state and threatened its political independence. Suspicions that the fire had been started as a political conspiracy by rebels or enemies proved unfounded. It was simply the freak weather conditions which caused the disaster—dozens of smaller fires broke out all over the city that night. As Sanudo commented fatalistically, 'God willed this to happen to punish us for our sins and injustices.'[57] But the diarist was probably right that Venice's enemies would have been delighted by the tragedy, for the very heart of the economy had been totally incapacitated.[58]

The state of dazed confusion and distress which followed was at least as tragic as the blaze itself. The cold continued unabated—the wind blew, the waterways froze harder, and snow fell. The day after the fire the Doge's advisors met at the Rialto to inspect the ruins and discuss plans for restoration, but in their state of shock they only succumbed to the temptation to hunt for

51

treasure in the debris.[59] Yet if Venice was to survive at all, commercial life had to be resumed as quickly as possible. And indeed, within a few days some return to normality had been achieved—stalls were rebuilt, and the banks reopened. Although the economy was in chaos because of the huge material loss and the activities of speculators, the government had no alternative but to rebuild the market.[60]

By the following summer four projects for the new Rialto had been submitted to a special committee of seven nobles. The architects of these schemes were Antonio Scarpagnino, Alessandro Leopardi, the Tellaroli brothers and Fra Giocondo. Vasari gives a full account of Fra Giocondo's ambitious model, which consisted of a symmetrical four-sided complex completely surrounded by water, with bankers' and jewellers' stalls around the central arcaded piazza. The textile markets would be located in porticoes flanking both sides of a street around the outside, and the food-stalls on the four waterfronts.[61] Eventually, however, the committee decided on the far less imaginative project submitted by Scarpagnino. This plan involved neither the expansion of the original area nor alterations in the disposition of the buildings. The only significant changes would be the construction of vaulted rather than beamed ceilings in the arcades—to reduce the fire danger and to admit more light to the shops—and the addition of an extra storey over the *draparia* or cloth market. The individual owners would pay for the reconstruction of the shops, while the rest of the scheme would be financed by the Salt Office, the magistracy which provided funds for most state building work in the city.[62] The design of the new market premises was strictly functional and devoid of ornament, with stuccoed brick walls and plain Istrian-stone window-frames (Plate 42).

Within ten years Scarpagnino's project had been executed, and it was no small triumph that almost no traces of the fire now remained. As soon as the basic fabric was rebuilt, it was decided to restore the Palazzo dei Camerlenghi, one of the few buildings which had survived the fire. In its conspicuous site at the foot of the bridge the old palace must have seemed a little shabby amidst the pristine new market buildings. In 1523 Scarpagnino recommended Guglielmo dei Grigi, then merely the scribe of the Proveditori di Rialto, to make improvements to the Grand Canal façade, incorporating the loggia on one side. This restoration, which provided the palace with its pretty Istrian-stone façade (Plate 43), was carried out during the following two years.[63] The only building not yet reconstructed when Jacopo Sansovino arrived in Venice in 1527 was the mainland section of the customs office, temporarily housed since the fire in two separate offices at San Marco and at the Rialto. It was not until the 1530s that the state decided to remedy this inconvenient and expensive situation, and finally rebuilt the *dogana da terra*.[64]

As the reconstruction campaign demonstrated, a deep-rooted conservatism characterised state building patronage of this kind. Several factors contributed to the rigid resistance to change. Although by the sixteenth century the market was extremely congested, there was no space available in the vicinity for expansion. The legal intricacies of the complicated network of state and private ownership of the shops, stalls and warehouses, further discouraged any radical changes in the layout. Most important, the financial straits caused by the Cambrai Wars compelled the Republic to rebuild the Rialto with the

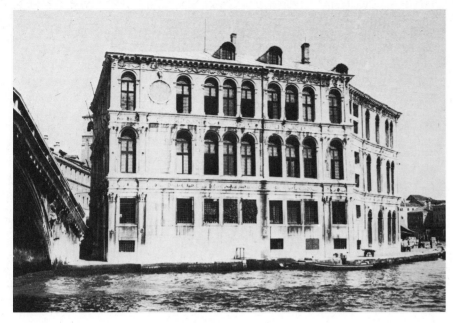

43. Guglielmo dei Grigi:
Palazzo dei Camerlenghi,
Venice, 1523–5.

strictest economy, re-using old foundations wherever possible to cut down the cost. Whereas public architecture in Piazza San Marco served as an instrument of political propaganda—a conspicuous display of magnificence and grandeur —the premises of the market were expected to be more prosaic, more strictly functional in character.

Nevertheless the Republic was not oblivious of the need for dignity in this highly prestigious part of the city. Parallel to the campaign to remove illegal or unsightly stalls from Piazza San Marco, efforts were being made from the 1520s onwards to clear similar obstructions from the porticoes and streets of the Rialto.[65] Already in a precarious state, the old bridge had been further weakened in the great fire of 1514.[66] As a result a number of the shops on the bridge had been abandoned and the owners provided with temporary premises in the market itself. In 1525 the Senate decided to elect a special magistracy of three nobles to organise the rebuilding of the bridge so that these makeshift shops in the Rialto could be removed.[67] In a similar vein, an order from the Salt Office in the following year forbade shopkeepers to obstruct the porticoes in front of their shops.[68]

As early as 1507 a motion of the Council of Ten had ordered the Salt Office to set aside 100 ducats each month for the construction of a stone bridge.[69] Yet the special magistracy to take charge of the bridge, proposed in the 1525 motion, did not come into existence for more than two decades. The only positive step in this direction before the middle of the century was taken by the Waterways Office who commissioned a model for a new bridge, hoping to improve the flow of water in the Grand Canal, which was impeded by the supports of the old structure. In 1546 various experts, including both Michele Sanmicheli and Jacopo Sansovino himself, were asked to give their opinions of the model, made by Piero Guberni, which consisted of a single span constructed in wood. Sansovino declared it 'a most beautiful work, worthy of

great praise', but was doubtful about its stability, while Sanmicheli thought it would be difficult to build, but should last for at least twenty-five years.[70] Faced with such discouraging reactions the Savi alle Acque lacked the necessary conviction to launch the scheme.

Meanwhile the Proveditori sopra i Monti, the magistracy in charge of the public debt, who administered many of the Rialto shop premises, began to construct a number of wooden shops along the bank of the Grand Canal between the fish market and the vegetable market, one of the few vacant sites left in the area. These stalls were erected in spite of opposition from the Savi alle Acque, who complained in 1542 that the new shops obstructed their four moorings rented by wine merchants along this portion of the bank.[71] By the late forties it was already becoming necessary to rebuild the shops. The Republic now began to realise that decaying wooden shops were hardly appropriate in such a prominent site—made all the more conspicuous by the curve of the Grand Canal at this point. In 1550, when the Proveditori sopra i Monti applied for approval of the sale of the newly-rebuilt shops, the Council of Ten reacted with a bold decision to demolish them and refund the cost to the owners. In the meantime they would discuss what kind of building to erect in their place.[72]

This decision marked a new awareness on the part of the Venetian government of the undignified appearance of the Rialto. In the following year the Senate again raised the question of the magistracy to supervise the building of the new Rialto bridge, which had been conceived more than two decades earlier but never set up. Now that work on the Doge's Palace was almost finished, it was high time to turn attention to improving this part of the city too. The Proveditori sopra la Fabrica del Rialto were finally elected and given the task of commissioning models for the new bridge. This was a very significant moment for Sansovino, for two of the three nobles elected were none other than the Procurators Vettor Grimani and Antonio Capello, his two most fervent supporters in the Procuratia de Supra.[73]

Unfortunately the state was determined not to allow the new magistracy complete freedom of action. According to the terms of the election, the models of the new bridge would have to be submitted to the Council of Ten for the final decision.[74] As it turned out, the renewed interest in reconstructing the bridge was short-lived, for the replacement of the demolished wooden stalls was considered more urgent, and it was this assignment which was awarded to Sansovino. But in this matter too, the Council of Ten asserted their authority. In 1553 they decided that motions regarding the Rialto shops could only be passed with the approval of at least three-quarters of their number.[75] Later in the same year the Ten went as far as to reject a resolution that the Proveditori al Sal should commission a model for the new building and leave the wooden shops standing meanwhile in order to put the rent towards the construction costs.[76] From the start, doubts and opposition hampered the progress of the project.

The drawing for the new building mentioned in August 1554 must have been the design commissioned from Jacopo Sansovino, for his completed model was submitted to the Council of Ten only a month later.[77] It is hardly surprising that the recently elected Proveditori sopra la Fabrica del Ponte di

Rialto—among them the two Procurators Vettor Grimani and Antonio Capello—should have chosen Sansovino, *proto* to the Procuratia de Supra, as architect. In August the Ten failed to give a sufficient majority to a motion that the Proveditori should commission a model, or several models, for the new building.[78] Fortunately, however, exactly three-quarters of their number approved Sansovino's project presented to the Council in September. (Despite its name the Council of Ten had well over ten members at this time.) They agreed that it was essential to remove the remaining twenty shops, which not only encouraged the Grand Canal to silt up, presumably because they discharged so much refuse, but also disfigured 'the most beautiful part of the city'.[79] The Ten decided to supply the necessary funds to finance the new building in the form of a loan from the Zecca. This grant was ultimately to be repaid from the income yielded by the new shops and warehouses. Although in practical terms the new building served no distinguished function—it was merely the new fruit market—the Council of Ten were fully conscious of the status of the site and hence the importance of its visual role, insisting that only the best quality stone should be used.[80]

According to the description submitted by the Proveditori sopra la Fabrica del Ponte di Rialto, the new building was to consist of sixteen shops on the ground floor, with fourteen rooms on each of the two upper storeys. Along the bank of the Grand Canal a vaulted portico would bring the building forward in line with the nearby cheese and rope markets. Twelve of the sixteen shops would be sold to private buyers, and four would remain under state ownership. The Proveditori were confident that it would be easy to find tenants for the upper rooms, especially since the owners of the ground-floor shops would need nearby warehouse accommodation. The prestigious site, the building's resistance to fire, and the convenience of the waterside location were further advantages. The Proveditori expected the eventual cost of the construction work—estimated on the basis of the tenders submitted—to amount to 5,565 ducats. Since they hoped to raise more than 9,000 ducats from the sale or lease of the new premises, they thus anticipated a profit of 3,440 ducats.[81] This calculation must have been the strongest inducement to the Council of Ten to approve the model.

Even after the project had been accepted, however, the state continued to obstruct and confuse its administration. Only two weeks later, the Senate decided to change the scope of the duties of the Proveditori sopra la Fabrica del Ponte di Rialto. They were now to take on the additional responsibilities of a magistracy approved in 1535, but never set up, to improve the appearance and commodity of the city's streets.[82] Soon afterwards, the Senate's decision was restated in a different form, on the grounds that the function of the Proveditori sopra l'Ornamento delle Strade was the more important of the two. Instead of incorporating this magistracy into the existing office of the Proveditori sopra la Fabrica del Ponte, it was decided to elect a new committee of three nobles responsible for the streets of the city, who were also to take charge of the new block of shops and storerooms planned for the Rialto.[83] It is not clear whether the elections actually took place, but the suggested replacement of the existing Proveditori, who were loyal patrons of Sansovino, must have to some extent disrupted the execution of the scheme.

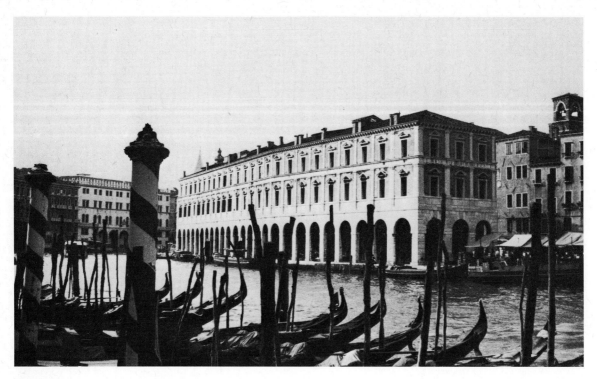

44. Jacopo Sansovino: Fabbriche Nuove di Rialto, Venice, begun 1554.

A state of tension seems to have developed during the 1550s between Sansovino and the Council of Ten. This was the period of the dispute between the Proveditori di Zecca and the Procuratia de Supra over the ownership of the cheese-shops along the front of the Mint, in which Sansovino took sides with the Procurators, rather than with the Zecca and hence with the Ten. This was also the decade in which he was apparently not given the commission to add an extra storey to his new Mint.[84] Only the existence of some such discord could account for the next decision of the Council of Ten concerning the Fabbriche Nuove. In 1555 they actually failed, even after two ballots, to give a three-quarters' majority to a motion that Sansovino should be officially put in charge of the execution of his model. Although he was already carrying out the task of giving measurements and profiles of the details to the builders, the Council of Ten refused to grant him a payment of 50 ducats for the job, or to entrust him with the responsibility for supervising the work, ensuring that good-quality materials were used, and bringing the scheme to completion.[85]

Yet in spite of Sansovino's failure to gain official recognition as supervisor, the work proceeded quickly, and by the beginning of the following year the new fruit market was virtually finished.[86] The Council of Ten must have been favourably impressed with the results, for in 1556 they approved with a large majority a new proposal from the Proveditori sopra la Fabrica del Ponte to add a connecting wing to one end of the new structure, along the edge of the space occupied by the vegetable market. This extension would provide a covered passage between the Grand Canal and the centre of the market, Campo San

56

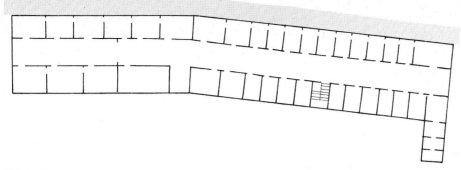

iv. Jacopo Sansovino: Fabbriche Nuove di Rialto, Venice, begun 1554, plan of the *piano nobile*.

Giacomo, as well as accommodation for a further four shops and twelve upper rooms. Sansovino submitted a written statement with his model, stressing that the addition would not only embellish the city but would also serve an extremely useful purpose. The workmen had promised that the extra portion could be completely finished without the cost exceeding the sum of 3,700 ducats, that is, the profit expected from the proceeds of the main block. Again the Proveditori were optimistic about the profitability of the scheme. They expected to raise a further 7,000 ducats from the lease or sale of the shops and storerooms of the extension, and promised eventually to repay the entire sum of 5,263 ducats which had been advanced by the Zecca to finance the main part of the new building.[87]

Although the Council of Ten had been far less reticent in accepting the proposal to build the extension than in approving the original project, they still refused to give Sansovino the authority to supervise its execution. According to the contracts finally awarded to the builders, the total outlay was now expected to amount to 460 ducats less than the sum of 3,700 ducats originally estimated. But not even this fact reconciled the Council to Sansovino. Another motion proposing that he should attend the site daily to supervise the workers, check that good materials were used, and see that the waterfronts were of the correct measurements, in return for a payment of 100 ducats, failed in two successive ballots to gain the support of three-quarters of the assembly.[88] After this further setback a delay of more than half a year ensued. Early in 1557 work had still not begun, presumably because the funds to be raised from the sale of premises in the main part of the new building had not yet materialised. The Council of Ten then ordered the Zecca to provide a loan of 700 ducats so that the last stage of the project could finally be set in motion.[89]

In contrast to Sansovino's earlier public commissions in Piazza San Marco the new building at the Rialto was not an extravagant or ostentatious project, but it was nevertheless intended to create a favourable visual impression (Plate 44). Since a prime motive for the commission was to improve the appearance of the Rialto, the Council of Ten had specified that no expense was to be spared in the purchase of the best possible materials. The new block, taking the place of temporary wooden shops on the site, was expected to be a relatively solid and durable construction.

57

PROFILO PRESO SOPRA
LA LINEA. A. B.

Piedi Veneti servono per il Profilo

45. Fabbriche Nuove di Rialto, section.

In the event the building became a constant problem to maintain. Sansovino had not entirely resolved the structural problems posed by the assignment. In spite of the fact that the embankment was moved outward to increase the space available, the site was excessively narrow (Figure iv). Sansovino was naturally reluctant to reduce the width even further by thickening the outer walls. Instead these were secured with iron tie-bars at frequent intervals—the system he had attempted unsuccessfully in the Library—but as time passed the ties broke or came loose. The structural instability also resulted from the placing of the partition walls of the two upper floors not over the walls of the ground-floor shops but above the spaces between them (Plate 45). The upper storeys each consisted of two rows of store-rooms separated by a narrow corridor. To make the structure as fire-resistant as possible Sansovino was obliged to use stone rather than wood wherever feasible. Being of stone (not even of brick) the dividing walls were inherently heavy, and in addition they transmitted the whole load of the roof to the points of weakest support. The weight of the merchandise stored in the upper rooms contributed a further strain.[90]

Within less than a century the Fabbriche Nuove needed extensive repairs, but the individual owners of the shops and store-rooms lacked the necessary resources. The State was forced to intervene periodically to carry out restoration work. In 1643 the ten bays towards the vegetable market, which were threatening to collapse completely, were reinforced with new metal chains, and in 1724 a similar repair saved the six bays at the opposite end over the fish market. By the 1740s the remaining nine bays in the centre of the building were in a precarious state and yet another restoration was necessary. In 1752–54 radical repairs were made to the foundations, which had apparently been constructed in materials of very poor quality. (In this instance Sansovino could not make use of existing foundations.) The defective bricks were replaced, and the upper walls were provided with provisional wooden supports. Nevertheless within twenty years the building again needed further repairs.[91] No one could possibly take issue with Tommaso Temanza, who had himself been involved in the eighteenth-century restorations, when in his *Life of Sansovino* he strongly criticised the Fabbriche Nuove on structural grounds.[92] Jacopo Sansovino was trained not as an engineer but as a sculptor, and in this case his empirical approach to structural difficulties proved sadly unsuccessful.

If criticism of the building's structural defects is entirely justified, the frequent comments on the austere, monotonous appearance of the Fabbriche Nuove are less perceptive.[93] Sixteenth-century responses to architecture were conditioned by a keen sense of decorum and propriety, propagated in Venice particularly by the early volumes of Serlio's treatise on architecture.[94] A rich or elaborate design in a structure as large as the Fabbriche Nuove, serving so mundane a function, would have seemed out of place in the context of the Rialto market. Although the extreme financial straits which accompanied the rebuilding of the greater part of the market after the great fire had now passed, there was no point in embarking on a pretentious propaganda project. A block of shops and warehouses did not merit the rich decoration of the nearby Palazzo dei Camerlenghi which housed one of the more distinguished magistracies of the city (Plate 43). Sansovino used as the starting-point for his design Falconetto's Monte di Pietà in Padua, which suggested the basic elements of

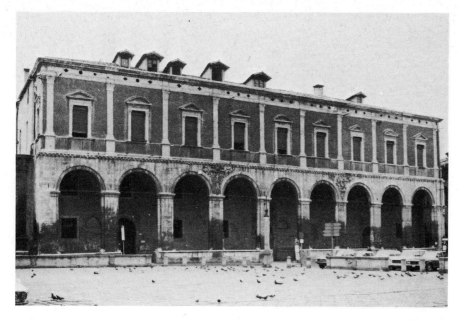

46. Falconetto: Monte di Pietà, Padua, 1530.

the elevation—the rusticated portico surmounted by simple pilaster orders with pedimented windows in each bay (Plate 46). Both buildings had façades of considerable length which commanded large open spaces—an ample piazza in one case, and the Grand Canal in the other. The Monte di Pietà was a particularly suitable prototype, for as in the case of the Fabbriche Nuove its site and function called for a dignified but restrained type of architecture.

The fact that the Fabbriche Nuove were not intended to be lived in played an important part in the design. The structure had neither chimneys nor drains (which—as an eighteenth-century surveyor's report commented—made it most unsuitable for the 'ladies' who rented many of the upper rooms at that time).[95] In buildings such as the Fondaco dei Tedeschi on the opposite side of the Grand Canal (Plate 41), where heating was needed for the merchants' apartments, the windows were best arranged in pairs so that each room had two windows flanking a fireplace. In the case of the Fabbriche Nuove, however, a simpler disposition of the windows was possible, for without chimneys only the walls between the rooms fell between the windows on the façade.

This was one of the few occasions when Sansovino was free to choose the alignment of a new building himself. Since no permanent structure had yet been built on the site there was no need to re-use old foundations as an economy measure. Again, the planning authorities were more ready to allow a change in the position of the canal bank for a public building than for a private one.[96] Taking advantage of the natural bend of the canal, Sansovino placed an oblique angle in the façade, breaking the monotony of the long frontage and leading the eye of the spectator around the curve (Plate 47). The use of plain Doric and Ionic orders over a rusticated basement added a dignified classical tone to the façade, but at the same time the nature of the commission called for reasonable economy in the choice of materials—with the Istrian-stone pilasters and window aedicules set in stuccoed brick walls. The placing of a second pilaster

59

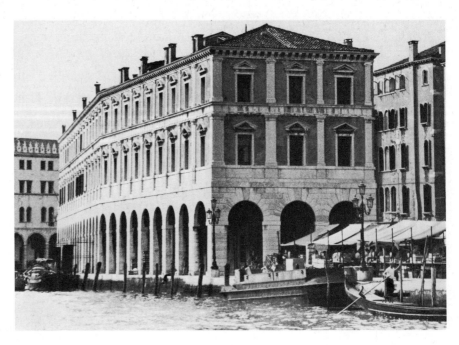

47. Fabbriche Nuove di
Rialto, Grand Canal façade.

behind the main order in the end bays and in the centre, helping to articulate
the otherwise repetitive elevation, was a response to the fact that the vaults of
the portico and the central archway needed a wider span than the other bays.

The rear of the building, facing the cheese market, has a tripartite division,
with a slight angle between each of the three sections equivalent to the single
bend on the canal side (Plate 48). The five central bays are emphasised by the
use of features borrowed from the canal façade—a rusticated basement,
pedimented windows on the *piano nobile*, and a conspicuous cornice. Mean-
while the simplicity of the side portions, with their plain rectangular windows,
reflects the design of the other market buildings erected by Scarpagnino after
the 1514 fire, thus harmonising the new structure with its surroundings. No
detail of the architecture seems casual or fortuitous, and the austerity alone can
hardly be said to indicate the architect's declining powers, lack of interest, or
exhausted imagination.

The Fabbriche Nuove were unusual among Sansovino's buildings in being
the only large scheme which was expected to pay for itself within a few years
of its construction. In the face of economic uncertainty and sharp inflation, the
building boom of the 1530s had now died down. By this stage in his career
Sansovino had few major new commissions. It was no longer possible for
patrons—public or private—to contemplate such ambitious architectural
ventures, except those which promised to be virtually self-supporting. It was,
of course, this financial feasibility above all which led the Council of Ten to
approve Sansovino's model. Yet nothing could persuade them to allow him
full authority over the execution of it, and Sansovino must surely have been
hurt and frustrated by this lack of co-operation on the part of his patrons.

In spite of such opposition from the state, Jacopo was one of the distinguished
architects—among them Michelangelo, Palladio and Vignola—who were

60

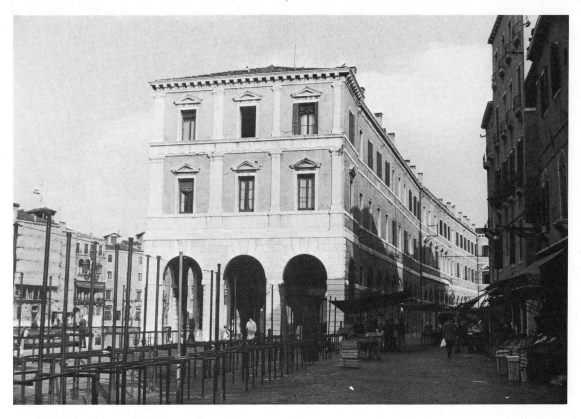

48. Fabbriche Nuove di Rialto, side and rear.

later asked to produce a model for the new Rialto bridge.[97] Francesco Sansovino tells us, with filial loyalty, that his father's project was the best of all, and that only the Turkish wars of the early 1570s prevented its realisation.[98] The stone bridge was finally erected from a design of Antonio da Ponte in the years 1588–91.[99] This was the last and most ambitious stage in the sixteenth-century renewal of the whole Rialto area. The new bridge is said to have cost as much as 250,000 ducats, and Venetians would have been gratified by the opinion of an English traveller, Fynes Moryson, at the end of the century, who called it the eighth wonder of the world.[100]. If Jacopo Sansovino's own contribution to the appearance of the Rialto Market was less dazzling, it was nevertheless a significant one. It seems only fair that the architect who transformed the appearance of the political centre of the city should also have left his mark on the heart of the city's commercial life.

IV. Ecclesiastical Patrons

CHURCHES form the nuclei in the cell-structure of the city of Venice. The first inhabitants, their numbers swelled by refugees from the Barbarian invasions on the mainland between the fifth and seventh centuries, settled in groups on the marshy islands of the lagoon.[1] Settlement began on the highest and driest land of each island—scanty patches of firm ground, surrounded by bleak expanses of mud, reeds and water which provided the fugitives' only defence. A small wooden church, on the edge of an open space known as a *campo* or field, acted as the focal point of each cluster of wooden houses. And each of these islands became one of the seventy parishes of the city.

As the centuries passed, land was gradually reclaimed on the damper fringes of the islands, until they coalesced to form the city of Venice as we know it, separated only by a network of canals. Yet the individual parishes have retained their identity to this day. The *campo*, with its public well, served as a meeting-place for the residents and gave prominence even to the smallest church. Francesco Sansovino reckoned that, despite the shortage of land, all the public open spaces of Venice placed side by side would easily make an area large enough for another great city.[2]

Parish loyalties were deepened by the traditional system of local administration. In Venice the parish priest was not appointed by a higher Church official, but was a layman elected by the non-noble house-owners of the parish, subject only to the approval of the Patriarch. This unusual practice seems to have resulted from the pattern of the city's evolution. Most of the earliest churches had been built by individual families, but with the expansion of these little colonies the inhabitants took to sharing the right to elect their priest: eligibility to vote incorporated the responsibility for building and maintaining the church, which would have become a heavy burden for a single family to bear.[3]

The early churches were simple wooden structures, many of them probably built in the Veneto-Byzantine Greek Cross plan. In these small buildings the parish priest conducted simple, mainly spoken services, in the midst of the parishioners who had elected him. His most important duties were to provide spiritual guidance and religious instruction through preaching, and to perform the various sacraments—baptism, marriage, and so on. The old wooden churches were later replaced by more permanent brick and stone buildings, but the shortage of space for expansion and the high cost of building new foundations tended to discourage radical changes of plan.

The parish priest was known in Venetian dialect as the *pievano*, a name derived, significantly, from the Latin word *plebs*. It was he who administered

the bequests and donations of the worshippers—to finance the building and upkeep of the church, the salaries of church officials, and the day-to-day running costs. In theory his administrative decisions needed the approval of his parish *capitolo*, that is, an assembly consisting of the other salaried priests, the deacon, sub-deacon, sacristan, and several unpaid clerics; but in practice the *pievano* himself was one of the most influential figures in local politics, representing the powerful citizen class in the community.

Later, a different type of religious institution was established alongside the ancient parish churches. Thirteenth-century Venice saw the founding of a series of splendid new monastic churches built by the Mendicant orders (among them the Franciscans, the Augustinians, and the Dominicans) which were then spreading rapidly throughout Italy. These foundations were much larger than the original Venetian churches. The great religious orders were not dependent on local parishes for revenue. Their fund-raising activities concentrated on begging for donations (as the word 'Mendicant' indicates) on a far wider scale. As a result, they were richly endowed with both land and capital, and could afford to buy ample sites and erect lavish buildings.[4] The liturgical needs of the monastery churches were somewhat different from those of the older-established parishes. The congregation was less intimately involved in the services, acting rather as an audience observing a more remote religious ritual. Furthermore, the monks needed secluded areas where they could hold their own services, away from the general public. Hence these new monastery churches were not small centralised structures, but were basilical in plan, with huge naves and separate chapels. Long after Gothic architecture had passed out of fashion, Francesco Sansovino included the finest of the Venetian Gothic monastic churches—Santa Maria dei Frari, Santi Giovanni e Paolo, and Santo Stefano—in the half-dozen churches he admired most of all in the city.[5]

It was an old-established policy of the Venetian state to keep tight control over the religious life of the city.[6] The secular clergy and the nunneries were under the authority of the Patriarch, who in turn was nominated by the Republic. The male religious orders were more difficult to control, for they were answerable only to the superiors of their own orders. Government authority in this case was limited to restrictions on the acquisition of property by monasteries and other ecclesiastical bodies. Already in the thirteenth century, government permission had been necessary to transfer property from secular to religious ownership. A decree of 1337 forbidding the erection of any new churches or monasteries in Venice, except with the authorisation of the Great Council, was renewed in 1515 and again in 1561, although it seems to have been difficult to enforce.[7] In a decree of 1536, the Senate complained that, as a result of bequests and donations, all the property of the city was passing into ecclesiastical ownership, and ordered that no real estate holdings in the Republic could be left or given to the Church for more than four years.[8] Nevertheless, these restrictions did not prevent the rebuilding of existing churches on their own sites, provided that funds were available to pay for their construction.

Jacopo Sansovino himself built six churches in Venice, all of which replaced earlier structures which had fallen into disrepair.[9] Three of these, San Martino, San Geminiano and San Giuliano, were ancient parish churches. Two, San

Francesco della Vigna and Santo Spirito in Isola, were later monastic foundations. The sixth, San Salvatore degli Incurabili, was the church of the syphilis hospital. Unfortunately no fewer than three of these six churches were demolished in the Napoleonic period. San Geminiano was pulled down in 1807 to make way for the new wing of Piazza San Marco, built to house an Imperial ballroom. The church of the Incurabili was destroyed in 1831 after its parent institution had been converted into barracks. The church of Santo Spirito was abandoned when the island was taken over for the storage of naval ammunition in 1806, and no longer exists. Yet, despite the ravages of the Napoleonic era, these projects still deserve our attention. The range of different commissions which Sansovino tackled, and the variety in his solutions, illustrate the opportunities offered to an ecclesiastical architect in Venice, and show what he himself contributed to sixteenth-century Venetian church design.

The Monastic Churches

Sansovino had begun two important churches in Rome, San Marcello al Corso and San Giovanni dei Fiorentini, but neither of these was finished before he left the city in 1527, and both were substantially altered after his departure.[10] In Venice he encountered a totally unfamiliar local tradition of church-building, and a unique system of ecclesiastical organisation. And within this new environment the monastic orders and the lay parishes were fundamentally different types of patrons—both in their methods of administration and finance, and in their forms of worship and building types. The state-aided hospital of the Incurabili presented yet another set of circumstances. Of his two monastic churches, San Francesco della Vigna is a more revealing example of the patronage of the religious orders than Santo Spirito in Isola, of which tantalisingly little is known.

Saint Francis himself is traditionally supposed to have spent some time in the Venetian lagoon in the 1220s, on the lonely island now called San Francesco del Deserto. After the saint's departure, the little island where he had stayed was granted to the Franciscan order (known in Italy as the *Frati Minori* or Lesser Friars). During the thirteenth century the Franciscans spread to Venice itself and founded two more churches: one was Santa Maria Gloriosa dei Frari, the other, built in a vineyard on the northern fringes of the city, was the aptly named church of San Francesco della Vigna.[11]

The vineyard, in the parish of Santa Giustina, was bequeathed to the Franciscan order by Marco Ziani in 1253, to found a convent for six friars. Included in the bequest of land was one of the most sacred spots of the city, commemorated by a tiny chapel which still existed in the convent orchard in the eighteenth century, but which has now disappeared.[12] In this very place an angel is supposed to have appeared to the shipwrecked Saint Mark and pronounced the famous words 'Pax tibi Evangelista meus . . .' By the end of the thirteenth century both the number of monks and the population of that quarter of the city had expanded to such an extent that the original church was now too small. In about 1300 a larger triple-naved Gothic church was erected by an architect called Marino da Pisa.[13] It is this church which appears in Barbari's plan of 1500, together with its cloisters and orchards stretching to the

49. Jacopo de' Barbari:
Map of Venice, detail
showing the monastery
of San Francesco della
Vigna, 1500.

water's edge (Plate 49). Three beautiful fifteenth-century cloisters still exist today, although one has been partly destroyed by fire. From Sabellico's comments, in his description of the city published in 1502, we can assume that the convent buildings were rather more impressive than the church itself.[14]

Venice in the early sixteenth century was the scene of a searching self-examination on the part of the Frati Minori; and the reconsideration of their aims and beliefs must have given an impulse to the rebuilding of this insignificant monument. The order was now split into two groups—the Frati Minori Conventuali, based at the Frari, and the Frati Minori dell'Osservanza at San Francesco della Vigna. In the mid-fifteenth century the Observant branch had taken over the ancient convent on the island of San Francesco del Deserto from the Conventuali, who had apparently lost interest in the virtues of a quiet and solitary life.[15] This difference continued to characterise their attitudes to religious practice, and in 1517 Pope Leo X finally sanctioned the existence of the two separate branches and agreed that each should appoint its own general.[16]

The first impulse to reform the Franciscan order, and to return to solitude penitence and poverty, came from Spain in the late fifteenth century.[17] In Italy the question of reform was taken up in earnest in the reign of Pope Clement VII (1523–34). This Pope was especially worried by the ferment among the Franciscans in Venice, where the extremist 'Zealant' movement was rapidly gaining ground. In 1530 he assigned to Gian Pietro Carafa, Bishop of Chieti and later Pope Paul IV, the task of reforming the Frati Minori in the city. The Zealants, or Frati Zoccolanti, were led by a certain Fra Bonaventura, a friar at San Francesco della Vigna and a friend of Carafa, who in 1532 was granted a Papal Bull authorising him to set up his own hermitages for those monks who wanted to return to a stricter regime. Even among the remaining Observant friars, those who did not believe in the values of complete seclusion, the need to review their priorities was now fully recognised. Carafa remained in Venice until 1536, one of his greatest achievements being the removal from office of the corrupt Provincial General of the Observants in 1533. New religious orders—the Theatines, Capuchins and Jesuits in particular—were growing in strength in Venice, but among the older monastic orders it was the Franciscan Observants, based at the convent of San Francesco della Vigna, who attempted the most radical internal reforms.[18]

By chance, the Papacy of Clement VII, who sponsored this movement of renewal, coincided with the reign of Doge Andrea Gritti in Venice (1523–38). As we have seen, Gritti was one of Sansovino's most enthusiastic and, of course, influential supporters. And it happened that Gritti's own family palace was only a few yards from the church of San Francesco della Vigna. By the time of Sansovino's arrival in Venice in 1527 the Doge had already begun to rebuild his private palace, hoping eventually to abdicate and retire to this secluded corner of the city.[19] He could hardly have failed to notice the shoddiness of the neighbouring church, and his initiative was surely a driving force in launching the rebuilding scheme.

The first definite indication that plans were afoot to reconstruct San Francesco della Vigna dates from 1527, for in April of that year a spice-merchant called Ambroso left 300 ducats for the building of the new church.[20] The convent had acquired several pieces of land around the site during the first decade of the century, but if a new church was already planned at this stage, the Wars of the League of Cambrai must have forestalled the project.[21] In 1529 the friars arranged to exchange some of their property for another piece of land nearby,[22] and in the following year they held a sale of indulgences in Holy Week to help to pay for the purchase of a vineyard adjoining the church.[23] The Papal Brief authorising the rebuilding scheme was dispatched from Rome in 1533,[24] and a year later, on 15 August 1534, Doge Andrea Gritti laid the foundation stone of the new church.

The foundation medal, struck by the medallist Andrea Spinelli to commemorate the event, shows Gritti's portrait on one side and a view of Sansovino's model for the new church on the other (Plate 50). This is the only known representation of the original project, for a year later Sansovino's design was altered to comply with the recommendations of one of the friars in the monastery, Fra Francesco Zorzi.[25] Zorzi had more than a casual interest in the building. He was one of a group of three friars who took special responsibility for the administration of the scheme. The other two were Fra Zuanne Barbaro who was the superior of the monastery and 'commissario della fabrica', and Fra Hieronimo Contarini, who took a less active part but whose name appears in occasional documents as 'procurator della fabrica' and once in 1538 as 'guardiano' and 'commissario sopra la fabrica', Barbaro's normal positions.[26] These friars were all members of distinguished noble families. Zorzi and Barbaro in particular were respected figures in the Venetian intelligentsia. Zuanne Barbaro was the uncle of Daniele, the well-known patron of Palladio and author of a commentary on Vitruvius published in 1556.[27] Zorzi himself wrote an erudite treatise on harmony and proportion;[28] and his eminence is clear from the fact that he represented the Observant Friars at Leo X's assembly of the Franciscan order in Rome in 1517.[29] The initiative and energy of Zorzi and Barbaro in organising the building of the new church is commemorated by an inscription in the choir.[30] Officially, decisions taken by Barbaro and his two deputies needed the authorisation of the provincial committee of the Observant friars in Verona, but in practice there is no evidence that their wishes were ever disputed.

In revising Sansovino's design for San Francesco, Zorzi aimed to achieve a perfectly harmonious space within the church by relating all the dimensions

50. Andrea Spinelli: Foundation medal for San Francesco della Vigna, 1534.

to a basic unit of three *passi*. He founded his scheme on the Platonic conception of the number three as a divine number. In Christian theology, too, this number has divine significance since it symbolises the Trinity. Zorzi proposed that the nave should be nine paces wide and twenty-seven paces long, and each of the side chapels three paces wide. Using the humanist analogy with the human body, Zorzi added that the chancel (the head) should be narrower than the nave (the body), and therefore suggested dimensions of nine paces in length and six paces in width for the chancel.[31] The reforms in the Franciscan order at this time were pressing for a return to the initial simplicity of the movement, and it seems likely that Zorzi's ideas about the form of the new church were affected by this search for spiritual purification. But his proposals were not just abstract philosophical notions. He was also concerned with practical problems, and his programme anticipated many features of Counter Reformation church design. Improvements in the effectiveness of services would have been a natural accompaniment to the Franciscan reforms. Thus Zorzi wrote:

I recommend to have all the chapels and the choir vaulted, because the word or song of the minister echoes better from the vault than it would from rafters. But in the nave of the church, where there will be sermons, I recommend a ceiling (so that the voice of the preacher may not escape nor re-echo from the vaults).[32]

The sympathy which is often expressed for Sansovino for having to submit to the wishes of a meddling neo-Platonist friar does not seem entirely justified.[33] Zorzi specifically stated at the outset of his memorandum that he wanted to make the proportions harmonious, but that 'this one can do without altering anything that has been done'.[34] He approved of the heights of the nave and chapels of Sansovino's model, and gave no indication that he wished to exclude the dome which appears on the foundation medal but was never built. It is conceivable that Sansovino himself had already omitted the dome from his design. He probably encountered the usual Venetian resistance to huge vaulted spaces in this commission, just as he did in the building of the Library and the Scuola della Misericordia. The raising of the side chapels and chancel on three steps, which Zorzi advised, was also a pre-existing feature of Sansovino's own design. The fact that two of the four witnesses to Zorzi's *scrittura* were Titian and Serlio—both of whom were friends of Sansovino's and shared many of his artistic ideas—does not suggest any hostility towards the architect's wishes. It is unlikely that Doge Andrea Gritti, who was a loyal admirer of Sansovino's and who presumably arranged the commission, specifically requested the friar's intervention. It seems more plausible that Zorzi was simply providing a philosophical basis for the design, in order to enhance the significance of the new building, and that this involved making only minor adjustments to the proportions suggested by Sansovino himself.

After Zorzi's programme was submitted in 1535, building work went ahead smoothly for a number of years. As we have seen, the prosperous thirties were favourable years for building in Venice. The monastery of San Francesco della Vigna was one of the better-endowed religious institutions in the city, and the patronage of the Doge gave added prestige to the building project. Between 1535 and 1538 most of the chapels in the new church were conceded to various Venetian families (Figure v). The kudos associated with the church is clear

from the fact that their names included some of the most distinguished families of the nobility—Grimani, Contarini, Giustiniani, Barbaro, Morosini, and so on. Citizens were only conceded chapels in return for exceptional devotion as worshippers. According to the standard form of agreement each family was granted the right to use the chapel for its tombs and to display its coat of arms there. Each family contributed a sum ranging from 200 to 350 ducats (one of the small chapels next to the chancel cost only 110 ducats) to pay for the construction of the chapel, while the windows, altar, altarpiece, seats and floor were provided at their own expense. The sale of chapels seems to have been one of the principal methods of fund-raising. It is inconceivable that the construction of a single, unembellished chapel could have cost as much as two or three hundred ducats, and any surplus would have made a useful contribution to the building of the main body of the church. The total proceeds from these sales amounted to over 4,500 ducats—considerably more than the funds available for any of Sansovino's parochial commissions.[35]

Doge Andrea Gritti acquired the right to be buried in a tomb in the floor of the chancel in front of the high altar, for which he made the exceptionally generous donation of 1,000 ducats.[36] He showed his special affection for San Francesco della Vigna in his will, bequeathing to the church his ducal robes to be made into vestments, processional banners and standards, a large carpet, and hangings to decorate the seats of the chancel on special occasions. He also provided an endowment of 30 ducats a year, equivalent to a capital sum of 600 ducats.

As well as Doge Gritti, two other patrons and close friends of Sansovino's were involved in the church. One was Marc'Antonio Giustinani who, according to Vasari, had met Sansovino in Rome, and who was one of the executors of the architect's will. It was Marc'Antonio who paid for the construction of the large Giustiniani chapel to the left of the chancel.[37] The chapel owes its special character to the fact that the beautiful Quattrocento relief sculpture from the Giustinani family chapel in the old church was preserved and re-installed in the new chapel. Superfluous reliefs which did not fit into the available space were apparently included in consignments of fine marble which Marc'Antonio supplied for Sansovino's Loggetta.[38]

The other important figure was the Procurator Vettor Grimani, brother-in-law of Marc'Antonio Giustinani, who in 1537 bought for himself and his brother, Cardinal Marino Grimani, the chapel nearest the main entrance on the left side of the nave. The concession agreements specified that all the side chapels in the church had to conform to Sansovino's model. The chapels which still preserve their original form today indicate that this model called for a plain barrel-vaulted structure, with the side walls articulated only by two cornices, the altar raised on three steps, and stone benches along the sides. The coat of arms of each family was placed in the keystone above the entrance arch. The floors were decorated in a diamond pattern of red and white marble like the floor of the nave. However, the influence wielded by the Grimani family is demonstrated by the fact that their chapel is far more sumptuous than any of the other chapels decorated in the sixteenth century, with ceiling paintings by Battista Franco, and murals by Federico Zuccaro who also painted the altarpiece (Plate 51). (The painted decoration was commissioned by Vettor's

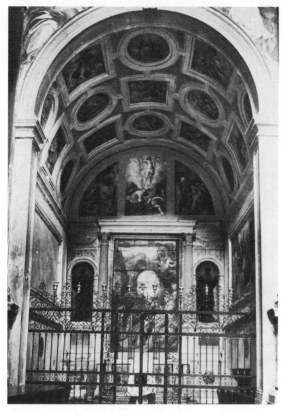

51. Grimani Chapel, San
Francesco della Vigna,
Venice, decoration begun
*c.*1560.

nephew Cardinal Giovanni Grimani.) The arrangement of the compartments
of the ceiling is characteristic of the type of coffering—inspired by Antique
vault decoration—which Sansovino often used; and it is not inconceivable
that he himself provided the design. The original gilded stucco ornament has
been removed, but the vault must once have resembled those designed by
Sansovino for the Scala d'Oro in the Doge's Palace and the staircase of the
Library.[39]

But the Grimani interest in the new church went much further. In 1542,
Vettor Grimani and his brother Cardinal Marino, as executors of the will of
their uncle Cardinal Domenico Grimani, acquired the right to build the façade
of the new church and to place on it the tomb of Doge Antonio Grimani, made
'according to the existing model'.[40] This stipulation probably referred to a
model which Sansovino had made for Doge Grimani's tomb, intended for the
church of San Antonio di Castello.[41] Shortly afterwards, the inside wall of the
façade, too, was conceded to the Grimani family, this time to Vettor alone for
tombs or monuments of himself and his heirs.[42] The final outcome was that
three Grimani sarcophagi, those of the two Cardinals Domenico and Marino,
and the Patriarch of Aquileia, Marco Grimani, were erected on the inside of
the façade wall above the main door. They were described in this position in
all three editions of Francesco Sansovino's guide, but have since disappeared.[43]
Doge Antonio Grimani himself was buried at San Antonio di Castello as
originally planned, but this church was destroyed by fire in 1687. The com-

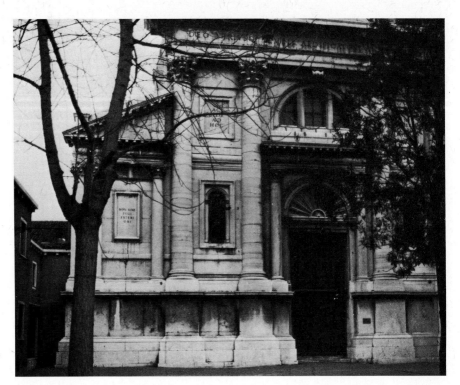

52. Andrea Palladio: San
Francesco della Vigna, façade,
commissioned 1562.

mission for the external façade of San Francesco was eventually awarded by
Cardinal Giovanni Grimani to Palladio in 1562—after the death of Vettor
Grimani, but during Sansovino's lifetime (Plate 52).[43] The inscription on
Palladio's façade, 'Non sine jugi exteriori interiorque bello', perhaps implies
an apology to the aged Sansovino for his disappointment. Two models of the
'fabricha de S. Francesco', recorded in the inventory of Vettor Grimani's
property after his death in 1558, are evidence of the Procurator's active interest
in the building.[45]

Apart from the façade, most of the church seems to reflect Sansovino's
amended model (Plate 53). Even the campanile was already under construction
in 1543.[46] By this time the building of the church was well advanced.[47] In 1554
the choir was already in use; and the church was finally consecrated in 1582.[48]
The flat coffered ceiling proposed by Zorzi was never built, and instead, the
exposed beams of the roof were covered by a false vault (Plate 54).[49]

San Francesco della Vigna has an important place in the history of sixteenth-
century Italian architecture. Sansovino himself had already used a similar plan
—a one-aisled nave with side chapels—for San Marcello al Corso in Rome.
There are also several earlier precedents for this arrangement, such as Michel-
ozzo's SS. Annunziata in Florence, Francesco di Giorgio's Church of the
Osservanza in Siena (like San Francesco built for the Observant branch of the
Franciscan order), and Alberti's Sant'Andrea in Mantua. The unimpeded nave
was ideal for preaching to large congregations, while the side chapels offered
secluded settings for smaller services. The new emphasis on preaching in the
Counter Reformation led to the widespread use of this type of plan later in the

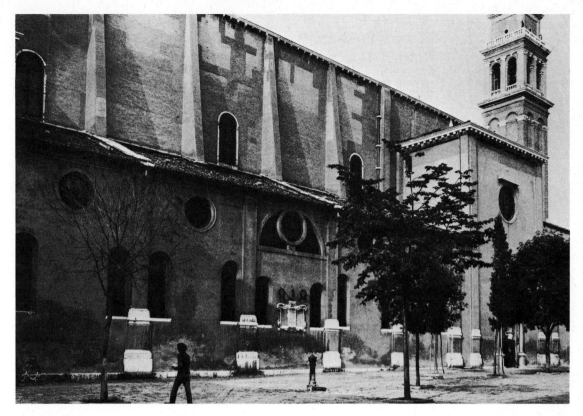

53. Jacopo Sansovino: San Francesco della Vigna, begun 1534, side view.

54. San Francesco della Vigna, section.

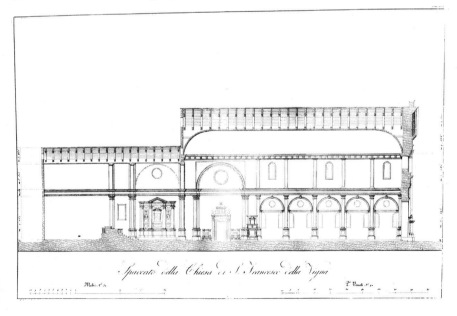

century—notably in Vignola's Gesù in Rome, begun in 1568, Alessi's San Barnaba in Milan, probably designed in 1558, and Palladio's Redentore in Venice commissioned in 1576.[50] In Venice the only recent precedent for a church with a long, spacious nave was San Salvatore, begun in 1506 by Giorgio Spavento, but in this case the nave was conceived as a succession of three centrally planned units each with a dome supported on free-standing piers. The concept of a huge unified nave-space looks back to the Gothic monastic churches such as the Frari and Santi Giovanni e Paolo; but the elimination of the side-aisles at San Francesco della Vigna, creating a completely unencumbered space, was a major innovation in Venice.

The restraint and asceticism of the decoration, too, reflect the fact that the Franciscans were in the vanguard of the Catholic Reform movement in the city. Here Zorzi's influence seems to have been important, for it was he who suggested painting the ceiling a sober grey, and recommended the use of the Doric order, which he considered 'proper to the saint to whom the church is dedicated and to the brethren who have to officiate in it'.[51] The church has a brightly lit white-washed interior, with plain Istrian-stone Doric pilasters raised on high bases (Plate 55). Sansovino's design is strongly reminiscent of another Franciscan church he had known in Florence, Cronaca's San Salvatore al Monte, begun in 1499 (Plate 56). These two churches have many features in common—the clerestory lighting, the two orders of simple Doric pilasters, the restrained decoration, and the single nave flanked by side chapels.[52] However, the Istrian stone used in the interior of San Francesco, which has now darkened to a sombre grey, would originally have been a brilliant white, creating an over-all luminosity far removed from the hard lines of the dark yellow *pietra forte* articulation in Cronaca's church. Yet again, Sansovino blended his Central Italian experience into the new Venetian setting. It is significant that Palladio, whose major ecclesiastical commissions were in Venice, recommended white as the perfect colour for church interiors, for white Istrian stone and distempered stucco were easily available materials in the city, and were widely used for that very purpose.[53]

The most revolutionary feature of the new church of San Francesco della Vigna was the extension of the chancel behind the high altar for the monks' choir (Figure v), a scheme which foreshadowed Palladio's two Venetian monastic churches, San Giorgio Maggiore (Figure vi) and the Redentore. We must not forget that Doge Andrea Gritti was an active patron of music as well as the other arts. It was he who persuaded the Procuratia de Supra to appoint the great Flemish composer Adriano Willaert as choir-master of St. Mark's in 1527. In Venice Willaert was an active promoter of polyphonic choral music, which was now beginning to supersede the traditional Gregorian chants sung in unison. He began to break away from the set patterns of tunes and rhythms in medieval music, and to make every note convey the content of the text.[54] The new emphasis on the clear expression of religious feelings in sacred music must have fitted well with the climate of thought in the Franciscan movement at this time. Apart from St. Mark's, it was chiefly the monastic churches which used choral music in their services, and Gritti himself probably gave positive encouragement to the choir of his local church.

72

v. Jacopo Sansovino: San Francesco della Vigna,
Venice, begun 1534, plan.

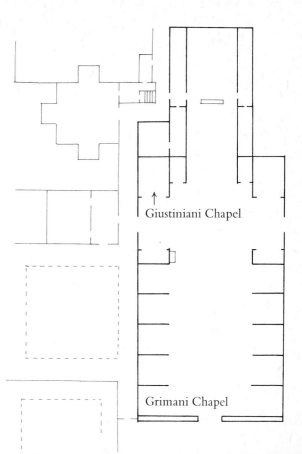

Giustiniani Chapel

Grimani Chapel

55. (below) San Francesco della Vigna, interior.

56. (below right) Cronaca: San Salvatore al
Monte, Florence, begun 1499.

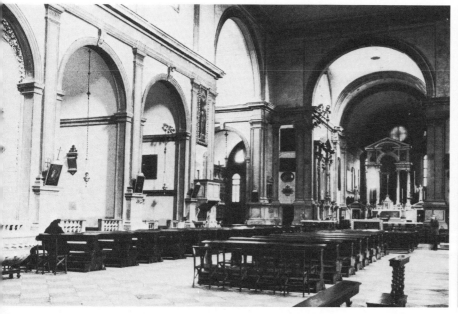

Other monastic churches in the Veneto—such as the huge Benedictine church of Santa Giustina in Padua, begun in 1521—had been provided with ample choir-space.[55] But the way in which the high altar of San Francesco served as a choir-screen was new to Venice (Plate 57). Sansovino seems to have borrowed the idea from Roman churches such as Santa Maria del Popolo.[56] This arrangement allowed the friars to sing hidden from the congregation, yet to remain easily audible, the sound of their voices reverberating against the barrel vault above. From Zorzi's memorandum we know that acoustics were a pre-eminent consideration in the design of the new church.[57] The illumination, too, seems to have been contrived to enhance the music. While the chancel, like the rest of the church, is brightly lit from above, the choir beyond is dark and mysterious, except for the *contre-jour* effect of the windows on the end wall. The light from these three windows would have suggested a divine luminosity emanating from the celestial chorus. Because of the long choir, the total length of the choir and chancel together is equal to the length of the nave; and as a result, the crossing becomes the central point in the church (Figure v). Standing in the building one is not aware of this, for the choir is relatively dimly lit and partly hidden by the high altar. It was Palladio, in his design for San Giorgio Maggiore, who fully exploited the potential ambiguity between the longitudinal and the centralised plan. In San Francesco della Vigna Sansovino achieved, instead, a sense of order, simplicity and clarity.

Differences between the styles of Palladio and Sansovino emerge, too, in their designs for the façade. Spinelli's medal (Plate 50) shows that Sansovino's project anticipated the four great columns on high bases in Palladio's executed façade (Plate 52). However, Sansovino's columns are spread across the whole elevation, while Palladio's embrace only the width of the nave. Instead of the one main order surmounted by an attic, Palladio uses a giant order which, combined with the closer spacing of the columns, gives a sense of horizontal compression and a dominant vertical emphasis to the façade. This effect, which is typical of Palladio's later work, is remote from the more relaxed feeling of Sansovino's design of three decades earlier. By the time the Grimani family came to erect the façade in the 1560s, Sansovino's original model would have seemed old-fashioned, and it is hardly surprising that they preferred to commission a more imposing alternative from Palladio.

At San Francesco della Vigna, Sansovino encountered a situation which was to become characteristic of Counter Reformation patronage later in the century. That is to say, he enjoyed the support of wealthy and distinguished patrons (until he was dropped in favour of Palladio at the very end of his life), against the background of the search for renewed austerity within the Franciscan order. It was this apparently incongruous combination which fostered the remarkable unadorned dignity of his first Venetian church.

Sansovino's other Venetian monastic commission, the completion of the church of Santo Spirito in Isola, remains something of an enigma. The first record of a monastery on the island, belonging to a branch of the Augustinian order known as the Canonici Regolari, dates from as early as 1140. Various other orders occupied the convent during the later fourteenth and early fifteenth centuries, until it was conceded to a newly established group of hermits

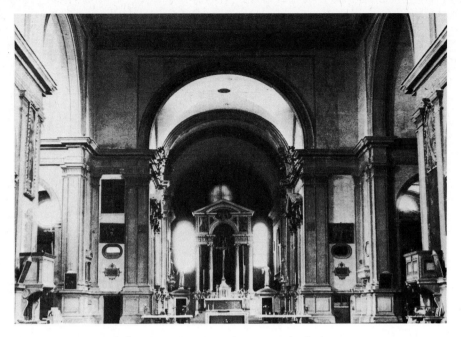

57. San Francesco della Vigna, interior, view towards choir.

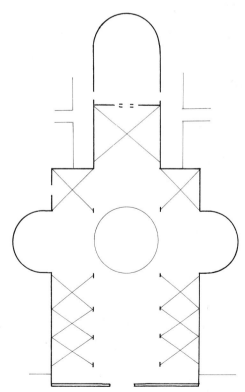

vi. Andrea Palladio: San Giorgio
Maggiore, Venice, begun 1565, plan.

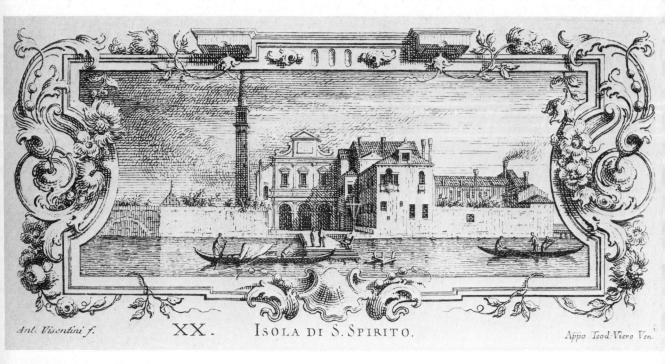

Ant. Visentini f. XX. ISOLA DI S. SPIRITO. *Appo Teod Viero Ven.*

58. Jacopo Sansovino: Santo
Spirito in Isola, engraving by
Visentini, published 1777.

associated with the Canonici Regolari in 1424. From then on the monastery
flourished under its new founder, Andrea Bondumiero, who died in 1465.[58]

By the sixteenth century, the order of the Canonici Regolari had become
extremely prosperous, and their holdings of land on the *terraferma* were
increasing steadily (restrictions on the acquisition of property by the Church
being less rigid on the mainland than in the city).[59] The monks had already
begun to build a new church before the Wars of the League of Cambrai. Two
altars were consecrated in 1505,[60] but as was the case with so many other
building projects, the subsequent troubles evidently delayed the work. At
what stage Sansovino was employed to complete the church is uncertain. The
main fabric of the building must have been virtually complete in 1542 when
Vasari was commissioned to decorate the ceiling. When the painter left
Venice in the summer of that year, he had not yet proceeded beyond the stage
of preparatory drawings, and the commission passed to Titian, who finished
the paintings by 1544. The layout of the compartments of the ceiling—a row
of three central panels bordered by eight roundels—was presumably designed
by Sansovino himself.[61] The four remaining altars were finally consecrated
in 1581.[62]

The church subsequently suffered badly, and it now no longer survives. In
1656 the order of the Canonici Regolari was suppressed and the paintings were
removed to the new church of the Salute. After a period of occupation by
Franciscan refugees from Crete between 1672 and 1806, the convent was taken
over by Napoleonic naval forces for the storage of gunpowder.[63]

The appearance of the façade is preserved in eighteenth-century engravings
of the island, which show a three-bay, two-order elevation, with a pedimented

76

attic story flanked by scrolls (Plate 58).[64] As the ceiling paintings indicate, the church was longitudinal in plan, the conventional form for Venetian monastic churches. In contrast to San Francesco della Vigna, its dimensions were relatively small, for there was no need to accommodate large congregations. The reclusive nature of the religious community at Santo Spirito made their needs and priorities very different from those of the monks at San Francesco. The monastery sought to provide an environment which would be conducive to study and meditation. But these hermits were by no means ascetics. They seem to have used their wealth freely to embellish their surroundings. In his guide of 1581 Francesco Sansovino marvelled at the fine buildings, the rich collections of statues and paintings, and the spacious gardens on the island.[65] Such rich, almost hedonistic patrons must have offered a rare opportunity to the architect, and the obliteration of the church is a tragic loss.

THE PARISH CHURCHES

The three parish churches on which Sansovino worked in Venice—San Martino, San Giuliano and San Geminiano—were all foundations of great antiquity. The original church of San Martino is said to have been founded by a group of Paduan nobles in 593.[66] San Giuliano was probably founded during the exile of Doge Giovanni Participizio some fifty years earlier.[67] The oldest of the three was San Geminiano, one of the two churches built in the time of Emperor Justinian to commemorate the victory of the Venetian general Narsete over the Goths in 532 (the other being the little chapel of San Teodoro in the precinct of San Marco).[68] Naturally all three had been rebuilt at least once by the time Sansovino arrived in the city a thousand years later.

Although they were all established by groups of the earliest settlers in the Venetian archipelago, these churches had very different geographical situations. San Geminiano had the most prestigious site of the three, on Piazza San Marco opposite the Basilica. When the area of the Piazza was extended by Doge Sebastiano Ziani in 1156, the canal in front of the church was filled in, and the church itself was moved back to the equivalent position on the enlarged Piazza, still facing San Marco.[69] San Giuliano also had a conspicuous situation, standing on a bend in the Merceria, the main street of Venice which linked Piazza San Marco with the Rialto. Thanks to their sites in the very centre of the city, these were two of the wealthiest parishes in the whole of Venice. San Martino, on the other hand, was far less favourably located, in a distant corner of the city near the Arsenal. Here land was cheaper and more plentiful, but at the same time the resources of the parish were limited by the relative poverty of the inhabitants. Since the parishes depended for revenue on the financial support of their residents—in contrast to the more broadly-based incomes of the great religious orders—these variations were to have a drastic effect on the sixteenth-century rebuilding schemes.

Little is known of the circumstances of Sansovino's commission to rebuild the church of San Martino. Francesco Sansovino records simply that the church had to be demolished because of its great age and that it was rebuilt 'in altra forma, sul modello Iacomo Sansovino'.[70] The date of 1540 given by Flamino Corner for the start of the project is plausible, but no other information about the building history survives.[71]

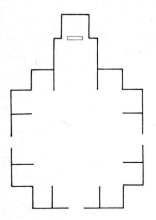

vii. Jacopo Sansovino: San Martino, Venice, begun c.1540, plan.

It seems curious that such a distinguished architect as Jacopo Sansovino should have been employed in this remote and unremarkable parish. Although Saint Martin (traditionally portrayed as the nobleman mounted on his horse, giving half his cloak to a beggar) has always been a popular saint in Venice, the church does not seem to have attracted pious bequests from outside the parish. Indeed it was extremely poorly endowed. In 1581, at the time of the Apostolic inspection of Venetian churches, the regular annual income from bequests (these numbering only four) amounted to a mere 36 ducats, together with some supplies of corn and wine, while there was as little as 25 ducats a year to spend on the building.[72] How they could afford to employ Sansovino is something of a mystery—either he was prepared to accept an unusually small payment, or some unknown benefactor subsidised his fees. Considering the parish's impecunious state he probably did no more than to supply the model.

The architect was certainly aware of the need to economise, for the church is constructed in the cheapest available materials (Plate 59). The walls are of brick, the ceiling is flat, and Istrian stone is used only for the details of the façade, such as the capitals, doorway and window-frames, and for the articulation of the interior. Even so, the building work was badly held up by the shortage of funds. The Apostolic visitors in 1581 found the church unfinished and still not consecrated.[73] According to Corner it would not have been completed at all, but for the exceptional generosity of the parochial clergy who raised 1,000 ducats from the sale of vineyards near the church to help to finance the building.[74] In view of the fact that the salary of the *pievano* of San Martino in 1581 was only 160 ducats a year, from which he had to pay for the upkeep of the church, and that of the three other salaried priests only 10 ducats, it is hardly surprising that the work went ahead so slowly.[75] The church was not finally consecrated until 1653.[76]

In spite of the meagre resources available, San Martino is a most satisfying solution to the problem of parish church architecture. It has a simple Greek Cross plan, with two chapels at each corner which enliven the box-like central space (Figure vii). Unfortunately the eighteenth-century illusionistic ceiling painting and the profuse wall decoration tend to obscure the simplicity of the original conception (Plate 60).[77] Here, in contrast to San Francesco della Vigna, economy rather than decorum determined the austere style. The subtlety and restraint of the detail of Sansovino's design can now only be appreciated by an effort of imagination; but the elegant, elongated Doric pilasters and the attractive coffering of the *sottarchi* hint at its original character. In the central cubic space light streams in from large rectangular windows, and the barrel-vaulted chapels are lit by round port-holes like the side chapels at San Francesco della Vigna. The façade of San Martino, reminiscent of the medal project for San Francesco, implies a triple-naved interior (Plate 61), but Coducci at San Giovanni Crisostomo had already shown how to relate a façade of this type to a centralised church.[78] As in most of his Venetian buildings, Sansovino incorporated indigenous motifs, such as the façade and chancel windows, which are derived from the architecture of Coducci (and which he also used on the side walls of the Loggetta).

It was Coducci who, at the turn of the century, had pioneered the revival of the Veneto-Byzantine centralised plan for parish churches (Figure viii).[79] The

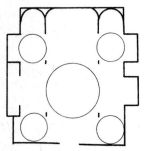

viii. Mauro Coducci: San Giovanni Crisostomo, Venice, begun 1497, plan.

78

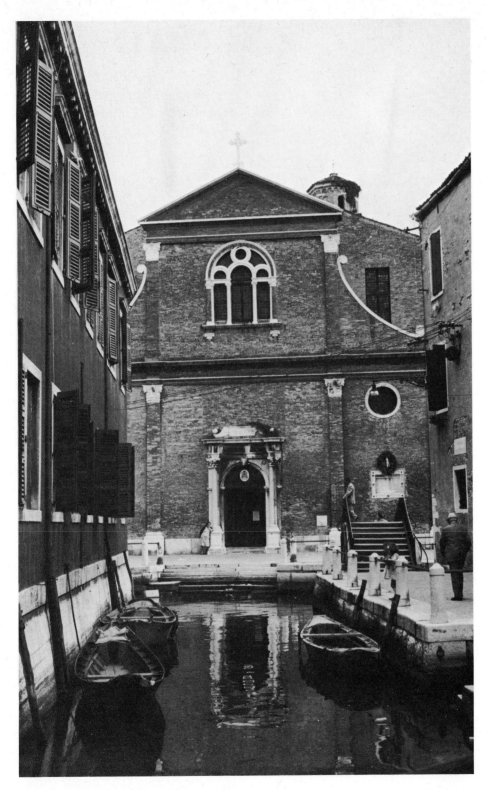

59. Jacopo Sansovino: San Martino, Venice, begun *c.* 1540.

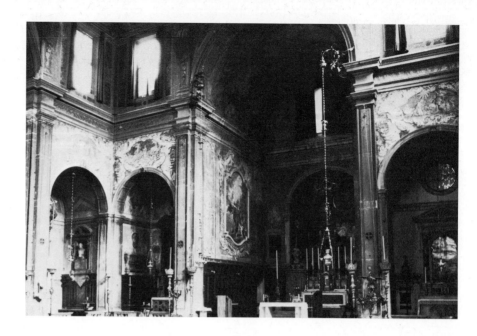

60. San Martino,
Venice, interior.

61. San Martino,
Venice, exterior.

flourishing of Greek studies in Venice at the time provided a congenial atmosphere for this trend. But the central plan also had certain practical advantages. A square central space was ideal for the preaching of sermons to small congregations and for performing the sacraments, allowing the *pievano* closer communication with his 'electorate'. In contrast to the monastic institutions, parish churches did not need extensive choir-space. Most of them relied chiefly on organ music.[80] (San Martino, however, must have had a small group of singers, for the church has a tiny choir behind the high altar.) From Barbari's plan we know that the previous church of San Martino was not centralised but longitudinal in plan, on an east–west axis (Plate 82). Sansovino changed the orientation as well as the plan, placing the high altar on the south side of the new church, although his reasons for making the change are not clear. Perhaps existing foundations beneath the previous building on the north side were usable, for otherwise a radical change of plan would have been a costly undertaking. As at San Francesco della Vigna there was no serious land shortage in this quarter of the city, but here the lack of funds restricted the size of the new church. Sansovino's choice of the Greek Cross plan was entirely deliberate; and it is significant that, as we shall see, the two other Venetian parish churches on which he was employed were both centrally planned.

The histories of Sansovino's involvement in both the latter churches, San Geminiano and San Giuliano, are closely intertwined. The common bond is one of the most remarkable figures in sixteenth-century Venetian patronage, the doctor and philologist from Ravenna, Tommaso Rangone. Through his skill as a physician Rangone had made a large fortune which he was eager to use for various worthy causes. He was a procurator of four churches in the city, including both San Geminiano and San Giuliano, and served as guardian of two of the Scuole Grandi, those of San Marco and San Teodoro.[81] And his munificence was combined with a curious obsession for having his image conspicuously portrayed in the institutions he supported.

The rebuilding of San Geminiano was begun in 1505 by the local architect Cristoforo da Legname. After an intermission caused by the wars of the League of Cambrai, the parish priest, Matteo Eletti, made further attempts to raise funds to finish the church, but after his death in 1523 the project lapsed.[82] The church was, however, usable for services—Sanudo's diaries record the annual visits of the Doge to hear mass on the Apostles' Sunday. It was about 1552 that Tommaso Rangone commissioned a new façade from Sansovino, to be erected at his own expense, bearing a statue of himself; but the Senate vetoed the project on the grounds that Piazza San Marco, the centre of government of the Republic, was not the place for the glorification of individuals.[83] (Perhaps to make up for this disappointment, Rangone had himself represented in a prominent position, in front of an extravagant church façade set at the end of a large piazza, in the painting of *The Carrying of the Body of St. Mark*, one of the series he commissioned from Tintoretto in 1562 for the Scuola di San Marco.)

Eventually, in 1557, the *pievano* Benedetto Manzini persuaded the Senate and the three Procuracies of St. Mark's to finance the completion of the church of San Geminiano. It was decided to appoint two of the Procurators to commission a model and to help Manzini to supervise the work.[84] Significantly,

ix. Cristoforo dal Legname: San Geminiano, Venice, begun 1505, plan.

the two elected were Antonio Capello and Vettor Grimani, Sansovino's two most zealous promoters in the Procuratia de Supra. Sansovino's model was approved, and work began soon afterwards.[85] The Senate awarded 400 ducats, and the three Procuracies a total of 1,600 ducats, and in the following year a further sum of 400 ducats was contributed by the Procuratia de Supra.[86] The building contract indicates that Sansovino was responsible only for building the central dome (with four windows in the drum), roofing the whole church, and replacing the entire façade from the foundations upwards, the rest of the church being already completed.[87]

Manzini's initiative was essential to the whole enterprise. As Francesco Sansovino wrote, 'The architect . . . was Sansovino, but the one who promoted and completed the whole work was Manzini . . .'[88] This *pievano* even paid for a new organ himself, at a cost of over 600 ducats.[89] In recognition of their efforts, marble busts of both Manzini and Matteo Eletti (the *pievano* who had begun the new building) were placed in the church, as well as a bronze head of the thwarted Rangone. A marble bust of Sansovino—a self-portrait—was put over the entrance to the Chapel of the Crucifixion, which he added in 1566.[90] The architect showed his special affection for the church in his last will, when he asked to be buried in this chapel.[91]

Like his two other parish churches, San Geminiano was small and centrally planned (Figure ix), but if the main part of the church was built before he even arrived in Venice, Sansovino obviously cannot be given credit for the ground plan. Cristoforo da Legname's design was strongly influenced by Coducci's San Giovanni Crisostomo, with its squarish plan, dominating central dome supported on four free-standing columns, and apsidal chapels on each side of the chancel (Figure viii).[92] The central dome and four smaller cupolas were highly appropriate for this church (Plate 62), which faced the splendid domes of San Marco at the other end of the Piazza. Thanks to the donations from the state and the Procuratie, who between them were responsible for the rest of the Piazza and were eager to make every monument in the city centre worthy of such a prestigious site, there was little need to economise. Since the church was already almost completed, the grant of 2,400 ducats for Sansovino's part alone was extremely generous. The Apostolic visitors in 1581 commented that the church was magnificently constructed and decorated, being 'entirely of marble'.[93] The rich marble interior seems to have been the product of the first stage of the work, for Benedetto Bordone's *Isolario*, published in 1534, describes San Geminiano as 'de pietre fine lavorata'.[94] The papal visitors could only conclude that the church was more than adequate for the needs of such a small parish, with its population of only 1,400.[95]

Sansovino's façade (Plate 63) was of white Istrian stone. The two-order scheme surmounted by an attic recalls his façade for Santo Spirito (Plate 58), but it has even closer affinities with Serlio's projects for temple fronts in Book IV of his treatise, published in Venice in 1537 (Plate 64).[96] The two orders correspond with the main horizontals of the elevation of the Library, which Sansovino intended to continue along the south side of the Piazza as far as the church itself. The façade had to play the difficult role of linking the three storeys of Buon's Procuratie Vecchie with the two storeys of Sansovino's design for the Procuratie Nuove (Plate 10). Thus the repeated vertical elements

82

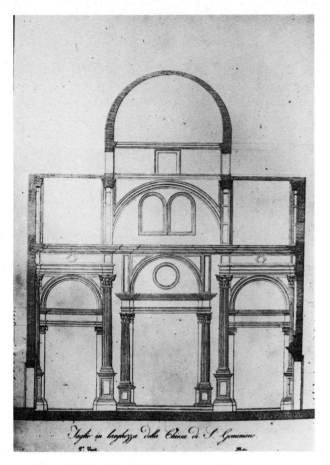

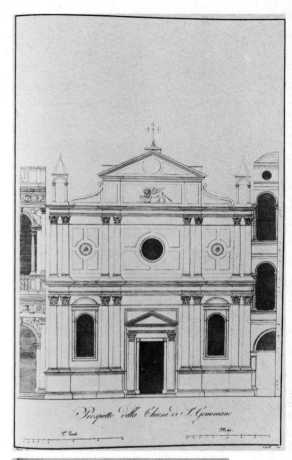

62. (above) Cristoforo dal Legname and Jacopo
Sansovino: San Geminiano, Venice, begun 1505,
section.

63. (above right) Jacopo Sansovino: San Geminiano,
façade, begun 1557.

64. (right) Serlio: Church façade, from Book IV of
his treatise, first published in Venice 1537.

65. Jacopo Sansovino: San Giuliano, Venice, façade, begun 1553.

of the two orders of paired columns helped to ease the transition between the two systems. The church fully lived up to its conspicuous and distinguished site—according to Francesco Sansovino it was 'judged by everyone to be almost like a ruby among many pearls'.[97]

In 1553, after his disappointment at San Geminiano, Tommaso Rangone offered the sum of 1,000 ducats for the thorough restoration of the old church of San Giuliano and the building of a new façade, in addition to which he would pay for a bronze statue of himself to be placed above the door. The ancient church, which had been rebuilt after a great fire in the early twelfth century, was now in a very precarious condition. This time the Senate were prepared to gratify Rangone's wishes, and the project was approved in September 1553.[98]

The inscription on the façade commemorating Rangone's benefaction bears the date 1554, the year in which Sansovino made the wax model for his effigy (Plate 65). The bronze statue was finally delivered in 1557.[99] Meanwhile, however, the demolition of the old façade and the start of the new foundations had caused the roof of the church to collapse. It became obvious that not only the façade but the whole structure needed rebuilding. In 1559 Rangone offered to pay a quarter of the total cost of the reconstruction, provided that the sum did not exceed 900 ducats. In return, he asked for the right to be buried in the chancel.[100]

84

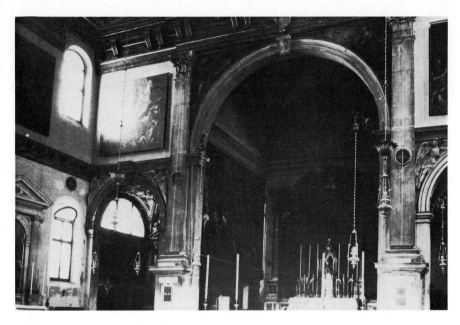

66. San Giuliano, interior, begun 1566.

The cost of such a radical scheme seems at first to have been prohibitive. The difficulties are clear from the tax return of the *pievano*, Tommaso Rumoni, in 1565. In this statement he explained that Rangone had invited all the parishioners to subscribe to a fund to pay for the rebuilding. In response to the appeal, hoping to set an example for the other parishioners, the *pievano* offered to contribute 50 ducats a year for five years, and the four salaried priests 20 ducats a year between them for the same period.[101] The cost of maintaining the old church was now becoming a great burden. The *pievano*, who had to finance the repairs from his own pocket, even complained of the constant damage to the roof from children's ball-games.[102]

At last, in 1566, a new agreement was concluded, by which Rangone would contribute 900 ducats, and the parish clergy and procurators 700 ducats. The aged Sansovino would then provide a model for the new nave. If the cost exceeded this amount, the difference would be split between the two parties in the same proportions so that the whole project could be carried through.[103] The agreement specified that all the materials from the old church were to be re-used, a common practice in Venice where building materials were so expensive. The basic sum of 1,600 ducats was not a lavish budget, even for a relatively small church. It is not surprising that San Giuliano is even simpler in plan than San Martino (Figure x). Sansovino's choice of plan was a conscious decision, just as it had been at San Martino. Again in this case the triple-naved Gothic church which appears on Barbari's map (Plate 7) was replaced by a simple cube-like central space with a flat roof. In view of the need to economise, it must have been possible to reuse at least some of the foundations of the old church. The chancel is flanked by two huge, very plain Corinthian pilasters, with a smaller chapel on each side (Plate 66). The side walls have no order at all. The two tiers of large, round-headed windows are designed to admit as much light as possible, but even so, the constricted site makes the

x. Jacopo Sansovino: San Giuliano, Venice, begun 1566, plan.

interior of the church extremely dark. The richly decorated ceiling, with its gilded coffering and scroll-work, was not part of Sansovino's design, but was commissioned with a special private endowment in 1585.[104]

Nevertheless, in comparison with San Martino, the relative prosperity of the church of San Giuliano is evident from the account of the Apostolic inspection in 1581. The church's notable collection of religious relics (including the bodies of Saint Paul the Hermit and the Oriental martyrs, Saint Julian himself and Saint Florian) were preserved in fine gilded tabernacles. The silver-ware, altars and paintings, too, were much admired. The report states that the annual income from endowments amounted to 324 ducats a year (almost ten times as much as that of San Martino).[105]

Although the new church had been consecrated in 1580, a patriarchal inspection in 1593 reported that the chancel, which had been conceded to Rangone for his tomb, was still not finished, and nor were the organ and another altar.[106] This delay in completing the building, together with the fact that both Sansovino and his former pupil Alessandro Vittoria are named as architects in Rangone's will of 1576, led Temanza to suggest that Vittoria had some part in the design, especially in the upper part of the façade.[107] Vittoria took over the execution of the project after Sansovino's death in 1570, and may have made some changes in the design.[108] However, one cannot exclude the possibility that even the more Mannerist features of the façade spring from Sansovino's own imagination.

The visual complexities are a sensitive response to the confined site. San Giuliano is unusual among Venetian parish churches in that its façade does not face on to a *campo*, a reflection of the acute shortage of land in the centre of Venice. Although six different streets converge at this point, it is impossible to take in the whole façade at a glance from any one approach, and it cannot be seen as a unified whole except from a very close viewpoint. Instead, it offers a series of changing perspectives as one moves around the church. The design consists of a series of superimposed triumphal-arch systems (Plate 67). The central unit of the lower Doric order, which bears Rangone's effigy, is emphasised by the fluted half-columns, while the rest of the façade is in relatively low relief. The segmental pediment over the central bays of the Ionic order, which seems to be pressed into the surface of the façade, is broken capriciously by a large 'serliana' window in the very top of the triangular pediment behind. We must not forget that the façade was originally intended for a triple-naved Gothic church. Unlike the old building, Sansovino's box-like structure which replaced it was no higher in the centre than at the sides, and the peculiar effect of compression at the top of the façade may in fact be the outcome of this change.

The fact that Rangone's effigy is seated above a sarcophagus suggests that this part of the façade was supposed to represent a tomb monument, trans-ported from the inside to the outside wall of a church, like the earlier monu-ments above the doors of two other Venetian churches, Sant'Elena and Santa Maria Formosa. The conception is purely symbolic since the doctor himself was actually buried in the chancel after his death in 1577. The paired columns on each side of the monument, framing panels of relief decoration, are characteristic of tomb architecture (Plate 65). The similar idea of placing Doge

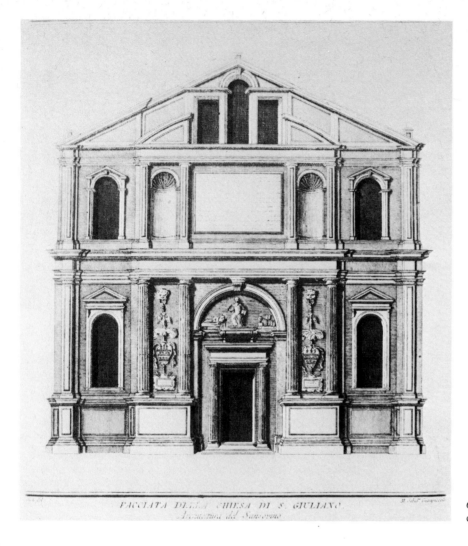

FACCIATA DELLA CHIESA DI S. GIULIANO.
Architettura del Sansovino

67. San Giuliano, façade,
eighteenth-century engraving.

Antonio Grimani's tomb on the façade of San Francesco della Vigna had been
dropped, but Rangone's insistent vanity allowed this notion to be realised at
San Giuliano instead.

Sansovino's three parish churches are a vivid illustration of the way an
architect is controlled by financial considerations. Because of its conspicuous
site San Geminiano, already a prosperous parish, had the advantage of state
patronage; while San Giuliano, which was also relatively wealthy, profited
from the generosity of an enthusiastic private benefactor. But at San Martino
resources were extremely sparse, and it was left to the clergy to subsidise the
building costs. Each serving a similar purpose, the three churches shared the
same basic structure, that is, small and roughly square in plan with a dominant
central space. But the details of the designs and the materials used give a clear
picture of the discrepancies in the fortunes of the three parishes.

87

For the church of the hospital of the Incurabili Sansovino was to produce one of his most original and influential designs.[109] There was no long-established tradition for hospital churches in Venice, for the hospitals were generally (with the exception of those attached to convents) secular institutions. Although their founders shared a deep religious commitment, they were run by laymen dedicated to the care of the sick and destitute. As a result, churches were not at first an important feature of hospital architecture in Venice. When Sansovino was commissioned to replace the makeshift church at the Incurabili with a more permanent structure, neither he nor his patrons can have had many preconceived ideas about the form of the new church.

Venetian hospitals were administered by a variety of different organisations. There were over forty hospitals in Venice by the second half of the sixteenth century, most of which were medieval foundations.[110] They were run by bodies such as artisans' guilds, foreign communities, religious orders, the Procuracy of St. Mark's, and the Scuole Grandi. The four principal state-supported hospitals were the Pietà, the Mendicanti, the Derelitti and the Incurabili. While the government tried to prevent people from leaving property to the Church and the religious orders, they positively encouraged pious bequests to these four hospitals. Indeed notaries were obliged by law to remind their clients to remember the hospitals when making a will. With subsidies from the state and from private benefactors, the Venetian hospital service was exceptionally advanced by sixteenth-century standards.

The hospital of the Incurabili was established in 1522 to deal with the rapidly increasing number of cases of syphilis. It was founded by the famous Catholic reformer Gaetano Thiene from Vicenza, then a member of the Society of Divine Love, with the help of two Venetian noblewomen. The 'mal francese' had been ravaging Italy ever since Charles VIII's invasion in 1494, and the wretched victims were a great problem to society.[111] In 1522 the Magistrato della Sanità ordered all incurables found begging in the streets of Venice to be taken into the hospital, and in the same year the Council of Ten gave the governors of the Incurabili authority to appeal for funds from any-where in the dominion.[112] In 1524 they began to accept orphans as well as syphilitics, lodging them in separate dormitories and teaching them reading and crafts.[113] By 1525 there were already as many as 150 inmates.[114]

Hospitals like the Incurabili were of great interest to the ascetically inclined Catholic reformers. Gaetano Thiene afterwards became a founder member of the Theatine order, together with Gian Pietro Carafa (the papal envoy sent to Venice in the 1530s to investigate the Franciscan order).[115] In 1537, Ignatius Loyola, founder of the Jesuits, on a visit to Venice with some of his companions, spent several months at the Incurabili and at the general hospital at Santi Giovanni e Paolo.[116] But the Venetian government was eager to preserve the secular status of the Incurabili. In 1539 the Great Council ordered the setting up of a governing body of between 12 and 24 laymen—nobles and citizens—to supervise its administration.[117] Although another religious society, the Compagnia dell'Oratorio, was later established at the hospital, where they ran a children's Sunday school, the institution retained its lay organisation.[118]

68. Hospital of the Incurabili, Venice, eighteenth-century plan.

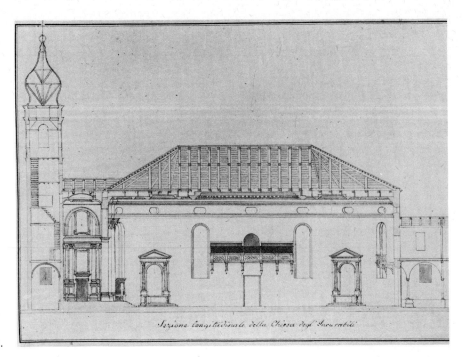

69. Jacopo Sansovino:
Church of the Incurabili,
Venice, begun 1565, section.

Papal permission to build the first church at the Incurabili was granted by the Apostolic Legate in 1523, only a year after the founding of the hospital.[119] The original church, as Francesco Sansovino tells us, was made of wood.[120] Sanudo's diaries record that services were already being held there in the twenties, and a sale of indulgences in 1531 raised more money for the completion of the church.[121]

However, before long this makeshift structure began to deteriorate. Its precarious condition was explained in a petition submitted to the Doge by the governors of the Incurabili in 1565: '. . . our wooden church, which was built at the time of the foundation of the hospital . . . is in a terrible state, completely decayed and on the point of collapse, and it is no longer possible to keep it upright.' They claimed that it had now become essential to rebuild the church in brick, as cheaply as possible, and they begged the Doge to subsidise the scheme, as had been done at other Venetian monasteries and pious institutions (including San Francesco della Vigna). And they complained of the '. . . poverty and infinite misery of the hospital resulting from the incredible and infinite amounts constantly spent on the care and sustenance of the patients and others, normally numbering approximately 350 mouths, and sometimes even 400'.[122]

In response to this pathetic appeal, the Senate granted the sum of 300 ducats for the reconstruction of the church.[123] Work must have begun quickly, for Cicogna records that in 1567 the walls had reached the height of the cornice.[124] The *proto* in charge of the execution of Sansovino's model and the day-to-day supervision on the site was Antonio da Ponte, the architect who later built the new Rialto Bridge.[125] Early in 1568 the church was half finished. However, the funds were now exhausted, and the governors of the hospital were forced to submit a second petition to the Doge. The church was still not usable for

90

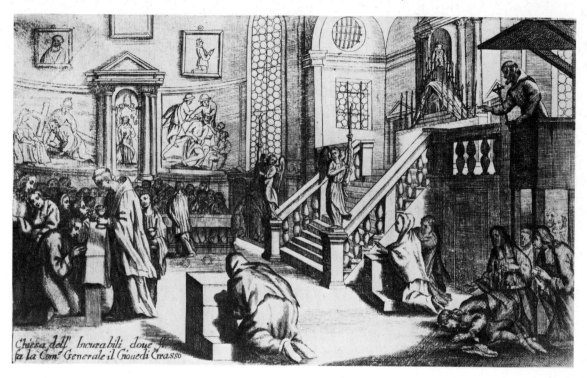

Chiesa dell' Incurabili, doue
fa la Com.^e Generale il Giouedi Grasso

70. The interior of the church of the Incurabili, eighteenth-century engraving.

services, and they claimed that the number of inmates at the hospital had now
risen to 450. Again the Senate responded almost unanimously to the plea, with
an offer of a further 300 ducats to finance the construction of the roof.[126] The
new church, dedicated to San Salvatore, was consecrated in 1600.[127]

That Sansovino was responsible for the design of this building is clear from
his son Francesco's guide to Venice.[128] Although the church was demolished
in 1831, some impression of its appearance can be gained from surviving plans
of the hospital (Plate 68), from Cicogna's section (Plate 69), and from a some-
what crude eighteenth-century engraving of the interior (Plate 70).[129] The
church stood in the courtyard of the hospital, a large quadrangular complex of
buildings on the Zattere. Most of the present hospital buildings were erected
by Antonio da Ponte after Sansovino's death, but it is likely that the whole
layout was already planned when Sansovino designed the church.[130] One of
the four wells which stand at each corner of the *cortile*, and which were clearly
part of the over-all scheme, is dated 1568.

The most remarkable feature of the church was its elliptical plan (Figure xi).
Serlio had published an oval plan in Book V of his treatise, and his teacher
Peruzzi had designed several oval buildings. In Rome Vignola was now using
this form, for instance in the churches of Sant'Andrea in Via Flaminia and
Sant'Anna dei Palafrenieri.[131] However, the oval seems to have been com-
pletely unprecedented in Venetian ecclesiastical architecture. The situation of
the church in the quadrangular courtyard (a space-saving measure) called for
a rounded structure rather than a rectangular one for visual reasons. The

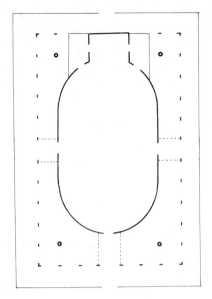

xi. Jacopo Sansovino: church of the
Incurabili, Venice, begun 1565, plan.

rounding of the corners of the building enabled more of the *cortile* to be visible
from any one point, and allowed freer circulation in the limited space remain-
ing. The effect of a rectangle in the cloister would have been uncomfortably
static by comparison. Bramante's circular Tempietto at San Pietro in Mon-
torio in Rome provided an obvious prototype for such an arrangement; but a
centralised building would not have been suitable for the Incurabili. Venetian
religious and charitable institutions, which were more closely involved with
Counter Reformation ideas than the parish churches, preferred longitudinal
plans because of their greater suitability for preaching and for sacred music.
And thus Sansovino took this rare opportunity of using the oval plan—the
perfect compromise between the circle and the rectangle.

Preaching had always played a particularly significant part of the services of
the Incurabili, for, since most of the patients would never recover, spiritual
comfort was the only possible treatment. However, music was now becoming
an even more notable feature of the religious life at the hospital than preaching.
While the orphan boys were taught useful trades and skills, the girls were
completely isolated from the outside world in order to conserve their purity.
In this strictly chaperoned existence, the only subject thought suitable for their
education was music. The choir of orphan girls was firmly established by the
time the church was built; by the end of the sixteenth century it was famous
throughout Venice, and it soon became one of the principal attractions for
visitors to the city.[132]

Sansovino's design pioneered the scheme adopted for two of the three other
orphanage churches, Scamozzi's San Lazzaro dei Mendicanti built between
1601 and 1631, and the Pietà which was begun from Massari's design in 1745.[133]
The three raised singing galleries, one on each side of the nave and one above
the entrance doorway, were reached directly by overhead passages from the
orphanage (Plate 69), so that the girls could not be corrupted by encounters
with the general public. In the galleries they were concealed by wrought-iron

71. Nave altar from the church of the Incurabili, now in the church of the Knights of Malta, Venice.

grilles to give the effect of mysterious angelic hosts. The row of elliptical windows above the cornice added a supernatural glow to the light from the lower windows which were partly obscured by the surrounding buildings. The promoter of the scheme, Antonio Zantani, was himself a keen musician, and he presumably discussed the musical properties of the church with the architect. Not only was the flat wooden ceiling ideal for projecting the sound, vibrating like the sounding-board of an instrument, but the three separate singing galleries gave marvellous scope for using divided choirs.[134] Contemporary musical developments were even more important to the design of the church of the Incurabili than to that of San Francesco della Vigna. The so-called *coro spezzato* or divided choir was a relative novelty in Venetian sacred music. Adriano Willaert at St. Mark's had demonstrated the effectiveness of answering choirs placed at various points in the raised galleries of the Basilica. By avoiding sudden changes of mood and harmony Willaert showed how to reduce the dissonance caused by the time-lag and echoes between the different groups of singers. The *coro spezzato* was used mainly in psalms to be performed at Vespers on important religious festivals. As a rule, the separate choirs sang alternating verses, joining together in a great climax at the end.[135] It was a favourite pastime of the Venetian nobility to go to hear sung masses, either in the Basilica or at one of the four hospitals.

The Incurabili was probably the cheapest of Sansovino's Venetian churches. The basic sum of 600 ducats provided by the Senate seems diminutive when one remembers that the Loggetta, also comparatively small in size, cost over 4,000 ducats.[136] Presumably the state grant was supplemented by private contributions. As at San Giuliano and San Martino, the limited budget called for restrained decoration inside the church. The Incurabili church, like San Giuliano, had no order on the side walls, the decoration being confined to the chancel and high altar, the singing galleries and the four minor altars (two of which are preserved in the Church of the Knights of Malta in Venice, Plate 71). The ornate ceiling was not added until the seventeenth century.[137] The fact that the church had no need of a façade, being hidden in the hospital cloister, was obviously a great saving financially. Yet despite the frugality, the project shows that even at almost 80 years of age Sansovino was still capable of great inventiveness. In his other Venetian churches he used traditional layouts as his starting-points, choosing longitudinal plans for monasteries and centralised plans for parishes. But at the Incurabili he was free to experiment, and it was he himself who created the precedent for the orphanage-choir-churches of the future.

Sansovino's ecclesiastical architecture in Venice shows no obvious stylistic development or underlying philosophy. In each church he offered a totally individual solution to a specific set of circumstances. As in his secular buildings, he responded sensitively to the particular needs and resources of his various patrons. Above all, he was fully aware of the gulf between the demands of the monasteries on the one hand and the parishes on the other. While the former were now beginning to reconsider their basic objectives, the latter were still resisting attempts to introduce reforms; and thus it was his monastic commissions rather than the parish churches which anticipated features of Counter Reformation architecture. In his small centrally planned parish churches he was more conservative. He certainly owed much to Mauro Coducci who, at the end of the fifteenth century, had first revived the Veneto-Byzantine central plan for this purpose. In most of Italy centralised plans were now losing popularity because of their liturgical inconvenience. Palladio, who in theory agreed with Serlio, that the circular plan was the most perfect for temples, built only one centralised church: this was the little family chapel for the Villa Barbaro at Maser, his only commission which did not call for a nave to accommodate a large congregation.[138] Sansovino, too, used central plans only in cases where they were liturgically practical, but in Venice the peculiar form of parish administration justified their retention. What he himself believed to be the perfect form for a church is a mystery. The high cost of building new foundations would in any event have discouraged the use of the circular plan, as opposed to the Greek Cross, whatever its aesthetic or philosophical merits. Not only do Sansovino's Venetian churches give no hint of his theoretical ideas about religious architecture, but unlike Palladio he left no treatise to enlighten us. There is now no trace of the sixty plans of temples and churches, apparently intended for publication, which according to Vasari Jacopo left to his son Francesco.[139] He was inventive, pragmatic, and supremely adaptable. Perhaps the very flexibility of his approach—combined with the obliteration

of three of his six Venetian churches under Napoleonic rule—may explain why Sansovino's reputation as an ecclesiastical architect in Venice does not match those of Palladio, Longhena, or even Coducci.

V. Charitable Institutions

By the sixteenth century an elaborate network of charitable institutions had developed in Venice. These fell into two main groups—self-governing *scuole* on the one hand, and state-run hospitals on the other. During the course of his Venetian career Sansovino was commissioned to rebuild one institution of each type. In 1531 the Scuola Grande della Misericordia selected his model for their new building;[1] and in 1545 he was asked to design the new Ca' di Dio, a hospital for sick or destitute women, which was at that time administered by his chief employers, the Procuratia de Supra.[2] His experience of these two projects will help to show how such institutions operated as instruments of architectural patronage in the city.

The Scuola Grande della Misericordia

It is curious that the role of the Church in the execution of poor relief and medical care was relatively insignificant in Venetian society. The parishes seem to have had neither the funds nor the necessary sense of social responsibility. Although the Scuole Grandi had arisen out of a thirteenth-century religious movement, their members consisted chiefly of laymen, and clergy were specifically excluded from their administration. This is not to say that religious fervour did not provide the initial motivation for their charitable works. The groups of *battuti* (so-called because of their practice of self-flagellation), who established the Scuole, sprang from a movement founded by a Perugian hermit, Ranieri Fasani, in 1260. These *battuti* quickly spread all over Italy, and stressed the importance of charity, suffering and humility to prepare for death and to save their own souls.[3]

The Scuole Grandi soon came to control vast amounts of wealth, amassed through subscriptions, gifts and bequests from their more prosperous members. The Scuole Piccole, which took the form either of artisans' guilds or centres for groups of foreign residents in the city, are less important in this context. At the time of Sansovino's arrival in Venice there were five Scuole Grandi—those of the Carità, San Giovanni Evangelista, the Misericordia, San Marco and San Rocco. In 1552 the Scuola di San Teodoro was raised to the status of a Scuola Grande, making one for each of the six *sestieri* or sectors of the city. By the sixteenth century, however, the activities of the Scuole had begun to acquire a very different emphasis. Self-flagellation had died out, except in processions, and with it the former stress on asceticism. As much as a third of the resources of a Scuola Grande might now be devoted not to works of charity but to conspicuous expressions of pomp and splendour—lavish

banquets, sumptuous displays at public *feste*, and extravagant buildings. Rivalry between the Scuole had now reached an absurd level, and even led to bitter disputes over which Scuola should take precedence in processions.[4] Spurred on by this acute sense of competition, each tried to outdo the others by means of splendid premises filled with magnificent works of art.

Hence the Scuole took on an immensely important role as patrons of the arts. Acting as the mechanism by which the *cittadini* governed their own affairs, they had considerable political and financial power in the society. Citizenship was open to non-noble inhabitants of the city after two generations of residence, or to respectable tax-payers of fifteen years' standing, with the exception of manual workers who formed the third and lowest class, the *popolari*.[5] Although the Council of Ten held ultimate authority over the Scuole Grandi and nobles could be admitted as members, the nobility, like the clergy, were allowed no part in the day-to-day running of the confraternities. Obviously any sense of real democracy in such a system would have been largely illusory, but the *cittadini* were by no means a deprived class in six-teenth-century Venice. Being excluded from the Great Council and ineligible for public office above the level of scribes or notaries (with the exception of the distinguished post of Cancelliere Grande), citizens were freed from time-consuming attendance in the councils and periods of service in magistracies, colonial posts and diplomatic missions. Instead they could devote their time to careers as tradesmen, manufacturers, lawyers or doctors. The prosperity of the citizen class increased steadily, and by the sixteenth century many were at least as rich as the average noble.[6] That the nobility now felt threatened by the potential power of the *cittadini* is implied in Gasparo Contarini's famous description of the Republic. In his patronising account of the activities of the Scuole, Contarini emphasised their importance as a means of satisfying the citizens' craving for political influence. For a citizen to hold office in one of the Scuole, he explained, was equivalent to the distinction of Procuratorial rank for a noble. In the Scuole the *cittadini* were given the chance to imitate the Procurators, though always subject to the overriding authority of the Council of Ten to safeguard the nobles from any real autonomy in the citizen class. 'Thus their desire for honour and ambition could be satisfied without in any way disturbing the status of the nobility . . .', concluded Contarini.[7]

His comment that the Scuole gave the citizens scope, as it were, to play Procurators—like children playing mothers and fathers—is in fact a valid observation, for the functions of the Scuole did closely resemble those of the three Procuracies. Their activities included the distribution of food, alms and clothing to their poorer members, the provision of dowries for the daughters of impoverished *fratelli*, the burial of paupers, and the running of hospitals and almshouses. Like the Procuracies they took on the administration of private estates and trusts, and were responsible for the execution of wills. They owned vast amounts of property all over the city, identified by the arms of the Scuola placed on each building, as well as estates on the mainland. However, the Scuole Grandi differed from the Procuracies in one important respect, that is, in the rapid rotation of officers. All the fee-paying members were entitled to attend the general assembly known as the Capitolo which was held three times a year. Each year the Capitolo elected a body of sixteen *fratelli* called the Banca,

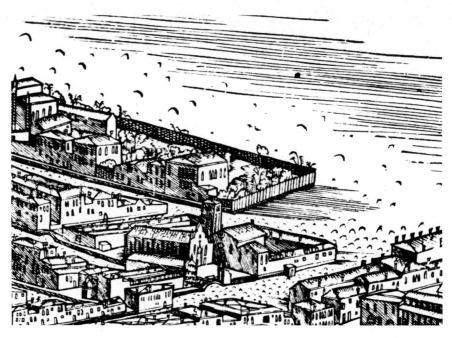

72. Jacopo de' Barbari: Map of Venice, detail showing the Misericordia, 1500.

consisting of the Guardian Grande (the chief officer) and the Vicario (his deputy), the Guardian da Mattin (director of processions), a scribe, and twelve officers known as the Degani (two to administer charity in each sector of the city). In 1521, to prevent the over-concentration of power among small groups of citizens, the Council of Ten ordered the election of a subsidiary body of twelve brothers, the Zonta, in each Scuola Grande. Although the Capitolo had to approve the most important decisions, the Banca and Zonta controlled most of the daily business of the confraternities.[8] The fact that office was held for only one year (whereas a Procurator was appointed for life) allowed repeated changes in the attitudes and policies of the Scuole; and this flexibility naturally led to inconsistencies in their approach to artistic enterprises as well as to the administration of charity.

By the time Sansovino arrived in Venice, a building-type had evolved to accommodate the functions of these characteristically Venetian institutions. The traditional Scuola consisted of two large halls, one above the other. In the lower hall, or *androne*, members paid their fees, and food and alms were distributed to needy *fratelli*. The great *salone* above was used for the assemblies of the Capitolo, and occasionally for special masses. A smaller room leading off the *salone*, which became known as the *albergo* (formerly the name applied to the whole building), was used for meetings of the Banca and Zonta. All the Scuole came to own relics and treasures—for instance the Byzantine image of the Madonna at the Scuola di San Marco, and the fragment of the True Cross at San Giovanni Evangelista—which were often housed in separate rooms or reliquary chapels.

The earliest confraternities, founded in Venice in the wake of the flagellant movement of 1260, had been affiliated to abbeys or churches; but as they

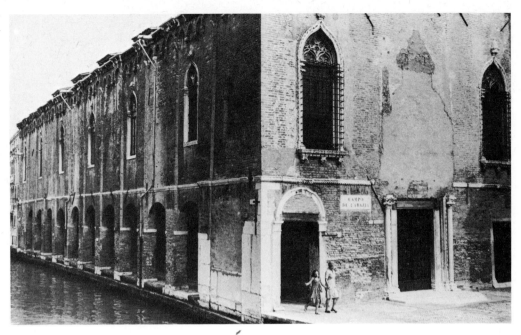

73. Scuola Vecchia della Misericordia, Venice, fourteenth century, enlarged and restored early fifteenth century.

expanded in wealth and numbers they moved to more spacious independent premises. The Scuola della Carità and the Scuola di San Marco date from 1260 itself, while San Giovanni Evangelista was established in the following year.[9] The Scuola which was to employ Sansovino as its architect, the Misericordia, was founded somewhat later, probably in 1308. Its emblem, bearing the letters SMV because of the dedication of the Scuola to Santa Maria di Valverde, is an evocative record of its site in a low-lying grassy meadow—a feature which is hard to imagine in the context of contemporary Venice. Originally the Scuola formed part of the abbey of Santa Maria della Misericordia di Valverde, situated among orchards and vineyards on the northern fringes of the city, looking across the lagoon towards the mainland (Plate 72). During the fourteenth century, as the confraternity grew, the abbey conceded various adjacent plots of land for a separate building, a cemetery, a hospital, and later for poor-housing.[10] Although the headquarters of the Scuola itself were reconstructed three times in the course of the century, building did not keep pace with expansion. In 1411/12 it was decided to enlarge the *albergo* yet again;[11] and two decades later a further extension was authorised by the nobles of the Moro family, who had become overlords of the priory in 1369.[12] The main structure must have been completed by the middle of the fifteenth century when work was begun on the sumptuous ceiling decoration inside (Plate 73).[13]

Yet even this splendid new Scuola—its façade then adorned by Bartolommeo Buon's beautiful Madonna della Misericordia above the door—was soon allowed to fall into disrepair.[14] By 1492 the Banca was forced to declare that the Scuola could not afford to restore the building.[15] The Misericordia was perpetually in financial difficulty. It seems never to have received donations

on the same scale as the other Scuole Grandi. The Scuola di San Marco, dedicated to the patron saint of the Republic, drew contributions from Venetians who particularly wished to express their patriotic loyalty. The Scuola di San Giovanni Evangelista, with its highly distinguished membership, was richly endowed and could spend lavishly not only on buildings and works of art but also on charity; the dowry fund was especially copious.[16] A deep fear of the plague provided a constant incentive for contributions to the Scuola di San Rocco which, although not founded until late in the fifteenth century, soon became the wealthiest of all the Scuole Grandi. In theory the Scuole were self-sufficient institutions, the contributions of the wealthier members supporting the poorer ones, as in freemasonry. However, large-scale building programmes could not be financed without substantial gifts as well as the regular subscriptions. Faced with the prohibitive expense of repairing their huge *albergo*, the Misericordia was authorised by the Council of Ten in 1492 to elect 100 new *fratelli* so that the entry fees could be spent on the restoration work.[17] The Scuola di San Marco had recently adopted the same method of fund-raising after their building was destroyed by fire in 1485. The new members of the Misericordia were forbidden to receive charity of any kind for at least five years, to ensure that extra finances would actually be available for the repairs.[18] The Council of Ten also authorised the suspension of the custom of annual almsgiving for five years to provide additional funds.[19]

Only five years were to elapse, however, before the Scuola conceived a startling new policy. The ambitious building programmes at San Marco and San Giovanni Evangelista must have encouraged the Misericordia to raise their sights drastically. In a motion of 1498 the Capitolo declared that their building was completely irreparable and, furthermore, too small for their needs! They decided instead to erect a new, larger Scuola on the site of their hospital.[20] Because of its situation on the northern borders of the city, an area which was still only partly built-up, the Misericordia was unaffected by the congestion which hampered building in the more central parts of Venice. As a result the Scuola was not deterred from undertaking this vast scheme, oblivious of the fact that the cost would grossly exceed the funds available.

In the early stages the project proceeded erratically. In 1503 various sources of income from investments and property were set aside for the building fund, but precedence was given to replacing the charity housing alongside the hospital which would also have to be demolished.[21] An agreement was drawn up with the landlords of the abbey of the Misericordia, the Moro family, in 1504, providing a piece of land on the west side of the old Scuola for the new almshouses and defining the site of the great new building.[22] The twenty-two new cottages, built around a courtyard, were allotted to poor *fratelli* in 1506.[23] The entrance doorway to this so-called Corte Nuova, with its attractive relief of the Madonna della Misericordia sheltering the *fratelli* under her cloak, survives today; and some of the original cottages, now much altered, are still visible inside.[24]

Even at this stage resources were sparse, and each succeeding Guardian Grande had different views over whether priority should be given to charity or to display. Stone, tiles and wood had been removed from the hospital and the old almshouses for use in the new buildings, and in 1506 the Banca ordered

that the six cottages left standing after this plunder should be restored for needy *fratelli*.[25] The following year attention was again directed towards the new Scuola. Several models were considered, although no final decision was reached,[26] and in 1508 work was begun on straightening the *fondamenta* or waterfront along one side of the site.[27] The next Guardian and his colleagues, realising the need for further funds if the charitable activities of the Scuola were not to suffer, proposed the election of 200 new members and also set aside part of the dowry fund for building work.[28]. But progress on the new Scuola was still negligible, and in 1509 it was decided to elect a *proto* to take charge of the work. In the event two *proti*, no lesser men than Pietro Lombardo and his son Tullio, were appointed and were enrolled as *fratelli* of the Scuola.[29]

The Lombardi could hardly have become involved with the project at a less propitious moment. They were to be confronted by an obstacle far more serious than the recent vacillations of policy, inherent in the system of annual re-election of officers. After May 1509, when the Capitolo again resolved to come to a final decision about the model for the new Scuola, the scheme was completely abandoned for more than two decades.[30] The interruption was caused by the war against the powers of the League of Cambrai, which reached its crisis-point in June 1509. The Scuole were heavily taxed by the Government in wartime and were therefore particularly susceptible to such calamities. Venice made only a slow recovery after the shock of the League of Cambrai; and the plague and famines of the later 1520s must have further drained the resources of the Scuole. In this intermission, the supplies of wooden piles and stone acquired for the foundations of the new Scuola della Misericordia were covered over so that people could cross the site more easily. Only the new *fondamenta* along one side had so far been completed.[31] Meanwhile, the income from investments in the Salt Office which had been set aside for the building project was simply allowed to accumulate, and a few tentative gestures towards reviving the scheme in the mid-twenties came to nothing.[32]

The Peace of Bologna, concluded in 1529, set Venice back on her feet. The first real signs of restored confidence on the part of the Misericordia appear in 1530. The Guardian Grande in that year, one Marc'Antonio Paseto, set about renewing the shabby image of the Scuola—he ordered chair-backs decorated with figures for the *albergo*, and a new banner for use in processions in place of the tattered old one; the flagstaff in the Campo was restored, the silver supports for the processional canopy were replaced, and a huge gold chandelier was acquired to go with the two already in the *sala*.[33] In the last months of his period of office he turned his attention to the long-neglected building project. First of all, the two deceased members of the building committee were re-placed.[34] Then the financial situation was re-examined and a campaign was launched to recover debts in order to augment the building fund.[35] Finally, on 24 February 1531, Paseto called a meeting of the Banca, the four members of the building committee, and twenty other specially elected *fratelli*, to discuss the enterprise once again.[36]

It is at this point that Sansovino enters the story, for the expert who was called to give advice on the suitability of a model still preserved in the Scuola was none other than the 'prudent and circumspect *proto* Mr. Jacopo Sansovino'. The Lombardi had vanished from the scene. Tullio was nearing the end of his

life (his death occurred in the following year), while his father had died in 1515. Evidently the surviving model, that by Alessandro Leopardi, now seemed anachronistic. The meeting decided instead to commission not fewer than four other competent masters to prepare models. In July of the same year the Capitolo assembled to consider the four entries—submitted by Sansovino himself, a certain Pietro Vido, and two long-established and notable local architects, Guglielmo dei Grigi and Giovanni Maria Falconetto—together with Leopardi's model. The only entry supported by a majority vote was Sansovino's. The old model by the defunct Leopardi was the least popular, and even those of Grigi and Falconetto received little support.[37] The fame and prestige of the newly arrived Central Italian artist must have prejudiced the ever-ambitious Scuola in his favour.

Thus Sansovino embarked upon what was surely his most discouraging and unpropitious commission. He inherited from his predecessors the legacy of an absurdly oversized idea, quite unrelated to the resources of the Scuola. In view of the fact that only the waterfront had so far been completed on the huge site, there was no need to adapt his project to any partially completed scheme. But Sansovino was to be constantly confronted by a succession of other obstacles. As long as thirty years later his son Francesco, in one of his early guides to Venice, described the work as '. . . eternal and worthy of this Dominion for its excessive beauty, if it is ever brought to completion'.[38]

The terms of Jacopo's employment seem to have been unsatisfactory from the outset. In 1532 his appointment as *proto* to the Misericordia was confirmed, and he was admitted as a *fratello* of the Scuola. In this position he was required to visit the site when necessary, and to come to the Scuola whenever the Guardian or the building committee (the *deputati sopra la fabrica*) requested, even if no work was in progress. His monthly salary of 5 ducats would be suspended whenever there was a hold-up in building, 'as is right and honest'.[39] This was hardly a convenient assignment. His post as *proto* to the Procurators of St. Mark's kept him perpetually busy in the centre of the city, and the Misericordia is a considerable distance from San Marco. Fortunately he was not compelled to be in constant attendance on the site, for one of the *fratelli* of the Scuola had recently been elected to take charge of such duties as supervising the unloading of materials.[40] The Guardian and the four *deputati sopra la fabrica* had the authority to purchase the supplies.[41] Sansovino was merely responsible for co-ordinating work and preparing contracts. Nevertheless, many of the subsequent misunderstandings and disagreements which arose between the Scuola and their architect must have been fostered by this difficulty of communication.

Even at the start Sansovino was given a totally inadequate briefing. The Scuola had neglected to tell him of the terms of the agreement drawn up in 1505 with the landlords, the Moro family, defining the site for the new building. His original model therefore took no account of the conditions of the lease, which specified that the new *fondamenta* was not to be covered by a colonnade. It seems that he had designed a building with an arcade along the waterfront, probably in order to increase the space on the upper floor. Not wishing to enter into any dispute with the landlords, the Scuola summoned Sansovino in 1532 to discuss the problem, and decided to proceed with the

existing model omitting the columns.[42] Three years later, however, the question had still not been resolved. In 1535 the Guardian then in office, a certain Francesco Felletto, urged the Banca, Zonta and *deputati sopra la fabrica* to allow Sansovino to produce a large model to demonstrate his idea for removing the colonnade from his design.[43] It was Felletto who was credited by Francesco Sansovino with starting the new Scuola, and it seems that he did in fact get the project under way at last.[44] Although work had been resumed on the site as early as 1532, the foundation stone was not formally laid until 1535, by Felletto's successor.[45]

No sooner had the scheme finally been launched, than the outbreak of war against the Turks, who invaded Corfu in 1537, effectively halted the work. War at sea had even more serious consequences than mainland campaigns for the Scuole, who were obliged to supply quotas of galleots from among their membership to man the Venetian galleys. To induce *fratelli* to volunteer they had to supplement the wages paid to galleots by the state, as well as to provide pensions for their families while the wage-earners were at sea. In March 1537 the Council of Ten passed a motion compelling each Scuola to accept a hundred new *fratelli* to serve in galley crews. [46] In June of the same year the Ten authorised the Misericordia to draw on the resources of certain trusts to provide financial support for the families of the galleots supplied for the navy. The Scuola was also permitted to admit sixty new *fratelli* at 4 ducats a head to augment their finances, which were already much depleted by the high cost of poor-relief and building work.[47] The Misericordia was not only the most heavily taxed of all the Scuole Grandi but also had to supply the largest number of galley recruits. In 1539 the Council of Ten demanded a further 150 men from this Scuola in the second call for galleots.[48] The war effort proved a terrible drain on the financial state of the Misericordia which was never really secure. The building probably suffered more than the charitable activities, for it was a less immediately urgent case. In 1540, the last year of the war, the Capitolo complained that the new building was now totally derelict, and that its neglect was the cause of great disapproval in the city.[49] The scheme already seemed destined to become a perpetual problem.

During the 1540s Sansovino came to experience another hazard of Scuola patronage—the inconsistent attitudes of the annually re-elected governing body. When his amended model was finally accepted in 1535, the assembly were unable to choose between the two alternative designs for the stairs which he offered. Since the building of Mauro Coducci's splendid staircases at the Scuola di San Giovanni Evangelista and the Scuola di San Marco at the end of the fifteenth century, great importance had been attached to this feature of Scuola architecture. However, the legacy of the tradition of external staircases in Venice determined that the stairs were not an integral part of the main structure of the Scuola but were attached at one side (Figure xii). Thus the Misericordia were able to delay reaching any decision while the lower *androne* was constructed. They merely resolved to reconsider the possibilities at a later stage, when the brick walls reached the level of the *androne* ceiling. The ornamentation would be chosen at the same time.[50]

The point came to make a definite choice in 1544, when Francesco Felletto was serving a second term as Guardian Grande. Yet even the re-election of

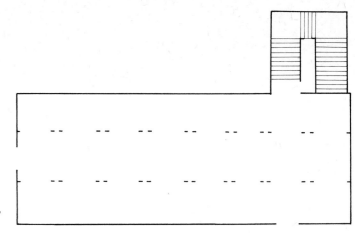

xii. Jacopo Sansovino: Scuola Grande della Misericordia, Venice, begun 1532, plan.

Felletto did not lead to a consistent approach. For a start, the Scuola opposed Sansovino's scheme for vaulted ceilings in the new building. They preferred to adhere to the traditional Scuola building-type with its wooden beamed ceilings. As for the stairs and the interior and exterior decoration, the Scuola ignored Sansovino's two earlier projects. They decided instead to commission four or five architects, starting with Sansovino himself, to produce new models, together with written descriptions and full measurements of every ornamental detail.[51] This rather insulting resolution must surely be an indication of the state of tension which had developed between the Misericordia and their *proto*.

The most serious obstacle of all which Sansovino had to face in the course of his activities at the Scuola della Misericordia was the shaky state of the institution's finances. From the start the building programme vastly over-estimated the wealth of the Scuola; and chaotic budgeting—at times even foolish or corrupt—did nothing to improve the situation.

Regular large-scale fund-raising had begun in 1525 with a motion that at least 500 ducats a year be set aside from the budget each year for the new building.[52] When work was actually resumed in 1531, the Capitolo resolved to spend all the surplus funds of the Scuola for the purpose. The *deputati sopra la fabrica* were authorised to examine the accounts month by month and to keep for the building any money remaining after the routine charitable duties had been carried out. It was hoped, too, to attract special gifts from private benefactors.[53] Yet these provisions soon proved to be inadequate. After the Scuola had been forced to lend between 150 and 200 ducats to the building fund in 1533 for the completion of the foundations, they began to investigate other potential sources of income.[54] In 1535 it was resolved to contribute to the project the income from any property entrusted to the Scuola for which no other use had been laid down by the testator.[55] In the same year the Misericordia resorted once again to the device of electing new *fratelli* so that their entry fees could be put towards the cost of the building.[56] The accounts were examined at this time and found to be well kept and administered.[57] To maintain this standard a book-keeper was appointed to record details of all the expenses on the building.[58] However, it soon emerged that there was in fact some corruption in the financial administration. Early in 1537 it was revealed

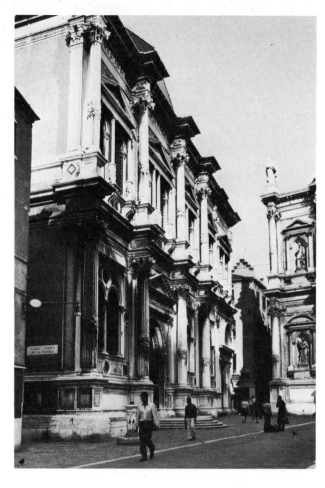

74. Buon and Scarpagnino: Scuola Grande di San Rocco, Venice, begun 1515.

that trust-money specifically designated for other purposes had instead been spent on the new building.[59] Three years later, in the last year of the war against the Turks, the Banca was informed that large sums of money had been drawn from the funds of the Scuola ostensibly to pay for the building work, when it was manifestly obvious that the work had in fact ceased completely. This scandal was arousing a great deal of disapproval both inside and outside the Scuola. Hoping to remedy such iniquities, the Banca elected two members of the Capitolo to carry out a thorough examination of all the accounts.[60]

In the circumstances it is hardly surprising that a satirical poem attacking the Scuole, *Il Sogno di Caravia* published in 1541, should severely censure the Misericordia for its bad government. The author of the poem, Alessandro Caravia, aimed to expose the warped priorities of the Scuole who were neglecting their original function of helping the sick and needy for the sake of lavish display and ostentatious buildings. According to Caravia, the Misericordia had been carried away by the notion of competing with the Scuola di San Rocco, then engaged in the most extravagant building programme of all (Plate 74). His description of the new Scuola della Misericordia is graphic and mocking:

Hanno fatto un principio si terribile
Che'n verità le mure son piu grosse
Di quelle dil bastion detto impossibile . . .

(They have made such a daunting start
That in truth the walls are thicker
Than those of an impregnable fortress . . .)[61]

Caravia's claim that thousands of ducats had already been spent on this building, leaving the poor to starve, contains a strong element of truth. Unlike the Scuola di San Rocco, who were flooded with contributions from benefactors hoping to earn protection from the plague, and with donations in honour of Titian's supposedly miraculous painting in the Scuola, the Misericordia were not well enough endowed to pursue the building project without economising on charitable activities. Attempts were repeatedly made to tackle the problem of how to fulfil the obligation to support the less fortunate *fratelli*. In 1531 it was resolved to restrict almsgiving to the most deserving and hard-working of the poorer members.[62] Two years later the Scuola took the important step of dividing the confraternity into two groups—the *fratelli di banca* who paid a larger entrance fee and were eligible for election to office, and the *fratelli di disciplina* who had no voting rights in the Capitolo, but who contributed only a small subscription and were entitled to charitable assistance if the need arose. The latter were subject to the 'discipline' of the Scuola; that is, they were required to perform the more arduous tasks such as carrying heavy weights in processions, serving in galleys, and accompanying corpses at funerals. All the Scuole Grandi were to adopt this distinction during the course of the sixteenth century, to ensure that a body of wealthier *fratelli* would be able to finance assistance given to members living in hardship.[63] Nevertheless it proved extremely difficult to establish a balance between the quotas of rich and poor members. During the forties and fifties the Misericordia made several requests to the Council of Ten for permission to augment their membership.[64] More *fratelli di banca* were needed to increase the numbers eligible for office, to prevent power becoming too concentrated. The requests for further *fratelli di disciplina* were prompted not by any altruistic motive but by the wish of the Scuola to put on a splendid show in public processions. In 1556, for example, they complained of the shortage of standard-bearers, the numbers of *fratelli di disciplina* being badly depleted by death and incapacity.[65] These decisions to expand the membership of the Misericordia seem to have been taken with very little foresight. The intake of *fratelli di disciplina* was particularly rash, for these only added to the eventual demand for poor relief. Members who joined on the point of death or on the verge of bankruptcy were a particular hazard. In 1560 the Scuola tried to eliminate this malpractice by declaring that only poor *fratelli* of one year's standing, who had carried out their duties conscientiously, were entitled to receive alms.[66]

Yet the growing cost of relief work was a dreadful drain on the resources of the Scuola. In 1561 it was revealed that since 1556 not a penny had been left over from the routine charitable expenses of the Scuola, which naturally meant that no money whatsoever had been available for the building. At this

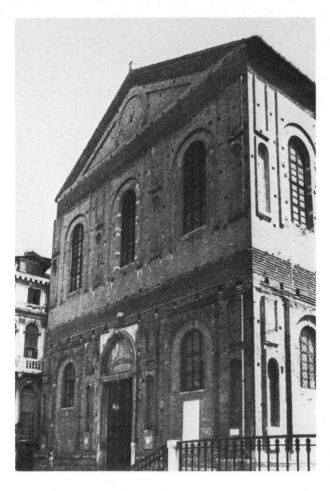

75. Jacopo Sansovino: Scuola Grande della Misericordia, Venice, begun 1532, façade.

point the Misericordia resolved to reorganise their finances. They decided to support alms-giving entirely from trust funds, which they believed would satisfy the wishes of the testators. All the regular income of the Scuola could then be devoted to the cost of finishing the new building. This would prevent the illegal use of trust income for this purpose, and would in theory provide considerably more than the annual sum of 500 ducats normally contributed to the project from the Scuola budget.[67] As a result of this measure the con-fraternity was tempted to expand the membership even further in order to support the vast cost of the building from the regular subscription income. In 1561 200 new *fratelli di banca* were elected so that their entry fees of 5 ducats a head could be spent on building work.[68] In 1565 a further 100 *fratelli* were admitted, evenly divided between the rich and poor orders.[69] But the situation grew rapidly worse. A revision of the Mariegola, or statutes, in 1564 had failed to solve the problem, despite its resolution to keep the membership within the ancient limit of 400.[70] By 1567 the account-books were in a state of total chaos, and the Scuola found itself in grave financial difficulty.[71] Two years later it admitted to being heavily in debt, with neither the resources to fulfil regular duties nor the means to complete the new Scuola.[72] By this stage

107

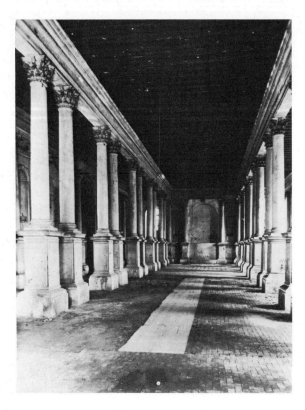

76. (left) Scuola Grande della Misericordia, ground-floor *androne*.

77. (right) Andrea Palladio: Project for the façade of the Scuola Grande della Misericordia, probably after 1570.

the Turkish threat to Venetian rule in Cyprus was looming. A recent request for yet another intake of new *fratelli* had specified that only half the entry fees should be contributed towards the building, the other half being set aside in reserve in case the need for galleots arose.[73] In the circumstances it is no wonder that in the same year, 1569, the records of the Scuola refer to tensions between the Scuola and the aged Sansovino over payments for building materials.[74]

A year later Sansovino died. During the period of almost forty years which had elapsed since his model had first been accepted by the Misericordia, both he and his employers must have felt a growing sense of disillusionment. The new Scuola was greatly admired (Plate 75), but praise was always dampened by comments on its state of incompletion. Vasari declared that when it was finished it would be the most superb building in Italy.[75] In his 1581 guide to Venice Francesco Sansovino claimed that the building was judged by experts the most notable and best-designed building in the city, though he doubted that it would ever be finished unless by chance some vigorous moving spirit appeared on the scene.[76] Francesco himself only impeded the project: after his father's death, in the course of his campaigns to recover large sums of money supposedly owed to Jacopo by various patrons, he even placed a claim with the destitute Scuola della Misericordia. The Scuola was forced to pay him the sum of 130 ducats to avoid embarking on a prolonged legal battle.[77]

Jacopo lived to see only the massive brick walls completed. The columns and friezes which he designed for the interior decoration of the lower *androne* were not put in place until 1576 (Plate 76); and the forbidding exterior lacks its

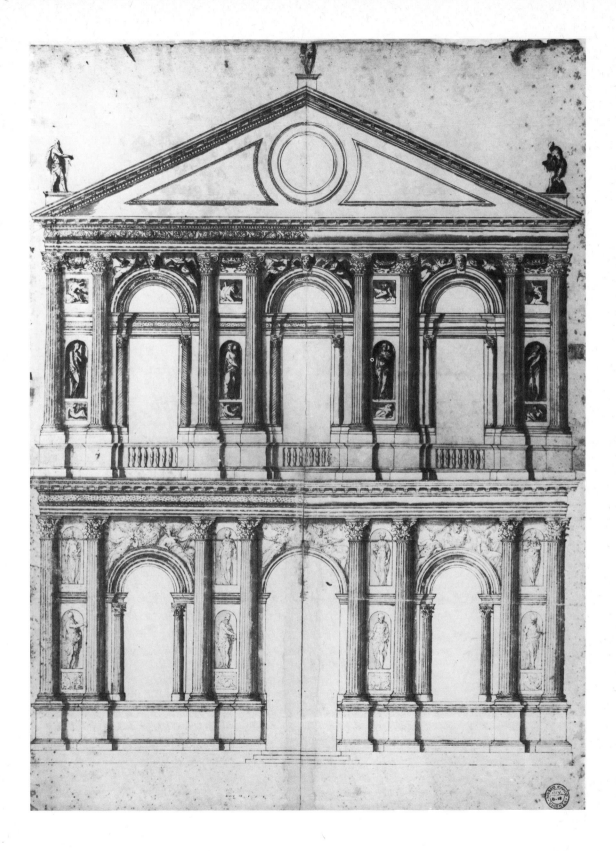

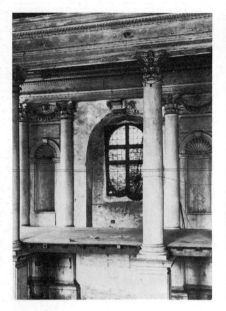

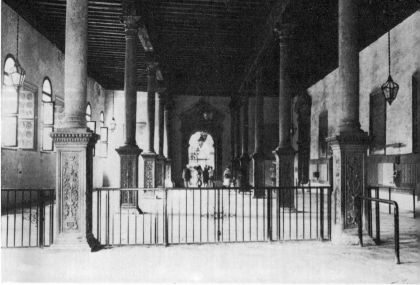

78. Scuola Grande della Misericordia, detail of ground-floor *androne*.

79. Pietro Lombardo and associates: Scuola Grande di San Marco, Venice, begun 1487, ground-floor *androne*.

ornamental stone facing to this very day.[78] A drawing in Vicenza attributed to Palladio seems to be based on one of Sansovino's designs for the façade (Plate 77).[79] The coupled Corinthian columns enclosing niches with statues, and the rich sculptural decoration of this scheme are reminiscent of both the Loggetta and the Library. Niches flanked by paired Corinthian columns, again with garlands suspended between the capitals, also characterise the decoration of the *androne* (Plate 78). In this room, to satisfy his conservative patrons, Sansovino adopted the traditional scheme common to all the Venetian Scuole Grandi, with the wooden-beamed ceiling supported by two rows of columns standing on high bases (Plate 79).

At the time of his death the building was still not roofed, there was as yet no floor in the upper room, and the staircase was also missing. Massive expenditure had brought the institution to financial ruin, yet the new Scuola was not even usable. The outbreak of war against the Turks in 1570 only added to the miseries of the Misericordia. By this time the old building was so decrepit that it had been abandoned.[80] The Scuola had moved to temporary premises at the Frari, only to be insulted by the friars on their feast day.[81] In 1570 the outlook was so bleak that they finally agreed to accept an offer of union with the Scuola di San Cristoforo at the Madonna dell'Orto who were then erecting a fine new building designed by Palladio.[82]

However, to be obliged to merge with a Scuola Piccola was a degrading fate for the Misericordia. Less than a decade afterwards, though impoverished by the recent war against the Turks, they declared their determination to make the new Scuola habitable. Money was raised to buy wooden beams for the roof in the form of a loan from their trust property together with the entry fees from a further intake of *fratelli*.[83] By 1582 the beams were in place, and

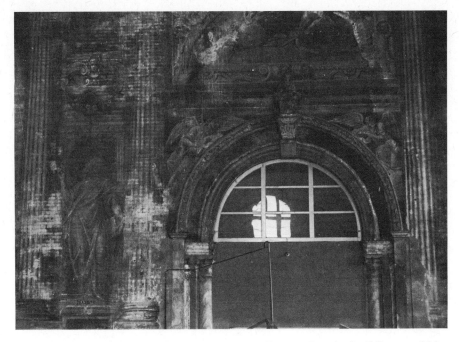

80. Scuola Grande della Misericordia, wall-decoration of upper *salone*, begun 1588.

the Scuola resorted to a temporary canvas ceiling so that the building could be occupied, justifying this measure with the excuse the Scuola di San Rocco had used a canvas roof in their new premises for years. At this point the Doge paid a visit to the new building to attend a special mass. The Scuola were hoping to draw his attention to the need for funds to complete such a laudable undertaking.[84] The stairs were still lacking, and the upper room was reached by way of a temporary ladder. The plot of land at the side of the building intended for the staircase had been let out to a stonemason since that depressing year 1570.[85]

The Scuola was still in desperate financial straits. In 1586 the Guardian Grande complained that there were now more than 1,500 *fratelli di disciplina* (those entitled to receive alms), although the number officially admitted amounted to only 606.[86] So much capital had now been invested in the new building that to abandon the project at this stage would only add to the distress of the Scuola.[87] A model for the staircase by Francesco Smeraldi was eventually chosen in 1587, and Francesco and his son Bernardin were appointed *proti*.[88] In 1588 a resolution to move into the new building on the first day of April in the following year provoked a last spurt of activity. It was decided to wall off one end of the large upper hall to serve as a temporary *albergo*, since the small room for meetings of the Banca had not yet been constructed. The canvas which had been rented as a substitute for the wooden ceiling was purchased, and the walls were prepared for the painted decoration.[89] References to an existing design with columns and niches suggest that, although Sansovino's various models for the stairs were ignored, the Scuola followed his scheme for the decoration of the upstairs *salone* (Plate 80).[90] These frescoes, attributed to the studio of Veronese, still survive if in poor condition, but Tintoretto's paintings for the *albergo* are now lost.[91]

111

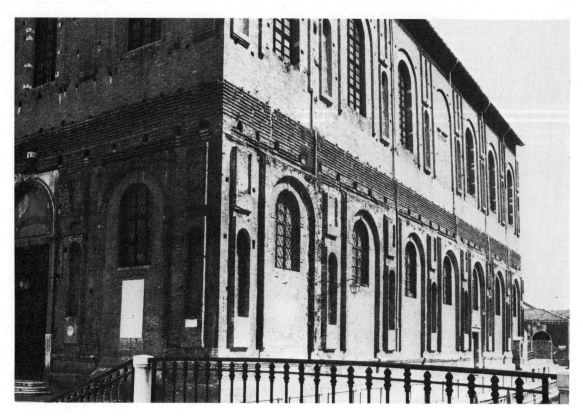

81. Scuola Grande della Misericordia, side view.

In 1589 a solemn procession was held to transport the precious sacred relics from the old Scuola to the new, and an even more solemn mass was celebrated there, before a magnificent new altar.[92] It only remained to fit window-frames and to transfer the altar, tribune and benches from the old *albergo*, before Sansovino's immense and ill-fated building was usuable at last.[93] To this day the massive hulk of brickwork (Plate 81)—now badly neglected, and used as a municipal gymnasium and basket-ball court—stands as a depressing monument to the absurd competitiveness of the Venetian Scuole Grandi in the sixteenth century.

THE CA' DI DIO
Whereas the Scuola della Misericordia expected Sansovino to conceive the most conspicuous and magnificent project possible, his commission to rebuild the Ca' di Dio was a relatively humble undertaking. The institution had been established at the time of the Crusades as a small pilgrim hospital run by friars. In 1272 the Maggior Consiglio authorised the building of the first hospital in the parish of San Martino not far from the Arsenal, on a site donated by a private benefactor.[94] This position on the quays of the Riva degli Schiavoni was particularly convenient for travellers embarking for the Holy Land. By

the fourteenth century, however, few pilgrims and crusaders now passed through the city. In about 1360 the redundancy of the original function of the Ca' di Dio was rudely brought to the notice of the Venetian government when the residents were found to include a group of Genoese 'friars' who had attempted to set fire to the Arsenal. With the permission of the Pope, the Council of Ten confiscated the hospital and installed a secular prior who, for reasons of security, had to be a true Venetian citizen. The secularised Ca' di Dio was placed under the authority of the Doge, but the Priors were nevertheless granted permission to build a church or chapel for the daily celebration of mass.[95] And the former pilgrims' hospice became a home for sick and destitute women.

The Ca' di Dio had none of the pretensions of a Scuola Grande. The inmates lived extremely modestly, to judge from a sixteenth-century record of the alms provided by the hospital:

Each day	2 14-ounce loaves of bread
Each month	one ducat
	2 pounds of oil
St. James' Day	4 *soldi* for melons
St. Michael's Day	one bowl of macaroni
St. Martin's Day	4 *soldi*
All Saints' Day	a quarter goose
Christmas Eve	one large cooked sausage cut in 3 pieces
	one orange
	12 *soldi* for poultry
Carnival	2 pounds of fresh pork, boned
	4 *soldi*
Giovedi Grasso [last	5 *soldi*
Thursday in Lent]	2 pounds of shoulder of pork
	one piece of vegetable pie
Carnival Sunday	one goose or 24 *soldi*
	12 cooked ravioli
Ash Wednesday	36 *soldi*
Easter	3 pounds of lamb
	12 eggs
	7 pounds of logs or 6 *lire* charity.

Any occupant who preferred not to receive alms was entitled to 40 ducats a year instead of the normal rations. Free medical care was also provided in case of illness.[96] An ample income from certain *terraferma* estates was used to finance the upkeep of the institution.

In 1527, the year of Sansovino's arrival in Venice, the constitution of the Ca' di Dio was revised by Doge Andrea Gritti, whose natural son Alvise was prior at the time. The revisions laid down that to avoid discord each woman was to have a fireplace in her own room for cooking; and instead of the bread ration flour would be supplied from the mainland estates. In addition, the monthly allowance of one ducat would be paid to each inmate. Fallen women were no longer to be admitted—the twenty-four occupants must be of good repute and lead an honest life. The prior was authorised to appoint a suitable priest to say mass each day and a skilled doctor to treat the women's ailments.[97]

82. Jacopo de' Barbari: Map of Venice, detail
showing the Ca' di Dio and the church of San
Martino, 1500.

Sansovino's involvement with the Ca' di Dio was brief but significant. It
happened that in 1542 his employers, the Procurators of St. Mark, were
delegated to act as governors of the hospital because the new prior, another
member of the Gritti family, was still under age. The Procurators were en-
trusted by the Doge with the responsibility of supervising the running of the
almshouse and the distribution of the income from the mainland property.
They had to inspect the accounts at six-month intervals, and send their agent
each day to visit the hospital to ensure that the poor women were well pro-
vided for.[98]

In their role as governors of the Ca' di Dio the Procurators immediately
organised the restoration of the farmworkers' residence on one of the estates
near Mestre.[99] They then turned their attention to the state of the hospital
itself, and reported to the Doge that the women's living quarters were ex-
tremely old and in danger of collapse. They suggested that the rooms should
be either rebuilt on the same site, or reconstructed in a more spacious and
comfortable form on the vacant piece of land near the bakeries, once the
orchard. Doge Pietro Lando responded by asking two of the Procurators,
Piero and Vettor Grimani, to discuss the idea with the builders and the *proto*
(that is, Jacopo Sansovino).[100] In 1545 Sansovino was asked to produce a

114

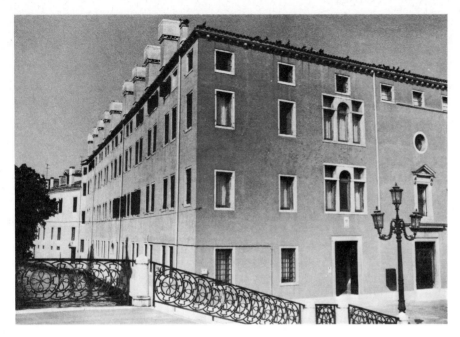

83. Jacopo Sansovino: Ca' di Dio, Venice, begun 1545. Since recent restoration.

model for the new hospital. The sum of 1,200 ducats, due to the hospital from one of the trusts administered by the Procuracy, was provided to finance the rebuilding, to be supplemented if necessary by an annual sum of 300 ducats from the income of the Ca' di Dio. Utility, not grandeur, was the prime consideration. The terms of Sansovino's commission specified an extremely unpretentious design—there were to be no columns on the façade, and Istrian stone was to be used only for doorways, balconies and gutters. It was decided to demolish the old structure, starting with the church which then stood on the corner between the Riva and the small side canal.[101] The appearance of the old hospital complex in the early sixteenth century is known from Barbari's view of Venice (Plate 82). The womens' quarters were then behind the little Gothic church, overlooking the *rio*.

The builders' contract, issued soon after the model was accepted, defined the exact nature of the project, which involved both the demolition work and the reconstruction of the twenty-four rooms together with a new church. The new foundations and walls were to be erected according to Sansovino's instructions, and the walls plastered and whitewashed; and the building was to be provided with its tiled roof and chimneys.[102] The scheme entailed the moving of the hospital church from its position on the corner to an adjacent site where a larger and more ornate church could be built. Papal authorisation was needed for the deconsecration of the old site, and this was granted through the Patriarchal Vicar in 1546.[103]

The following year Sansovino produced a statement of the dimensions of the parts of the building executed so far. The foundations of the wing over the *rio* had been completed, and the walls of this section, consisting of eight rooms flanked by a wide corridor, were now about twenty-seven feet high.[104] This

84. (right) Ca' di Dio, *rio* façade before recent restoration.

xiii. (left) Jacopo Sansovino: Ca' di Dio, Venice, begun 1545, plan.

was Sansovino's last recorded intervention as architect of the Ca' di Dio. Six months later, in December 1547, the new Doge Francesco Donado took over direct control of the hospital once again, releasing the Procurators from their duties as governors.[105] Nevertheless, when the original builders failed to complete the work, the same contract was re-awarded to another builder adhering to Sansovino's scheme.[106] It is therefore fair to assume that the section of the Ca' di Dio overlooking the *rio*, with its three storeys of small rooms, eight on each floor making twenty-four in all, together with extra service rooms, was executed according to Sansovino's specifications (Plate 83, Figure xiii). Each room comprised two windows with a fireplace between, so that the women could do their own cooking as Doge Andrea Gritti had recommended in 1527.

Though a functional and economical design devoid of any ornamental feature, the *rio* façade with its slight angle at one end following the curve of the canal and its row of imposing chimneys is one of Sansovino's most elegant inventions (Plate 84). Only the cheapest materials were employed—stuccoed brick walls with plain *pietra viva* window frames. Materials from the original building were even re-used for the sake of economy, a frequent practice in Venice.[107] Sansovino's imagination was obviously captured by the Venetian concept of chimneys as a conspicuous and decorative feature. The end of this side wing facing the lagoon, which probably also preserves Sansovino's own design, shares with the *rio* façade the combination of extreme simplicity and well-judged proportions (Plate 85). Its only decorative feature is the plain Serliana window at the end of the great corridor on the *piano nobile*, framing the superb view of San Giorgio Maggiore from inside the building.

There is no certain evidence that the church was actually rebuilt during Sansovino's lifetime. All that is known is that in 1570, the year of Sansovino's

116

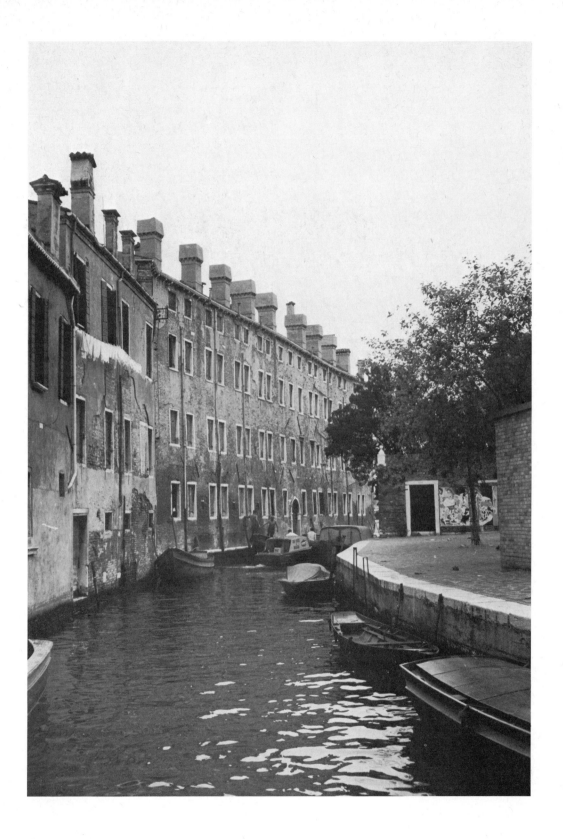

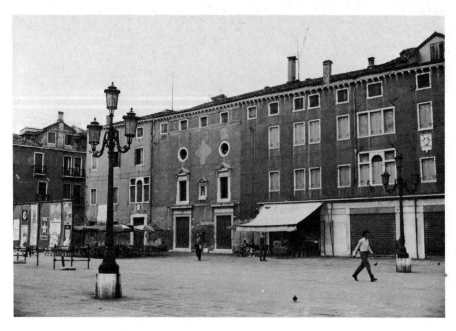

85. Ca' di Dio, *riva* façade before recent restoration.

death, twenty-four poor women were already housed in the new hospital. Unlike the Scuola della Misericordia the Ca' di Dio managed to remain solvent, in spite of the high rate of inflation, for their income from the land increased considerably faster than their running expenses. By 1570 enough money had been put aside for the building of ten more rooms in the hospital, but Sansovino cannot have been responsible for this later addition.[108] And he certainly had no part in the design of any of the Riva façade to the right of the church, or the jumble of buildings at the back of the courtyard. During the next fifty years after his death the institution almost doubled in size—there were as many as forty-seven residents in 1623.[109] Since then the Ca' di Dio has undergone numerous repairs and extensions, including alterations to the façade in the eighteenth century, and culminating in the recent elaborate restorations.[110]

The efficiency and sobriety of the running of the Ca' di Dio soon lapsed after Sansovino's death. By 1595, despite the recent establishment of a special magistracy to supervise the ducal properties, great disorder had developed in the financial administration of the hospital, both in the use of the income and in the distribution of alms.[111] In the early seventeenth century the hospital quickly acquired a distinctly dubious reputation. In 1613 the prior was put on trial for maladministration of funds.[112] Two years later a canon from the Basilica of St. Mark was tried, together with three of the inmates, on charges of immoral behaviour during 'confessions' in their rooms.[113] In 1616 criminal charges were brought against the next prior for holding a masked ball in the Ca' di Dio during Carnival. He defended himself on several grounds: that his predecessors had held balls too, and had even put on plays with mixed casts; that other hospitals and almshouses also indulged in Carnival festivities; that the guests on this occasion included many people of quality; and that no

women were present at the two private dinner parties which he gave in the course of the celebrations. He was, however, found guilty and fined 20 ducats.[114] Several years later he was again put on trial after the fifty occupants had complained to the Doge of his lack of respect for their privacy; he was also accused of corrupt administration of the hospital finances.[115] A succession of ducal decrees attempted to reform the institution. Since 1601 the women had been obliged to inhabit their own rooms and not to live outside the hospital.[116] In 1623 another decree sought to improve the calibre of the residents by admitting only respectable unmarried women from the noble or citizen classes, confirming that they were each to occupy their own rooms and not even to share rooms with other women.[117] The next Doge ordered that secure padlocks be fitted to the doors leading to the women's quarters.[118] But the series of further revisions to the regulations which were made during the late seventeenth and eighteenth centuries—that the occupants were not to sleep out without permission, that the doors should be kept locked, that no male visitors be allowed, and that the women should dress modestly and abstain from dancing—suggest that the Ca' di Dio never recovered the austerity which characterised the institution during Sansovino's lifetime.[119]

Obviously the architect cannot be blamed for the subsequent decadence, which was related to changes in the whole nature of Venetian society.[120] He provided the hospital with a simple, serviceable and dignified residential building, as restrained as the new Scuola della Misericordia was ostentatious. These two institutional projects exemplify the sensitivity of Sansovino's responses to the particular needs and expectations of his patrons.

VI. The Patriciate

THE palaces of Venice have always been one of the most impressive sights of the city. An English traveller commented in 1549:

... I think of no place of all Europe able at this day to compare with that city for number of sumptuous houses, specially for their fronts. For he that will row through the Canale Grande and mark well the fronts of the houses on both sides shall see them more like the doings of princes than private men. And I have been with good reason persuaded that in Venice be above 200 palaces able to lodge a king.[1]

As well as undertaking restorations and alterations for various Venetian patricians, which need not concern us here, Jacopo Sansovino was the architect of two palaces on the Grand Canal, the Palazzo Dolfin and the Palazzo Corner, and was also involved in the design of the Palazzo Moro, a highly unusual project in the outer reaches of the city.

Sansovino arrived in Venice with the experience of a notable palace commission behind him. The Palazzo Gaddi, his most complete surviving building dating from the period before the Sack of Rome, was begun shortly before 1520 for his great friend, the wealthy banker Giovanni Gaddi (Plate 86).[2] It lies in the Via del Banco di Santo Spirito, in the heart of the banking quarter of Renaissance Rome. The tall three-bay façade, its restraint and elegance appropriate to the dignity of the patron, is carefully adapted to the restricted width of the street, while the plan, with its two adjoining courtyards, makes the best possible use of the space available in the peculiarly long narrow site. The project totally belies Sansovino's lack of experience as an architect. Indeed, it demonstrates that he was already fully capable of adjusting his designs to a particular physical environment and to the needs of the individual patron. In his Venetian palace commissions Sansovino was to encounter both these controlling conditions in an extreme form. Not only was the terrain—or lack of it—a unique problem, but the Venetian nobility had developed their own particular family structure reflecting the social and economic organisation of the society. A highly specialised type of building had evolved to house these family units.

The Venetian economy was founded on trade, and most commercial activity was organised on a family basis. Thus the palace had to serve both as a family residence and as the headquarters for trade ventures. Each family unit comprised as many as three or four generations, all housed in the same building. On the death of the head of the family the estate would pass jointly to all the male heirs. The brothers were expected to form a *fraterna* or family partner-

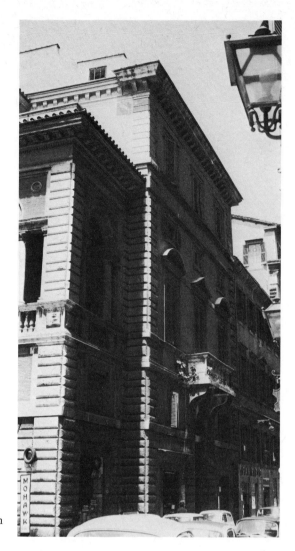

86. Jacopo Sansovino:
Palazzo Gaddi, Rome, begun
before 1520.

ship, acting as associates in trade, and sharing all the food and household expenses. A separate trading company was organised for each voyage to allow the greatest possible flexibility in the face of changing marketing conditions. The element of risk was greatly reduced by the fact that in such a system merchants were not forced to specialise in a limited range of commodities but were able to deal in a variety of different goods. With the exception of widows, who sometimes took an interest in business and kept a stern maternal eye on the running of the *fraterna*, noble women had only a limited role in the society. Young ladies rarely left their homes, and then only veiled and strictly chaperoned. Their economic importance was, however, immense, for the distribution of wealth among the various families was radically affected by the payment of dowries. Advantageous marriage settlements were essential to the prosperity of a Venetian family. Many members of the nobility combined trading enterprises with careers in politics. Since the beginning of the four-

121

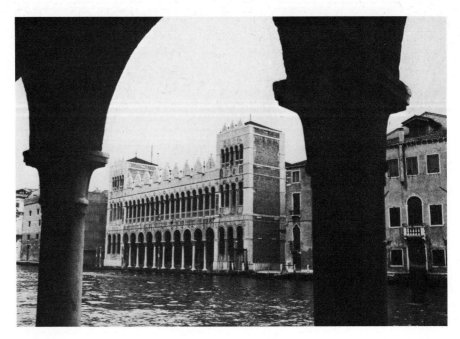

87. Fondaco dei Turchi, Venice, early thirteenth century, restored nineteenth century.

88. Palazzo Loredan, Venice, two lower storeys built twelfth–thirteenth centuries.

teenth century nobles had held the exclusive right to take part in the government of the Republic. From the age of twenty-five every Venetian noble was expected to attend the sessions of the Great Council in the Doge's Palace each Sunday. A successful political career involved a slow process of promotion through a succession of posts in government magistracies, the colonial service, and diplomatic missions. Since office-holding was extremely time-consuming and interfered with commercial activity, few nobles distributed their energies and resources evenly between trade and politics, and their preference would often be reflected in the character of the palaces they occupied.[3]

The Venetian palace had originated as the Veneto-Byzantine *casa fondaco*, a type of building derived from the Arab *fondouk* or trading centre.[4] Introduced to Venice through trading contacts with the East, the *casa fondaco* was particularly well suited both to the physical environment and to the functional requirements of the Venetian palace. It was characterised by a waterfront portico for loading and unloading merchandise, a *piano nobile* above containing the main living quarters, a crenellated roofline, a walled courtyard at the back and, probably, low corner towers at each end of the façade. Few buildings of this type survive today—the Fondaco dei Turchi is perhaps the best illustration, in spite of the 'embellishments' of a fanciful nineteenth-century restoration (Plate 87). Some other examples are preserved in the Byzantine lower storeys of palaces, such as the Palazzo Loredan, which were later enlarged by the addition of extra floors above (Plate 88). This upward expansion was a typical Venetian practice, resulting both from the shortage of vacant land in the city and from the high cost of foundations.

Most Byzantine buildings were constructed on the firmest parts of the city, where alder stakes about one metre long and walls of large stone blocks provided an adequate substructure. By the fifteenth century, however, only the more marshy sites were still free and a new system had to be introduced. First the site was drained and protected by a wooden enclosure. Then oak and larch piles at least four or five metres long were driven into the ground with heavy hammers. The spaces between were filled with chips of Istrian stone and crushed bricks, and covered by two layers of larch mats set in cement. Foundation walls were buried about three metres below high-tide level. This technique was extremely expensive—foundations of this type might take up as much as a third of the total cost of a new building. Wood was a particularly costly building material in the city, for it was also in great demand for shipbuilding, and the mainland forests were being steadily depleted.[5]

The form of the typical Venetian Gothic palace developed from the Veneto-Byzantine *casa fondaco* (Plate 89). The corner towers were now incorporated into a higher block-like structure to provide more accommodation inside. Only the sparser distribution of windows in the side portions of the façade betrayed the vestigial towers. The waterfront arcade for depositing cargoes was superseded by a long ground-floor *androne* perpendicular to the façade. Warehouses for storing merchandise, a boathouse for gondolas, and storage space for household provisions such as wine, flour and wood occupied the ground-floor rooms leading off the central *androne*. Dampness and the danger of flooding made the *pianterreno* unsuitable for habitation. The largest room on the *piano nobile* was the long spacious *salone* directly above the

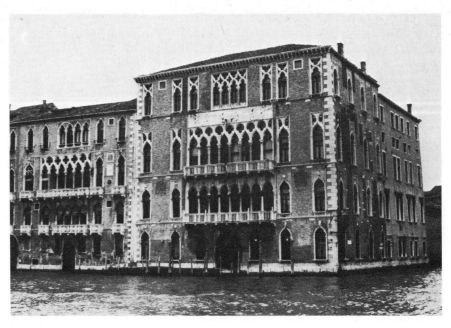

89. Ca' Foscari, Venice, mid-fifteenth century.

androne. The smaller rooms of the main living apartments flanked this huge central hall, linked together with interconnecting doors and also directly accessible from the *salone*. Privacy was hardly a feasible concept for residents of a Venetian palace. The head of the family or the married brothers of a *fraterna* usually occupied the *piano nobile* and perhaps the floor above. Widows and unmarried brothers were relegated to other apartments in the upper parts of the palace. The business offices and the strong-rooms for the safe-keeping of cash and valuables were generally located in small rooms on the mezzanine level between the ground floor and the *piano nobile*. The attic contained the servants' quarters.

It was in Gothic palaces that projecting balconies first became a significant architectural element. These offered a view of the city to the Venetian gentleman, allowing him to emerge from his stuffy palace to take the air on summer evenings. As space for private gardens was severely limited in the centre of Venice, delight in the urban scene had to take the place of a noble's pride in the prospect of his own property.

Inside the palaces only the bedrooms were heated. According to Francesco Sansovino fires were believed to purge the evil vapours in the air.[6] In winter the unheated *saloni* can only have been tolerable to those dressed in the heavy velvet cloaks and furs seen in so many Venetian portraits. In the nineteenth century Effie Ruskin, complaining of the insufferable cold inside Venetian palaces, commented that Venetians at that time carried pots of hot charcoal on their arms.[7] The rooms were roofed with wooden beams, often exquisitely decorated. (Sansovino himself is reputed to have discovered a method of preventing dust from falling through wooden ceilings.[8]) In the residential quarters of the palace, floors were covered with a special Venetian surface

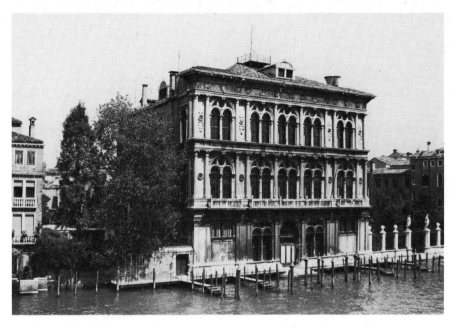

90. Mauro Coducci (?): Palazzo Vendramin–Calergi (formerly Loredan), *c*.1500–10.

known as *terrazzo*, composed of two layers of crushed pebbles and bricks set in cement and well beaten down with rammers and irons. The upper layer, which incorporated chips of coloured marble, was highly polished with mill-stones and oiled to bring out the colours and produce a brilliant shine. Like the beamed ceilings, *terrazzo* floors had the advantage of a certain elasticity.[9] The floors of the *androne*, which were likely to become wet and dirty, were laid instead with tiles of coloured stone and marble.

The fact that windows were glazed in Venice, even in the humblest build-ings, greatly impressed visitors to the city.[10] Whereas domestic buildings in other parts of Italy had to depend on oiled paper or canvas for their windows, glass was readily available in Venice on account of the important glass factories on the island of Murano. The small circular panes were held in place by lead and iron in wooden frames. The plentiful supply of glass was particularly fortunate in view of the fact that there was often little or no space between individual buildings to allow light to penetrate. Because of the shortage of land, palace interiors extended far back from the façades, and the maximum possible window area was therefore needed to cast light deep into the buildings. In the cold, rain and mist of a Venetian winter large expanses of window would have been inconceivable but for the availability of glass. In contrast to other Italian cities, most notably Florence, the internal social and political conflicts were not usually resolved by violence, so that the nobility were able to occupy these relatively unprotected homes without feeling threatened by the rest of the population.

Until the sixteenth century the staircases of Venetian palaces were external structures, situated in the courtyard at the back, again to economise on space. The courtyard also contained the private well, an essential feature of the com-

125

plex. Rain-water draining from the tiled roof was collected in stone gutters and fed into underground tanks where it was filtered in sand. The well-head was located in the open air because sunlight kept it dry and free from mould.[11] Water shortage was a perpetual problem in the city—in dry weather the well supply had to be supplemented with fresh water transported from the mainland.

Towards the end of the fifteenth century elements of classical vocabulary began to appear in Venetian palace architecture. The new forms were integrated into this highly specialised building-type, replacing the Gothic style just as the Gothic itself had earlier superseded the rounded Byzantine arch. The most conspicuous new palace at the time of Sansovino's arrival was the Palazzo Loredan, later known as the Palazzo Vendramin-Calergi and now the winter headquarters of the Casino (Plate 90). Mauro Coducci is usually credited with the design of this palace, which was built during the first decade of the sixteenth century.[12] The use of the Corinthian order on each of the three storeys, including the prosaic ground floor, added a new quality of dignity to the traditional scheme. The ostentatious façade with its heavy cornice and frieze of classical motifs hardly seems organically related to the rest of the structure, but serves rather as a symbol of the status of the rich and distinguished family. This was the first of the four principal Venetian palaces singled out for special praise by Francesco Sansovino. Francesco based his selection on the criteria of architectural merit, grandeur, size, cost, skilled stone-carving and, above all, adherence to the rules of Vitruvius.[13]

The 'top four' palaces also included two designed by Francesco's own father —the Palazzo Dolfin and the Palazzo Corner—the fourth being the Palazzo Grimani built by Jacopo's Veronese contemporary Michele Sanmicheli. All four had the distinction of sites on the Grand Canal. And all were built at vast cost to their owners (though Francesco's claim that each project cost more than 200,000 ducats seems something of an exaggeration) during periods of relative prosperity—the Palazzo Loredan in the first decade of the century and the three others between 1530 and 1570. By the sixteenth century the noble class was beginning to lose its economic security. Commercial enterprises were more risky than ever, in the context of the changing pattern of international trade. The vast outlay on dowries drained the resources of families unlucky enough to have several daughters. To maintain a fine old palace was just an added financial burden for the less fortunate family. Yet even in this period of uncertainty a few families were immensely rich. The need for huge amounts of capital for investment in trade, shipowning or land, and the redistribution of wealth through marriage settlements merely accentuated the gulf between the richest and poorest members of the nobility. Poor members were unable to marry wealthy members of the citizen class without losing their patrician status. It was only the few most prosperous families who could afford to express their wealth and status by erecting magnificent new palaces.[14]

THE PALAZZO DOLFIN
The Palazzo Dolfin was commissioned from Jacopo Sansovino by a wealthy young patrician called Zuanne Dolfin, an important shipowner and merchant who combined his trading activities with a respectable career in public service.[15]

126

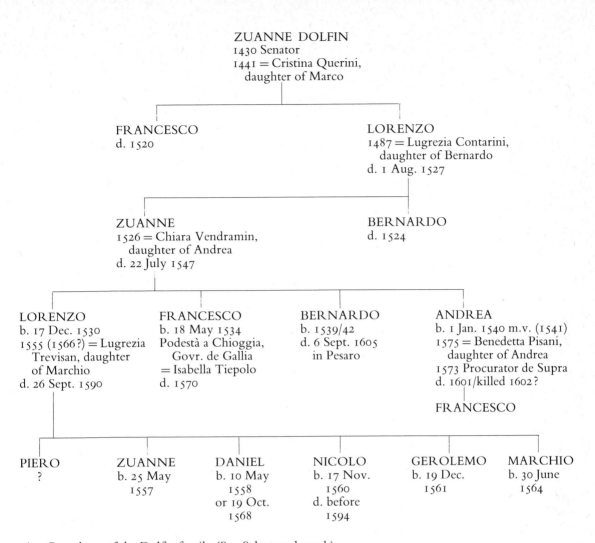

Between 1524 and 1530 he held a succession of government posts, and by 1531 he was a Senator.[16] In September of that year he became a Savio di Terraferma, despite his requests to be excused from the post because of his own involvement in the grain trade.[17] After his term ended in the spring of 1532 he was appointed to perhaps the most prestigious colonial post of all, that of Podestà di Verona.[18] Finally, in September of the following year he resigned and returned to Venice, where he entered the Zonta of the Council of Ten in order to pursue his public service career in a purely voluntary capacity.[19] Throughout these years he was also active in shipping and trade, transporting cargoes such as grain, cotton, salt and pepper, and even pilgrims.

 Like his father before him, Zuanne was one of two brothers the other of whom died leaving no children (Figure xiv). On the death of his father Lorenzo in 1527, he therefore inherited the entire family property, concentrated rather than divided through inheritance. His fortune was augmented by the dowry

91. (left) Jacopo de' Barbari: Map of Venice, detail showing the Palazzo Dolfin, San Salvatore, 1500.

92. (right) Jacopo Sansovino: Palazzo Dolfin, San Salvatore, Venice, begun 1538.

of his wife Chiara, daughter of Andrea Vendramin, whom he married in 1526. The Dolfin inheritance included extensive *terraferma* estates, several properties in Venice itself, and the family palace on the Grand Canal near the Rialto Bridge, on the bank known as the Riva del Carbon. The old palace consisted of two main storeys, below which were warehouses for stores such as corn, wine and wood, some of these rented out to tenants.[20] A small alley from the Campo di San Salvador provided access to the land entrance at the back, while another public street ran along the *fondamenta* on the Grand Canal (Plate 91). One one side a bridge across the Rio di San Salvador linked this street with the *fondamenta* in front of the distinguished Gothic palace belonging to the Bembo family. On the other, the street passed beneath a *sottoportego* or arcade under a smaller Gothic house, separated from the Dolfin palace by a narrow passage.

Planning permission was always required in Venice for private building schemes, to prevent encroachments on public streets and waterways. In 1536, following Zuanne Dolfin's decision to rebuild his palace, the magistracy in charge of the upkeep of streets, the Giudici del Piovego, measured all the streets and alleys near the property.[21] Eighteen months later Zuanne submitted the plans for the new palace to the Proveditori di Comun who were responsible for the maintenance of canals. This project consisted of two main upper stories, like the old palace, but in order to increase the space inside he asked for authorisation to move the line of the Grand Canal façade forward as far as the water's edge. The public street would run through a portico underneath. Early in 1538 these plans were approved, and Zuanne was given permission to remake the *fondamenta* or water-front, and to rebuild the stone bridge across the Rio di San Salvador.[22]

A few months afterwards he declared in his tax return that he had already pulled down part of the old palace. He was still living in the remaining section but planned to demolish that too before long.[23] Two years later he bought a neighbouring palace, part of which he intended to demolish at once to make way for the new building.[24] The *fondamenta* on the Grand Canal side had now been remade, and the Giudici del Piovego carried out further measurements

128

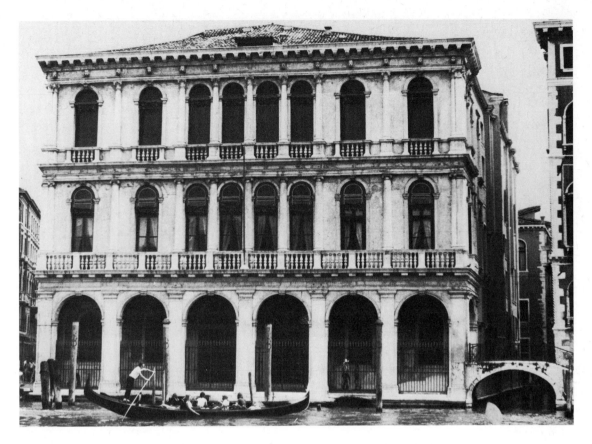

to check that Zuanne had not abused his rights.[25] The *rio* flanking the site was remeasured in 1545, again because he intended to proceed with the new building.[26] Reconstruction in stages was a typical Venetian practice resulting from the scarcity of land—ideally as little of the site as possible should be out of use at any one time.

Zuanne Dolfin died in 1547 leaving the latter stages of the work incomplete, but his four sons who inherited the estate not only finished the project but also acquired yet more property at the back and added a further extension to the new palace. Zuanne left his property jointly to his four sons according to the Venetian custom, entrusting his wife with the task of supervising the *fraterna* and inspecting the household accounts each week. When the *fraterna* finally split up in 1577 the three surviving brothers complied with their father's request that the two principal floors of the palace should each remain intact. Andrea and Lorenzo were allotted these two apartments, while the third brother Bernardo inherited the ground-floor warehouses and the mezzanine above, as well as the *traghetto* station in the portico.[27]

Unfortunately only the façade of Sansovino's original palace has been preserved (Plate 92). The whole of the interior was rebuilt at the end of the eighteenth century by Giovanni Antonio Selva for the last Doge of Venice, Ludovico Manin. However, the main features of the sixteenth-century palace can be reconstructed from various surviving descriptions and plans.[28]

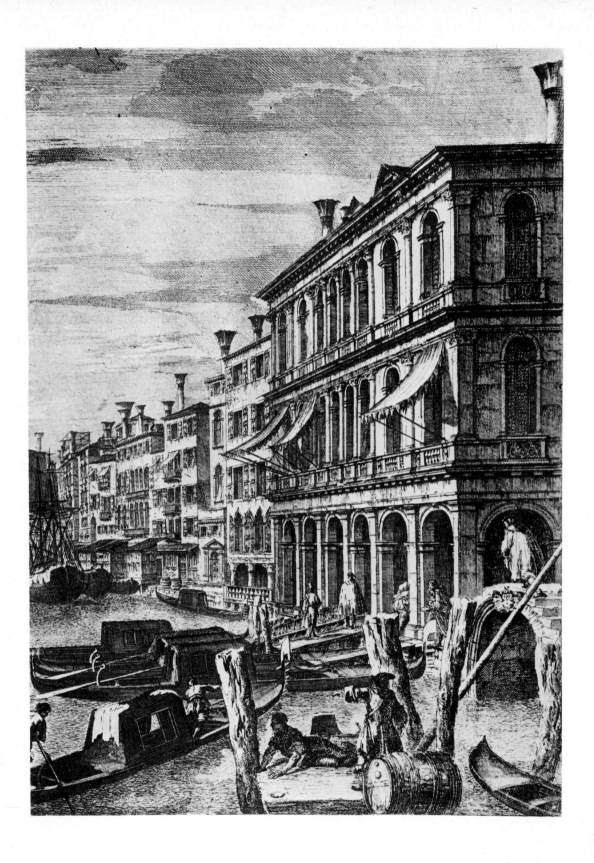

93. (left) Michele
Marieschi: Engraving
of the Palazzo Dolfin,
published 1741.

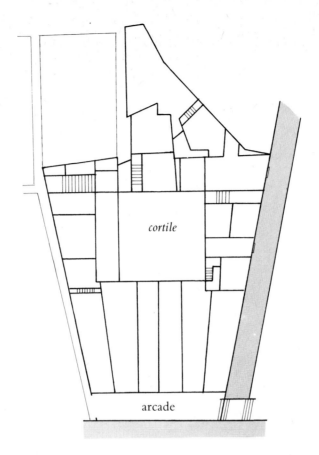

cortile

arcade

xv. Jacopo Sansovino:
Palazzo Dolfin, San
Salvatore, begun 1538,
plan (before
rebuilding, taken from
an eighteenth-century
plan on which no
doors are marked).

The ground-floor plan was in the form of a trapeze, becoming narrower towards the Grand Canal, with an irregular cluster of annexes at the back (Figure xv). It seems likely that Sansovino's original project consisted of the basic trapeze-shaped block with its systematic arrangement of rooms, while the rear extensions were the portions added by Zuanne's sons. In the centre was a square courtyard with a loggia along one side. As in the old palace the land entrance was at the end of the narrow street leading to Campo San Salvador. The water entrance was on the *rio* side, entering the *cortile* on the opposite side to the loggia. The main staircase to the *piano nobile* was situated at one end of this loggia, while another staircase on the *rio* side gave direct access to the second-floor apartment. This was one of the first Venetian palaces to have its stairs integral to the main structure instead of an external staircase in the courtyard. The provision of separate stairways to each of the principal floors was a characteristic feature of sixteenth-century palace architecture in Venice, allowing the various members of the family a certain degree of independence within the whole complex. The large central *saloni* in both apartments, occupying the two middle bays of the façade, were flanked by smaller living rooms and bedrooms in the normal Venetian way.

The Palazzo Dolfin offers striking parallels with Sansovino's Zecca which was also designed in the years 1536–38. These two buildings share the trapeze-

shaped plan and the courtyard surrounded by balconies with a main loggia on one side (Figures xv and iii).[29] Both projects entailed the moving of the façade forward to increase the space in the upper floors, incorporating a row of shops in the case of the Zecca and a public street in the case of the Palazzo Dolfin (Plate 93). In both schemes the main water entrance was not a feature of the principal façade, but was placed on the small *rio* flanking one side of the site.

The even number of bays on the Grand Canal façade of the Palazzo Dolfin leads to a solid element rather than a void in the centre. This arrangement, obviously unsuitable for a single main entrance, is surprising until one views the building in its surroundings. Whereas Sanmicheli in his Palazzo Grimani, which lies not far from the Palazzo Dolfin on the same side of the Grand Canal, sought to honour his eminent patron with a palace which totally dominated all the buildings around it, Sansovino's Palazzo Dolfin was consciously adapted to the scale and character of the adjacent palaces.[30] The Gothic Palazzo Bembo on the right provided the basic scheme and dimensions for the façade design (Plate 94). Sansovino imitated the shape of the roofline and placed his two principal storeys at a similar height to those of the Bembo home. He took over the typical Venetian arrangement of the windows with the denser fenestration in the central portion. He adopted the restrained character of the decoration of the neighbouring palace, replacing the Gothic forms with a simple classical vocabulary. The orthodox succession of the Doric, Ionic and Corinthian orders, a clear statement of the principles of Vitruvian architecture, was applied to the traditional Venetian palace façade. And it was from the Palazzo Bembo that Sansovino derived the curious solution of the solid central axis which precluded a main entrance on to the Grand Canal.

The obligation to retain the public street in front of the palace made the waterfront portico along the entire length of the façade imperative (Plate 92). Yet Sansovino exploited this feature to reflect the mercantile interests of his patron. Instead of the common Venetian type of *sottoportego* with a straight architrave supported on piers, he designed a row of large Doric arches reminiscent of the portico of a Veneto–Byzantine *casa fondaco*. The spacious arcade was useful for unloading goods into the six long narrow warehouses on the ground floor of the palace (Figure xv). In contrast, Sanmicheli's nearby Palazzo Grimani, designed for a family who were distinguished chiefly for their political and ecclesiastical activities, had a relatively confined entrance (Plate 95). After all, the main purpose of this grandiose doorway, modelled on the antique triumphal arch, was not for the unloading of bulk cargoes, but for the occupants to make impressive entrances and exits in full public view. Sansovino provided Zuanne Dolfin with a true merchant's residence, a most appropriate modernisation of an ancient Venetian building-type.

THE PALAZZO CORNER

Sansovino's other commission for a major palace on the Grand Canal came from the Corner family, who were not only active and wealthy traders, but also highly distinguished in both politics and the Church. Unlike the Grimani who did not rise to prominence until the fifteenth century, they were one of the oldest families of the Venetian nobility. In 1527, at the very time when Sansovino was fleeing from the Sack of Rome, the eminent and venerable

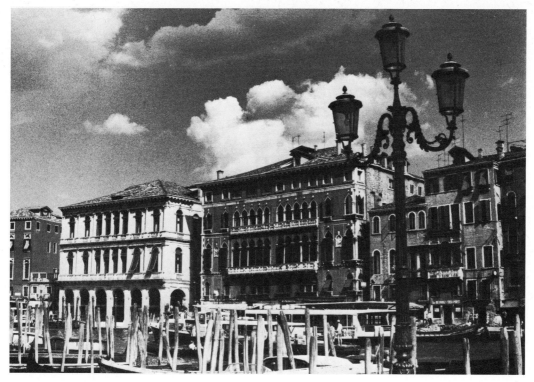

94. Palazzo Dolfin and Palazzo Bembo, Venice.

95. Michele Sanmicheli: Palazzo Grimani, San Luca, Venice, designed 1556–59.

Zorzi Corner, knight and Procurator, died in Venice leaving an immense fortune. Zorzi was the brother of Queen Caterina of Cyprus who had been widowed in 1473 soon after her marriage to James III, the last king of the island. After the subsequent death of her baby son, who lived only a few months, she was persuaded by her brother to abdicate and hand over her kingdom to Venetian rule. Caterina retired to the rural tranquillity of Asolo where she lived, surrounded by poets and humanists, for most of the rest of her life. She died in 1510. Meanwhile Zorzi Corner was richly rewarded by the Republic for his initiative in the transaction, and as a result he came to own vast estates in Cyprus which yielded huge crops of sugar, cotton and wheat.

Zorzi bequeathed his fortune to four of his five surviving sons, Francesco, Zuanne, Hieronimo and Giacomo (Figure xvi). The other son, Andrea, Archbishop of Spalato, was excluded from the *fraterna* ostensibly because of his high ecclesiastical office (he was in fact illegitimate). He was merely allotted the income from capital worth 2,000 ducats. Besides the property in Cyprus Zorzi's estate comprised extensive land-holdings on the mainland (including the country villas of both his wife and his sister), substantial possessions in Venice itself, a collection of works of art, and large amounts of cash, silver and jewellery.[31] He was particularly concerned about the fate of the splendid family palace at San Maurizio (Plate 96) which according to Sanudo was an extremely beautiful house, 'the most beautiful in Venice—one might say the finest in Italy—lordly, magnificent and commodious'. Zorzi had bought the palace from the Malombra family for 20,000 ducats, and had spent over 10,000 ducats on restoring and embellishing it.[32] In 1517 he had also acquired a court of eleven small houses and a boatbuilders' yard with some empty land on the Grand Canal next to the great palace.[33] In his will Zorzi declared that the palace, together with this adjacent property, was to remain in the Corner family for ever, and on no account to be sold, divided, given away, or used to pay dowries or taxes. He charged his eldest son with the responsibility for maintaining the palace in its pristine state. If it was later decided to build on the Grand Canal site (incorporating the neighbouring houses if necessary) Zorzi's executors were to spare no expense to ensure that the project was worthy of the name.[34]

Alas, only five years after Zorzi's death, the magnificent palace was destroyed in one of the most spectacular conflagrations ever seen in Venice. The vivid description in Sanudo's diary tells how fire broke out in the Palazzo Corner in the early hours of 16 August 1532. One of the brothers, Zuanne, whose son was in command of Cyprus, had been sent a cargo of sugar and cotton from the island, but the cases of sugar were damp from the voyage and had been put to dry in the attic, warmed by the sun during the day and by a brazier of embers at night. Zuanne, like so many members of his family, suffered from agonising attacks of gout, and that night he had retired to bed with some heated Indian wood to relieve the pain. The process of preparing the remedy had led to such overheating in the attic above his room that during the night the roof-beams began to smoulder. Soon the crates of sugar caught fire, and within minutes the building was alight. The family had dined so late that they were fast asleep and heard nothing. At last they were roused by the frenzied knocking at their doors, and rushed to save the valuables and documents kept

96. Jacopo de' Barbari: Map of Venice, detail showing the Palazzo Corner, San Maurizio, 1500.

xvi. Genealogy of the Corner family (San Maurizio branch).

in the mezzanine offices over the ground-floor warehouses. Eventually the doors had to be unlocked because of the raging fire, and as a result some of the money and treasure was stolen by looters. Much of the cotton and sugar stored in the ground floor was rescued by boat, but the pictures, 600 cartloads of wood, the wine, and all the other stores were destroyed, as well as the grain and sugar in the roof. The beautiful marble columns on the façade fell irretrievably into the water, killing three people standing in the portico. According to Sanudo it was like the burning of Troy, only worse. After the fire nothing remained of the palace but some columns on the waterfront and parts of the wall facing Ca' Duodo which were too precarious to be left standing. Giacomo Corner can hardly have felt comforted by Sanudo's words of consolation: 'Deus dedit, Deus abstulit' (God gave, God took away)![35]

The Corner brothers were not left homeless after the fire. The eldest brother Francesco had moved to Rome in 1528, having been made a Cardinal. Zuanne and Giacomo went to live in the family palace at San Cassan, formerly the Venetian residence of their aunt Queen Caterina, where the fourth brother Hieronimo had been living since his return from Crete in 1528. Zuanne planned to move from there as soon as possible to the third great palace bequeathed to the *fraterna* by Zorzi, the former home of the famous *condottiere* Gattamelata at San Polo.[36] By 1533 both Zuanne and Giacomo were settled at San Polo and had already resumed their lavish banquets and parties in spite of the recent disaster.[37]

Meanwhile plans were made for the rebuilding of the ruined palace at San Maurizio. The family had suffered a severe financial setback as a result of the fire, but as Sanudo pointed out they had enormous wealth, and it was assumed that they would comply with the terms of Zorzi's will and build a new palace. Sanudo estimated their regular income at 10,000 ducats, supplemented by a further 10,000 ducats from three abbeys, 3,000 ducats from various benefices held by Cardinal Francesco, and substantial amounts of land, silver, jewellery and other property.[38] Nevertheless, the Corner brothers did not consider their normal means adequate to cover the cost of rebuilding the *palazzo*. Soon after the fire Giacomo and Francesco each sent petitions to the Doge explaining the situation. The high cost of Francesco's cardinalate had been met from the resources of the *fraterna*, while the three other brothers between them had eight daughters who would eventually need dowries, and they also had numerous sons. To build a palace large enough to accommodate these three brothers and their families would cost at least 50,000 ducats. Both Giacomo and Francesco, pointing out how a splendid new palace in such a conspicuous site would greatly enhance the beauty of the city, begged the Republic to support the enterprise, as it had done in the past for institutions and private individuals who had suffered similar disasters. The Corner brothers claimed to be the lawful heirs to the dowry of Queen Caterina, which had been deposited with the Republic when her kingdom was handed over to Venetian rule. They suggested that this dowry, which amounted to 61,000 ducats, should be used to finance the reconstruction of their palace. Their family had always served the State loyally and generously—now it was up to the Republic to offer support in return. The money had purposely not been claimed at the time of the Queen's death in 1510 because Venice was then deeply involved in the wars against the League of Cambrai.

These petitions were not in vain. Now that the Republic was recovering its prosperity and self-confidence, the Council of Ten welcomed this opportunity to embellish the city and readily approved the suggestion. They offered to repay the Corner brothers 30,000 ducats of Queen Caterina's dowry, in the form of investments in Cyprus which would be liquidated to finance the rebuilding of the palace.[39] This was considerably less than the sum requested by Giacomo, but it would still provide substantial funds for launching the scheme. After all, 30,000 ducats was roughly equivalent to the amount spent during Sansovino's lifetime on each of his two largest buildings in the centre of the city—the Library and the Mint.[40]

Only two months after the fire, work was begun on renewing the water-front or *fondamenta*, which must have been in an untidy state.[41] In the following year the Giudici del Piovego carried out routine measurements on the site of the boatyard next to the ruined palace to ensure that the new *fondamente* would not encroach on public property.[42] There is no evidence, however, that a model for the new building had already been prepared at this stage. Sansovino must have received the commission to design the new palace by 1537, for Aretino referred to the project in his famous letter to the architect in November of that year. But although he displayed an accurate knowledge of Sansovino's other projects in hand at the time, Aretino could offer no indication of the appearance of the model of the Palazzo Corner. He merely referred to the 'foundations on which the superb home of the Cornaro family is to be erected'. Since the letter shows Aretino to have had knowledge of Sansovino's schemes at the studio stage, it seems likely that no model had yet been produced.[43] In their tax return at that time Giacomo and his brothers described the San Maurizio property as 'the empty site with its burned and ruined houses', which certainly does not suggest that the new building had been started. In the same statement they explained that the adjacent property was not let because they hope to demolish the buildings on the site to make way for the new palace.[44] They had the project in mind, but investigations of the family circumstances during this period indicate that, apart from the repair of the *fondamenta*, work was in fact held up for at least a decade after the fire.

The Corner family may have been exceedingly rich, but their domestic problems seriously interfered with their building patronage. Less than three years after the burning of the San Maurizio palace the family suffered another setback. By an incredible stroke of fate, their palace at San Polo was also destroyed by fire early in 1535.[45] This second blaze left the three married brothers with only one surviving palace, at San Cassan, but they showed little inclination to cohabit. By 1538 only one of them, Hieronimo, was living there.[46] The system of sharing all household expenses had become un-manageable now that the family was scattered. In that year they began to negotiate the division of Zorzi's estate.[47] The break-up of a *fraterna* was a common enough event in Venice—family partnerships did not usually last for more than a generation—but the division of Zorzi's many properties was a long and complicated process which was to leave a residual bitterness even after the transactions had finally been completed.

The *terraferma* holdings were split up by means of an agreement of 1540,[48] but the division of the Venetian property was not even started until 1542, by which time one of the four brothers, Giacomo, had already died. In that year

137

the division of the estate into four principal sections, each consisting of a major property supplemented by smaller items, was arranged. Estimates of the value of each part could then be checked before the parts were finally allotted. The first quarter consisted chiefly of the ruins of the burnt palace at San Maurizio. The clause in Zorzi's will that the San Maurizio property was not to be divided was overlooked, with special permission from the state. Instead the land was bisected by dividing the Grand Canal frontage into two exactly equal lengths. The adjacent site with the boatyard, bought from Zuanne del Pin, formed the nucleus of the second part. The ruined palace at San Polo made up most of the third quarter, while the fourth part was based on Queen Caterina's palace at San Cassan.[49]

The four parts were finally distributed among Zorzi's heirs in 1545. It had already been agreed that Hieronimo should inherit the property at San Cassan, as he had been living there for many years.[50] Zuanne (who in the meantime had resorted to buying another palace, the so-called Palazzo Corner-Spinelli at S. Angelo[51]) received the remains of the burned-down palace at San Polo. Giacomo's son Zorzi, known as Zorzetto or Little George to distinguish him from his cousin of the same name, inherited the ruins of his grandfather Zorzi's great palace at San Maurizio; while the adjacent site passed to the heirs of Cardinal Francesco, who had died in 1543.[52] The Cardinal left his estate to his two surviving brothers, in the proportion of two-thirds to Zuanne and one-third to Hieronimo, which meant that Zorzetto had no claim to any part of the land flanking his own property.[53] The 1545 settlement must have been a relief to the members of the *fraterna*. The family archives contain several documents referring to internal disputes over the *fraterna* accounts, which persisted even after the division was completed. The tensions seem to have been caused chiefly by an argument between Giacomo's son Zorzi and Hieronimo. The latter claimed to be entitled to a rebate for his share of the *fraterna*'s household expenses (these included wine, corn, wood, oil, meat and fish, servants' wages, doctors' fees, horses, falcons, dogs and entertainment) during the period when he was still living in Crete.[54]

These complications of the division, the direct result of the peculiar Venetian system of inheritance, seem to have effectively obstructed the rebuilding of both the destroyed family palaces. It is often assumed that the construction of the new Palazzo Corner at San Maurizio began almost immediately after the fire.[55] Yet in the years 1532–42 only about 2,000 ducats was spent on the new *fondamenta* or waterfront, and no expense whatever on the building of the palace was recorded.[56] As late as 1543 Zorzi's heirs had still not rebuilt the *riva* along the *fondamenta* which had been destroyed in the fire.[57] Even in the 1545 settlement, the property at San Maurizio was still described as the *casa brusada* (burned house).[58] It is virtually inconceivable that the palace could have been started before the limits of the site were defined in 1542. In fact the new building was probably begun after 1545 when it was confirmed that Zorzi (whom both Vasari and Francesco Sansovino name as Jacopo's patron) was to inherit that part of his grandfather's estate.[59] The Palazzo Corner cannot be safely considered as one of Sansovino's first Venetian works. Even if an early model had been supplied, the architect would probably have revised his ideas before work was finally begun. It seems more likely that a verbal agreement

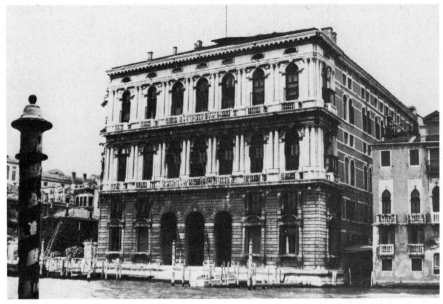

97. (above) Jacopo
Sansovino: Palazzo
Corner, San
Maurizio, Venice,
begun *c*.1545.

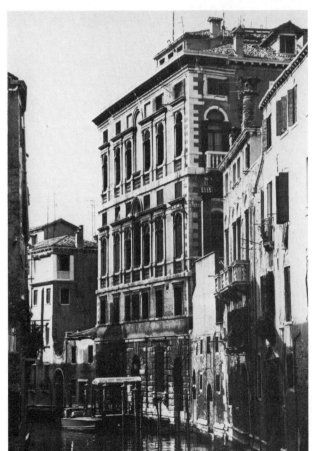

98. Michele
Sanmicheli: Palazzo
Corner, San Polo,
Venice, begun *c*.1545.

was reached between the family and Sansovino before Aretino wrote his 1537 letter, and that the project was actually begun after Zorzetto inherited the site in 1545. The new palace at San Polo, designed for Zuanne Corner by the Veronese architect Sanmicheli, was probably started at about the same time.[60]

Neither of the huge new buildings was completed quickly. Work at San Polo was still in progress in 1560, but the palace had been completed by the time of the tax survey in 1566.[61] In the same series of tax returns, Zorzi Corner declared that he too was now living in his new home at San Maurizio although this building was not yet finished.[62] Fifteen years later, at the time of the 1581 tax survey, Zorzi's palace was still not quite completed.[62] There is, of course, no need to fall back on the widely accepted notion that Scamozzi designed the third order after Sansovino's death, for the uppermost storey is an integral part of the whole scheme and in no way conflicts with Sansovino's own style.[64]

A comparison between these two palaces, designed at more or less the same time by the two greatest architects then working in the Veneto for two branches of the same family with similar financial means at their disposal, is a revealing exercise. Both were considerably larger than any of the surrounding buildings, as if to draw attention to the enormous wealth of their owners. The sheer vastness of the two palaces almost persuades one to believe the tradition that the Senate asked the family to split up into several palaces, so that their residence would not be unsuitably large for a private family.[65] Yet the two locations offered very different scope to the architects. The palace at San Maurizio, with its conspicuous site on the Grand Canal, is the first magnificent building to strike the visitor travelling by boat from San Marco to the Rialto (Plate 97). On the other hand, the water-façade of the Palazzo Corner at San Polo looks on to a narrow and little-frequented *rio*, with no possibility of a distant prospect except from the side (Plate 98). Its land entrance, opening on to the vast expanse of the Campo San Polo, is more likely to attract attention, although no more than the rear corner of the palace is visible from this side.

Both façades are given the appropriate expression of status through the correct use of the orders. In each case a rusticated Doric basement is surmounted by Ionic and Corinthian upper storeys. Both palaces have three ample doorways opening on to the water for unloading merchandise and stores—both families had large households, and their extensive properties in Cyprus and on the mainland must have yielded substantial quantities of agricultural produce. The mundane use of the ground floors as warehouse space makes the rustication of the Doric order especially suitable. Both buildings conform to the normal Venetian arrangement of the long central *androne* surmounted by large *saloni* on each of the main floors (Plate 99, Figure xvii), with the central portion indicated on the façade by the closer spacing of the windows to allow more light into these long rooms.

Yet the two architects had to approach their commissions from very different standpoints. The palace at San Polo (Plate 98) was intended to serve as two superimposed palaces, with the top storey let out to another family as a source of extra income.[66] This factor accounts for the remarkable height of the façade in proportion to its width. Sanmicheli coped with this difficult requirement by means of the ingenious use of large mezzanine windows in the façade, which enabled him to incorporate extra floors into the three-order elevation.

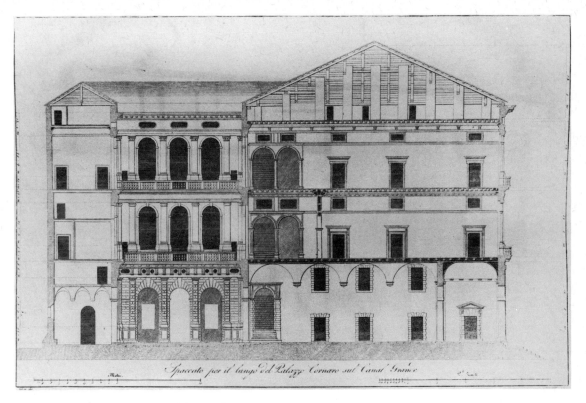

Spaccato per il lungo del Palazzo Cornaro sul Canal Grande

99. Palazzo Corner, San Maurizio, section.

cortile

xvii. Jacopo Sansovino: Palazzo
Corner, San Maurizio, Venice,
begun 1545, plan.

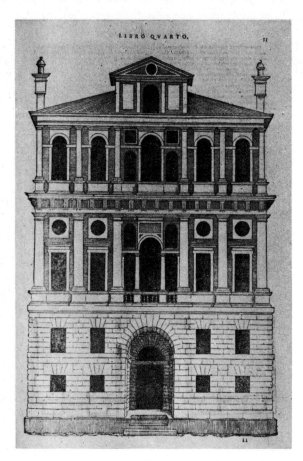

100. (left) Serlio: Venetian palace façade, from Book IV of his treatise, 1537.

101. (right) Palazzo Corner, San Maurizio, courtyard.

These mezzanines lead to intriguing visual ambiguities, for they can be read either with the storey above or with the one below. Since the façade cannot be viewed from a distance, it is composed as a complex agglomeration of parts rather than as a unified whole. Sanmicheli's palace recalls Serlio's schemes for Venetian palace façades (Plate 100), with its central 'serliana' windows and restrained ornamentation.[67] Lavish expense on costly materials for a palace façade so difficult to admire would have been wasted, and instead the upper storeys are built chiefly in brick with *pietra d'Istria* detailing.

In contrast, the façade of the Palazzo Corner at San Maurizio (Plate 97), like Sanmicheli's Palazzo Grimani at San Luca, was intended to create an impression of great magnificence. Since the Grimani and the Corner were two of the wealthiest and most distinguished families in sixteenth-century Venice, these two splendid Grand Canal façades, completely faced in *pietra d'Istria*, served as ostentatious manifestations of their status. The interior arrangements of both palaces were very much in the Venetian tradition, but their exteriors displayed an unprecedented erudition and competence in the handling of classical forms. As inhabitants of a city eager to establish a reputation as the 'new Rome', the patrons must have welcomed the wealth of *all'antica* detail. In the San Maurizio palace, as in Sansovino's prestigious projects in Piazza San Marco, Roman reminiscences abound. The coupled columns over the rusticated basement, the

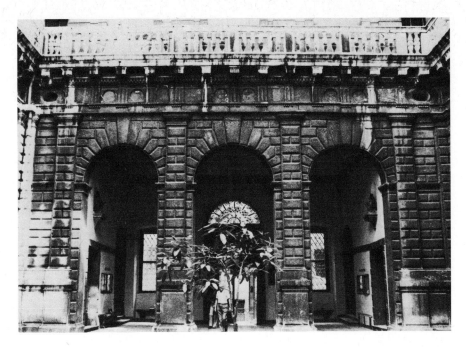

individual balconies at the side windows, even the elegant corner solution, look back to Bramante's House of Raphael. The antique-style armour, weapons, spoils and classical torsoes in the spandrels, the imposing keystone heads, and the tiny lions' heads in the cornice are self-conscious *all'antica* details. At the same time, Sansovino included many of his more personal motifs— the blocked balustrade which he had already used in the Library and the Palazzo Dolfin, the oval attic windows recalling those of the Library, and the long consoles flanking the mezzanine windows which appear on the Loggetta and in the loggia on the *piano nobile* of the Mint.

Unlike Sanmicheli in his Venetian palaces, Sansovino made the courtyards an important architectural feature in his buildings. As in the case of the Zecca, the *cortile* of the Palazzo Corner has the same sequence of orders as the façade, here translated into a more clean-cut and urbane form. The three bays on each side of the court reflect the triple doorway on the Grand Canal (Plate 101).[68] Unusual details, such as the Doric frieze with its pairs of sunken circular panels in the metopes over each bay and its elongated oval metopes in the corners, or the diamond-shaped projections in the blocks of the balusters, contribute to the effect of sophistication. Sansovino probably intended a complete series of oval windows in the top frieze of the *cortile*, again to harmonise with the façade. The original well, now moved to Campo Santi Giovanni e Paolo, with its playful decoration of *putti* with garlands, would have helped to lighten the effect of daunting severity in the courtyard (Plate 102).[69]

Whereas the Palazzo Corner at San Polo was provided with a main staircase for the use of Zuanne's family living on the *piano nobile* and a smaller staircase to give separate access to the tenants of the upper storey, the San Maurizio palace was intended to be inhabited as a single unit—that is by Zorzi Corner and his family only—and therefore had a single grand interior staircase leading

102. Well-head from the Palazzo Corner, Campo di Santi Giovanni e Paolo, Venice.

103. Palazzo Corner, San Maurizio, main staircase.

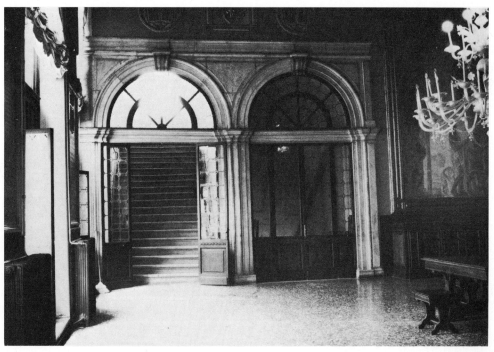

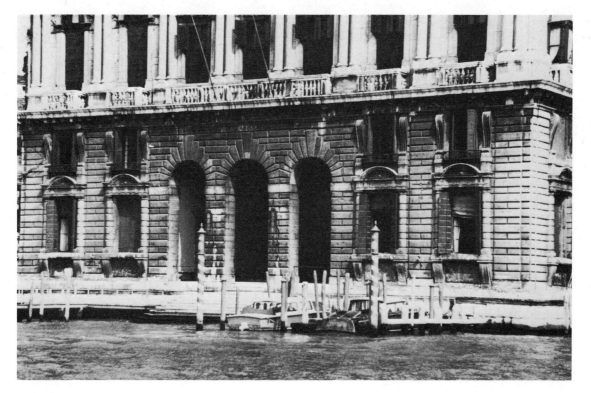

104. Palazzo
Corner, San
Maurizio, detail of
façade.

to both the main living apartments (Plate 103). There were also two smaller service stairways; and traces of a secret staircase to a second-floor bedroom were discovered during repairs some years ago, supposedly to allow some member of the family holding ecclesiastical office to admit women surreptitiously.[70]

The profusion of sophisticated and imaginative features in Sansovino's palace at San Maurizio, contrasting sharply with the cool simplicity of his Palazzo Dolfin, seems to reinforce the later date for the design. The window aedicules on the ground floor of the façade, with their segmental pediments compressed on each side by the long consoles perched on projecting blocks above, are especially elegant (Plate 104). And the handling of the coupled columns on the one completed corner on the Grand Canal is a masterful stroke of virtuosity. While the grandiose façades of Coducci's Palazzo Loredan and Sanmicheli's Palazzo Grimani at San Luca seem like ill-fitting scenery placed in front of the palaces, Sansovino managed to incorporate the grand Istrian-stone façade of his Palazzo Corner into the whole structure of the building, wrapping it around the side like the façade of the Palazzo Dolfin. It is sad that the uncertain destiny of the adjacent site, caused by the complexities of the family inheritance, prevented the building of a similar corner on the other side. In case Cardinal Francesco's heirs should wish to build on the empty land, the palace was cleanly cut off at this point, as if sliced by a sharp knife (Plate 105). In his treatise on architecture Scamozzi illustrates his own design for a palace on this next-door site, produced for the San Polo branch of the family (who inherited two-thirds of the Cardinal's estate), but never in fact executed.[71]

145

105. Palazzo Corner, San Maurizio, view showing unfinished side.

Francesco Sansovino rated the Palazzo Corner at San Maurizio as the most
memorable of all the four principal Venetian palaces on account of its magni-
ficence, capacity, richness of materials, structure and symmetry. He particu-
larly admired the commodity and capaciousness of the accommodation.[72]
Vasari even reports that the palace was reputed to be 'perhaps the finest in
Italy'.[73] Certainly the influence of the design on later architects working in
Venice, above all Longhena, is a measure of its success.

THE PALAZZO MORO
In addition to his two famous palaces on the Grand Canal, Sansovino designed,
or helped to design, a third patrician's residence of a totally different nature,
in a remote, almost suburban corner of the city. This palace, built for Sanso-
vino's friend Leonardo Moro at San Gerolemo, is now almost forgotten and
is long thought to have disappeared. In the sixteenth century, however, the
palace was by no means ignored. Both written and graphic descriptions of the
period convey its striking and unusual appearance. According to Vasari it
seemed 'almost like a castle', while in his 1581 guidebook Francesco Sansovino
also likened the palace to a huge *castello*.[74] Maps and views of the city from the
1560s onwards show the building as a vast quadrangular structure, with four
corner towers linked by long connecting wings, and a magnificent garden in
the spacious courtyard (Plate 106).[75] Francesco's guidebook mentions it not

146

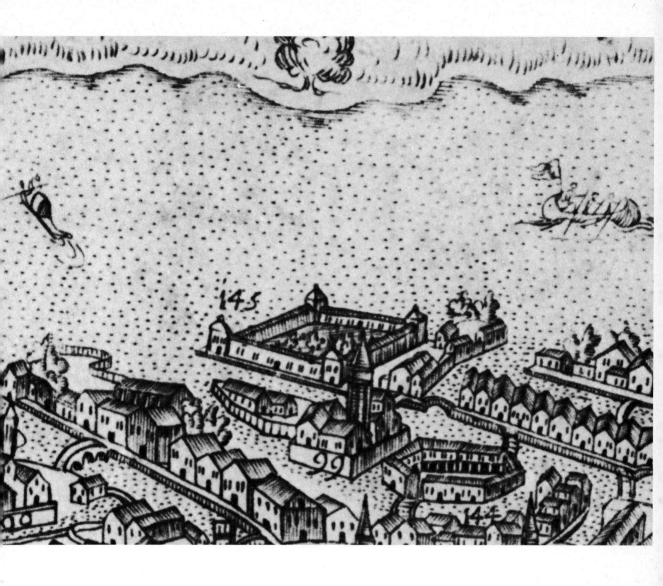

106. Paolo Furlani: Map of Venice, published by Zalterii, 1566, detail
showing the Palazzo Moro, San Gerolemo.

107. Jacopo Sansovino (and Leonardo Moro?): Palazzo Moro, San Gerolemo, Venice, begun c.1544.

only among the most notable palaces but also as one of the finest Venetian gardens.[76] The garden still existed as late as the mid-nineteenth century when Effie Ruskin went there to take a walk.[77] The fact that in 1879 Tassini recorded that the corner towers were no longer to be seen is no more than an indication of the building's inaccessibility, for in fact two of the towers and the connecting wing along the Rio di San Gerolemo still exist today, if in a badly neglected state (Plate 107).[78]

It was Vasari who attributed the building to Jacopo Sansovino.[79] According to Francesco it was the work of Leonardo Moro, but since Moro was one of the executors of Sansovino's will one can assume that they were well acquainted, and Moro must at least have discussed the project with his architect friend.[80] Indeed it is not unreasonable to suggest that Sansovino made a significant contribution to such an unconventional design.

Leonardo Moro was the only son of the senator Carlo Moro, who in 1526 had made history with his two brothers Bernardo and Zuanne when they all entered the Senate in the same year (Figure xviii). All three were appointed on payment of large entry fees during a financial crisis.[81] Their father, also called Leonardo, had been declared bankrupt in 1473, and had left virtually nothing to his sons when he died in 1490. The three Moro senators, together with a fourth brother, Gerolemo, had managed to restore the family fortunes, chiefly

148

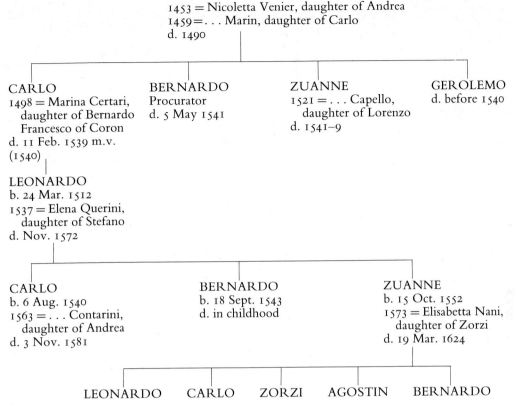

LEONARDO MORO
1453 = Nicoletta Venier, daughter of Andrea
1459 = . . . Marin, daughter of Carlo
d. 1490

CARLO
1498 = Marina Certari,
daughter of Bernardo
Francesco of Coron
d. 11 Feb. 1539 m.v.
(1540)

BERNARDO
Procurator
d. 5 May 1541

ZUANNE
1521 = . . . Capello,
daughter of Lorenzo
d. 1541–9

GEROLEMO
d. before 1540

LEONARDO
b. 24 Mar. 1512
1537 = Elena Querini,
daughter of Stefano
d. Nov. 1572

CARLO
b. 6 Aug. 1540
1563 = . . . Contarini,
daughter of Andrea
d. 3 Nov. 1581

BERNARDO
b. 18 Sept. 1543
d. in childhood

ZUANNE
b. 15 Oct. 1552
1573 = Elisabetta Nani,
daughter of Zorzi
d. 19 Mar. 1624

LEONARDO **CARLO** **ZORZI** **AGOSTIN** **BERNARDO**

xviii. Genealogy of the Moro family (San Gerolemo branch).

through commerce. Both luck and hard work contributed to their success as merchants; and in his will Bernardo also confessed to unscrupulous practices such as contraband, fraud and tax evasion which he claimed no merchant could avoid![82] Three of the brothers made successful careers in public service as well as in trade, each holding a series of respectable posts in government magistracies. Carlo Moro, Leonardo's father, was elected to the public health office in 1528, an important post at that plague-ridden time. He then served in the treasury, the tax office and the grain magistracy. Bernardo even achieved the honour of election to the Procuratia de Ultra in 1537, on payment of 14,000 ducats.[83] Carlo was the only one of the four Moro brothers to leave any legitimate heirs. He was lucky in having only one daughter, which cut down his outlay on dowries.[84] His son Leonardo, Sansovino's friend, who also bought himself a seat in the Senate, was especially fortunate, for he inherited not only his father's estate but also the property of each of his three uncles. Like Zuanne Dolfin, the patron of Sansovino's first Venetian palace, Leonardo was the single heir to a whole branch of his family, and therefore found himself in an excellent position to embark on an ambitious building project.[85]

The scheme evolved in a curiously random way. Francesco's comment in his earliest guide to Venice, the 1556 dialogue, alludes to its haphazard quality, describing it as 'that castle or that chaos of houses'.[86] A sketchy outline of the

149

108. Jacopo de' Barbari: Map of Venice, detail showing the site of the Palazzo Moro, 1500.

development of the project can be compiled from fragmentary references in the Venetian archives. Tassini noted the date 1544 on one of the corner pilasters, and this appears to be a perfectly plausible date for the start of the building.[87] The last of Leonardo Moro's uncles, Zuanne, died some time between 1541 and 1549, leaving him in possession of the whole family inheritance.[88] Leonardo decided to let his uncles' palace at Sant'Agostin, and instead built himself another home at San Felice, where he was already living when he submitted his tax return in 1549. Meanwhile he also began a row of twenty houses for letting at San Gerolemo, of which half were already finished and occupied by tenants in 1549.[89] It was this row of twenty houses, merely a speculative venture at the outset, which formed the starting-point for the remarkable four-cornered structure in which Sansovino seems to have been involved. Two years later, in his tax return of 1551, Leonardo declared that the ten remaining houses were now completed. Only nine of them had in fact been let, because Leonardo himself wanted to move into the tenth.[90] From this sudden change of plan one can only conclude that during its execution the project had captured Leonardo's imagination to such an extent that he had even decided to abandon his new palace at San Felice to take up residence there.

Barbari's view of Venice in 1500 shows the site at San Gerolemo before Moro's houses were started (Plate 108). It was an attractive area of vineyards and orchards projecting into the lagoon on the far north-west corner of the city. The original twenty houses seem to have been those along the Rio di San

xix. Jacopo Sansovino (and Leonardo Moro?): Palazzo Moro, San Gerolemo, Venice, begun *c*. 1544, reconstruction of façade.

Gerolemo which still survive today. The two corner-towers are of a respectable size, and Leonardo presumably intended to occupy one of these, perhaps the one which still bears the family coat-of-arms on the corner-stone. The eighteen small houses between are simple artisans' cottages, each consisting of a workshop on the ground-floor surmounted by the main living-storey with an attic above. Like the towers they are built in the most economical materials—stuccoed brick with plain Istrian-stone window-frames. This type of property development was not unusual at this time in the more peripheral parts of Venice, where land was relatively cheap and plentiful.[91] The appearance of the complex today certainly justifies Francesco's comment about the 'chaos of houses'. Even allowing for subsequent changes in the fenestration and the arrangement of the doorways, it is not easy to detect a regular pattern in the elevation. The section immediately to the left of the centre is particularly discordant, and seems to have been rebuilt at a later date, although it is just conceivable that a building already existing on the site could have been incorporated into the series of new houses. A reconstruction of the whole *rio* façade can be proposed on the basis of the surviving components (Figure xix). Each of the smaller houses probably had a double doorway, like the two preserved at the left-hand end of the series. Double entrances were often a feature of row-housing of this type, one half of the doorway giving access to the ground-floor workshop space or kitchen and the other opening on to the staircase.[92]

As soon as Leonardo had decided to move to San Gerolemo himself, the concept began to expand. By 1552 he had bought more land—a vineyard—at San Gerolemo, presumably on the lagoon side of the site.[93] The records of the magistracy which administered the lagoon waters contain two requests by neighbours of Moro in the early 1560s for permission to build *fondamente* along the edge of the lagoon, continuing the lines of embankments newly built by Leonardo.[94] It was on these new waterfronts that the two remaining towers and connecting walls or wings, as they appear in Furlani's map of 1565 for example, were to be constructed, enclosing the huge square for the garden.[95] It is difficult to ascertain how much of the quadrangle was actually built at that time. The sixteenth-century views may simply have added any missing sections to complete the pictorial effect. The present buildings at the back of the site are nineteenth-century constructions (Plate 109), but the two side wings which figure in the first detailed ground-plans such as Ughi's map of 1729, with a connecting wall at the rear, may well have been part of the original concept.[96] A similar U-shaped plan closed by a wall on the fourth side is a

109. Palazzo Moro, corner tower and view towards lagoon.

notable feature of Sansovino's only *terraferma* villa, the Villa Garzoni at Pontecasale.

The notion of a palace with corner towers was not unprecedented in Venice. The Byzantine *casa fondaco* had established the tradition, and even the sixteenth-century Fondaco dei Tedeschi had turrets at either end of the façade. Filarete's treatise, which was then well known in Venice thanks to the beautiful manuscript copy in the library at Santi Giovanni e Paolo, illustrates a scheme for a Venetian patrician palace with corner towers (Plate 110).[97] The huge Ca' del Duca, commissioned by the Duke of Milan in the mid-fifteenth century, was likewise intended to have a tower at each end of the façade, as well as a large garden in the courtyard. Although this building was never erected, it was well known in Venice on account of its conspicuous rusticated foundations on the banks of the Grand Canal.[98] The design of the San Gerolemo complex also recalls certain Veneto villas and farms, with their walled enclosures and defensive look-out towers.[99] The fact that both Vasari and Francesco Sansovino compared the building to a *castello* suggests that they associated the design with these fortified prototypes on the mainland, although the San Gerolemo building itself had no crenellations and its row of doors along the façade looked utterly defenceless. Jacopo Sansovino could also have drawn ideas from his early career in Central Italy. He probably knew of Leonardo da Vinci's elaborate designs for many-towered French *chateaux*.[100] More significantly, he must have been familiar with the huge quadrangular palace with a central courtyard and four corner blocks designed by Giuliano da Sangallo for the

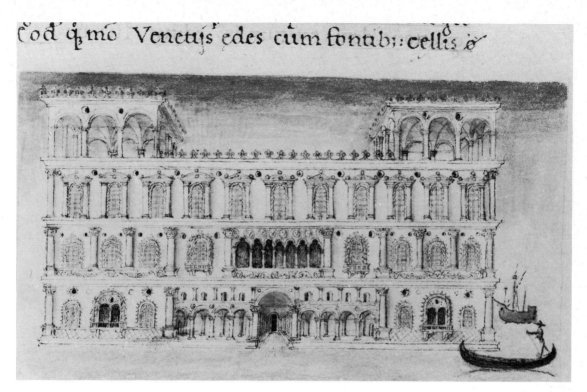

110. Filarete: Venetian palace façade, from his treatise on architecture, mid-15th century.

King of Naples in 1487, as well as Bramante's project for the Palazzo di Giustizia in Rome;[101] and both Bramante and Giuliano had been important figures in Sansovino's career, giving help and advice during his early years in papal circles.[102]

Leonardo Moro's palace can best be considered the Venetian equivalent of the Central Italian *villa suburbana*, a hybrid of urban and rustic building-types, where the senator could live in rural tranquillity within the confines of the city itself. Not surprisingly the Moro family felt great affection for their unusual home and its huge garden, almost surrounded by open water, looking out across the lagoon towards distant mountains. A clause in the will of Leonardo's son Zuanne, who inherited the property at San Gerolemo, shows how much the building had come to mean to them:

I do not wish my palace, which I occupy and enjoy at the present time, that is, including the large orchard and the gardener's house, the plants in the courtyard, the small orchard, the world-maps in the portico, and the lamp and pictures in the large bedroom, to be divided, because that would spoil and ruin everything . . .[103]

The original row of houses had not been intended to serve as a nobleman's palace, yet the result was a conception of considerable dignity. It is impossible to define what part Jacopo Sansovino actually took in the project, or at what stage in its evolution he was brought in. Perhaps Moro was one of those *dilettante* Venetian nobles, like Francesco Zen and Alvise Corner, who enjoyed

153

playing the role of the amateur architect, assisted by the friendship of a notable professional.[104] Yet to judge by the complexity of the design, and the variety of the sources it recalls, Sansovino's contribution seems to have been a radical one. Although Moro remains a shadowy character, and our knowledge of the history of the building is tantalisingly limited, the scheme stands out as one of the most interesting, if enigmatic, of Sansovino's Venetian assignments.

Each of Sansovino's three great Venetian palaces had a totally distinctive character. The Palazzo Dolfin was a restrained, functional and dignified design to suit a prosperous patrician shipowner. The Palazzo Corner served as an ostentatious display of wealth and splendour for one of the richest and most distinguished families in the city. For his special friend Leonardo Moro, Sansovino conceived a delightful suburban retreat, with a garden on the edge of the lagoon—a pleasure also enjoyed by Titian, who was another of the architect's greatest friends. This variety testifies yet again to the architect's inventiveness, and to his capacity to draw inspiration from the specific case of each of his patrons.

VII. Conclusion

To a remarkable extent architecture expresses the needs and attitudes of the society which creates it. Exploring the social and economic conditions of sixteenth-century Venice, we can begin to understand the circumstances which led to each of Sansovino's architectural commissions. Even after so long, the monuments themselves take on a new vitality and interest—they are conceived, erected, paid for, lived in. At the same time the architect begins to emerge as a human character in his own right. We become aware of the professional and personal problems which punctuated his career. We see how in every one of his works he was obliged to make concessions and compromises, and to adapt his design to a tightly defined set of physical, financial and sociological conditions. Naturally this pattern is not unique to Sansovino. Architects throughout history have had to face up to such challenges and frustrations. The intention of this book has been not simply to show that these controls operated, but rather to demonstrate how a deeper understanding of their exact nature can influence our assessment of the architect's achievement.

To illustrate the point with a specific example, let us consider the Library and the Fabbriche Nuove. Superficially the two projects seem comparable. Both are public buildings in prominent positions—one in Piazza San Marco, the other on a conspicuous curve in the Grand Canal near the Rialto Bridge. Both have long façades with a repeatable bay unit articulated by the classical orders. In each case the orders are arranged in orthodox succession—Doric and Ionic in the two-storey Library, and Rustic, Doric and Ionic in the three-storey Fabbriche Nuove. Both have ground-floor arcades with shops. But there the resemblances end. While the Library is totally encrusted in elaborate sculptural decoration, brought to life by the play of light and shade on the broken surface of the stone, the façade of the Fabbriche Nuove is plain and two-dimensional, with the minimum of ornamentation. What accounts for this striking difference? The dates of the two commissions—the Library begun in 1537, the Fabbriche Nuove in 1554—might suggest a marked stylistic change, a move from the richness, chiaroscuro and vivacity of Sansovino's early Venetian work to the more sober, economical and static style of his later career.

It is not, however, irrelevant that the earlier building was commissioned by Sansovino's principal patrons, the Procurators of St. Mark's, with whom he shared a strong mutual respect and affection, while the later one was erected at the instigation of the Council of Ten who gave the architect only the most half-hearted support. Furthermore, the building of the Library took fifty years and cost over 30,000 ducats, while the Fabbriche Nuove were completed

within three years and cost considerably less than a third as much. The Library was commissioned at the peak of Venetian prosperity and optimism, while the Fabbriche Nuove were the product of a relatively disillusioned decade. Most important of all, the Library was destined for Cardinal Bessarion's precious bequest of books, as well as for the Procurators' own offices and dwellings, and served to give a new grandeur to Piazza San Marco as a whole. The Fabbriche Nuove, on the other hand, had a more humble purpose, being simply a block of shops and warehouses on the edge of the Rialto market.

As soon as we begin to take factors such as these into consideration, we become aware of the difficulties in tracing the development of Sansovino's architectural style. Even two buildings started at more or less the same time may show no stylistic affinity whatsoever, for instance, the Palazzo Corner and and Ca' di Dio, both begun in about 1545. Here the controlling factors were so strong (one was a charity home for twenty-four destitute women, built with the strictest possible economy, the other the home of a branch of the richest noble family in the city) that they almost completely obscure the architect's own inclinations.

How, then, did his creative ideas mature? In the last comparison one has to assume that only in the Palazzo Corner, where he had virtually no economic restrictions, was he able to give full flight to his imagination. The Ca' di Dio is a strictly practical solution, elegant in its sheer simplicity; but the Palazzo Corner, with its inventive details and controlled grandeur and sophistication, flaunts the status of the Venetian dynasty which commissioned it.

This is not to say that Sansovino's architecture has no individual style. Repeatedly we come across his own particular characteristics—the deft integration of Venetian and Central Italian ideas, the subtle control of lighting, and the ingenious adaptation of each design to its function. Again and again we encounter his favourite motifs—oval attic windows, balusters with square blocks in the centre, elongated consoles, prominent keystone heads, and his own brand of *all'antica* ceiling coffering. But the buildings are not linked together in any obvious sequence. Each one is distinctive, almost startling in its individuality. In Italy Sansovino was probably the most eloquent exponent of the ideas which his friend Serlio propagated in his treatise; and it was Serlio who said, 'These days it is novelty which pleases, and things that have not been over-used.'[1]

Nevertheless, a faint thread of chronological evolution can be detected. In Sansovino's first Venetian works, such as the shops on the Ponte della Pescaria and the Palazzo Dolfin, we find clear statements of the purest style of the Roman High Renaissance. San Francesco della Vigna, another example from the thirties, is effectively a transposition of a Florentine prototype to Venetian soil, with no obvious concessions to local architectural convention. As his career proceeds, Sansovino begins to absorb Venetian elements more thoroughly, and to handle classical syntax with a more Mannerist daring— illustrated most vividly by the Palazzo Corner. The façade of San Giuliano, one of his later works (even allowing for the fact that Vittoria may have had a hand in the design of the upper part), shows a complexity and ambiguity which he had never attempted in the thirties.

Yet throughout his career, this progression is concealed by the adjustments which he had to make to suit specific conditions. Thus the unorthodox heavy lintels above the first-floor windows of the Mint, one of his first Venetian works, were devised to fill the space occupied by the vault inside, vaulted rooms being a particular requirement of the commission. In the Library and the Scuola della Misericordia, also conceived in the 1530s, Sansovino was already making liberal use of local building traditions. And the spare simplicity of the church of the Incurabili, one of his very last works, was a direct outcome of the paucity of available funds. His architectural style continually evades generalisation and categorisation.

The variety in Sansovino's buildings was no mere caprice. 'It is a fine thing', wrote Serlio, 'for an architect to be rich in inventions, because of the diversity of the circumstances which occur in building.'[2] It is only by investigating the particular context of each commission that we can appreciate why, in any one instance, he chose one solution rather than another. Such an enquiry does not reduce the architect to a pawn of society, but shows how, in his art, he is guided and stimulated by historical circumstances. It was Sansovino's fertile imagination which allowed him to satisfy his heterogeneous collection of patrons, and to maintain a thriving architectural practice in Venice for over forty years. Not only did he solve the problems put to him—for an architect of any calibre produces solutions of sorts—but he did so in a particularly sensitive and apposite way. His position of supremacy in the city remained unchallenged until the arrival of Palladio in the very last decade of his life; and his ideas were to be imitated there for centuries to come.

APPENDIX I

This letter of 20 November 1537 from Aretino to Sansovino was first published in Venice in 1538. The translation given here is taken from the Italian text in *Del primo libro de le lettere di M. Pietro Aretino* (Paris 1609), c. 190t.–191t. The letter is also published in Italian, more accessibly, in P. Aretino, *Lettere sull'arte*, ed. E. Camesesca, i (Milan 1957), pp. 81–83.

TO MESSER JACOPO SANSOVINO

Now that the materialisation of your finest designs is adding the finishing touches to the splendour of the city which we, thanks to its generous hospitality, have chosen as our home (and we have been lucky, for a good foreigner here is accepted not only as a Citizen but even as a Gentleman), you see that good has come of the evil of the Sack of Rome, in that your sculpture and your architecture are now being created in this divine place.

It does not surprise me that the magnanimous Giovanni Gaddi, the apostolic cleric, like the Cardinals and Popes, torments you with letters begging you to return to the Papal Court to grace it with your presence once again; but it would seem to me a very odd decision to give up your secure position here and plunge into danger, abandoning the Venetian senators in favour of the prelates of the Papal Court. However, one can understand their reasons for putting pressure on you, for your temples, statues and palaces are on a par with those of the ancients. It would be impossible for them to look at the church of the Fiorentini which you founded on the banks of the Tiber, to the amazement of Raphael of Urbino, Antonio da Sangallo and Baldassare Peruzzi of Siena; or to turn to your work at San Marcello, or the marble figures, or the tombs of Aragon, Santa Croce and Aginense (which few others would know how to start), without lamenting your absence; in the same way that Florence grieves for you when gazing lovingly at the stunning virtuosity of the Bacchus in the Bartolini gardens, together with all the other marvels which you have carved and modelled. But they will have to do without you, because your creative talents have enshrined themselves in this fine place.

Moreover, a gesture of greeting from these noble Venetian sleeves is worth far more than a gift from those ignoble mitres. Anyone who wishes to see the style in which a Republic like this supports the artists who create all its glories, should look at your house, a worthy prison of your art, where the products of your hands and your mind are taking shape all day long.

Who could fail to praise the way you have restored the church of San Marco to endure for ever?

Who is not stupefied by the huge Corinthian structure of the Misericordia?

Who is not struck dumb by the Rusticated and Doric building of the Zecca?

Who is not dazzled by the sight of the work, started opposite to the Doge's Palace, in carved Doric with a suitably decorated Ionic order above?

How splendid the building to be erected beside it will look, in marble and other types of stone, with its large columns! It will consist of all the finest elements of Architecture, acting as a loggia where members of the nobility will gather.

How can I fail to mention the foundations on which the superb home of the Cornaro family is to be erected?

What about the Vigna? And what about the Arsenal Madonna? And what wonderful mother and child crowning the patron saint of this unique state, whose story you tell in bronze, in a marvellous setting of figures, on the pulpit of his resting-place?

You fully deserve the prizes and honour bestowed on you by their excellencies the nobility of the Republic, which is the soul of the loyal subjects of Saint Mark.

Now may God grant us both long lives, so that you can continue to serve the Venetians, and I to sing their praises.

Venice. 20 November 1537.

APPENDIX II

The main concessions for burial rights and family chapels in San Francesco della Vigna were as follows (numbering chapels from main door towards high altar):

DATE	NAME	PLACE	PRICE (ducats)	ARCHIVE REFERENCE
before 21 Nov. 1535	Francesco Barbaro q. Daniele	No. 5 (right)	?	b. 2, part i, 367
21 Nov. 1535	Pietro Badoero	No. 4 (right)	250	b. 2, part i, 366–69
21 Apr. 1536	Lorenzo Giustinian Procurator	No. 5 (left)	200	b. 1, part ii, 254 b. 2 part i, 374–75
25 Jul. 1536	Doge Andrea Gritti	Chancel	1,000	b. 4, 236–43
18 Aug. 1536	Marciano Morosini (trust c/o Procuratia de Supra)	No. 6 (right)	250	b. 1, part ii, 49t.–53t. b. 3, part i, 129 part ii, 19–20t. b. 5, part i, 229–31
4 Feb. 1536 m.v. (1537)	Zuanne Contarini q. Alvise	No. 3 (right)	250	b. 2, part i, 369–73
12 Apr. 1537	Vettor Grimani Procurator	No. 1 (left)	200	b. 4, 250–55
25 May 1537 & 8 May 1538	Vincenzo Grimani Procurator	No. 3 (left)	300	b. 1, part ii, 158t.–59 b. 2, part i, 420–24 b. 3, part i, 59t.
22 Aug. 1537	Alvise Badoero	two on left	500	b. 2, part i, 381–405 and 409–11
10 Sept. 1537	Gerolamo Bragadin Procurator	No. 1 (right)	350	b. 2, part i, 411–13
24 Feb. 1537 m.v. (1538)	Francesco Ruzzin	unspecified chapel	3–400	b. 2, part i, 417–19
22 Oct. 1538	Piero Falgaro	small chapel on right of chancel	110	b. 2, part i, 424–25
25 Aug. 1548	dal Basso brothers (*cittadini*)	No. 3 (left)	300	b. 2, part i, 506–12
27 Mar. 1554	Zuan Francesco Lippomano	choir	200 (+ 50 for decoration)	b. 1, part ii, 250t.–51t. b. 2, part i, 454–61 b. 3, part ii, 90t.–91
14 Oct. 1555	q. Bernardo Dandalo	No. 4 (left)	300	b. 2, part i, 543–53
6 Jan. 1562 m.v. (1563)	Lorenzo Donado	floor of chancel	100 whenever requested	b. 1, part ii, 353 b. 2, part i, 606–08 and 626–29 b. 3, part i, 128–28t.

CHAPTER I

1. Vasari–Milanesi, vii, p. 509.

2. Jacopo Sansovino was baptised on 3 July 1486 in Florence (Vasari–Milanesi, vii, p. 486, n. 1). His arrival in Venice is first recorded in two letters of Lorenzo Lotto, dated 5 and 12 Aug. 1527 (*Lettere inedite di Lorenzo Lotto su le tarsie di Santa Maria Maggiore in Bergamo*, ed. L. Chiodi (Bergamo 1962), pp. 47–48).

3. Lotto, op. cit., p. 48.

4. Vasari–Milanesi, vii, p. 499; and F. Sansovino, *Del Secretario di M. Francesco Sansovino*, Libro VII (Venice 1584), c. 221–221t.

5. Lotto, op. cit., p. 55.

6. The notice of Sansovino's death, which took place on 27 Nov. 1570, was discovered by Temanza in the records of the Venetian Proveditori alla Sanità (T. Temanza, *Vite dei più celebri architetti e scultori veneziani* (Venice 1778), p. 198).

7. Vasari–Milanesi, vii, p. 511. He was given a letter of recommendation to Duke Cosimo de' Medici by Mendoza, the Spanish ambassador in Venice (Archivio di Stato di Firenze, Archivio Mediceo, f. 347, c. 305, 31 Oct. 1540).

8. Ibid., pp. 485 ff.

9. Ibid., p. 497.

10. Lotto, op. cit., p. 47: '. . . in Roma et Firenze è grande homo dopo Michel Agnolo'.

11. Vasari–Milanesi, vii, pp. 499–500. On 7 Aug. 1527, only two days after Lotto first reported Sansovino's arrival in Venice, the Procurators allocated the large sum of 500 ducats for repairs to the Basilica (ASV, PS, Atti, reg. 124, c. 27).

12. Ibid., c. 53, 7 Apr. 1529.

13. See R. Gallo, 'Contributi su Jacopo Sansovino', *Saggi e Memorie di Storia dell'Arte*, i (1957), pp. 83–86.

14. See G. Luzzato, *Storia economica di Venezia dal' XI al XVI secolo* (Venice 1961); B. Pullan (ed.), *Crisis and Change in the Venetian Economy in the Sixteenth and Seventeenth Centuries* (London 1968); D. S. Chambers, *The Imperial Age of Venice 1380–1580* (London 1970); J. R. Hale (ed.), *Renaissance Venice* (London 1973).

15. On the Venetian desire to emulate Ancient Rome, see Chambers, op. cit., pp. 12–32.

16. See G. Fiocco, 'Le Architetture di Giovanni Maria Falconetto', *Dedalo*, anno xi (1931), pp. 1203–41, and G. Schweikhart, 'Studien zum Werk des G. M. Falconetto', *Bollettino del Museo Civico di Padova*, lvii (1968), pp. 17 ff.

17. *M. Vitruvius per Iocondum solito castigatior factus cum figuris et tabula ut iam legi et intelligi possit* (Venice 1511).

18. Vasari–Milanesi, vii, pp. 502–03.

19. D. Howard, 'Sebastiano Serlio's Venetian Copyrights', *Burlington Magazine*, cxv (1973), pp. 512–16.

20. S. Serlio, *Regole generali di Architettura sopra le cinque maniere de gli edifici* (Venice 1537).

21. S. Serlio, *Il terzo libro di Sabastiano Serlio Bolognese, nel qual si figurano le antiquita di Roma . . .* (Venice 1540). See also W. B. Dinsmoor, 'The Literary Remains of Sebastiano Serlio', *Art Bulletin*, xxiv (1942), pp. 55–91, 115–54.

22. Serlio, like Sansovino, was a close friend of the poet Pietro Aretino; and a letter written by the latter to Serlio in Dec. 1550 confirms that Serlio and Sansovino themselves were friends (P. Aretino, *Lettere sull'arte*, ed. E. Camesasca (Milan 1957–60), ii, p. 385).

23. See R. Gallo, 'Michele Sanmicheli a Venezia', in *Michele Sanmicheli, Studi raccolti dall'Accademia di Agricoltura, Scienze e Lettere di Verona* (Verona 1960), pp. 97–160.

24. Vasari–Milanesi, v, p. 324.

25. S. Serlio, *Regole generali di architettura . . .*, p. iii, in the dedication to Hercole II, Duke of Ferrara.

26. Vasari-Milanesi, vii, p. 508; N. Barbarigo (attrib.), 'Vita di Andrea Gritti doge di Venezia, tradotta dal Latino al volgare 1686', Biblioteca Correr, MS. Gradenigo–Dolfin 50, p. 61.

27. PS, Atti, reg. 124, c. 33–33t. Willaert died in 1562. See chapter IV.

28. P. Aretino, *Il primo libro delle lettere* (Paris 1609), c. 2t.–4.

29. See A. Stella, 'La crisi economica veneziana nella seconda metà del secolo XVI', *Archivio veneto*, 5th ser., lviii (1956), pp. 17–69; Pullan, op. cit., pp. 146–74; and F. Braudel, *The Mediterranean and the Mediterranean World in the Age of Philip II*, transl. Reynolds, vol. i (London 1972), pp. 517 ff.

30. M. Tafuri, *Jacopo Sansovino e l'architettura del '500 a Venezia* (Padua 1969, revised paperback edition, Padua 1972). The Villa Garzoni has been omitted from the present study, but see Tafuri's book for profuse illustrations and further bibliography.

31. In his last will Jacopo left his drawings to his son Francesco, but the fate of these drawings is unknown (ASV, Notarile, Testamenti, Cesare Zilioli, b. 1258, no. 452, 16 Sept. 1568). In my opinion there is no secure basis for the attribution to Sansovino of a group of miscellaneous architectural drawings in the Gabinetto di Disegni of the Uffizi (coll. Sant. 1–3, and architectural series, nos. 4, 5, 433, 437–38, 1760–61, 1948–65, 2059, 3957, 4325–39, 4364, 4373, and series E, nos. 5110–12).

32. Vasari-Milanesi, vii, pp. 509–10.

33. Ibid., p. 503.

CHAPTER II

1. The body of Saint Mark was brought to Venice from Alexandria by two Venetian merchants in 828. On the early history of the Procuracy see O. Demus, 'The Church of San Marco in Venice', *Dumbarton Oaks Studies*, vi (1960), pp. 52–54.

2. For 15th- and 16th-century accounts of the Procuracies see M. Sanudo, *Cronachetta* (1493), ed. R. Fulin (Venice 1880), pp. 112–17; D. Giannotti, *Libro de la Republica de Vinitiani*, s.d. (*c.* 1530?), c. 75–76t.; G. Contarino, *La Republica e i magistrati di Vinegia*, transl. from Latin (1544), c. 58–59; Sansovino–Martinioni, pp. 297 ff.

3. For a detailed account of the development and financial role of the Procurators, see R. C. Mueller, 'The Procurators of San Marco in the Thirteenth and Fourteenth Centuries: a Study of the Office as a Financial and Trust Institution', *Studi Veneziani*, xiii (1971), pp. 105–220.

4. Giannotti, op. cit., c. 76t. On wage-levels in 16th-century Venice, see F. Braudel, *The Mediterranean and the Mediterranean World in the Age of Philip II*, transl. S. Reynolds, vol. i (London 1972), p. 458.

5. G. Savina, 'Cronaca veneta', MS. Marc. It. VII, no. 134 (=8035), c. 51t.

6. PS, Atti, reg. 124, c. 53, 7 Apr. 1529; c. 71t., 25 May 1530; and c. 83t., 10 Nov. 1530. In the following year he was granted the use of the workshop and two mezzanines below his house (ibid., c. 108t., 19 May 1531). See R. Gallo, 'Contributi su Jacopo Sansovino', *Saggi e Memorie di Storia dell'Arte*, i (1957), pp. 83–86.

7. Translated from Vasari–Milanesi, vii, p. 508. See J. Schulz, 'Vasari at Venice', *Burlington Magazine*, ciii (1961), pp. 500–11, and P. Sanpaolesi, 'La Vita vasariana del Sansovino e l'Ammannati', *Studi Vasariani* (Ist. Naz. di Studi sul Rinascimento, Florence 1952), pp. 134–39.

8. D. Howard, Two Notes on Jacopo Sansovino, *Architectura*, (1974), pp. 132–33.

9. See W. Braunfels, *Mittelalterliche Stadtbaukunst in der Toskana* (Berlin 1953), pp. 216 ff.

10. PS, Atti, reg. 124, c. 131–131t., 19 Apr. 1532.

11. For instance, he was consulted over salaries for building workers and craftsmen and Church officials, and witnessed decisions ranging from the keeping of journals and accounts to the distribution of alms. See Howard, op. cit., p. 133, n. 3.

12. PS, Atti, reg. 123, c. 86t., 23 Mar. 1525. The wide-ranging reforms to the Procuratia de Supra decreed by the Maggior Consiglio in 1531 redefined the Procurators' powers regarding the upkeep of their buildings, and raised the upper limit for unauthorised repairs to 3 ducats (Maggior Consiglio,

Deliberazioni, reg. 26 DIANA, 11 June 1531, c. 123t.).

13. Most of the documents relating to Sansovino's activity in the Basilica were published in F. Ongania, *Documenti per la storia dell'augusta Ducale Basilica di San Marco in Venezia* (Venice, 1886), pp. 30 ff. See B. Boucher, 'Sansovino's Bronzes for St. Mark's', unpublished M.A. report, University of London, Courtauld Institute (1974).

14. e.g. Vasari–Milanesi, vii, pp. 513 ff.; and Ongania, op. cit., pp. 34–51.

15. Ziani covered the Rio Batario which originally ran across the centre of the present Piazza, and incorporated into the area the orchard, or *broglio* beyond, which he bought from the nuns of San Zaccaria. Francesco Sansovino noted in 1581 that some of Ziani's original corridor still survived in the Piazza (Sansovino–Martinioni, p. 293).

Professor Wolfgang Lotz, in his pioneering studies of the 16th-century redevelopments in Piazza San Marco, incorrectly supposed that the west side of the Piazzetta had no arcade when Sansovino arrived in Venice. (W. Lotz, 'La Libreria di San Marco e l'urbanistica del Rinascimento', *Bolletino del Centro . . . Andrea Palladio*, iii (1961), p. 85; idem, 'Sansovinos Bibliothek von San Marco und die Stadtbaukunst der Renaissance', *Kunst des Mittelalters in Sachsen, Festschrift W. Schubert* (Weimar 1967), p. 338; idem, 'Italienische Plätze des 16. Jahrhunderts', *Jahrbuch des Max-Planck-Gesellschaft* (Mainz 1968), p. 53). Evidence to the contrary is provided by M. A. Sabellico, *Del sito di Venezia città* (1502), ed. G. Meneghetti (Venice 1957), p. 31.

16. Bellini's painting, dated 1496, is in the Accademia in Venice. The picture attributed to Bastiani in the Museo Correr may represent the visit of Ercole d'Este of Ferrara to Venice in 1487. See A. Delle Rovere, 'Vittore Carpaccio: Arrivo di Ercole I e di Alfonso I a Venezia', *Rassegna d'Arte*, ii (1902), pp. 33–36.

17. For details of other late 15th-century views of Venice, see J. Schulz, 'The Printed Plans and Panoramic Views of Venice (1486–1797)', *Saggi e Memorie di Storia dell'Arte*, vii (1970), Cat. Nos. 154–59.

18. See M. Sanudo, *Diarii*, vol. 14, p. 305, 10 June 1512; and vol. 15, p. 541, 11 Feb. 1512 m.v. (1513). The attribution to Buon is given by Sansovino–Martinioni, p. 293.

19. Sabellico, op. cit., p. 30.

20. Vasari–Milanesi, vii, p. 501; and Sansovino–Martinioni, p. 317. Various isolated attempts had in fact already been made to make the Piazza look more respectable, e.g. the resolution of the Senate to remove unsightly obstructions on 14 Mar. 1504

(Senato Terra, reg. 15, c. 2; see P. Molmenti, *La storia di Venezia nella vita privata*, 4th edn. (Bergamo, 1905–08), ii, pp. 77–78); and a decision of the Procurators during Buon's period of office as *proto* that even the temporary stalls erected during the Festa della Sensa should be designed by the *proto* (PS, b. 4, proc. 49, fasc. 1, c. 1, 21 May 1519).

21. Sabellico, op. cit., p. 31. The Piazzetta hostelries are described in detail in an inventory of the property of the Procuracy dated 20 Nov. 1502 (PS, b. 32, Proprietà e Dritti, Varie Osterie, proc. 64, c. 3–4).

22. PS, Atti, reg. 124, c. 74–74t., 10 June 1530; and Sanudo, *Diarii*, vol. 53, p. 277, 18 June 1530. The rents ranged from 42 to 64 ducats p.a.

23. Maggior Consiglio, Deliberazioni, reg. 26 DIANA, 11 June 1531, c. 125:

> ... essendo sta deliberato per essi procuratori tenir la Piazza nostra verso le colone libera et expeditta da ogni impedimento. Il che e cosa laudabile et di gran ornamento della Citta nostra, pero sia preso che ditta piazza recto tramite ab utroque latere fino all'acqua, et dal ponte della paglia fino al principio delle botege novamente fatte, de herbaroli in pescaria, nec non l'altra parte in essa Piazza principiando dalla bocca di Marzaria fino à San Giminian ab utroque latere sia sempre tenuta libera et neta, et senza impedimento alcuno, ne di lignami, ne di stuor tal che la resti sempre expeditta, Eccettuando però li tempi della Sensa, et de altre solennita publice, secundo che accadeno di tempo in tempo.

24. In 1539 the bakery shops on the site of the Library were demolished and moved to the foot of the columns (PS, Atti, reg. 125, c. 49, 11 Feb. 1538 m.v. (1539)). In 1550 they were rebuilt at the base of the Campanile (PS, Atti, reg. 126, c. 131, 5 Aug. 1550). The Procurators failed to find a more suitable place, and the shops remained there until they were destroyed in the great fire of 1574 (PS, Atti, reg. 133, c. 19t., 1 June 1574; and c. 23t., 7 July 1574). According to the Procuracy's accounts, even after the fire the stalls were rebuilt at the foot of the Campanile (PS, reg. 3, Cassier Chiesa, 10 July 1574). The cheese-and-salami shops on the site of the Mint were temporarily placed at the foot of the columns from 1539 until 1543 (PS, reg. 125, c. 144–144t., 29 Jan. 1542 m.v. (1543)).

25. PS, Atti, reg. 125, c. 16, 22 June 1537. Similar orders are recorded in the same *registro*, c. 95, 13 May 1541; c. 98, 28 June 1541; and c. 177, 7 Mar. 1544. Decisions to demolish illegal stalls were also taken (PS, Atti, reg. 126, c. 33, 21 Nov. 1546; and c. 105, 12 July 1549).

26. PS, Atti, reg. 126, c. 147t., 16 June 1551. Four days later Sansovino was a witness to an order

threatening two obstinate fruit-sellers with a six-month prison sentence and a fine of 50 ducats if they refused to leave the Piazza (ibid., c. 149, 20 June 1551).

27. PS, Atti, reg. 128, c. 2t., 27 Aug. 1552; and c. 5, 10 Sept. 1552. Further orders to evict illegal traders followed on 7 July 1562 (reg. 129, c. 123t.), 15 July 1566 (reg. 131, c. 12t.), and 16 June 1568 (ibid., c. 74t.). In 1561 the distribution of permitted stalls was reorganised, moving more greengrocers' stalls from the Piazzetta to the waterfront along the Bacino. But 33 *hortolani* were still to be provided for, and were placed temporarily at the foot of one of the great columns (PS, Atti, reg. 129, c. 92–92t., 26 June 1561).

28. Consiglio di Dieci, parti Comuni, reg. 29, c. 66t.–67, 22 Sept. 1569. On 23 Dec. 1569 a dispute over some salami stalls in the Piazza was sent to arbitration in the Collegio, when the stall-holders claimed that they had been unjustly evicted from the Piazza by the Procurators (PS, Atti, reg. 131, c. 114t.).

29. L. B. Alberti, *L'Architettura (De Re Aedificatoria)*, transl. G. Orlandi, with notes by P. Portoghesi (Milan 1966), ii, p. 714; J. R. Spencer (ed.), *Filarete's Treatise on Architecture* (New Haven, Conn. 1965), i, pp. 271–83. These divisions had survived since Antiquity in cities such as Verona and Brescia.

30. See W. Lotz, 'Italienische Plätze des 16. Jahrhunderts', *Jahrbuch der Max-Planck-Gesellschaft* (Mainz 1968), pp. 41–60; and the other articles by Lotz cited in note 15.

31. The construction of the final bays of this wing, adjoining the church of San Geminiano, was begun under Sansovino's direction, following Buon's design, in 1530 (PS, Atti, reg. 124, c. 64–65, and c. 133t.). A sheet of information compiled from the Procurators' accounts in about 1580 records payments on this building between March 1530 and February 1546 m.v. (1547) (PS, b. 74, proc. 168, fasc. 1, c. 21). This document is cited in full in note 118.

32. See the inquiry held in 1569 into the Procurators' expenditure on the repair of their own homes (PS, b. 65, proc. 143, fasc. 1, libretto no. 25).

33. PS, Atti, reg. 125, c. 2:

> Die suprascripta [14 July 1536]
> Suprascripti Clarissimi Domini Deliberaverunt ad busulos et ballotas per omnes sexto ballotas de sic quod fiat unus modelus per protum procuratie nostre de de [*sic*] domibus novis fabricandis, in locis ubi ad presens Existunt domus veteres Inhabitate per clarissimos Dominos procuratores Cum tota facie anteriori Incipiendo ab ecclesia sancti geminiani, fabricando ipsas domus in duobus solarijs de subtus et supra; itaque unus procurator habitare possit in parte superiori, et alius in parte inferiori, respiciendo usque ad rivulum de retio et

cum omnibus comoditatibus prout melius fieri poterit.

<div align="right">ambrogio D. Castaldio</div>

34. Ibid., c. 12–12t.:

Die suprascripto [6 Mar. 1537]

Clarissimi Domini petrus Lando, et College procuratores de Supra ecclesie Sancti marci absente tantum Clarissimo domino Joanne de lege eorum Collegarum, Cupientes & Intendentes exequi et adreplere voluntatem Illustrissimi Dominj nostri circa fabricam librarie edificande pro collocandis libris quondam Reverendissimi Domini D. Cardinalis niceni, deliberaverunt ballotari debere infrascriptam opinionem propositam circa dictam librariam tenoris infrascripti viz—

Quod fieri debeat libraria pro Collocandis et gubernandis libris grecis et latinis bone memorie quondam Excellentissimi domini Cardinalis niceni super loco fabrice noviter incohate ubi erant appotheca panatarie appellate super plathea Sancti marci, secundum formam & modum modeli facti seu fiendi per Dominum Jacobum Sansovinum protum procuratie nostre et quod pro fabrica dicte librarie expendi, neque tangi possint neque debeant ullo pacto pecunie existentes, et exacte ac que in futuro exigentur per procuratiam nostram de ratione tam capitali mentis novi conditional-[iter], quarumque comissariarum in procuratia nostra existentium.

Suffragate et aprobate per omnia suffragia de sic
<div align="center">D. petrus de ludovicus Castaldio
D. Sanctus barbadico.</div>

35. Sansovino-Martinioni, p. 309.

36. See the articles by Lotz cited in note 15.

37. On 2 August 1568 the Procuracy resolved to demolish the old loggia in front of the church on the basis of Sansovino's designs, in order to continue the arcade (PS, b. 64, proc. 139, c. 8–9t.).

38. Scamozzi executed the last five bays at the lagoon end of the Library, and the whole of the south wing of the Piazza, now known as the Procuratie Nuove.

39. See Lotz: 'Italienische Plätze . . .'

40. An account of the origins of the Biblioteca Marciana and the history of the building is given in the important article by G. Lorenzetti, 'La Libreria Sansoviniana di Venezia,' *Accademie e Biblioteche d'Italia*, ii (1928–29), pp. 73–98; and iii (1929–30), pp. 22–36.

41. The documents relating to the bequest by Cardinal Bessarion of Trebizond, Patriarch of Constantinople, also called Cardinal Niceno, of his library to the Venetian Republic in 1468, are contained in the volume MS. Marc. Lat. XIV, 14, sec. XV. The same documents are quoted in other manuscript and printed sources, e.g.—Ps, b. 68, Libreria Pubblica, proc. 151, fasc. 1; J. Valentinelli, *Biblioteca Manuscripta ad S. Marci Venetiarum*, i (Venice 1868), pp. 21 ff. See also L. Labowsky, 'Manuscripts from Bessarion's Library found in Milan, Bessarion Studies I', *Mediaeval and Renaissance Studies*, v (1961), pp. 108–31; eadem, 'Il Cardinale Bessarione e gli inizi della Biblioteca Marciana', *Venezia e l'oriente fra tardo Medioevo e Rinascimento* (Florence 1966), pp. 159–82. The volume *La Biblioteca Marciana nella sua nuova sede* (Venice 1906) has a full bibliography. Bessarion's collection was the only Renaissance library in which Greek codices actually outnumbered those in Latin. It was typical of 15th-century libraries in its high proportion of religious writings. The other fields best covered by the collection were philosophy, history and literature.

42. MS. Marc. Lat. XIV, 14, c. 13t.–14.

43. At first the books were placed in the Sala Novissima in the Doge's Palace (Valentinelli, op. cit., p. 33). By 1485, however, this room was needed for meetings of the Capi de Quaranta, and the Senate ordered that the 50 or so crates should be piled up one above the other and closed off by a wooden screen, to occupy as little space as possible (Valentinelli, op. cit., p. 34, n. 3). The decision to consign the bequest to Santi Giovanni e Paolo was taken in 1494 (Valentinelli, op. cit., p. 36).

44. On 7 Feb. 1514 m.v. (1515), Sanudo recorded in his diary a proposition, debated in the Council of Ten, to house the Bessarion Library near the Fondaco della Farina, that is, on the west side of the huge granaries (Sanudo, *Diarii*, vol. 19, p. 424). On 5 May 1515 the Senate voted to house the bequest in Piazza San Marco 'apud novam fabricham' (Senato Terra, reg. 19, c. 33t., and Sanudo, *Diarii*, vol. 20, pp. 181–82). Sanudo identified the proposed locations more precisely as 'in una di le caxe nuove si farà di la procuratia, qual è in mezo' (Sanudo, *Diarii*, vol. 20, p. 178). The decision to provide the necessary funds was passed on 8 June 1515 but immediately revoked (Senato Terra, reg. 19, c. 42).

45. On 26 April 1531 the Council of Ten decided that the Sala della Libreria was needed both for the meetings of the Senate and for the storage of the archive of the Cancelleria (Consiglio di Dieci, Comuni, reg. 7, c. 18t.). The provision of alternative accommodation in the Basilica was included in the Procuratia de Supra's programme of reforms drawn up in the same year (Maggior Consiglio, Deliberazioni, reg. 26 DIANA, c. 125t., 11 May 1531). Two letters of the librarian Pietro Bembo to his nephew indicate that the books were probably transferred in the spring of 1532 (P. Bembo, *Opere* (Venice 1729), iii, pp. 417–18).

46. Vasari–Milanesi, vii, p. 508. Vettor Grimani was elected to the Procuratia de Supra in 1523, and he died on 22 Aug. 1558 (Cronaca dei Procuratori di Marco Barbaro, MS. Marc. It. VII, 380 (=7471), c. 91–92).

47. PS, Atti, reg. 124, c. 130, 4 Apr. 1532.

48. Sanudo, *Diarii*, vol. 56, p. 94, 22 Apr. 1532. The conclusion reached on this occasion was a repeat of that taken in 1515—to locate the Library in the north wing of the Piazza, but again it had no outcome. The friendship which existed between Sansovino and Bembo is clear from their surviving correspondence —a letter from Sansovino to Bembo in Rome dated 4 Oct. 1546 (M. G. Bottari and S. Ticozzi, *Raccolta di Lettere*, v (Milan 1822), pp. 204–05); and Bembo's reply written on 23 Oct. 1546 (Bembo, *Opere*, iii, p. 502). They had probably met in Papal circles in Rome before Sansovino's flight to Venice in 1527.

49. Bembo was appointed librarian by the Council of Ten on 30 Sept. 1530 (see Sanudo, *Diarii*, vol. 54, p. 186, 21 Dec. 1530). On his activities as librarian see C. Castellani, 'Pietro Bembo, bibliotecario della Libreria di S. Marco in Venezia', *Atti del R. Ist. Veneto di Scienze, Lettere ed Arti*, series VII, vol. vii (1895–96), pp. 862–98; idem, 'Il prestito dei codici manoscritti della Biblioteca di San Marco in Venezia', ibid., vol. viii (1896–97), pp. 311–80; C. Volpati, 'Per la storia e il prestito di codici della Marciana nel secolo XVI', *Zentralblatt für Bibliothekswesen*, xxvii (1910), pp. 35–61; V. Cian, *Un decennio della vita di M. Pietro Bembo 1521–1531* (Turin 1885), pp. 173 ff.; A. Del Piero, 'Della vita e degli studi di Giovanni Battista Ramusio', *Nuovo Archivio Veneto*, N.S. II, iv (1902), part 1, pp. 5–112.

50. In Northern Italy he knew and admired not only Sansovino, but also Falconetto, Genga, and Michele Sanmicheli (Vasari–Milanesi, v, p. 321; and Bembo, *Opere*, iii, pp. 331 and 499). He also had architectural contacts in Rome. He had accompanied Raphael on the famous visit to Tivoli with Navagero and Beazzano in 1516 (Ibid., iii, p. 10); and he later submitted ideas from Roman experts for the corner solution of Sansovino's Library (Sansovino–Martinioni, p. 309).

51. The original commission to Sansovino to design a model for the Procurators' new houses had specified two main living storeys, whereas the Library as constructed has only one storey above the ground floor. However, there is no evidence to ascertain whether a two-storey model was ever in fact produced.

52. The first *polizze* for demolition work on the site were issued on 19 and 27 Jan. 1536 m.v. (1537) (PS, reg. 2, Cassier Chiesa III). A payment recorded in Sansovino's own accounts on 19 January confirms that the demolition of the hostelries had begun (PS, b. 77, proc. 181, fasc. 1, published by Ongania, op.

cit., p. 36). The sheet of building costs cited in note 118 gives the date of the first payment for construction work on the Piazzetta site as 28 Jan. 1536 m.v. (1537).

53. PS, reg. 2, Cassier Chiesa III. See Lorenzetti, op. cit., pp. 87 ff. This phase in the building was interrupted for about a year from the end of February 1539 m.v. (1540), until January 1540 m.v. (1541). This sudden halt was probably due to a decision, recorded in the *atti* of the Procuratia de Supra on 5 Dec. 1539, to suspend building work in the Piazza, probably for financial reasons (PS, Atti, reg. 125, c. 61t.). In the late 1530s the three Procuracies were having to provide massive loans to the state to finance the war effort against the Turks (PS, b. 71, proc. 155b, fasc. 2, c. 57 ff.).

54. The payment for the initial demolition mentioned in note 52 referred only to 'una partte della fabricha della ostaria'. No provision for moving the Pellegrin was made until 4 Nov. 1544, so that its facilities cannot have been severely restricted in the early stages of the work (PS, Atti, reg. 125, c. 185t.; and reg. 127, c. 5). On the fate of the bakers' stalls see note 24.

55. PS, Atti, reg. 125, c. 185t., 4 Nov. 1544; and reg. 127 (ii), c. 5.

56. Ibid., and PS, Atti, reg. 127, part I, c. 10t.–11t., 4 Nov. 1544. It was decided to convert the homes of three craftsmen (a cutler, a tailor and a plumber) and a hat-maker's warehouse, as economically as possible. As part of the scheme, two houses at the end of the Calle Larga were demolished to make a new street linking the end of the Spadaria with the Merceria, bordered by new shops.

57. Vasari–Milanesi, vii, pp. 500–02; and Howard, op. cit., pp. 134–35.

58. Vasari–Milanesi, vii, p. 502.

59. P. Aretino, *Lettere sull'arte*, ed. E. Camesasca, i (Milan 1957), p. 82, 20 Nov. 1537. See the English translation of this letter in Appendix I.

60. Vitruvius, *The Ten Books on Architecture*, transl. M. H. Morgan (New York 1960 edn.), pp. 109–10, Book IV, Chap. III; and Sansovino–Martinioni, pp. 309–10. The Istrian stone for the corner was shipped from Istria in the summer of 1539 (PS, reg. 2, Cassier Chiesa III). Sansovino probably derived his solution from Giuliano da Sangallo's reconstruction of the Basilica Emilia in Rome (C. Huelsen, *Il libro di Giuliano da Sangallo, Cod. Vat. Barb. Lat. 4424* (Leipzig 1910), c. 26. For other examples of the same arrangement see Lotz, 'The Roman Legacy . . .'

61. PS, b. 77, proc. 181, fasc. 1, c. 1; Lorenzetti, op. cit., pp. 89–93; and PS, Atti, reg. 126, c. 8, 5 Feb. 1545 m.v. (1546).

62. PS, b. 68, Amministrazione Libreria Publica,

proc. 151, fasc. 3.

63. M. G. Bottari and S. Ticozzi, *Raccolta di lettere*, v (Milan 1822), p. 204. In January 1546, Aretino wrote to Francesco Salviati: 'La rovina de la felicità del Sansovino è stata più piccola ne la verità del caso, che non è paruta grande ne la bugia de la fama.' (Aretino, op. cit., ii, p. 137).

64. The inquest on the causes of the collapse was held on 22 Dec. 1545 (PS, b. 68, proc. 151, fasc. 3; published by F. Sapori, *Jacopo Tatti, detto il Sansovino* (Rome 1928), pp. 85–89).

65. On the technical problems of building in Venice, see the discussion in chapter VI.

66. Report by Antonio Scarpagnino, *proto* to the Ufficio del Sal, and Bernardin, *proto* to the Proveditori di Comun, presented on 28 Nov. 1546 (PS, b. 68, proc. 151, fasc. 3).

67. PS, Atti, reg. 126, c. 48, 19 Apr. 1547.

68. PS, Atti, reg. 127, part I, c. 44t.–45, 3 Feb. 1547 m.v. (1548).

69. PS, Atti, reg. 130, c. 72, 20 Mar. 1565.

70. Letter cited in note 63.

71. PS, Atti, reg. 127, part I, c. 36–37, 28 Nov. 1546; part II, c. 13t., 31 Dec. 1546; reg. 126, c. 46, 22 Mar. 1547. The new shops had been allotted to tenants before 7 Sept. 1548, when an eviction order was served on one tenant (PS, Atti, reg. 126, c. 85).

72. On 27 Jan. 1552 m.v. (1553), the first occasion on which the window balconies of the new building were allotted to various Procurators so that they could watch the Giovedi Grasso festivities, seven bays were available for the ballot (PS, Atti, reg. 128, part I, c. 11t.).

73. PS, Atti, reg. 126, c. 137, 12 Nov. 1550; c. 137t., 7 Dec. 1550; and c. 139, 29 Jan. 1550 m.v. (1551).

74. PS, Atti, reg. 128, part I, c. 6t., 12 Nov. 1552; c. 10, 11 Dec. 1552; c. 10t., 31 Dec. 1552; c. 13, 22 Feb. 1552 m.v. (1553); c. 13t., 1 Mar. 1553; c. 20t., 27 June 1553; c. 21, 27 June 1553; c. 28t., 2 Jan. 1553 m.v. (1554); and PS, b. 31, proc. 60, fasc. 1, c. 39–39t., 5 Mar. 1555.

75. PS, Atti, reg. 128, part I, c. 50, 25 June 1556; and PS, b. 33, proc. 68, fasc. 2, inventory of property in Campo Rusulo, 1569.

76. Vasari–Milanesi, vii, p. 501. In 1569 the annual rents of the hostelries of the Pellegrin, Cavaletto and Lion were 451, 302 and 101 ducats respectively, compared with 105, 20 and 60 ducats in 1502. Thus between 1502 and 1569 the rent of these three hostelries increased by 669 ducats (PS, b. 32, proc. 64, c. 3t.–4; and b. 33, proc. 68, fasc. 2).

77. PS, b. 30, Varie Osterie, proc. 57.

78. PS, Atti, reg. 126, c. 157t.–158, 5 Sept. 1551.

79. Ibid., c. 165t.–167, 23 Mar. 1552; published by Ongania, op. cit., pp. 54–55.

80. PS, Atti, reg. 128, part I, c. 13–13t., 22 Feb. 1552 m.v. (1553).

81. On 13 Feb. 1550 m.v. (1551) it was resolved to put 1,200 ducats from rent increases on their shops in the Zecca towards the Library building (PS, Atti, reg. 126, c. 139t.). On 13 Jan. 1551 m.v. (1552) the Procuracy bemoaned the fact that over 4,000 ducats were owed in unpaid rents, and decided to evict all tenants who were unable to pay the arrears (ibid., c. 160t.–161). On 23 Mar. 1552 it was decided to auction an estate in the Piove di Sacco (document cited in note 79). In 1553 capital was drawn from interest on government bonds held by the Procuracy (PS, Atti, reg. 128, part I, c. 21, 4 July 1553). A year later the Procurators voted to repay 500 ducats derived from this source, and instead to draw 500 ducats from the rent of two priories in the Bergamasca (ibid., c. 39, 24 July 1554). On 6 Dec. 1553, it was resolved to repay 600 ducats, borrowed from the *terraferma* income to finance work on the roof, from rents due from the tenants of the Beccaria or meat market (ibid., c. 26). On 10 Mar. 1554, the debts owed to the Cassa della Chiesa, and hence the income in the form of interest, were transferred to the Cassa della Fabricha (ibid., c. 33).

82. The progress of the building can be charted by the annual ballot of the Library windows allotted to the Procurators as viewpoints for watching the Giovedi Grasso festivities (PS, Atti, reg. 128, part I, c. 28–28t., 2 Jan. 1553 m.v. (1554); and c. 48t., 4 Feb. 1555 m.v. (1556)).

83. The contract for the carving of the marble ornament for the doorway was issued on 17 Aug. 1553 (PS, b. 68, proc. 151, fasc. 2, c. 5–5t.). The inscription above the door is dated MCXXXIII which, according to the Venetian calendar counting from the supposed date of the foundation of the Republic, A.D. 421, is equivalent to the year 1553. Both the portal and the inscription were originally in the vestibule, on the outside of the entrance to the reading-room, but were removed to their present position inside the reading-room when the vestibule was converted into the Grimani Museum in the 1590s (F. Sansovino: *Venetia città nobilissima . . .*, ed. G. Stringa (Venice, 1604), c. 207t.).

84. PS, b. 68, proc. 151, fasc. 2. The painters were Guiseppe Salviati, Battista Franco, Giulio Licinio, Paolo Veronese, Giovanni de Mio, Andrea Schiavone, and Battista Zelotti. A gold chain, awarded by the Procurators for the best of the ceiling paintings, was won by Paolo Veronese for his portrayal of Music (Vasari–Milanesi, vi, pp. 372–73; and C. Ridolfi, *Le maraviglie dell'arte* (1648), ed. D. von Hadeln, i (Berlin 1914), pp. 249, 305–07). The judges in the competition were Sansovino and his

great friend Titian.

85. According to a decree of the Senate passed on 26 Sept. 1558 the Procurators were eager to move the books from the Basilica to the newly completed building (PS, b. 68, proc. 151, fasc. 1, c. 37). They had certainly been transferred by 11 Feb. 1564 m.v. (1565) (PS, Atti, reg. 130, c. 64t.).

86. Contracts for Cristoforo Rosa's perspective ceiling decoration and for the floor of the Vestibule are preserved in PS, b. 68, proc. 151, fasc. 2, c. 20–21. On 29 Feb. 1559 m.v. (1560) an agreement was drawn up with Sansovino's former pupil Alessandro Vittoria for the stucco decoration of the staircase ceiling 'juxta il principio ci mostra per esso messer vittorio sin'hora fatto' (ibid., c. 23). Entries in Vittoria's account-books record regular payments to assistants for work on the ceiling from 16 Dec. 1559 until 28 June 1560. Three of these entries are dated 13, 20 and 27 Apr. 1556 (sic), but since these correspond perfectly with the weekly intervals of the previous and subsequent payments, the date 1556 seems to be an error for 1560 (R. Predelli, Le memorie e le carte di Alessandro Vittoria (Trento 1908), pp. 127 ff.).

87. The earliest record of the vestibule's function occurs in Francesco Sansovino's first guide to Venice, published under the pseudonym of A. Guisconi in 1556 (A. Guisconi, Tutte le cose notabili e belle che sono in Venetia (Venice 1556), p. 12). See also Sansovino–Martinioni, p. 313, and B. Nardi, Saggi sulla cultura veneta del quattro e cinquecento, ed. P. Mazzantini (Padua 1971), pp. 3 ff. On 12 July 1560 when a Venetian patrician, Federigo Badoer, was given permission to hold meetings of his Accademia della Fama in the vestibule, the school was already in operation (PS, Atti, reg. 129, c. 34–37). Badoer's Academy was short-lived, ending in bankruptcy shortly afterwards (M. Maylender, Storia delle Accademie d'Italia (Bologna 1930), v, pp. 436 ff.).

88. PS, reg. 3, Cassier Chiesa V (1568–80). On the conversion of the vestibule see Sansovino–Martinioni, p. 312; and M. Perry, 'The Statuario Publico', Saggi e Memorie di Storia dell'Arte, viii (1972), pp. 75–150.

89. On 8 May 1554, an agreement was reached in the Consiglio di Dieci between the Procurators and the Proveditori di Zecca, in which the latter agreed to allow the extension of the new building to incorporate the entrance to the Mint (Consiglio di Dieci, Comuni, f. 62, c. 88).

90. I have discussed in detail elsewhere the negotiations over the fate of the Beccaria, since they demonstrate that Tafuri's hypothesis that Sansovino himself intended the Library to be only 17 days long is not supported by the documentary evidence (D. How-

ard, 'Two notes on Jacopo Sansovino', Architectura, (1974), pp. 137–46; and Tafuri, op. cit., p. 76).

91. Vasari-Milanesi, vii, p. 503.

92. A. Palladio, I quattro libri dell'architettura (Venice 1570), Book I, p. 5.

93. Aretino, Lettere sull'arte, ii, p. 78, letter of July 1545.

94. On the Venetian aspiration to emulate the ancients, see D. S. Chambers, The Imperial Age of Venice 1380–1580 (London 1970), pp. 12 ff.

95. Senato Terra, reg. 19, c. 33t., 5 May 1515.

96. At the time of Bessarion's bequest the only public library since Antiquity was the Library of S. Marco in Florence (B. L. Ullman and P. S. Stadter, The Public Library of Renaissance Florence (Padua 1972), pp. 3–20). Later in the 15th century Pope Sixtus IV established his Library in the Vatican with the intention that it should be open to all scholars; and in Venice itself Cardinal Domenico Grimani specified in the bequest of his books to the monastery of San Antonio di Castello in 1523 that it should be accessible to the general public (P. Kibre, The Library of Pico della Mirandola (New York 1936), p. 19).

97. MS. Marc. Lat. XIV, 14, c. 13t–14.

98. Vitruvius, The Ten Books on Architecture, transl. M. H. Morgan, pp. 195–96, Introduction to Book VII; and L. B. Alberti, L'Architettura, transl. G. Orlandi, ii, pp. 764–69, Book VIII, Chap. IX.

99. Pausanias, Guide to Greece, transl. P. Levi, i, Central Greece (Harmondsworth 1971), p. 53.

100. On ancient libraries, see J. W. Clark, The Care of Books, an Essay on the Development of Libraries and their Fittings from the Earliest Times to the End of the Eighteenth Century (Cambridge 1901), pp. 1–60. For 16th-century accounts of ancient Roman libraries, see A. Fulvio, Antiquitates Urbis (Rome 1527), c. lxxxii t.–lxxxiii, and B. Marliani, Urbis Romae Topographia (Venice 1588 edn.), c. 25, 34t., 51, 94t.–95, & 102t.

101. See J. W. Thompson (ed.), The Medieval Library (Chicago 1939), J. F. O'Gorman, The Architecture of the Monastic Library in Italy 1300–1600 (New York 1972), and J. S. Ackerman, The Architecture of Michelangelo (London 1961), i, pp. 33–44. Like Michelangelo, Sansovino omitted the columns of the traditional nave-and-aisles arrangement of the medieval monastic library, but retained the tripartite division in the ceiling decoration. The contracts for the floor of Sansovino's reading-room indicate that the desks were arranged with a main aisle down the centre and smaller gangways on each side (PS, b. 68, proc. 151, fasc. 2, c. 19–19t., 16 Dec. 1558; and Atti, reg. 130, c. 41t.–42, 14 Apr. 1564). The original wooden desks and the red, white and black marble

floor have now been removed, but desks of the same 'pew' type are preserved in Michelangelo's Laurentian library, and in the Malatesta Library at Cesena which was modelled on Michelozzo's Library at S. Marco in Florence (see Clark, op. cit., pp. 199–205; and O'Gorman, op. cit., pp. 1–2). Michelozzo himself designed a library in Venice, on the island of S. Giorgio Maggiore, when he accompanied Cosimo de' Medici into exile in 1433–34. Sansovino would certainly have known this library, which was replaced by Longhena's famous library in the 17th century. The brief descriptions by Vasari and Francesco Sansovino tell almost nothing about its appearance (Vasari–Milanesi, ii, p. 434, and Sansovino–Martinioni, p. 219). Sansovino probably saw Michelangelo's Laurentian Library under construction on his visit to Florence in 1540 (Vasari–Milanesi, vii, p. 511).

102. Vitruvius, op. cit., p. 181, Book VI, chap. iv. This recommendation was certainly known in 16th-century Rome (Fulvio, op. cit., c. xxxiii). The comment in Fra F. Manfredi, *Degnità Procuratoria di San Marco di Venetia* (Venice 1602), p. 16, implies that the eastern aspect of Sansovino's library was regarded as intentional.

103. *M. Vitruvius per Iocundum solito castigatior factus cum figuris et tabula ut iam legi et intelligi possit* (Venice 1511).

104. Vasari–Milanesi, vii, pp. 502–03. See W. Lotz: 'The Roman Legacy in Sansovino's Venetian Buildings', *Journal of the Society of Architectural Historians*, xxii (1963), pp. 3–12, and J. B. Onians, 'Style and Decorum in Italian Sixteenth Century Architecture', unpublished Ph.D. thesis, University of London, Warburg Institute (1968).

105. On the iconography of the library sculpture, see the articles by N. Ivanoff listed in the bibliography. The decoration of the interior of the Library, with Tintoretto's full-length painted philosophers, must have been a self-conscious attempt to imitate Antique prototypes (see Clark, op. cit., pp. 34–35). Some Renaissance libraries had been decorated with Doctors and Philosophers, but the entirely secular programme in the Library of St. Mark's was highly unusual (Clark, op. cit., p. 214, and N. Ivanoff, 'La Libreria Marciana: arte e iconologia', *Saggi e Memorie di Storia dell'Arte*, vi (1968), p. 75).

106. According to Francesco Sansovino the original Loggetta at the foot of the Campanile was struck by a thunderbolt in 1489 (Sansovino–Martinioni, p. 307). Paoletti discovered a payment for wood supplied for the Loggetta in that year (P. Paoletti, *L'architettura e la scultura del Rinascimento a Venezia* (Venice 1893), i, p. 118). On the damage caused by the earthquake in 1511 see Sanudo, *Diarii*, vol. 12,

p. 80, 26 Mar. 1511, and p. 91, 30 Mar. 1511. During the night of 11 Aug. 1537 it was again damaged in a storm and needed further repair (PS, reg. 2, Cassier Chiesa III, 27 Aug. 1537).

107. See Appendix I.

108. PS, Atti, reg. 125, c. 29, 15 Feb. 1537 m.v. (1538).

109. PS, reg. 2, Cassier Chiesa III. The date 1540 appears in the left-hand arch. On the building history see G. Lorenzetti: 'La Loggetta al Campanile di San Marco', *L'Arte*, xiii (1910), pp. 108–33.

110. PS, Atti, reg. 126, c. 9–9t., 10 Feb. 1545 m.v. (1546); published by Ongania, op. cit., p. 51.

111. PS, Atti, reg. 126, c. 78t.–79, 17 May 1548.

112. Sansovino–Martinioni, p. 308.

113. Consiglio di Dieci, Parti Comuni, reg. 29, c. 65t.–66, 22 Sept. 1569.

114. Coryat referred to the Loggetta as 'a place where some of the Procurators of Saint *Markes* doe vse to sit in iudgement, and discuss matters of controuersies' (T. Coryat, *Crudities* (London 1611), p. 185); and in the *atti* some of the meetings are recorded as held in the Loggetta. The Procurators had also made constant use of the old Loggetta (Sanudo, *Cronachetta*, p. 115).

115. Lorenzetti, 'La Loggetta . . .', p. 111.

116. Ibid., pp. 114–18. There is no evidence in 16th-century sources to support the idea propagated at the beginning of the 17th century by Manfredi, op. cit., p. 41, that the Loggetta should have been continued around the other three sides of the Campanile. There is, in any case, insufficient space between the Library and the Campanile for this to work visually.

117. Early accounts stressed the polychromatic richness of the Loggetta (e.g. Coryat, op. cit., pp. 185–86), a fact which underlines the importance of the recent cleaning. This restoration, completed in September 1974, was financed by the Venice in Peril Fund.

118. PS, b. 74, proc. 168, fasc. 1, c. 21:

> 1579 Campaniel
> Spese fatte per la reparation
> del campanil da di 28 mazo
> 1511 fino 1579 14 ottobre
> compreso leror de dti. 1000
> nel reporto del Libro f ———— dti. 7459 dti. 17
>
> Spese fatte In La Loza dal
> campanil dadi 1537 fino 1580— dti. 4258 dti. 14
>
> Spese fatte per le case brusade
> et fatte nove in piaza da di 4
> settembre 1512 fino tutto lano
> 1525———— dti. 23107 dti. 2
> Ittem dal 1526 9 marzo fino
> tutto febraro susequente

———————dti. 1998 dti. 16
Ittem dal 1530 31 marzo fino
10 febraro susequente
———————dti. 140 dti. 4
Ittem da di 31 mazo 1532 fino
tutto febraro 1546
———————dti. 10561 dti. 7
Ittem in Libro g c. 201
———————dti. 1030 dti. 18

———————————————————

Summa———dti. 36837 dti. 23— dti. 36837 dti. 23

Spese fatte In la fabricha nova
sopra la piaza pichola permezo
Il palazo da dj 28 Zener 1536
fino 1554— dti. 15962 dti. 18
Ittem dal 1555 fino 1576
abatudo leror del reporto dal
Libro g al Libro j de
dti. 1000 — dti. 12058 dti. 5

———————————————————

Summa — dti. 28020 dti. 23 dti. 28020 dti. 23

[On reverse of sheet]

Summa delle spese fatte a reparar il campanil,
far la lozeta, le case nove In piaza, Le fabriche
della Libraria—No. 62

119. Payments to 'maestro polo da san michiel taia
pietra da Verona' are recorded in PS, reg. 2, Cassier
Chiesa III. On Marc'Antonio Giustinian, see Chapter
IV.

120. See M. Muraro, 'La Scala senza Giganti', in De
Artibus Opuscula XL, Essays in Honor of Erwin
Panofsky, ed. M. Meiss, i (New York (1961), pp.
350–70, especially p. 352.

121. This drawing, in the Escorial, is inscribed
'PORTICVS VENETIARVM IN PLATEA DIVI MARCI' (see E.
Tormo: Os Desenhos das Antigualhas que vio Fran-
cisco d'Ollanda, Pintor Português . . . 1539–1540 . . .
(Madrid 1940), pp. 187–89).

122. Vasari–Milanesi, vii, p. 495; H. R. Weihrauch,
Studien zum bildnerischen Werke des Jacopo Sansovino
(Strassburg 1935), pp. 54–55; Lotz, 'The Roman
Legacy . . .', pp. 3–7.

123. F. Sansovino, Delle cose notabili che sono in
Venetia (Venice 1561), c. 21t.

124. Sansovino–Martinioni, pp. 307–08; and Guis-
coni (=F. Sansovino), op. cit., pp. 9–11. David
Rosand has pointed out to me the additional
significance of Mercury as the god of commerce, his
importance to Venice being manifested by his
prominent position in Jacopo de'Barbari's view of
Venice.

125. e.g. Contarini, op. cit., and Giannotti, op. cit.
See also F. Gilbert, 'The Date of the Composition of

Contarini's and Giannotti's Books on Venice',
Studies in the Renaissance, xiv (1967), pp. 172–84.

126. PS, Atti, reg. 124, c. 112, 6 July 1531. I pub-
lished this document, together with a discussion of
the conversion project, in Howard, op. cit., pp.
132–36.

127. PS, Atti, reg. 124, c. 166t., 7 May 1533.

128. Maggior Consiglio, Deliberazioni, reg. ROCCA,
c. 45t.–46, 7 June 1556.

129. PS, b. 65, proc. 143, fasc. 1, libretto no. 25.

130. PS, b. 33, proc. 67, c. 35t.–36.

131. Vasari–Milanesi, vii, pp. 509–10.

CHAPTER III

1. Scarpagnino's successors as proto to the Salt Office
were Zuan Antonio Rosso (until 1553), Piero de'
Guberni (1553–63), and Antonio da Ponte (from
1563). Documents recording the activities of all these
proti are given in G. B. Lorenzi, Monumenti per servire
alla storia del Palazzo Ducale in Venezia, i (Venice
1868), pp. 264–318.

2. See R. Gallo, 'Michele Sanmicheli a Venezia',
Studi raccolti dall'Accademia di Agricoltura, Scienze e
Lettere di Verona, per la celebrazione del IV centenario
della morte (Verona 1960), pp. 99 ff.

3. G. Luzzato, Storia economica di Venezia dall'XI al
XVI secolo (Venice 1961), p. 30; A. da Mosto, I Dogi
di Venezia (Milan 1960 edn.), p. 16; G. Galicciolli,
Delle memorie venete antiche profane ed ecclesiastiche, i
(Venice 1795), p. 389; G. Majer, 'L'officina monetaria
della Republica di Venezia', Archivio Veneto, series
V, lii–liii (1953), p. 32; H. Kretschmayr, Geschichte
von Venedig, ii (Gotha 1920), p. 317.

4. The Florentine Mint was originally housed in the
Torre della Zecca opposite to the Palazzo della
Signoria, and later in a group of nearby houses
behind the Loggia de' Signori (H. Saalman, 'Michel-
ozzo Studies—the Florentine Mint', in Festschrift für
Ulrich Middeldorf (Berlin 1968), pp. 140–42). The
Vatican Mint was constructed in the papacy of Leo
IV next to the entrance to the Papal Palace (F.
Biondo, Roma ristaurata, et Italia illustrata, transl. L.
Fauno (Venice 1542), Libro I, c. 13). Vitruvius and
Filarete both recommended that the mint, or
treasury, should be situated near the centre of govern-
ment (Vitruvius, The Ten Books on Architecture,
transl. M. H. Morgan (New York 1960 edn), p. 137,
Book V, Chapter ii; and J. R. Spencer (ed.), Filarete's
Treatise on Architecture (New Haven, Conn. 1965), i,
p. 126).

5. Consiglio di Dieci, Comuni, reg. 8, c. 24, 25 May
1532; ibid., c. 19, 29 Apr. 1532; ibid., c. 85–85t., 11
Oct. 1532.

6. Sanudo, Diarii, vol. 57, p. 415, 13 Jan. 1532 m.v.

(1533). The visit was prompted by an outbreak of fire in the Mint six months earlier (ibid., vol. 56, p. 516, 7 July 1532).

7. Consiglio di Dieci, Comuni, reg. 11, c. 79–79t., 4 Dec. 1535. This document and the one cited in the next note were first published by V. Lazari, *Scrittura di Jacopo Sansovino e parti del Consiglio de' Dieci reguardanti la rifabbrica della Zecca di Venezia* (Venice 1850) (1851 edn.), pp. 7–9.

8. Consiglio di Dieci, Comuni, reg. 11, c. 105t.–106, 23 Mar. 1536.

9. Ibid., c. 106–106t., 31 Mar. 1536. On the fundraising for the new Zecca, see F. Berchet, 'Contributo alla storia dell'edificio della veneta Zecca, prima della sua destinazione a sede della Biblioteca Nazionale Marciana', *Atti del R. Ist. Ven. di Scienze, Lettere ed Arti*, lxix (1909–10), part II, pp. 339–67.

10. Consiglio di Dieci, Comuni, reg. 11, c. 106.

11. The decision to rebuild the Mint proposed that 'far se debba la cecha nostra tuta in volto, et a parte à parte, principiando da quella parte che sia piu necessaria' (ibid., c. 79).

12. Ibid., c. 104t.–105t., 23 Mar. 1536. The techniques of minting at this period are fully described in Vannuccio Biringuccio's metallurgical treatise *De la pirotechnia*, first published in Venice in 1540 (V. Biringuccio Senese, *Pirotechnia* (Bologna 1678 edn.), pp. 486–93).

13. By 9 Jan. 1536 m.v. (1537), the construction was sufficiently well advanced for the contract to be awarded for the vaults of part of the ground floor; and in August 1537 the contract for the vaults of the upper floor of this first section was issued (Proveditori di Zecca, Terminazioni, reg. 22, c. 72–72t., 20 Aug. 1545).

14. The appointment was made on 1 Mar. 1537 (ibid., c. 82, 3 Jan. 1547 m.v. (1548)).

15. Proveditori di Zecca, Capitolar dalle Broche, reg. 5, c. 100t., 1 Aug. 1537.

16. Consiglio di Dieci, Comuni, reg. 12, c. 87t., 28 Nov. 1537. This document (from the copy in the Capitolar dalle Broche) was published by Lazari, op. cit., p. 10.

17. PS, Proprietà e Dritti, b. 33, proc. 67, c. 64–71.

18. Ibid., c. 34.

19. Ibid., c. 70.

20. PS, Atti, reg. 125, c. 144, 29 Jan. 1542 m.v. (1543). The new shops were fewer in number than those they replaced, but they were also 'ben piu belle et piu comode'. The rents for the new shops ranged from 51 to 68 ducats a year.

21. Consiglio di Dieci, Comuni, reg. 13, c. 117t.–118, 27 Jan. 1539 m.v. (1540). 4,000 ducats of the initial sum had so far arrived, and by November 1539 approximately 3,200 ducats had already been spent on the building.

22. Consiglio di Dieci, Comuni, f. 33, c. 22–22t., 8 Mar. 1543.

23. Ibid., f. 35, c. 78, 8 Apr. 1544.

24. Proveditori di Zecca, Terminazioni, reg. 22, c. 82, 3 Jan. 1547 m.v. (1548).

25. PS, b. 33, proc. 67, c. 58–58t. The order was given on 13 Apr. 1554, asking for rents of only 30–40 ducats for most of the shops.

26. The Consiglio di Dieci decided on 12 Sept. 1554 to set up a tribunal of 25 Senators to adjudicate (Consiglio di Dieci, Comuni, reg. 21, c. 127). The hearing did not in fact take place until four years later. On 13 July 1558 the tribunal was reconstituted (ibid., reg. 23, c. 160t.). The Procuracy's case was presented on 18 Aug. 1558, and the case was finally decided in favour of the Procurators on 2 Jan. 1558 m.v. (1559) (PS, b. 33, proc. 67, c. 64–71, and fasc. A).

27. On 5 Sept. 1558 the Proveditori di Zecca objected to several of the Procuracy's witnesses including 'messer Giacomo Sansoino per esser suo salariato, et etiam venuto con li Signori Procuratori à diffender essa causa' (ibid., fasc. A, c. 4–4t.).

28. Consiglio di Dieci, f. 72, c. 203, 28 June 1558. The documents relating to the addition of the third storey were discovered by R. Gallo, 'Contributi su Jacopo Sansovino', *Saggi e Memorie di Storia dell'Arte*, i (1957), pp. 89–90.

29. Collegio, Notatorio, reg. 31, c. 157.

30. It is significant that when he gave evidence to the hearing on 16 Sept. 1558 Sansovino described himself as 'salariato della Procuratia et pagato etiam da altri luoghi Publici, secondo le occurentie', but made no mention of the Zecca although the model for the extra storey had by then been approved (PS, b. 33, proc. 67, c. 67).

31. Ibid., c. 60, 4 May 1558; Consiglio di Dieci, Comuni, f. 72, c. 203, 28 June 1558. There are no particulars of the increases since the total of 21,000 ducats ordered by 1544.

32. Senato Terra, f. 108, 15 Sept. 1588; PS, b. 33, proc. 67, c. 34–40t.

33. See the English translation of this letter, dated 20 Nov. 1537, in Appendix I.

34. Vasari–Milanesi, vii, p. 505.

35. Sansovino–Martinioni, p. 315.

36. Ibid.; and Vasari–Milanesi, vii, p. 504.

37. F. Sansovino, *Delle cose notabili che sono in Venetia* (Venice 1561), c. 24.

38. See L. Beltrami, *La Ca' del Duca sul Canal Grande* (Milan 1900), and J. R. Spencer, 'The Ca' del Duca in Venice and Benedetto Ferrini', *Journal of the Society of Architectural Historians*, xxix (1970), pp. 3–8.

39. L. Angelini, *Le opere in Venezia di Mauro Codussi* (Milan 1945), Fig. 69 and Fig. 3.

40. S. Serlio, *Tutte l'opere . . .* (Venice 1619), c. 133t.

41. See E. Nash, *Bildlexicon zur Topographie des Antiken Rom* (Tübingen 1961), i, pp. 243 ff. and ii, pp. 225 ff.

42. L. Puppi, *Michele Sanmicheli* (Padua 1971), pp. 25 and 88–90; and R. Gallo, 'Michele Sanmicheli a Venezia', pp. 99 ff. Giulo Romano used the rusticated Doric order for a similar purpose in his designs for the Porta della Cittadella in Mantua, begun in 1533 (F. Hartt, *Giulio Romano* (New Haven, Conn. 1958), i, pp. 194–99, ii, Figs. 415–17). See also L. Heydenreich, 'Il bugnato rustico nel quattro e nel cinquecento', *Bollettino del Centro . . . Andrea Palladio*, ii (1960), pp. 40–41.

43. C. L. Frommel, 'Baldassare Peruzzi als Maler und Zeichner', *Beiheft zum Römischen Jahrbuch für Kunstgeschichte*, xi (1967/68), p. 125, Cat. No. 89. The drawing, which is in the Louvre, is illustrated in Plates LXII and LXIIIa.

44. V. Scamozzi, *Idea della architectura universale* (Venice 1615), part II, Book VI, p. 171.

45. D. Howard, 'Two notes on Jacopo Sansovino', *Architectura* (1974), pp. 137–46.

46. F. Moryson, *An Itinerary* (London 1617), part I, p. 77. Moryson visited Venice in 1594.

47. Sanudo, *Diarii*, vol. 17, p. 459; Vasari–Milanesi, v, p. 269.

48. On the evolution of the Rialto see the full account in R. Cessi and A. Alberti, *Rialto, l'isola—il ponte—il mercato* (Bologna 1934). This book is an essential source for the content of this chapter.

49. See F. C. Lane, 'Venetian Shipping in the Commercial Revolution' (1933), essay republished in *Venice and History* (Baltimore 1966), pp. 3 ff.

50. Sansovino–Martinioni, p. 364.

51. See F. C. Lane, *Andrea Barbarigo Merchant of Venice 1418–1449* (Baltimore 1944).

52. F. Moryson, op. cit., p. 87.

53. M. A. Sabellico, *Del sito di Venezia Città* (1502), transl. G. Meneghetti (Venice 1957), p. 17.

54. H. Simonsfeld, *Der Fondaco dei Tedeschi in Venedig* (Stuttgart 1887), ii, p. 107 ff.

55. The form of the new building was strictly in the Byzantine *fondaco* tradition, with turrets at each end of the façade, a waterfront portico for unloading merchandise, and a central *cortile*. See M. Dazzi, M. Brunetti, G. Gerbino, *Il fondaco nostro dei Tedeschi*, a cura del Ministero delle Comunicazioni, Direzione Generale delle Poste e Telegrafi (Venice 1941). See also G. Scattolin, *Le Case-fondaco sul Canal Grande* (Venice 1961).

56. Sanudo, *Diarii*, vol. 17, pp. 458 ff.

57. Ibid., p. 462.

58. Ibid., p. 460.

59. Ibid., pp. 466–7.

60. Cessi, op. cit., pp. 91 ff.

61. Vasari–Milanesi, v, p. 269 ff.

62. Cessi, op. cit., pp. 105 ff.

63. Ibid., pp. 111–13.

64. Ibid., pp. 113–14.

65. Ibid., pp. 117 ff.

66. In May 1514 Antonio Scarpagnino carried out, as economically as possible, a repair to the foundations of the bridge (Sanudo, *Diarii*, vol. 18, p. 233).

67. Senato Terra, reg. 24, c. 37t.–38, 25 Sept. 1525.

68. Proveditori al Sal, b. 297, Notatorio, reg. 10, c. 114t., 28 Feb. 1525 m.v. (1526).

69. Proveditori sopra la Fabrica del Ponte di Rialto, b. 3, copy from the Consiglio di Dieci, 22 Oct. 1507.

70. Savi ed esecutori alle acque, f. 119, Relazioni periti circa la laguna (1493–1579), c. 164 ff. See Cessi, op. cit., pp. 184–5.

71. Savi ed esecutori alle acque, f. 116, Scritture sopra la laguna (1474–1580), 25 Sept. 1542, agreement between the Savi alle Acque and the Proveditori sopra i Monti. The latter were to take over the moorings and to pay 80 ducats a year to the Savi alle Acque in compensation. These moorings had been granted to the Savi alle Acque by the Collegio on 1 Sept. 1539. See Cessi, op. cit., pp. 123–4.

72. Consiglio di Dieci, Comuni, reg. 19, c. 146t., 27 Aug. 1550. See Cessi, op. cit., pp. 124–5.

73. Senato Terra, reg. 37, c. 88–88t., 17 Jan. 1550 m.v. (1551).

74. Ibid.

75. Consiglio di Dieci, Comuni, reg. 21, c. 58t., 21 Oct. 1553.

76. Ibid., c. 59t., 25 Oct. 1553.

77. Ibid., c. 119t., 13 Aug. 1554: 'havendosi dato principio a far un dessegno della detta fabrica'. That the model presented on 12 Sept. 1554 (ibid., c. 127t.) was commissioned from Sansovino is indicated by a resolution of the following year (ibid., reg. 22, c. 16t., 18 June 1555).

78. Ibid., reg. 21, c. 119t., 13 Aug. 1554.

79. Two of the shops had already been bought by the state at a cost of 1,500 ducats (ibid., f. 60, no. 164, 11 Oct. 1553).

80. Ibid., reg. 21, c. 127t., 12 Sept. 1554.

81. Ibid., f. 63, no. 104, 12 Sept. 1554, published by Cessi, op. cit., Doc. XVI.

82. Senato Terra, reg. 39, c. 164t.–165, 27 Sept. 1554.

83. Ibid., c. 187 t., 3 Nov. 1554, and c. 189, 14 Nov. 1554. See Cessi, op. cit., pp. 122–23.

84. See above, p. 42.

85. Consiglio di Dieci, Comuni, reg. 22, c. 16t., 18 June 1555.

86. 27 of the 28 upstairs *volte* had now been built (ibid., f. 68, no. 40, 23 Mar. 1556).

87. Ibid. These transactions were published by Cessi, op. cit., Doc. XVIII. This project also involved the extension of the new waterfront which had been constructed along the banks of the Grand Canal on the site of the Fabbriche Nuove. The Savi alle Acque had not hesitated to authorise the advancement of the bank by three feet for the original scheme, on the grounds that the new building was 'fabricha publica et necessaria'. In fact, however, the encroachment into the Grand Canal amounted to more than three feet, and terminated in an abrupt right angle at one end. It was therefore decided to build an embankment with steps and moorings along the edge of the Piazza occupied by the vegetable market, to continue the line of the new waterfront (ibid.). The curved *riva* with its steps along the water's edge still exists today.

88. Consiglio di Dieci, Comuni, reg. 22, c. 123, 11 May 1556.

89. Ibid., c. 194, 22 Jan. 1556 m.v. (1557).

90. Full explanations of the structure and its problems are given in reports contained in Proveditori al Sal, Miscellanea, b. 46, Rialto—fabbriche dette le nuove—ristauri 1726–1794.

91. For details of these restorations see ibid.

92. T. Temanza, *Vite . . .*, p. 249.

93. e.g. G. Lorenzetti, *Venice and its Lagoon*, transl. J. Guthrie (Venice 1960), p. 648: 'A dull work unhappily conceived in classical style'.

94. Book IV of Serlio's treatise, on the orders, was published in Venice in 1537, and Book III, on the buildings of Antiquity, in 1540.

95. Proveditori al Sal, Miscellanea, b. 46, report of Zuane Castai, 19 July 1754.

96. See note 87.

97. No record of the appearance of Jacopo's design survives. Palladio's project was well known, and even appears in a number of Canaletto's *capriccii*.

98. Sansovino–Martinioni, p. 364.

99. Cessi, op. cit., pp. 204 ff.

100. F. Moryson, op. cit., p. 88.

CHAPTER IV

1. F. C. Lane, *Venice, A Maritime Republic* (Baltimore and London 1973), pp. 2 ff.

2. Sansovino–Martinioni, p. 290.

3. On Venetian parish administration, see G. Cappelletti, *Storia della Chiesa di Venezia dalla sua fondazione sino ai nostri giorni* (Venice 1849–51), ii, pp. 209 ff.; B. Cecchetti, *La Republica di Venezia e la Corte di Roma nei rapporti della religione* (Venice 1874), i, pp. 115 ff.; O. Logan, 'Studies in the Religious Life of Venice in the Sixteenth and early Seventeenth Centuries: the Venetian clergy and religious orders 1520–1630', unpublished Ph.D. thesis (Cambridge 1967), pp. 416–35.

4. On the monastic orders in Venice, see Cecchetti, op. cit., pp. 198 ff.; Logan, op. cit., pp. 393 ff.

5. A. Guisconi (i.e. F. Sansovino), *Tutte le cose notabili e belle che sono in Venetia* (Venice 1556), p. 16.

6. For instance, anti-government sermons were forbidden, and as early as 1249 Venice set up her own Inquisition to punish heretics. See Cecchetti, op. cit., pp. 81 ff.; Logan, op. cit., pp. 83 ff.

7. ASV, Senato Terra, reg. 19, 2 June 1515, c. 23–23t.; Maggior Consiglio, reg. ROCCA, 27 Sept. 1561, c. 118t.–119.

8. In its original form the decree stipulated a 2-year period, but this was amended to four years. At the end of that period the property was to be sold by auction, and the proceeds returned to the executors (Senato Terra, reg. 29, c. 83t.–84, 22 Dec. 1536).

9. In addition to these six churches Sansovino carried out additions and alterations to other churches in the city, such as the choir of San Fantino (a convincing but unconfirmed attribution) and the sacristy and high altar of San Basso. The new church of San Fantino was begun in 1507, probably from designs by Antonio Scarpagnino. After his death in 1549, Sansovino is supposed to have continued the building which was apparently completed in 1564 (G. Lorenzetti, *Itinerario sansoviniano a Venezia* (Venice 1929), pp. 73–74). The fact that on 5 March 1548 the Proveditori di Comun recorded that the old *capella grande* had just been demolished adds weight to the attribution of the new choir to Sansovino (Proveditori di Comun, busta 11, Libro 13, c. 87). The alterations to the church of San Basso (formerly in Piazza San Marco near the Clock Tower and now demolished), which were begun in 1568, were one of Sansovino's last tasks as *proto* to the Procuratia de Supra (PS, b. 64, proc. 139, c. 8–9t.).

10. See Vasari–Milanesi, vii, pp. 497–99. In 1518 Pope Leo X chose Sansovino's model for San Giovanni dei Fiorentini, submitted in competition with such illustrious architects as Raphael, Peruzzi and Antonio da Sangallo the Younger. However, because of structural difficulties with the foundations on the bank of the Tiber, the more experienced engineer Antonio da Sangallo was called in to continue the project. See also J. S. Ackerman, *The Architecture of Michelangelo* (London 1961), ii, pp. 117 ff. The rebuilding of San Marcello al Corso was begun by Sansovino after a fire in 1519, but here again he was superseded by Sangallo.

11. F. Corner, *Ecclesiae Venetae Antiquis Monumentis* (Venice 1749), viii, pp. 13–14; N. Spada, 'I Frati

Minori a Venezia nel terzo decennio del ducento', *Le Venezie Francescane*, i (1932), pp. 71–76; *Breve guida della Chiesa di San Francesco della Vigna in Venezia*, pp. 6–9. (A copy of this booklet, written by the previous parish priest of S. Francesco, Padre Marcelliano Giuliani, was kindly given to me by the present *parocco*, Padre Gabriele Zan, to whom I am grateful for his help.)

12. On 16 Sept. 1767 Gradenigo recorded that the ancient chapel of St. Mark had been newly restored (P. Gradenigo, *Notizie d'arte*, ed. L. Livan (Venice 1942), p. 164).

13. The new church was financed by the generosity of the Marcimani family. See Corner, *Ecclesiae Venetae*, viii, pp. 13–14.

14. M. A. Sabellico, *Del sito di Venezia città* (1502), ed. G. Meneghetti (Venice 1957), pp. 24–25: 'La fabbrica di questo tempio non è notevole, ma gli edificij d'attorno et quelli, che nel mare scendono sono ampissimi, et grandi portici d'ogni intorno si spandono.'

15. Padre B. Barban, *L'Isoletta di San Francesco del Deserto* (Vicenza 1927), p. 83.

16. Sanudo, *Diarii*, vol. 24, pp. 321–22, 324.

17. *The Cambridge Modern History*, ii, *The Reformation* (Cambridge 1903), pp. 399–400; A. G. Dickens, *The Counter Reformation* (London 1968), pp. 45–50.

18. Logan, op. cit., pp. 393–415; E. P. D'Alençon, 'Gian Pietro Carafa e la Riforma nell'Ordine dei Minori dell'Osservanza', *Miscellanea Francescana*, xiii (1911), pp. 33–48, 81–92, 112–21, 131–44. On Venice and the Counter Reformation, see H. Jedin, 'Gasparo Contarini e il contributo veneziano alla Riforma Cattolica', *La civiltà veneziana del Rinascimento* (Florence 1958), pp. 103–24; A. Stella, *Chiesa e Stato nelle relazioni dei nunzi pontifici a Venezia* (Vatican 1964), pp. 3 ff.; F. Gaetà, *Un nuncio pontificio a Venezia nel cinquecento* (Venice 1960); Logan, op. cit., pp. 46–82.

19. N. Barbarigo (attr.), 'Vita di Andrea Gritti doge di Venezia tradotta dal latino al volgare (1686)', Biblioteca Correr, MS. Gradenigo-Dolfin 50, p. 53; and Sanudo, *Diarii*, vol. 46, p. 286.

20. ASV, Materie Ecclesiastiche, S. Francesco della Vigna, b. 1, part ii, c. 29, 21 Apr. 1527.

21. In 1504 the monastery bought part of a nearby orchard at Sta. Giustina for 200 ducats from Benedetto Contarini (S. Francesco della Vigna, b. 4, Registro Comprite e Vendite, pp. 78–82, 99–103). In 1506 they acquired from the Corbelli family houses and part of a vineyard adjoining the church (ibid., pp. 82–88, 93–98).

22. An agreement concerning the exchange, which involved land belonging to Michele Contarini 'apud Ecclesiam sancti francisci à Vinea', dated 18 Jan. 1537

m.v. (1538), refers to earlier proceedings in 1529, 1532, 1533 and 1534 (S. Francesco della Vigna, b. 4, pp. 243–50).

23. Sanudo, *Diarii*, vol. 53, p. 143. The subsequent controversy over the use of this land in 1533 is recorded in S. Francesco della Vigna, b. 5, part i, Registro di sentenze giudiziarie, pp. 199–203, 228.

24. Sanudo, *Diarii*, vol. 58, p. 677, letter from Rome of 4 Sept. 1533. Papal indulgences were granted to the new church on 10 Sept. 1536 (Corner: *Ecclesiae Venetae . . .*, viii, p. 49).

25. Zorzi's original *relazione*, once in the archives of the convent, has now disappeared, but a copy in the Manin family archives was published in G. Moschini, *Guida per la Città di Venezia* (Venice 1815), i, pp. 55–61. It is quoted in an English translation in R. Wittkower, *Architectural Principles in the Age of Humanism* (London 1962 edn.), Appendix I, pp. 155–57. The four witnesses to the memorandum were Titian, Serlio, Fortunio Spira of Viterbo and Jacopo Zanabelli (Corner, *Ecclesiae Venetae . . .*, viii, p. 20).

26. On 25 May 1537 Fra Zuanne Barbaro was officially appointed 'commissario e presidente della Fabrica' by the Provincial Superior and Committee of the Franciscan order, and given authority to concede altars and chapels (Corner, op. cit., viii, pp. 20, 52–53). The Minister General of the Frati Minori confirmed Barbaro's responsibility for the building on 28 May 1546 (ibid., pp. 20, 54–55).

27. D. Barbaro, *I Dieci Libri dell'Architettura di M. Vitruvio tradutti et commentati . . .* (Venice 1556). Daniele Barbaro employed Palladio to build his famous villa at Maser (see L. Puppi, *Andrea Palladio* (Milan 1973), ii, cat. no. 55). For a discussion of Daniele Barbaro's family circumstances, his intellectual background, and his artistic ideas, see P. Laven, 'Daniele Barbaro, patriarch elect of Aquileia, with special reference to his circle of scholars and to his literary achievement', unpublished Ph.D. thesis (London 1957). Fra Zuanne Barbaro is mentioned as the 'brother of Francesco, son of Daniele' in San Francesco della Vigna, b. 4, p. 297. This Francesco Barbaro was the father of Palladio's patron Daniele. Zuanne was born between 1500 and 1510 (ASV, Barbaro, Albori, II, c. 199 and c. 200). He was also the nephew of the great humanist Ermolao Barbaro, Patriarch of Aquileia Elect. I am extremely grateful to Oliver Logan for helping me to identify Fra Zuanne and for other information about him.

28. Fra F. Zorzi, *De harmonia mundi totius* (Venice 1525). For an account of Zorzi's ideas see D. P. Walker, *Spiritual and Demonic Magic from Ficino to Campanella* (London 1958), pp. 112 ff.

29. Sanudo, *Diarii*, vol. 24, pp. 321–22.

30. HONORI AC MERITIS CLARISS. PATRVM NOBILIVM VENETOR. FRANCISCI ZORZI ET IO. BARBARO REGVL. OBSERV. S.P.N. FRANC. QVI DEI ZELO DUCTI IN EXCITANDO PERFICIENDO Q. HOC S. FRANC. VINEARVM TEMPLO STRENVE ADLABORARVNT.

31. See the detailed analysis of Zorzi's memorandum in Wittkower, op. cit., pp. 102–07.

32. Wittkower, op. cit., pp. 156–57.

33. e.g. G. Lorenzetti, *Itinerario sansoviniano a Venezia* (Venice 1929), pp. 81–82.

34. Wittkower, op. cit., p. 155.

35. The document cited in note 122 states that the state also provided direct financial aid for the building of the new church. For details of the concessions for burial rights and family chapels, see Appendix II.

36. The agreement was drawn up on 25 July 1536 (S. Francesco della Vigna, b. 4, pp. 236–43). The terms are restated in Gritti's will on 12 Mar. 1539, quoted in b. 3, part i, c. 62t.–65, and b. 3, part ii, c. 32t.–33t. The monuments to Doge Andrea Gritti on the left wall of the chancel and to Triadano Gritti on the opposite side were erected after Sansovino's death, and are usually attributed to Vincenzo Scamozzi.

37. Marc' Antonio's responsibility for the chapel is clear from his will (Not. Test. Marsilio, b. 1220, no. 14, 10 Feb. 1552 m.v. (1553)), drawn up when the chapel was still unfinished. On Marc' Antonio's friendship with Sansovino see Vasari–Milanesi, vii, p. 508. Sansovino's will, dated 16 Sept. 1568, is preserved in Not. Test, Cesare Zilioli, b. 1258, no. 452.

38. P. Paoletti, *L'architettura e la scultura del Rinascimento in Venezia* (Venice 1893), i, p. 196, n. 2.

39. See R. Rearick, 'Battista Franco and the Grimani Chapel', *Saggi e Memorie di Storia dell'Arte*, ii (1958–9), pp. 107–139, and W. Wolters, *Plastische Deckendekorationen des Cinquecento in Venedig und im Veneto* (Berlin 1968), pp. 13–19. Rearick pointed out that the stucco decoration was mentioned in most sources before the 19th century (op. cit., p. 123, n. 85). The painted decoration must have been begun by about 1560, for Franco died in 1561. Zuccaro's altarpiece of the Adoration of the Magi is dated 1564. A related pattern decorates the tombstone of Hieronimo Bragadin, dated 1545, on the floor of the opposite chapel. As Carolyn Lewis pointed out in a paper read at the Titian–Aretino–Sansovino conference held at King's College, Cambridge, in 1973, Vettor Grimani married Marc' Antonio Giustinian's sister Isabetta.

40. S. Francesco della Vigna, b. 2, part i, pp. 437–40, 20 Apr. 1542.

41. Lorenzo Lotto stated in a letter of 12 Aug. 1527 that Sansovino was working on a tomb for Cardinal Domenico Grimani when he fled from Rome (L.

Lotto, *Lettere inedite su le tarsie di Santa Maria Maggiore in Bergamo*, ed. L. Chiodi (Bergamo 1962), p. 48). According to A. Da Mosto, *I Dogi di Venezia* (Milan 1960), p. 234, Cardinal Domenico Grimani in his last will wished a monument to his father, Doge Antonio Grimani, who died on 7 May 1523, to be erected at the church of San Antonio di Castello in Venice, under the direction of the Canon of Aquileia, Stefano Illigio, using a design of Sansovino. Documents relating to the making of this tomb, which was finished in about 1542, are preserved in PS, Atti, reg. 124, c. 76, 21 July 1530; Atti, reg. 125, c. 102t.–104, 5 Sept. 1541; and c. 125, 26 May 1542.

42. San Francesco della Vigna, b. 2, part i, pp. 440–43, 9 June 1542.

43. F. Sansovino, *Venetia città nobilissima* (Venice 1581), c. 14; F. Sansovino, *Venetia città nobilissima*, ed. G. Stringa (Venice 1604), c. 115–115t.; and Sansovino–Martinioni, p. 48.

44. See L. Puppi, op. cit., ii, cat. no. 77, for an account of Palladio's façade project, with further bibliography.

45. Atti notarili, protocolli, V. Maffei, b. 8119, c. 364, inventory dated 26 Oct. 1558. I am most grateful to Douglas Lewis for drawing my attention to this entry.

46. On 12 Sept. 1543 the Scuola di S. Francesco were granted a site for their staircase, in return for the sum of 100 ducats together with 40 ducats' worth of wood to be used for the 'opus Iam Inceptum pro conficiendo, et Complendo Campanilem dicti monasteri' (S. Francesco della Vigna, b. 4, pp. 277–81).

47. Hieronimo Bragadin, whose family chapel (the first on the right side) was now completed, opposed the agreement of 20 Apr. 1542, conceding to the Grimani family the right to build the façade, because he was afraid the façade might obscure his chapel (S. Francesco della Vigna, b. 4, pp. 255–57). Most of the other chapels were probably also completed by this time.

48. Lippomano's acquisition of the choir for his sepulchral chapel on 27 Mar. 1554 refers to 'La Capella del Coro dove Cantano li predetti Padri in detta Chiesia di San Francesco' (S. Francesco della Vigna, b. 2, part i, p. 457). The consecration is recorded in Corner, *Ecclesiae Venetae . . .*, viii, pp. 55–56.

49. According to Padre Giuliani the present ceiling was built in 1630, covering the open rafters of the roof, in order to keep out the cold in winter, but he gives no source for this statement (*Breve guida . . .*, p. 16).

50. P. Murray, 'Palladio's Churches', *Arte in Europa, Scritti di Storia dell'Arte in onore di E. Arslan* (Milan 1966), pp. 597–608; J. S. Ackerman, *Palladio*

(Harmondsworth 1966), pp. 126–30; idem, 'The Gesù and Contemporary Church Design', in R. Wittkower and I. B. Jaffé (eds.), *Baroque Art: the Jesuit Contribution* (New York 1972), pp. 19–24.

51. Wittkower, *Architectural Principles . . .*, p. 157.

52. Capitals of this type also occur in the Cornaro Chapel in SS. Apostoli, one of the best examples of early Renaissance architecture in Venice.

53. A. Palladio, *I quattro libri dell'architettura* (Venice 1570), Libro IV, p. 7.

54. F. Caffi, *Storia della Musica sacra nella già Cappella Ducale di San Marco in Venezia* (Venice 1854), i, pp. 81 ff.; G. Benvenuti, *Andrea e Giovanni Gabrieli e la musica strumentale in San Marco*, i (Milan 1931), pp. xxvi ff.; E. E. Lowinsky, 'Music in the Culture of the Renaissance', *Journal of the History of Ideas*, xv (1954), pp. 509–53; M. F. Bukofszer, *Studies in Mediaeval and Renaissance Music* (London 1951), pp. 176–89; G. Barblan, 'Aspetti e figure del cinquecento musicale veneziano', *La civiltà veneziana del Rinascimento* (Florence 1958), pp. 57–80; G. Reese, *Music in the Renaissance* (London 1954), pp. 368–79; K. G. Fellerer, 'Church Music and the Council of Trent', *The Musical Quarterly*, xxxix (1953), pp. 576–94.

55. See W. Timofiewitsch, *Die sakrale Architektur Palladios* (Munich 1968), p. 35.

56. Bruce Boucher very kindly pointed out this link to me.

57. Wittkower, op. cit., pp. 156–57.

58. F. Corner, *Notizie storiche delle chiese e monasteri di Venezia* (Padua 1758), pp. 493–97; *Venezia e le sue lagune*, ii. 2 (Venice 1847), p. 488; P. Molmenti and D. Mantovani, *Le isole della laguna veneta* (Venice 1895), p. 52; A. Zorzi, *Venezia scomparsa* (Milan 1971), ii, pp. 411–13.

59. See A. Stella, 'La proprietà ecclesiastica nella Republica di Venezia dal secolo XV al XVII', *Nuova Rivista Storica*, xlii, fasc. 1 (1958), pp. 50–77, especially p. 64. Documents relating to the *terraferma* property of the monastery are contained in ASV, Materie Ecclesiastiche, Santo Spirito in Isola, b. 1.

60. Corner, *Notizie storiche*, pp. 496–97. Titian's early altarpiece of *St. Mark enthroned* (H. E. Wethey, *The Paintings of Titian*, i, *The Religious Paintings* (London 1969), cat. no. 119) may have been painted for one of these altars.

61. According to Lorenzetti, *Itinerario sansoviniano*, p. 24, Sansovino himself built only the choir and the façade. On the ceiling see J. Schulz, 'Vasari at Venice', *Burlington Magazine*, ciii (1961), pp. 500–11; idem, *Venetian Painted Ceilings of the Renaissance* (Los Angeles and Berkeley 1968), pp. 77–79, cat. no. 20; Wethey, op. cit., i, cat. nos. 82–85. Richard Cocke's suggestion that all three ceiling panels should lie on the same axis seems unconvincing, for in other surviving ceilings of the period, such as those of S. Sebastiano and the reading-room of Sansovino's Library, the panel over the door, being invisible from the entrance, is reversed so that it faces the spectator after he has entered the room (R. Cocke, 'Titian's Santo Spirito Ceiling: An Alternative Reconstruction', *Burlington Magazine*, cxiii (1971), p. 734). On the iconography of the Santo Spirito ceiling, see M. Kahr, 'Titian's Old Testament Cycle', *Journal of the Warburg and Courtauld Institutes*, xxix (1966), pp. 193–205; E. Panofsky, *Problems in Titian, Mostly Iconographic* (London 1969), pp. 31–35.

62. Corner, *Notizie storiche*, pp. 496–97.

63. *Venezia e le sue lagune*, vol. ii. 2 (1847), p. 488. Two rectangular buildings (measuring about 12·50 × 33·50 m and 11·50 × 36·50 m respectively) survive on the island, but both have been so radically rebuilt that it is difficult to say with certainty which of them preserves the foundations of the original church.

64. The church is illustrated in V. Coronelli, *Singolarità di Venezia*, i, *Le Chiese* (Venice 1708–09), and *Libro di molte singolarità di Venezia* (Venice 1708–09), both unnumbered plates; *Il Forestiero illuminato intorno le cose più rare . . . di Venezia* (Venice 1740), p. 279; A. Visentini: *L'Isolario veneto* (Venice 1777), no. xx.

65. Sansovino–Martinioni, pp. 229–30.

66. Ibid., p. 34; S. Tramontin *et al.*, *Culto dei Santi a Venezia* (Venice 1965), p. 120; M. Sanudo, *Cronachetta*, ed. R. Fulin (Venice 1880), p. 19.

67. Corner, *Ecclesiae Venetae . . .*, iii, p. 317.

68. E. A. Cicogna, *Delle iscrizioni veneziane*, 6 vols. (Venice 1824–53), iv, p. 5.

69. Sansovino–Martinioni, p. 109.

70. Ibid., p. 34.

71. Corner, *Ecclesiae Venetae . . .*, iv, p. 332. Corner records that the *pievano* at the time was one Antonio Contarini.

72. Archivio Patriarcale di Venezia, Visitationes Apostolicae, Anno MDLXXXI, c. 261.

73. Ibid., c. 262.

74. Corner, *Ecclesiae Venetae . . .*, iv, pp. 332–33. Corner does not indicate when this contribution was made.

75. Visitationes Apostolicae . . ., c. 261.

76. Corner, *Ecclesiae Venetae . . .*, iv, p. 333. The consecration is recorded by an inscription behind the high altar.

77. Gradenigo recorded on 20 Feb. 1763 m.v. (1764) that the ceiling had been repainted (Gradenigo, op. cit., p. 105). The artist was Jacopo Guarana. The brickwork suggests that windows above the side doors have been blocked in.

78. See L. Angelini, *Le opere in Venezia di Mauro Codussi* (Milan 1945), fig. 58.

79. See W. Timofiewitsch, 'Genesi e struttura della chiesa del Rinascimento veneziano', *Bolletino del Centro . . . Andrea Palladio*, vi (1964), pp. 271–82, and J. McAndrew, 'Sant'Andrea della Certosa', *Art Bulletin*, li (1969), pp. 15–28. For a brief survey of Venetian *quattrocento* churches, see L. H. Heydenreich and W. Lotz, *Architecture in Italy 1400–1600* (Harmondsworth 1974), pp. 83 ff.

80. In his 1581 guidebook, in the statistics given at the end of each *sestiere*, Francesco Sansovino recorded a total of 144 organs compared with only 121 churches, suggesting that virtually every church in 16th-century Venice was fitted with an organ.

81. See A. Tessier, 'Di Tommaso Rangone denominato il Filologo di Ravenna, e della sua statua in bronzo', *La Scintilla*, vi (Venice Jan. 1892). On Rangone's patronage see also P. Paoletti, *La Scuola Grande di San Marco* (Venice 1929), pp. 173–74. During his period as Guardian Grande a motion was passed to erect a full-length statue of himself in a niche on the façade of the Scuola, but it was later annulled (ibid., p. 174).

82. Sansovino–Martinioni, p. 109; P. Paoletti, *L'Architettura e la scultura*, i, p. 294; R. Gallo, 'Contributi su Jacopo Sansovino', *Saggi e Memorie di Storia dell'Arte*, i (1957), p. 96.

83. Gallo, op. cit., p. 96. (Gallo's reference for this document is incorrect, and I have found no mention of either Rangone or San Geminiano in the proceedings of the Senate for 1552.) Gallo discovered all the documents cited here relating to the building of these two churches, except for those in the Archivio Patriarcale, and summarised their contents in his article. Cicogna, *Iscrizioni veneziane*, iv, pp. 5–123, gives a long coverage of the church of San Geminiano, relating chiefly to the inscriptions in the church.

84. Senato Terra, reg. 41 (1557–58), c. 2t.–3, 13 Mar. 1557; Collegio Notatorio, reg. 31 (1557–58), c. 3t., 14 Mar. 1557.

85. Collegio Notatorio, reg. 31, c. 8t., 29 Mar. 1557. When approving the model, the Collegio added that 'al qual modello in luogo delli dui S. Marchi possino esser fatte ditte fenestre, over tondi corrispondenti à quello di mezzo, si come meglio parerà à predetti procuratori, non si potendo nel resto in modo alcuno alterar ditto modello.' The altered model was clearly the one adopted, perhaps in order to admit more light (PS, b. 64, proc. 138, fasc. 1, c. 3–4t., 27 Aug. 1557).

86. Senato Terra, reg. 41 (1557–58), c. 2t.–3, 13 Mar. 1557; PS, b. 64, proc. 138, fasc. 1, c. 1t., 22 Oct. 1558.

87. PS, b. 64, proc. 138, c. 3–4t., 27 Aug. 1557.

88. F. Sansovino, *Delle cose notabili della Città di Venetia* (Venice 1583 edn.), p. 60: 'l'architetto di esso fu il Sansovino, ma il promotore e finitore di tutta

l'opera fu il Manzino . . .' The inscription on the façade paid tribute to Manzini's initiative in building the church (Sansovino–Martinioni, p. 109).

89. F. Sansovino, *Delle cose notabili della città di Venetia* (Venice 1583), p. 60; Biblioteca Correr, Cod. Cic. 165, 'Feste di Palazo, Et giorni ne quali sua Serenita esce di quello', c. 54–54t.; R. Gallo, 'Per la datazione delle opere del Veronese', *Emporium*, lxxxix (1939), pp. 145–52.

90. Sansovino–Martinioni, p. 110. The bust of Eletti was by Cristoforo da Legname and that of Manzini by Alessandro Vittoria. The Cappella del Crocefisso is on the ground floor of a two-storey house which was rebuilt at the expense of the Procuratia de Supra beginning in 1566 (Gallo, op. cit., p. 100; and PS, b. 64, proc. 138, c. 8–13t., and 23–24). I discussed this project more fully in my Ph.D. thesis, pp. 104–05.

91. Sansovino's request of 12 June 1570 is found in ASV, Atti Notarili, V. Maffei (protocollo), b. 8113, c. 314t.–316t. It was published by Cicogna, *Iscrizioni Veneziane*, vi. 2, p. 816, from the original MS. in Cod. Cic. 3350.

92. See Angelini, op. cit., Fig. 57.

93. Archivio Patriarcale di Venezia, Visitationes Apostolicae, Anno MDLXXXI, c. 211. An inventory of the contents of the church at the time of demolition is found in Direzione generale del Demanio, Ufficio Comunale, Pietro Edwards: Quadri, Elenchi ed Inventari, 22 Mar. 1808.

94. B. Bordone, *Isolario . . . nel qual si ragiona di tutte l'isole del mondo*, (Venice 1534), c. xxviii.

95. Visitationes Apostolicae . . ., c. 211.

96. S. Serlio, *Tutte l'opere . . .*, c. 175t.

97. F. Sansovino, *Delle cose notabili della città di Venetia* (Venice 1583 edn.), p. 60.

98. Senato Terra, f. 18, 1 Sept. 1553. On 12 Sept. 1553 the Giudici del Piovego measured the site, prior to the construction of the new façade (Giudici del Piovego, b. 21, Libro Misure 1, c. 85t.).

99. Gallo, op. cit., pp. 104–05.

100. Atti notarili, b. 8116, V. Maffei (protocollo), c. 146t.–148t., 8 Feb. 1558 m.v. (1559).

101. Archivio Patriarcale di Venezia, Parrochia di S. Giuliano, unnumbered busta, 'Copia Fedelmente estratta Dall'Autentica Schedula conservata nell'-Archivio delle Decime Del Clero in Rialto . . . Presentata li 2. Ottobre 1564'.

102. Ibid.

103. Biblioteca Correr 1432, 'Raccolta di legali Istromenti, di Testamenti, e di altre carte ricavate dagli originali che si conservano nell'Archivio, Parrocchiale, e Collegiata Chiesa di S. Giuliano di Venezia', pp. 55–57, 26 Apr. 1566.

104. Schulz, *Venetian Painted Ceilings*, cat. no. 6;

Wolters, op. cit., pp. 79–80.

105. *Visitationes Apostolicae* . . ., c. 102–106t.

106. Archivio Patriarcale di Venezia, Parrocchia di S. Giuliano, busta of miscellaneous 16th-century documents, c. 44–49, 21 Feb. 1593.

107. Temanza, *Vite dei più celebri architetti* . . ., p. 251. Gallo's researches have revealed that Vittoria also assisted Sansovino in the preparation of the model of Rangone's statue for casting (Gallo, op. cit., p. 103).

108. See R. Predelli, 'Le memorie e le carte di Alessandro Vittoria', *Archivio Trentino*, xxiii (1908), pp. 192–93.

109. See E. Bassi, 'Il Sansovino per l'ospizio degli Incurabili', *Critica d'Arte*, lvii–lviii (1963), pp. 46–62. Bassi published the Fustinelli plans for the first time, and examined the church in the context of the whole history of the hospital.

110. B. Pullan, *Rich and Poor in Renaissance Venice* (Oxford 1971), pp. 206 ff.

111. Ibid., pp. 223 and 235.

112. Ibid., pp. 235–36; Cicogna, *Iscrizioni veneziane*, v, p. 309. Cicogna gives a full account of the history of the hospital, including the references from Sanudo's diaries and documents from the now lost archives of the hospital (ibid., v, pp. 297–405).

113. ASV, Proveditori sopra Ospitali e Luoghi Pii, b. 71, fasc. 118, Regolarmenti interni (later summary), 27 Sept. 1524. There were 33 *putti* at the time of this entry.

114. Pullan, op. cit., p. 236.

115. Ibid., p. 258. In 1527 Thiene and Carafa were delegated by the Governors of the Incurabili to represent the interests of the hospital at the Holy See (ibid.).

116. Ibid., pp. 264–65.

117. Maggior Consiglio, Deliberazioni, reg. 27 NOVUS, c. 39, 7 Jan. 1538 m.v. (1539).

118. D. Giovan Paolo da Como, *Ordini et Capitoli della Compagnia dell'Oratorio il quale è nell'Hospitale degli Incurabili in Venetia* (Venice 1568); and Pullan, op. cit., pp. 403–04.

119. Cicogna, *Iscrizioni veneziane*, v, pp. 309–10. In 1525 Pope Clement VII conceded to the hospital 'grazie, indulgenze, e privilegi' (ibid., p. 310). His *indulto* called for the annual appointment of a good priest to give the Papal benediction, and for the hospital to be directly under the protection of Rome and free from patriarchal or episcopal intervention (Biblioteca Correr, MS. Gradenigo–Dolfin, 171, Luoghi Pii, c. 173).

120. Sansovino–Martinioni, p. 272.

121. Cicogna, *Iscrizioni veneziane*, v, pp. 306–09.

122. Senato Terra, f. 44, 22 Sept. 1565:
'Serenissimo Principe: Illustrissima Signoria. Humilmente à piedi di Vostra Serenita Ricorremo

Noi Governatori Del povero et Miserabil vostro Hospital de M. Jesu Christo djncurabili Narando a vostra serenita, Conciosia che La Gesia nostra de legname, qual dal Principio della fundatione de ditto Hospitale fù fatta del 1521 [m.v. = 1522] è In malissimo Termine, Tutta marza, et va in manifesta Ruina, et non è possibile tenerla più in piedi, Essendo astretti da Estrema Necessita di Dover al tutto rifarla, si è Deliberato far'una opera perpetua de Muro cum quella Minor spese che sia possibile, (non comportandola) la Tenuita, et Miseria Infinita del Detto Hospitale, per le Incredibile, et Infinite spese, che ci vanno di continuo nel curar, et nutrir gl'infermi, et altri di continuo sono da boche no. 350 in ca., et talvolta 400, non volendo prevenir li Poveri Miserabili, et gli orphani destituti, quali di continuo Pregano la Maesta de Dio Benedetto, per la conservatione di vostra serenita. Et exaltatione de questo Inclito Dominio, et quelle Dispensassimo nella fabrica della gesia. Pur Circa questa fabrica ci è fatto molte consideratione: et Deliberatione: et forzo ci è al tutto fabricar ditta gesia per poter In quella Essercitar li Divini offitij, et Principalmente la predica del verbo de Dio, Dalla quale se Traze pur qualche sovegno, per Manutentione del Detto Hospitale, et volendo fabricar vediamo non poter far senza laiuto delli buoni: et amorevoli Cristiani verso le operationi Pie: Religiose: et Sante: per poter dar Principio nostro à questa buona operatione Ci hà parso primo ricorrer a piedi di vostra celsitudine Religiosissimo Serenissimo Principe come protector, et singular Benefattor de ciascun loco pio, et particularmente del sodetto suo Hospedal djncurabili, et supplicamo Humilmente vostra Serenita che quella sia contenta per sua pieta: et benegnita concederci qualche pio suffragio di quella quantita, et qualita de danari che parera alla serenita vostra come altre volta per quella fù conceduto a diversi Monasterij et loci pii cioe a san francesco della vigna, alle monache de san daniel. al corpus Domini Santo. Isepo et a santa croce di venetia et altri loci pij. accio possiamo Ridur ditta fabrica à perfettione, a laude, et gloria di Nostro Signor Dio benedetto et utile di questo povero, et miserabil luoco. Et alla bona gratia di Vostra Serenita humilissimamente ci Raccomandamo.

123. Ibid.

124. Cicogna, *Iscrizioni veneziane*, v, p. 310, 15 Jan. 1566 (presumably m.v. (= 1567)), from a document in the archives of the Incurabili.

125. Ibid., document of 12 Mar. 1566, contract for ironwork.

126. Senato Terra, f. 48, 29 Feb. 1566 m.v. (1567).

127. Corner, *Ecclesiae Venetae* . . ., v. p. 151.

128. Sansovino–Martinioni, p. 272: 'Fatto per tanto il luogo di legno, Pietro Contarini che fu poi

Vescovo di Basso, fu il primo, che lo fondasse di muro. & non molto dopo, Antonio Centani Caualiero figliuolo di Marco, diede principio alla Chiesa ouata, sul modello del Sansouino.' The document quoted in note 122 implies that Francesco Sansovino was mistaken in his statement that an intermediate brick church built by Pietro Contarini replaced the original wooden structure before Sansovino's oval church was erected.

129. Elena Bassi discovered two plans of the hospital (ground and first floors) in the Biblioteca Correr, MS. P.D. c. 818/31 (Bassi, op. cit., figs. 77 and 78). The 18th-century engraving of the interior of the church in the Biblioteca Correr (photo M.4636) shows the celebration of holy communion on Giovedi Grasso. Lazzari's plan and section of the church in Bibl. Correr, Cod. Cic. 3236, I, are published in Cicogna, *Iscrizioni Veneziane*, v, pp. 315 and 316. The hospital was taken over by the Commune in 1807. In 1819 it became a barracks and the church was closed. The marble and paintings were removed in 1825, and in 1831 the church was pulled down (G. Tassini, *Edifici di Venezia distrutti o volti ad uso diverso* (Venice 1885), pp. 73–74). The 17th-century high altar was sold to the cathedral church of Vittorio Veneto, while two of the four original side altars—simple pedimented Corinthian altars in Istrian stone—are now on either side of the nave of the church of S. Giovanni dei Cavalieri di Malta in Venice (Plate 71). An inventory of the marble and stone in the church, prepared at the time of demolition, is preserved in Bibl. Correr, MS. P.D.c. 716/11 (24); and Cod. Cic. 3236, I, contains an inventory of the paintings.

130. Bassi, op. cit., p. 49. Building work was in progress in the mens' infirmary in 1572 and in the womens' infirmary in 1588. In the latter year the Senate allotted a grant of 1,500 ducats to enlarge the hospital (Cicogna, *Iscrizioni veneziane*, v, p. 311). The notion of placing the hospital church in a courtyard recalls Filarete's Ospedale Maggiore in Milan, a project which Venetians could have known from the account in his treatise (J. R. Spencer (ed.), *Filarete's Treatise on Architecture* (New Haven, Conn. 1965), i, p. 311). There was a fine manuscript copy of Filarete's treatise in the monastic library of Santi Giovanni e Paolo in Venice.

131. S. Serlio, *Tutte l'opere d'architettura et prospettiva* (Venice 1619), c. 204t.; W. Lotz, 'Die ovalen Kirchenräume des Cinquecento', *Römisches Jahrbuch für Kunstgeschichte*, vii (1955), pp. 7 ff.; J. S. Ackerman and W. Lotz, 'Vignoliana', in *Essays in Memory of Karl Lehmann* (New York 1964), pp. 1 ff. It is intriguing that the church of the syphilis hospital in Rome, San Giacomo degli Incurabili, designed by Francesco da Volterra and begun in 1592, is also oval in plan (see Lotz and Heydenreich, op. cit., pp. 282–83).

132. On the Incurabili choir see Bassi, op. cit., pp. 46–48; Cicogna, *Iscrizioni veneziane*, v, pp. 317–25; S. H. Hansell, 'Sacred Music at the Incurabili in Venice at the time of J. A. Hasse', *Journal of the American Musicological Society*, xxiii (1970), pp. 282–301, 505–21. An anonymous pamphlet on the supervision of the orphanage indicates how strictly isolated the girls were kept (*Capitoli et ordini da osservarsi dalla Priora, Maestre, e Figlie del Pio Ospitale dell' Incurabili, rinovati dalla Pia Congregatione il dì 27. Genaro 1704* (Venice 1754)).

133. See E. Bassi, *Architettura del Sei e Settecento a Venezia* (Naples 1962), pp. 314–21.

134. See Francesco Caffi's letter to Cicogna about music at the Incurabili (Cicogna, *Iscrizioni veneziane*, v, pp. 325–32, especially p. 330).

135. On the development of the *coro spezzato* in Venice, see G. D'Alessi, 'Precursors of Adriano Willaert in the Practice of Coro Spezzato', *Journal of the American Musicological Society*, v (1952), pp. 187–210; D. Arnold, 'The Significance of "Cori Spezzati"', *Music and Letters*, xl (1959), pp. 4–14; and the treatise written by Willaert's pupil Zarlino, G. Zarlino, *Le istitutioni harmoniche* (Venice 1562 edn.), p. 268.

136. See above, p. 31.

137. The ceiling decoration was executed between 1635 and 1644 (Cicogna, *Iscrizioni veneziane*, v, pp. 311–13). See also Schulz: *Venetian Painted Ceilings*, p. 55.

138. A. Palladio, *I quattro libri . . .*, Libro IV, p. 6; S. Serlio, *Tutte l'opere . . .*, c. 202.

139. Vasari–Milanesi, vii, p. 507.

CHAPTER V

1. Scuola Grande della Misericordia, busta 166, Notatorio II, c. 238, 9 July 1531.

2. PS, Atti, registro 127 (ii), c. 11, 19 June 1545.

3. Brian Pullan, *Rich and Poor in Renaissance Venice* (Oxford 1971), pp. 33 ff. Professor Pullan's excellent and pioneering book has been an indispensable source in preparing this chapter.

4. Ibid., pp. 51–52, pp. 125 ff.

5. Ibid., pp. 99 ff.

6. See J. C. Davis, *The Decline of the Venetian Nobility as a Ruling Class* (Baltimore 1962).

7. Gasparo Contarini, *La Republica e i magistrati di Vinegia*, transl. from the Latin (1544), pp. 68–9. This treatise was probably begun in the 1520s (see Felix Gilbert, 'The date of the composition of Contarini's and Giannotti's books on Venice', *Studies in the*

Renaissance, xiv (1967), pp. 172–84).

8. Pullan, op. cit., pp. 63 ff.

9. Ibid., pp. 37–38. The Scuola di San Marco was originally established at the church of Santa Croce in Luprio, but moved in 1437 to a new site provided by the Dominicans at Santi Giovanni e Paolo. The Scuola di San Giovanni Evangelista was founded at the church of Sant'Apollinare, and was transferred to its present site at the beginning of the 14th century. The first confraternity of San Rocco, established much later in 1478, was located at San Giuliano. Two years later it merged with another *scuola* dedicated to the same saint at the Frari, but after a quarrel with the friars four years later the institution was installed briefly at San Silvestro. Meanwhile a special church was erected near the Frari to house the saint's body, which was brought from Germany to Venice at the end of the 15th century; and in 1515 the Scuola began their own building beside this new church. See Sansovino–Martinioni, pp. 281 ff.; F. Corner, *Notizie storiche delle chiese e monasteri di Venezia* (Padua 1758), pp. 370 ff.; P. Paoletti, *La Scuola Grande di San Marco* (Venice 1929), pp. 13 ff.

10. Corner, op. cit., pp. 339 ff. See also three 19th-century pamphlets in the Biblioteca Correr, Cod. Cicogna 1133, nos. 21, 22 and 31.

11. The Scuola della Carità also enlarged their *albergo* in 1411/12, one of the many examples of parallel bursts of activity in the building and decorative projects of the Scuole. (This was kindly pointed out to me by David Rosand, who is preparing a monograph on the Scuola della Carità.)

12. Cod. Cicogna 1133, no. 31, p. 4.

13. On the construction of the 15th-century Scuola, see P. Paoletti, *L'architettura e la scultura del Rinascimento in Venezia* (Venice 1893), i, p. 55.

14. The Madonna relief, now in the Victoria and Albert Museum, was transferred to the doorway of the Scuola Nuova in the 17th century (Sansovino–Martinioni, p. 286).

15. Scuola Grande della Misericordia, b. 166, Notatorio II (1480–1544), c. 15t., 20 June 1492.

16. Sansovino–Martinioni, pp. 284–85.

17. Scuola Grande della Misericordia, b. 166, c. 15t. The new members were required to pay an entry fee of at least 10 ducats a head.

18. Ibid., c. 19, 24 Feb. 1492 m.v. (1493).

19. Ibid., c. 16t., 16–17 Sept. 1492. This motion, approved in the Council of Ten on 26 Sept. 1492, applied to all the Scuole Grandi, which were to set aside 200 ducats a year for building or decoration instead of distributing alms.

20. Ibid., c. 37t., 14 Jan. 1497 m.v. (1498). Again the Scuola was permitted by the Council of Ten to suspend the annual distribution of alms for 5 years to provide additional funds for the building programme, and to deposit 200 ducats at the salt office for the same purpose (ibid., c. 38, 25 Jan. 1497 m.v. (1498); approved by the Ten on 30 Mar. 1498).

21. Scuola Grande della Misericordia, b. 166, Notatorio II, c. 62, 5 Mar. 1503; and c. 64, 29 June 1503.

22. Ibid., c. 65, 19 July 1503; c. 67t., 9 June 1504; and c. 74, 16 Mar. 1505.

23. Ibid., c. 80t., 1 Apr. 1506. Cf. also ibid., c.75t., 20 Apr. 1505; and c. 76, 3 May 1505.

24. The inscription over the doorway is dated 1505.

25. Scuola Grande della Misericordia, b. 166, c. 82t., 8 Nov. 1506.

26. On 5 Aug. 1507 the Banca decided to accept the model by Alessandro Leopardi unless a better model was produced within the next month (ibid., c. 86t., 5 Aug. 1507). This model had been delivered in 1504, together with another by a stonemason called Sebastiano (ibid., c. 67, 26 Mar. 1504). On 21 Aug. 1507 the Banca considered a model submitted by Zuane Fontana and declared it superior to Leopardi's (ibid., c. 86). However, the entry in the Notatorio on 20 May 1509 records that a final decision had still not been reached (ibid., c. 105t.).

27. Ibid., c. 87, 10 Feb. 1507 m.v. (1508).

28. Ibid., c. 88t., 22 Apr. 1508; and c. 93, 21 Oct. 1508. In the same year it was decided to construct an arcade along the canal-front of the Scuola Vecchia to provide access to the Corte Nuova (ibid., c. 91, 9 May 1508).

29. Ibid., c. 96, 1 and 18 Feb. 1508 m.v. (1509). Payments for work on the *sottoportego* beneath the old Scuola, and on the *fondamenta* or water-front on the site of the new building, from April 1508 until April 1509, are recorded in accounts given in the Notatorio (ibid., c. 99t.–103t.). These accounts also record the entry of Pietro and Tullio Lombardo as *fratelli* (ibid., c. 102t., 30 Mar. 1509).

30. Ibid., c. 105t., 20 May 1509. The Capitolo decided to elect 20 former members of the Banca to help the present Banca and the four *deputati sopra la fabrica* to choose the model. The only flicker of interest during this interlude seems to have been a further decision of the Banca to commission a model for the Scuola from Leopardi on 2 Dec. 1515 (ibid., c. 135t.).

31. Ibid., c. 167, 22 Nov. 1523. On the Scuola's contribution to the war effort, see Pullan, op. cit., p. 147.

32. Scuola Grande della Misericordia, b. 166, c. 176t., 6 Aug. 1525; and c. 178, 17 Dec. 1525. It was resolved that each Guardian Grande should put 500 ducats towards the building fund (ibid., c. 178t., 17 Dec. 1525); and two of the Zonta were elected as extra

deputati sopra la fabrica (ibid., c. 187t., 18 Nov. 1526).
33. Ibid., c. 232, 5 Feb. 1530 m.v. (1531).
34. Ibid., c. 230, 22 Jan. 1530 m.v. (1531). These so-called *deputati sopra la fabrica* were four in number.
35. Ibid., c. 232, 12 Feb. 1530 m.v. (1531).
36. Ibid., c. 232t.–233, 24 Feb. 1530 m.v. (1531). It later turned out that Paseto was an outrageous swindler. In 1538 he was accused of numerous fraudulent activities by the Scuola and declared bankrupt (ibid., c. 359, etc.).
37. Ibid., c. 238, 9 July 1531. The voting was as follows:

no. 1 mro. Jacopo Sansovino
 de si no. 25 de no no. 17
no. 2 mis. pietro vido
 de si no. 17 de no no. 25
no. 3 ser allexandro del Cavalo
 de si no. 6 de no no. 36
no. 4 mro. vielmo de Jacopo
 de si no. 13 de no no. 29
no. 5 mro. Zuan maria falchoneto
 de si no. 9 de no no. 33

Leopardi's model may have been either the one delivered in the first decade of the century, or a later model requested by the Scuola in 1515 (Paoletti, *L'architettura e la scultura*, i, p. 248).
38. F. Sansovino, *Delle cose notabili che sono in Venetia* (Venice 1561), c. 29.
39. Scuola Grande della Misericordia, b. 166, c. 256t., 13 Oct. 1532.
40. Ibid., c. 255t., 10 Sept. 1532.
41. Ibid., c. 254t., 4 Sept. 1532.
42. The agreement of 5 Apr. 1505, referring to the straightening of the *fondamenta*, gave '. . . licentia, liberta et auctorita a esso guardian e Compagni et a suo successori in perpetuo poter su dicta fondamenta si facta come da esser facta far far Capitellj meter Collone, Collonele, et tuti lj altri ornamenti lj parera et piacera per ornamento di essa schola, non cover-zando quella altramente che cum capitellj e pozuolj . . .' In other words, the Scuola could be built with any appropriate ornamentation, provided that the *fondamenta* was not covered. (The agreement was transcribed in the Notatorio on 12 July 1530, ibid., c. 234t.–235.) From the entry in the Notatorio on 4 Sept. 1532 it appears that Sansovino's model contra-vened this clause: '. . . volendosi fabrichar dita scholla nostra In Colone segondo chome per el modelo aprobato apar saria de Direto Contra la forma de dito Instrumento et mete la Scuola In perpetua lita con dito prior Et Zentilomenj Da Camoro cossa veramente Da fuzir . . .' However, the architect assured the *deputati sopra la fabricha* that his model could be adjusted to satisfy the conditions of the lease (ibid., c. 255).

43. Ibid., c. 284t.–285, 16 and 26 Apr. 1535.
44. Sansovino–Martinioni, p. 285.
45. Scuola Grande della Misericordia, b. 166, c. 254t., 4 Sept. 1532; and c. 285t., June 1535. On 1 May 1534 the contract was settled with Simplizio Moro, a stonemason, to construct the stone bridge which was to replace the wooden one at the end of the new *fondamenta* leading to the church of the Misericordia (ibid., c. 273, contract drawn up on 29 Oct. 1533). The previous year, after repeated pressure from the Proveditori di Comun, the Scuola had provided 100 ducats for the replacement of this bridge (ibid., c. 255t., 10 Sept. 1532; and Proveditori di Comun, Atti, b. 9, Libro 7, c. 132, 22 Apr. 1533). The walls of the Scuola were begun by 4 July 1535 (Scuola Grande della Misericordia, b. 166, c. 285t.).
46. Consiglio di Dieci, Comuni, reg. 12, c. 6, 12 Mar. 1537. See Pullan, op. cit., p. 90.
47. Consiglio di Dieci, Comuni, reg. 12, c. 41t.–42, 20 June 1537. A month later the Misericordia was authorised to accept 56 new *fratelli* to make up the quota of 120 galleots demanded by the state and to draw on further trust funds to finance the campaign (ibid., c. 52t., 27 July 1537).
48. The Misericordia's petition to be allowed to use money from both the dowry fund and the building fund, and to accept as many galleot volunteers as necessary as well as 70 *homini de Rialto* at 4 ducats each, was approved by the Ten on 10 July 1539 (Consiglio di Dieci, Comuni, reg. 13, c. 38). See also Pullan, op. cit., pp. 147–49, and 175, and Scuola Grande della Misericordia, b. 166, c. 379t., 22 Mar. 1542.
49 Scuola Grande della Misericordia, b. 166, c. 345t., 12 Sept. 1540.
50. Ibid., c. 285t., 4 July 1535.
51. Ibid., c. 409t.–410, 25 May 1544.
52. Ibid., c. 178t., 17 Dec. 1525. The annual sum of 500 ducats was to be added to the income accumu-lated from investments in the Salt Office for the building.
53. Consiglio di Dieci, Parti Comuni, reg. 7, c. 11–12, 29 Mar. 1531. In 1535 the same policy was reiterated, this time to remain in effect not for 5 years only but until the building was finally completed (Scuola della Misericordia, b. 253, Parti della Scuola, fasc. 1, 27 Feb. 1534 m.v. (1535)).
54. Scuola della Misericordia, b. 166, c. 269, 19 Oct. 1533.
55. Ibid., c. 283t., 11 Apr. 1535.
56. Ibid., c. 288t., 14 Nov. 1535. This motion pro-vided for the admission of 100 *fratelli* at 6 ducats a head 'to assist the completion of the building of our new Scuola'. A recent decision to elect 30 new members at 3 ducats a head had been intended

chiefly to increase the numbers available for election to office, but the entry fees would be contributed to the building fund just the same (ibid., c. 281t., 12 Mar. 1535).

57. Ibid., c. 284, 11 Apr. 1535.

58. Ibid., c. 286t., 26 July 1535.

59. Ibid., c. 302t., 14 Feb. 1536 m.v. (1537).

60. Ibid., c. 342, 9 May 1540.

61. A. Caravia, 'Il Sogno di Caravia' (Venice 1541), Biblioteca Marciana, Misc. 2477–74, c. 13. See Pullan, op. cit., pp. 117 ff.

62. Scuola Grande della Misericordia, b. 166, c. 231t., 5 Feb. 1530 m.v. (1531).

63. Consiglio di Dieci, Comuni, reg. 9, c. 144–46, 30 Dec. 1533; and Pullan, op. cit., pp. 80 ff.

64. On 23 Aug. 1545 an application was made to the Council of Ten to elect 50 *fratelli di banca* at 4 ducats a head and 50 *di disciplina* at 2 ducats a head (Scuola della Misericordia, b. 253, Parti della Scuola, fasc. 1). On 26 Sept. 1550 the Scuola was authorised to accept 40 *fratelli di banca* at 5 ducats a head (Consiglio di Dieci, Comuni, reg. 19, c. 162). On 17 Mar. 1553 a request to admit a further 25 *fratelli di banca* at 4 ducats a head was approved by the Ten (ibid., reg. 21, c. 3t.). On 31 Aug. 1554 the Council of Ten permitted the election of 80 new members including 40 *fratelli di banca* at 4 ducats each (ibid., c. 124t.).

65. Ibid., filza 67, c. 110, 23 Jan. 1555 m.v. (1556). The Scuola was authorised to admit 60 *fratelli di disciplina*, and their fees of 2 ducats a head were to be contributed towards the building.

66. Ibid., reg. 25, c. 1t.–2, 6 Oct. 1560.

67. Scuola della Misericordia, b. 253, fasc. 2, 15 June 1561. 60 new *fratelli di disciplina* had only just been accepted into the Scuola at a minimum fee of 1 ducat per head (Consiglio di Dieci, Comuni, reg. 25, c. 1t., 14 Mar. 1561).

68. Ibid., c. 49, 26 Sept. 1561.

69. Consiglio di Dieci, Comuni, reg. 127, c. 10, 30 Mar. 1565.

70. Scuola Grande della Misericordia, b. 9, Mariegola Riformata (1564). Provisions to regulate the spending on the building had been taken on previous occasions. On 25 Nov. 1554 the Capitolo resolved that each of the four *deputati sopra la fabrica*, who since 1540 had been elected for two-year periods rather than for life, should serve a six-month term as treasurer of the building fund (Scuola della Misericordia, b. 253, fasc. 1). In 1561 measures were taken to improve the keeping of the Scuola accounts, including the building expenses (ibid., fasc. 2, 10 Mar. 1561).

71. Scuola Grande della Misericordia, b. 167, Notatorio IV, c. 2t., 21 Sept. 1567.

72. Ibid., c. 27t.

73. Ibid., c. 24t., 27–28 Mar. 1569.

74. Ibid., c. 34, 28 Oct. 1569.

75. Vasari–Milanesi, vii, p. 503. Vasari's statement that 130,000 ducats were spent on the building must surely be exaggerated, for even work on the Library and the Mint cost only about 30,000 ducats each during Sansovino's career (see chapter II), while about 50,000 ducats was spent on the sumptuous new Scuola di San Rocco (Pullan, op. cit., p. 130). But if at least 500 ducats were as a rule contributed towards the building each year from 1525 onwards, the expense must have amounted to well over 20,000 ducats by the time of Sansovino's death.

76. Sansovino–Martinioni, p. 286.

77. Scuola Grande della Misericordia, b. 167, c. 55t.–56, 14 Jan. 1570 m.v. (1571). In the same year Francesco Sansovino, then an officer of the Banca, was reprimanded for neglecting his duties to appear as a flagellant in processions (ibid., c. 61t., 30 Apr. 1571).

78. Ibid., c. 119, 6 Apr. 1576. Unfortunately the third Notatorio, recording the proceedings of the Banca and Capitolo from 1544 to 1567, is missing, so that it has been impossible to give more than a sketchy account of the progress of the building during this period.

79. Museo Civico, Vicenza, Inv. D.18. Howard Burns has discussed this drawing in the exhibition catalogue *Mostra del Palladio* (Vicenza 1973), pp. 152–53; and he will add a further comment in the forthcoming issue of the *Bollettino del Centro . . . Andrea Palladio*. See also L. Puppi, *Andrea Palladio* (Milan 1973), ii, cat. no. 111.

80. In the late 1580s Tintoretto was to use the enormous deserted room to paint the huge canvasses for his picture *Paradise* for the Doge's Palace (C. Ridolfi, *Le maraviglie dell'arte*, ed. D. von Hadeln, ii (Berlin 1924), p. 61).

81. Scuola Grande della Misericordia, b. 9, Mariegola Riformata, c. 53.

82. Ibid., c. 52–56, Nov. 1570. The Scuola di San Cristoforo, like the Misericordia nominally dedicated to the Mercadanti (merchants), had first suggested the merger in 1556 (ibid., c. 27, 25 Jan. 1555 m.v. (1556)). See also Scuole Piccole e Suffragii, b. 436, c. 94–99; and Sansovino–Martinioni, pp. 165–68.

83. Scuola Grande della Misericordia, b. 167, c. 150–150t., 26 Nov. 1578; and c. 186, 4 Mar. 1581.

84. Ibid., c. 203t., 30 Dec. 1582.

85. Ibid., c. 52t., 18 June 1570; and c. 57, 23 Feb. 1570 m.v. (1571).

86. Ibid., c. 248t., 23 Feb. 1585 m.v. (1586). This resolution which determined to accept no more *fratelli* for 10 years was, however, soon contravened.

In 1589 a further 100 *fratelli di disciplina* were admitted, and their entry fees put towards buying materials for the stairs (ibid., c. 300, 18 Mar. 1589).

87. Ibid., c. 287t., 22 Apr. 1588. In this motion the Scuola stressed the need for economies in all their activities. They also decided to borrow a capital sum of 500–1,000 ducats for building work.

88. Ibid., c. 274, 14 May 1587; c. 280t., 20 Dec. 1587; c. 283t., 20 Jan. 1587 m.v. (1588); and c. 299, 27 Feb. 1588 m.v. (1589).

89. Ibid., c. 291t.–292t., 12 Dec. 1588.

90. Ibid., c. 203t., 211t., and 292t.

91. Ridolfi, op. cit., ii, pp. 64 and 257–58; Lorenzetti, *Itinerario sansoviniano*, p. 78. (One cannot discount the possibility that Ridolfi's account in fact refers to the Scuola di S. Cristoforo.)

92. Scuola Grande della Misericordia, b. 167, c. 304t., 24 June 1589.

93. Ibid., c. 308t., 29 Oct. 1589. A splendid floor in squares of fine white marble with stripes of green and black from the upper room of the Scuola was transferred to the Marciana Library in the Napoleonic era, but has since disappeared (Biblioteca Marciana, Cod. Marc. It. VII, 2148 (=9116), 'Biblioteche pubbliche e private, antiche e moderne in Venezia . . . Memorie raccolte da Franceso Fapanni' (1891), p. 9).

94. Avogaria di Comun 18/1, Deliberazioni di Maggior Consiglio, c. 36, 29 Aug. 1272; Cancelleria Inferiore (Doge), b. 209, Atti ed Istrumenti appartenenti ai Beni della Ca' di Dio, c. 3t.–4, 31 Aug. 1272.

95. Cancelleria Inferiore (Doge), b. 211, Ca' di Dio, fasc. 4. The Capitolo of the parish church of San Martino proposed the building of the church on 10 Aug. 1364, and permission was granted by the Patriarch of Grado on 6 Sept. (Cancelleria Inferiore (Doge), b. 212, Ca' di Dio, fasc. 6, c. 40).

96. Ibid., c. 8, n.d.

97. Cancelleria Inferiore (Doge), b. 209, c. 175t., 1 May 1527. Alvise Gritti was elected prior on 23 Sept. 1523 (Biblioteca Correr, MS. Gradenigo–Dolfin 171, Luoghi Pii, c. 53).

98. PS, reg. 125, Atti, c. 138t., 5 Dec. 1542. The new prior was Andrea Gritti, son of Lorenzo.

99. Ibid., c. 141, 4 Jan. 1542 m.v. (1543); c. 150, 6 Apr. 1543; and c. 160, 14 Aug. 1543.

100. PS, b. 109, proc. 256, Ca' di Dio, 20 Aug. 1544.

101. PS, reg. 127 (i), Atti, c. 19, 19 May 1545. The model was approved on 19 June 1545 (ibid. (ii), c. 11). See the account of the project by R. Gallo, 'Contributi su Jacopo Sansovino', *Saggi e Memorie*, i (1957), pp. 91–94.

102. PS, b. 109, proc. 256, 22 June 1545.

103. Ibid., 4 Oct. 1546.

104. Miscellanea Gregolin di Carte private, b. 48, 22 June 1547, with autograph signature by Sansovino.

105. PS, Atti, reg. 127 (ii), c. 19, 18 Dec. 1547. On 4 June 1548, finding himself too busy to carry out the responsibilities, the Doge delegated a certain Doctor Antonio Zucholo to supervise the running of the Ca' di Dio to ensure that the finances be properly administered and to see to the health and welfare of the inmates (Cancelleria Inferiore (Doge), b. 213, fasc. 9, c. 39).

106. PS, b. 109, proc. 256.

107. Ibid.

108. Cancelleria Inferiore (Doge), b. 211, fasc. 3, no. 35, 7 June 1570; Collegio, Notatorio, filza 36, 18–20 June 1570. The healthy state of the finances had prompted the Maggior Consiglio to pass a motion in 1556 ordering the saving of any surplus cash left over after the prior's salary of 300 ducats a year had been paid, and the women's needs attended to, to be used for the building of extra rooms at the time of the election of the next prior (Maggior Consiglio, Deliberazioni, reg. 28 ROCCA, c. 46, 7 June 1556).

109. Cancelleria Inferiore (Doge), b. 211, fasc. 3, no. 27, after 6 Feb. 1622 m.v. (1623).

110. The façade was given a new look in 1750 (Biblioteca Correr, MS. Gradenigo–Dolfin 171, c. 43). Extensive enlargements to the living quarters were carried out at the beginning of the 17th century (Cancelleria Inferiore (Doge), b. 211, fasc. 1, c. 4–4t., and c. 61–61t.).

111. Cancelleria Inferiore (Doge), b. 211, fasc. 3, no. 9, 2 Aug. 1595; ibid., b. 213, fasc. 9, c. 1, 10 Dec. 1587.

112. Ibid., b. 211, fasc. 1.

113. Ibid., fasc. 2.

114. Ibid., b. 213, fasc. 12–13, 1616–17.

115. Ibid., fasc. 14, 1624–25.

116. Ibid., b. 211, fasc. 1, c. 4.

117. Maggior Consiglio, Deliberazioni, reg. 35 Arcangelus, c. 115, 19 Aug. 1623.

118. Cancelleria Inferiore (Doge), b. 211, fasc. 3, no. 27.

119. Ibid., b. 210, fasc. 2, nos. 13–14; and b. 211, fasc. 3, nos. 17 and 24. See D. L. Gardani, 'La Dogale Ca' di Dio in Venezia', *Ateneo Veneto* N.S. ii, part 1 (1964), pp. 112–16.

120. See J. C. Davis, *The Decline of the Venetian Nobility as a Ruling Class* (Baltimore 1962); B. Pullan, 'Service to the Venetian State', *Studi Secenteschi*, v (1964), pp. 95–147.

CHAPTER VI

1. W. Thomas, *The History of Italy* (1549), ed. G. B. Parks (Cornell 1965), p. 65.

2. The Palazzo Gaddi is fully discussed in C. L. Frommel, *Der Römische Palastbau der Hochrenaissance* (Tübingen 1973), i, pp. 120–22; ii, cat. no. XVI, pp. 198–206; iii, Plates 78–81.

3. On the structure of Venetian noble families see especially C. Yriarte, *La Vie d'un patricien de Venise au 16e siècle* (Paris 1874); F. C. Lane, *Andrea Barbarigo Merchant of Venice, 1418–1449*, The Johns Hopkins University Studies in History and Political Science, vol. LXII, no. 1 (Baltimore 1944); idem, 'Family Partnerships and Joint Ventures in the Venetian Republic', *Journal of Economic History*, iv (1944), pp. 178–96; J. C. Davis, *The Decline of the Venetian Nobility as a Ruling Class*, The Johns Hopkins University Studies in History and Political Science, vol. LXXX, no. 2 (Baltimore 1962); B. Pullan, 'Service to the Venetian State', *Studi Secenteschi*, v (1964), pp. 95–147, esp. pp. 135 ff.

4. On the evolution of Venetian palace architecture see the dated but informative book T. Okey, *The Old Venetian Palaces and the Old Venetian Folk* (London 1907).

5. See the full accounts of Venetian building techniques by A. Sagredo, *Sulle consorterie delle arti edificative in Venezia* (Venice 1856), pp. 37–45, and M. Pavanini, 'Traditional House Construction', *Architectural Review*, cxlix (May 1971), special issue devoted to Venice, pp. 297–302. On the supplies and costs of material see also A. Wirobisz, 'L'attività edilizia a Venezia nel XIV e XV secolo', *Studi Veneziani*, vii (1965), pp. 307–43. On timber supplies in Venice see F. C. Lane, *Venetian Ships and Shipbuilders of the Renaissance* (Baltimore 1934), pp. 217–33.

6. Sansovino–Martinioni, pp. 383–84. Francesco Sansovino's chapter on Venetian palaces (pp. 381–89) is an essential and rich source.

7. M. Lutyens (ed.), *Effie in Venice, Unpublished Letters of Mrs. John Ruskin written from Venice between 1849 and 1852* (London 1965), p. 81.

8. T. Temanza, *Vite dei più celebri architetti e scultori veneziani* (Venice 1778), p. 267.

9. Sagredo, op. cit., pp. 44–45; E. R. Trincanato, *Venezia minore* (Milan 1948), p. 110. The latter source, though dealing with more humble types of buildings, gives a useful survey of the peculiarities of Venetian architecture.

10. Sansovino–Martinioni, p. 384.

11. Ibid. An explanation of the workings of a Venetian well is given in Trincanato, op. cit., pp. 112–15.

12. P. Paoletti, *L'architettura e la scultura del Rinascimento in Venezia* (Venice 1893), i, pp. 187–88.

13. Sansovino–Martinioni, p. 387.

14. See the sources cited in note 3, and also B. Pullan (ed.), *Crisis and Change in the Venetian Economy in the Sixteenth and Seventeenth Centuries* (London 1968); and O. Logan, *Culture and Society in Venice 1470–1790* (London 1972).

15. The attribution of the palace to Sansovino is given both by his son Francesco (Sansovino–Martinioni, p. 388) and by Vasari (Vasari–Milanesi, vii, p. 503). According to Vasari the cost of the new palace was 30,000 ducats.

16. The early career of Zuanne Dolfin is fully documented in the diaries of Sanudo (*Diarii*, vols. 34 ff.). Between 1524 and 1529 he held the offices of Podestà & Capitanio a Bassan, Podestà de Ixola, Proveditor sopra la Revision dei Conti, Avogador di Comun, Savio a Terraferma, Capitanio a Bergamo, and Proveditor General in Campo. As one of the two Proveditori Generali he welcomed the Emperor at Peschiera in April 1530, returning to Venice immediately afterwards (Sanudo, *Diarii*, vol. 53, pp. 152–53, 181).

17. Ibid., vol. 54, p. 621; vol. 55, pp. 5, 13, 15.

18. Ibid., vol. 56, pp. 6, 281; vol. 57, p. 64 etc.

19. Ibid., vol. 58, p. 731. In 1546 he was elected a public censor (Secretario alle Voci, reg. ex 8 (1523–56), c. 75t.).

20. See the tax declarations of Zuanne's father Lorenzo and his uncle Francesco returned in 1514 (Dieci Savi sopra le Decime in Rialto, b. 63, Redecima 1514, S. Salvador, nos. 16 and 18).

21. Giudici del Piovego, b. 24, Libro de mesure principia 1526 . . ., c. 55–55t., 9 June 1536. This document and those cited in notes 23, 25 and 26 were first quoted in R. Gallo, 'Contributi su Jacopo Sansovino', *Saggi e Memorie*, i (1957), p. 87.

22. Proveditori di Comun, b. 10, Atti 1534–45, Libro no. 9, c. 7–7t., 12 Jan. 1537 m.v. (1538); Ibid., c. 9t., 15 Jan. 1537 m.v. (1538); Ibid., c. 11–11t., 21 Jan. 1537 m.v. (1538).

23. Dieci Savi sopra le Decime in Rialto, b. 93, Redecima 1538, S. Marco, no. 607, 29 Apr. 1538.

24. Dieci Savi sopra le Decime, Traslati, b. 1234, c. 218, 28 Feb. 1539 m.v. (1540).

25. Giudici del Piovego, b. 21, reg. Misure 1, c. 3t.–4, 10 May 1540.

26. Ibid., c. 28t.–29, 15 Apr. 1545.

27. The tax returns of Lorenzo and Andrea in 1581 state that they were then occupying the two main apartments of the palace (Dieci Savi sopra le Decime in Rialto, Redecima 1581, b. 157 bis, S. Marco nos. 737–38). A copy of the will of Zuanne, drawn up on 21 July 1547, is preserved in Archivio Dolfin, b. 1, fasc. 1. His death is recorded in the Necrologio dei Nobili, Avogaria di Comun, b. 159, reg. 1. Copies of the settlement of 16 May 1577, dividing his estate on the break-up of the *fraterna*, are found both in

Archivio Dolfin, b. 2, fasc. III, no. 1; and in Atti Protocolli, Pietro Giovanni Mamoli, b. 8296, c. 206t.–214.

28. See D. R. Paolillo and C. Dalla Santa, *Il Palazzo Dolfin Manin a Rialto* (Venice 1970). The most complete written description of the interior is the estimate of the value of the property prepared in 1787 (Archivio Dolfin, b. 22, fasc. XVII, no. 13). A series of five plans of the palace (ground floor, mezzanine, *piano nobile*, second floor and attic) is found in the same *fascicolo*. Another copy of the 1787 description is preserved in the Archivio di Stato di Udine (Archivio Manin, cartella 45), together with full information on the reconstruction of the palace in the 1790s.

29. The plans indicate a four-bay loggia on one side of the courtyard only, but Francesco's comment that the *cortile* was 'circondato di loggie all'usanza Romana' suggests that all the main rooms overlooking the court were provided with balconies (Sansovino–Martinioni, p. 388).

30. The Palazzo Grimani at San Luca was commissioned by Girolamo Grimani between 1556 and 1559, and erected from Sanmicheli's model under the supervision of Gian Giacomo de'Grigi. The work was still in progress as late as 1575, although the palace was then habitable. See R. Gallo, 'Sanmicheli a Venezia', in *Michele Sanmicheli, Studi raccolti dell'Accademia di Agricoltura, Scienze e Lettere* (Verona 1960), pp. 97–160, especially pp. 120–25. The Grimani were not among the most ancient distinguished families of the Venetian patriciate, but rose to prominence as late as the 15th century when Antonio Grimani made a vast fortune in trade. Antonio later became Doge, but died after only two years in office in 1523. Girolamo Grimani, Cavaliere and Procurator, who built the great palace at San Luca, was the father of Doge Marino Grimani. The palace was later the setting for the magnificent celebrations for the coronation of the Dogaressa in 1597.

31. Zorzi made his will on the occasion of an exceptionally serious attack of gout on 25 July 1524 (Not. Testamenti, Giacomo Grassolario, b. 1183, no. 216). A day later one of his sons, the Cardinal Marco, died suddenly, apparently as a result of having rushed back from Rome by post-horse to be at his father's sickbed, though some attributed his death to an excessive dose of rhubarb syrup! (Sanudo, *Diarii*, vol. 36, pp. 491–92, 26 July 1524). The death of Zorzi occurred on 31 July 1527 (Sanudo, *Diarii*, vol. 45, p. 559). On the Corner family and their wealth see O. M. T. Logan, 'Studies in the Religious Life of Venice in the Sixteenth and early Seventeenth Centuries', unpublished Ph.D. thesis (Cambridge 1967), pp. 236 ff.

32. Sanudo, *Diarii*, vol. 56, p. 751.

33. Dieci Savi sopra le Decime, Traslati, reg. 1231, c. 186, 3 Feb. 1521 m.v. (1522), recording a sale completed on 1 Apr. 1517. Zorzi's heirs were still making payments for Pin's property in the 1530s (Biblioteca Correr, MS. P.D. 2384/18, c. 55). The sale had not yet been registered with the Tax Office in 1540 (Dieci Savi sopra le Decime in Rialto, Redecima 1540, b. 107, no. 1080).

34. Not. Testamenti, Grassolario, b. 1183, no. 216.

35. Sanudo, *Diarii*, vol. 56, pp. 751–4. The day after the fire the Senate issued a proclamation ordering all property salvaged or stolen from the burning palace to be handed in to the office of the Avogadori di Comun within three days. Looters who failed to comply with the order were liable to two years' imprisonment, a 500 *lire* fine, and 10 years' exile from Venice (Senato Terra, reg. 27, c. 47t., 17 Aug. 1532).

36. Sanudo, *Diarii*, vol. 56, p. 754. On the Corner family palaces, see the thoroughly documented article by R. Gallo, 'Sanmicheli a Venezia', pp. 112–18.

37. Sanudo, *Diarii*, vol. 57, pp. 478–79, 525–26. The second of these parties was to celebrate the wedding of Zuanne's daughter to an extremely wealthy noble, Piero Moresini, son of Zuan Francesco. The Corner family were by no means impoverished by the San Maurizio fire, for the bride had a huge dowry worth 10,000 ducats.

38. Sanudo, *Diarii*, vol. 56, p. 754.

39. Ibid., pp. 953, 975–76; and Consiglio di Dieci, Parti Comuni, reg. 8, c. 75–77t., 20 Sept. 1532. The sum of 30,000 ducats was dispatched from Cyprus in August 1533 (Sanudo, *Diarii*, vol. 58, pp. 187, 589).

40. See above, pp. 42–3 and p. 168, n. 118.

41. Details of the execution of Zorzi's will, compiled in about 1542, give the date for the beginning of the building work as 19 Oct. 1532 (Biblioteca Correr, MS. P.D. 2384/18, c. 55). Another version of the execution of the will, quoting the identical figures, states that this entry referred only to the *fondamenta* of the burnt palace (ibid., c. 61).

42. Giudici del Piovego, b. 24, Libro de Mesure, c. 31–31t., 27 June 1533.

43. 'Doue lascio io i fondamenti, in cui debbon fermarsi i superbi tetti Cornari?' (*Del primo libro de le lettere di M. Pietro Aretino* (Paris 1609), c. 191t.). See the English translation of this letter in Appendix I. In the case of the Scuola della Misericordia, the Zecca, the Library and the Loggetta, archival records of the progress of the building work indicate that Aretino's knowledge could not have been gained merely from on-the-spot investigation on the sites.

44. Dieci Savi sopra le Decime in Rialto, b. 93, Sezione II, Condizione de Decima 1537, San Marco, no. 489, registered 30 Apr. 1538.

45. On 27 Jan. 1534 m.v. (1535), Giacomo Corner, on behalf of Zorzi's heirs, requested a reduction in taxes because the palace at San Polo 'had miserably burned down in the last few days' (Dieci Savi alle Decime, reg. 758, Traslati, Libro di Terminazioni, c. 15t.).

46. Dieci Savi sopra le Decime, b. 93, sez. II, S. Marco, n. 489.

47. Biblioteca Correr, MS. P.D. 2384/18, c. 11. In this document Sansovino and Antonio Scarpagnino were selected to prepare the estimates of the value of Zorzi's real-estate properties.

48. Biblioteca Correr, MS. P.D. 2393/7, 6 Feb. 1539 m.v. (1540), copy from the notarial acts of Bonifazio Soliano. In a tax return of Oct. 1540 Zuanne Corner confirmed that so far only the *terraferma* holdings had been divided among Zorzi's heirs (Dieci Savi sopra le Decime, Redecima 1540, b. 107, no. 1080).

49. Biblioteca Correr, MS. P.D. 2384/18, c. 1–5 (another copy is on c. 12 ff.) and c. 28. The division was drawn up by the notary Bonifazio Soliano in November 1542. Giacomo died on 9 Nov. 1542 (Avogaria di Comun, b. 159, Necrologio dei Nobili, reg. 1).

50. The San Cassan property had been promised to Hieronimo in writing by Zuanne on 14 Mar. 1538 (Biblioteca Correr, MS. P.D. 2384/18, c. 28).

51. Gallo, 'Sanmicheli a Venezia', p. 116.

52. Proveditori sopra la Fabrica del Ponte di Rialto, b. 2, c. 51t.–55t., copy of property settlement of 10 July 1545 from the notarial acts of Bonifazio Soliano. The division was reported to the Tax Office in 1546 (Dieci Savi alle Decime, Traslati, reg. 1238, c. 102t., 18 June 1546). These transactions, however, were incorrect, and the errors were corrected in a revised version on 28 Jan. 1548 m.v. (1549) (Dieci Savi alle Decime, Traslati, reg. 1239, c. 38t.).

53. Ibid., c. 39, 26 Jan. 1548 m.v. (1549).

54. Biblioteca Correr, MS. P.D. 2384/18, c. 97, n.d., and c. 50, 3 Sept. 1548; and Archivio Privato Corner, no. 1, n.d.

55. Gallo used the evidence of the 1533 measurements carried out by the Giudici del Piovego (see note 42) and the date given by Zorzi's executors (see note 41) to confirm the early date (Gallo, 'Contributi su Jacopo Sansovino', p. 87, and 'Sanmicheli a Venezia', p. 114), but both these documents refer only to work on the waterfronts. In his recent monograph, however, Tafuri cast vague doubts on the early date, pointing out how slowly the work seems to have started (Tafuri, op. cit., p. 28).

56. Biblioteca Correr, MS. P.D. 2384/18, c. 55 and

61.

57. Giudici del Piovego, b. 21, Libro 1, Misure, c. 21, 28 June 1543.

58. Proveditori sopra la Fabrica del Ponte di Rialto, b. 2, c. 51t.–52t.

59. Vasari–Milanesi, vii, p. 503, and Sansovino–Martinioni, p. 388.

60. Gallo, 'Sanmicheli a Venezia', p. 117. Gallo must be mistaken in saying that by 1545 the family were already residing in the new palace at San Maurizio.

61. Ibid., and Dieci Savi sopra le Decime a Rialto, b. 126, Redecima (1566), S. Marco, no. 350, tax return of Zuanne's sons. Zuanne himself had died in 1551 (Avogaria di Comun, b. 159, Necrologio dei Nobili, reg. 1).

62. Dieci Savi sopra le Decime, b. 128, Redecima (1566), S. Marco, no. 886.

63. Ibid., b. 158, Redecima (1581), S. Marco, no. 1034.

64. See Lorenzetti, *Itinerario sansoviniano*, p. 74.

65. Gallo, 'Sanmicheli a Venezia', p. 112.

66. Dieci Savi sopra le Decime, b. 126, Redecima (1566), S. Marco, no. 350. In this tax return, Zuanne's sons described the palace as 'newly built in two storeys, which forms two houses'.

67. See the schemes for Venetian palaces in Serlio's Book IV, the first part of the treatise to be published, which was issued in Venice in 1537. (S. Serlio, *Tutte l'opere d'architettura et prospettiva* (Venice 1619), c. 155 and 156).

68. This triple entrance recalls the similar doorway of Giulio Romano's Palazzo del Te near Mantua which Sansovino probably knew first-hand.

69. The well was removed to Santi Giovanni e Paolo in 1824 (Lorenzetti, *Venice and its Lagoon*, p. 340). The statue of Apollo in the niche above the present well is the work of a certain Francesco Penso, called Cabianca (*c.* 1665–1737). The niche is early 19th-century (see *Il Restauro di Palazzo Corner*, published by the Provincia di Venezia (Venice (1935)).

70. This secret staircase is now inaccessible. The Palazzo Grimani at Santa Maria Formosa has a similar secret staircase to one of the bedrooms.

71. V. Scamozzi, *Idea della architettura universale* (Venice 1615), part 1, pp. 244–46. The design was commissioned by Cardinal Federigo Corner, one of Zuanne's sons.

72. Sansovino–Martinioni, p. 388.

73. Vasari–Milanesi, vii, p. 503.

74. Ibid., and Sansovino–Martinioni, p. 387.

75. See J. Schulz, 'The Printed Plans and Panoramic Views of Venice 1486–1797', *Saggi e Memorie di Storia dell'arte*, vii (1970), pp. 24–25. The first accurate representation of the palace occurs in the small plan published by Matteo Pagan 1559–c.1562

(Schulz, cat. no. 37). Even more precise views appear in two plans published in 1565, one by a certain Master I.C.A. published by Domenico de' Franceschi, the other by Paolo Furlani published by Bolognino Zalterii (Schulz, cat. nos. 36 and 39). In the plan by Paolo Furlani, which was reissued by Zalterii for several years, the Palazzo Moro is marked as no. 145, 'Le Case da Ca' Moro'. It was the source for many subsequent maps, especially those by Giacomo Franco (cf. Schulz, p. 25 and cat. nos. 42–65).

76. Sansovino–Martinioni, p. 369.

37. M. Lutyens (ed.), *Effie in Venice*, p. 309. The elaborate garden as it existed at this period appears in A. Quadri, *Descrizione topografica di Venezia* (Venice 1844), iii, parish of San Marzilian.

78. G. Tassini, *Alcuni palazzi di Venezia* (Venice 1879), pp. 168–69.

79. Vasari–Milanesi, vii, p. 503.

80. Sansovino–Martinioni, p. 387. Sansovino's will, naming Moro as one of his executors, was drawn up on 10 Sept. 1568 (Not. Testamenti, b. 1258, Cesare Zilioli, no. 452).

81. Sanudo, *Diarii*, vol. 42, pp. 493 and 623; vol. 43, p. 586; and vol. 44, p. 11. Carlo's entry payment was 400 ducats, while Bernardo paid 200 ducats.

82. See Bernardo Moro's will, Not. Testamenti, b. 1206, Antonio Marsilio, no. 114, 19 June 1529.

83. Carlo was elected Proveditor sopra la Sanità in October 1528, Camerlengo di Comun in the following December, Savio sopra le Decime in Rialto in 1530, and Proveditor sopra le Biave in 1532. Gerolemo was a Giudice di Procurator before being elected a Proveditor sopra il Cotimo di Londra in 1527, a member of the Camera degli Imprestiti in 1529, and a Proveditor di Comun in 1529. Bernardo was a Proveditor al Sal, then became a Savio ad aldir li Tansadi in 1525, and a Proveditor sopra la Mercantia in 1530, and finally a Procurator de Ultra in 1537. (Secretario alle Voci, reg. 10 ex 14 (1524–34), serie mista, c. 9, 17, and 46; and reg. 11 ex 8 (1523–56), c. 13, 41, 42, 43t., 46, 70t., and 72t. Biblioteca Correr, MS. Gradenigo–Dolfin 212, Libro dei Procuratori di San Marco di Venezia, c. 150t.–121.) Zuanne was Capitano di le Galie di Alexandria in 1523 (Sanudo, *Diarii*, vol. 34, pp. 249, 250). He also served in the Zonta of the Council of Ten, and in 1530 he was elected a Proveditor sopra i Banchi (ibid., vol. 54, p. 51; vol. 56, pp. 199, 1032).

84. Bernardo's will mentions Carlo's daughter, called Marina (Not. Testamenti, b. 1206, Marsilio, no. 114).

85. In the Giuntina edition of his life of Sansovino published in 1568, Vasari estimated the cost of Moro's palace at 20,000 ducats (Vasari–Lorenzetti,

p. 113).

86. A. Guisconi (=F. Sansovino), *Tutte le cose notabili e belle che sono in Venetia* (Venice 1556), p. 15 (page number from the copy in the Biblioteca Correr).

87. Tassini, op. cit., p. 168. I could find no trace of this date, supposedly written in Roman numerals, although the pilaster with the Moro *stemma* mentioned by Tassini still exists.

88. A joint tax-return by Zuanne and Leonardo was submitted in 1541, by which time Carlo, Bernardo and Gerolemo had all died (Dieci Savi sopra le Decime in Rialto, b. 111, Redecima 1541, no. 99). In 1549 Leonardo's property declaration was submitted independently, with no mention of Zuanne who had presumably died by this time (Dieci Savi sopra le Decime, b. 116, Redecima 1554, no. 97, 22 Nov. 1549).

89. Ibid. I have not been able to identify the palace at San Felice.

90. Ibid., no. 280, 28 June 1551. This document raises a problem of interpretation, in that these ten houses were stated to be not at San Gerolemo, but in the nearby parish of San Marcuola. Since it is extremely likely that the remaining ten houses at San Gerolemo would have been completed at this time, and since we know that Leonardo did eventually move to the San Gerolemo building, I believe this to be a slip on Leonardo's part.

91. Trincanato, op. cit., pp. 151 ff.

92. Ibid., p. 156. cf. also A. Boethius, *The Golden House of Nero* (Ann Arbor 1960), p. 169.

93. Dieci Savi sopra le Decime, Traslati, b. 1239, c. 150t., 17 Dec. 1552.

94. In 1562 Antonio da Ponte, deputy *proto* to the Waterways Office, reported that the request of a certain Luca Corbeli to construct a *fondamenta* in line with Moro's should be approved because it might encourage others to do the same (Savi ed Esecutori alle Acque, f. 119, Relazioni Periti circa la Laguna (1493–1579), c. 229, 22 June 1562). In the following year the nuns of San Gerolemo who owned an adjacent site also applied for permission to build a *fondamenta* to protect their land, in line with the corner of Leonardo Moro's embankment (Savi ed Esecutori alle Acque, f. 116, 1 Sept. 1563).

95. Schulz, cat. no. 40.

96. Schulz, cat. no. 116.

97. See J. R. Spencer (ed.), *Filarete's Treatise on Architecture* (New Haven, Conn. 1965), ii, p. 146. The Venetian manuscript copy, prepared for Matthias Corvinas King of Hungary, is now in the Biblioteca Marciana (Cod. Marc. Lat. VIII, 2).

98. See L. Beltrami, *La Ca' del Duca sul Canal Grande* (Milan 1900); and J. R. Spencer, 'The Ca' del

Duca in Venice and Benedetto Ferrini', *Journal of the Society of Architectural Historians*, xxix (1970), pp. 3–8.

99. Ackerman suggested that the antique Roman villa type was perpetuated through the Middle Ages as the Venetian palace before being re-established in its rural setting. This theory is tenable in the sense that both the Roman villa and the Venetian *casa fondaco* developed from common eastern Mediterranean origins, although it is not inconceivable that some houses of this type were to be found on the Italian mainland throughout the Dark Ages. See J. S. Ackerman, *Sources of the Renaissance Villa*, Studies in Western Art II (Princeton 1963), pp. 6–18; B. Rupprecht, 'Ville venete del '400 e del primo '500: forme e sviluppo', *Bollettino del Centro . . . Andrea Palladio*, vi.2 (1964), pp. 239–50; M. Rosci, 'Forme e funzioni delle ville venete pre-palladiane', *L'Arte*, ii (1968), pp. 27–54; L. Puppi, 'Un Letterato in Villa: Giangiorgio Trissino a Cricoli', *Arte Veneta*, xxv (1971), pp. 72–91.

The farm illustrated in Pietro Crescenzi's treatise *De Agricoltura*, published in Venice in 1495, has a fenced farmyard, but instead of corner towers the villa block has a central look-out tower. Both the Ca' Brusa' and the Villa Porto-Colleoni, two quattrocento villas near Vicenza, have tower-blocks at each end of the façade. The villa at Cricoli built by the 16th-century humanist Giangiorgio Trissino has four corner towers similar to those of Moro's palace, but the building is considerably smaller and has no central courtyard.

100. See L. Heydenreich, *Leonardo architetto* (seconda lettura vinciana) (Florence 1963), p. 9; C. Pedretti, *A Chronology of Leonardo da Vinci's Architectural Studies after 1500* (Geneva 1962), pp. 137 ff.

101. A. Bruschi, *Bramante architetto* (Bari 1969), pp. 593 ff. and cat. no. 37.

102. Vasari–Milanesi, vii, pp. 488 ff.

103. Not. Testamenti, b. 1279, Trevisan, no. 59, 8 Nov. 1622. Zuanne wished his four sons together to inhabit the house as a *fraterna*.

104. Francesco Zen (d. 1538) designed a series of three palaces for his family near the church of the Gesuiti, with the advice of his friend Sebastiano Serlio (G. Moschini, *Guida per la Città di Venezia* (Venice 1815), i, p. 672). The excellent architectural knowledge of Alvise Corner (1475–1566), an important patron of Falconetto, was stressed by Vasari (Vasari–Milanesi, v, p. 321). See G. Fiocco, *Alvise Cornaro, il suo tempo e le sue opere* (Venice 1965).

CHAPTER VII

1. S. Serlio, *Tutte l'opere d'architettura et prospettiva* (Venice 1619), c. 147t.

2. Ibid., c. 135.

SELECT BIBLIOGRAPHY

EARLY BIOGRAPHICAL SOURCES

The correspondence of Pietro Aretino provides a wealth of biographical detail. His letter to Sansovino written on 20 November 1537 is published in English translation in Appendix I. For the other letters referring to Jacopo Sansovino see
P. ARETINO, *Lettere sull'arte*, ed. E. Camesasca, 3 vols. (Milan 1957–60).

Vasari's life of Sansovino, first published in the Giuntina edition of his *Vite* in 1568, was reissued as an individual revised edition after Sansovino's death. See
G. VASARI, *Vita di Jacopo Tatti detto il Sansovino*, ed. G. Lorenzetti (Florence 1913).

The edition referred to in the notes of this book is
G. VASARI, *Le vite de' più eccellenti architetti, pittori, et scultori italiani*, ed. G Milanesi, 9 vols. (Milan 1878–85), cited as Vasari–Milanesi.

Another important biographical source is
T. TEMANZA, *Vita di Jacopo Sansovino fiorentino* (Venice 1752), reissued in
T. TEMANZA, *Vite dei più celebri architetti e scultori veneziani* (Venice 1778).

DESCRIPTIONS OF VENICE

The most useful accounts of the city before Sansovino's arrival are
M. SANUDO, *Cronachetta* (1493), ed. R. Fulin (Venice 1880),
M. A. SABELLICO, *Del sito di Venezia città* (1502), transl. from the Latin, ed. G. Meneghetti (Venice 1957), and
M. SANUDO, *I Diarii*, ed. R. Fulin *et al.*, 58 vols. (Venice 1879–1903).

Jacopo Sansovino's son Francesco wrote two important descriptions of Venice. The earlier one is is in the form of a dialogue between a Venetian and a stranger, the principal editions being
A. GUISCONI (=F. SANSOVINO), *Tutte le cose notabili e belle che sono in Venetia* (Venice 1556),
F. SANSOVINO, *Delle cose notabili che sono in Venetia* (Venice 1561),
F. SANSOVINO, *Delle cose notabili della città di Venetia* (Venice 1583).

The second, a considerably more substantial work, is his famous guidebook F. SANSOVINO, *Venetia città nobilissima et singolare* (Venice 1581). A new edition with corrections and additions was published by Giovanni Stringa in 1604. Giustiniano Martinioni produced a second revised and enlarged edition in 1663, though retaining the original text intact. The Martinioni edition, now reissued in a modern facsimile (Venice 1968), has been used for the notes of this book, cited as Sansovino–Martinioni.

The best modern guidebook is G. LORENZETTI, *Venezia e la sua laguna* (Rome 1956) (English translation by J. Guthrie (Rome 1961)).

HISTORICAL BACKGROUND

Useful general works include
F. BRAUDEL, *The Mediterranean and the Mediterranean World in the Age of Philip II* (1966 edn.), transl. S. Reynolds, 2 vols. (London 1972–73);
D. S. CHAMBERS, *The Imperial Age of Venice 1380–1580* (London 1970);
J. R. HALE (ed.), *Renaissance Venice* (London 1973);
F. C. LANE, *Venice and History* (Baltimore 1966);
——, *Venice, A Maritime Republic* (Baltimore 1973);
O. LOGAN, *Culture and Society in Venice 1470–1790* (London 1972);
G. LUZZATO, *Storia economica di Venezia dall'XI al XVI secolo* (Venice 1961);
P. MOLMENTI, *La storia di Venezia nella vita privata*, 4th edn., 3 vols. (Bergamo 1905–08);
B. PULLAN (ed.), *Crisis and Change in the Venetian Economy* (London 1968);
B. PULLAN, *Rich and Poor in Renaissance Venice* (Oxford 1971).

SANSOVINO'S VENETIAN ARCHITECTURE

Some of the documents relating to his public buildings are published in
G. B. LORENZI, *Monumenti per servire all storia del Palazzo Ducale di Venezia*, part I, *1253–1600* (Venice 1868),
F. ONGANIA (ed.), *Documenti per la storia dell'augusta Ducale Basilica di San Marco in Venezia* (Venice 1886), and
R. CESSI and A. ALBERTI, *Rialto, l'isola—il ponte—il mercato* (Bologna 1934).

The chief twentieth-century studies of Sansovino's architecture in Venice are
E. BASSI, 'Il Sansovino per l'ospizio degli Incurabili', *Critica d'Arte*, lvii–lviii (1963), pp. 46–62;
R. GALLO, 'Contributi su Jacopo Sansovino', *Saggi e Memorie di Storia dell'Arte*, i (1957), pp. 85–105;
N. IVANOFF, 'Il ciclo allegorico della Libreria sansovinana', *Arte Antica e Moderna* (Bologna), xiii–xvi (1961), pp. 248–58;
——, 'Il coronamento statuario della Marciana', *Ateneo Veneto*, N.S. ii, no. 1 (1964), pp. 100–12;
——, 'Il ciclo dei filosofi della Libreria Marciana a Venezia', *Emporium*, cxl, no. 2, (1964), pp. 207–10;
——, 'I cicli allegorici della Libreria e del Palazzo Ducale di Venezia,' in V. Branca (ed.), *Rinascimento Europeo e Rinascimento Veneziano* (Florence 1967), pp. 281–97;

——, 'La Libreria Marciana: arte e iconologia', *Saggi e Memorie di Storia dell'Arte*, vi (1968), pp. 33–78;

G. LORENZETTI, 'La Loggetta al Campanile di San Marco', *L'Arte*, xiii (1910), pp. 108–33;

——, 'La Libreria sansoviniana di Venezia', *Accademie e Biblioteche d'Italia*, ii, fasc. 6 (1928–9), pp. 73–98; and iii, fasc. 1 (1929–30), pp. 22–36;

——, *Itinerario sansoviniano a Venezia* (Venice 1929);

W. LOTZ, 'The Roman Legacy in Sansovino's Venetian Buildings', *Journal of the Society of Architectural Historians*, xxii (1963), pp. 3–12;

——, 'La trasformazione sansoviniana di Piazza San Marco e l'urbanistica del cinquecento', *Bollettino del Centro . . . Andrea Palladio*, viii, part 2 (1966), pp. 114–22;

——, 'Sansovinos Bibliothek von San Marco und die Stadtbaukunst der Renaissance', *Kunst des Mittelalters in Sachsen, Festschrift W. Schubert* (Weimar 1967), pp. 336–43;

——, 'Italienische Plätze des 16. Jahrhunderts', *Jahrbuch der Max-Planck-Gesellschaft* (1968), pp. 41–60;

G. MARIACHER, *Il Sansovino* (Milan 1962);

J. B. ONIANS, 'Style and Decorum in Italian Sixteenth Century Architecture', unpublished Ph.D. thesis, Warburg Institute, London University (1968);

M. TAFURI, *Jacopo Sansovino e l'architettura del '500 a Venezia* (Padua 1969), and revised paperback edition (Padua 1972). (Notes in the text refer to the hardback edition.)

OTHER ARCHITECTS

On Sansovino's predecessors and contemporaries in Venice see

P. PAOLETTI, *L'architettura e la scultura del Rinascimento in Venezia*, 3 vols. (Venice 1893);

L. HEYDENREICH and W. LOTZ, *Architecture in Italy 1400–1600*, Pelican History of Art (Harmondsworth 1974);

L. ANGELINI, *Le opere in Venezia di Mauro Codussi* (Milan 1945);

S. SERLIO, *Tutte l'opere d'architettura et prospettiva* (Venice 1619) (facsimile edition, Farnborough 1964);

L. PUPPI, *Michele Sanmicheli, architetto di Verona* (Padua 1971);

L. PUPPI, *Andrea Palladio*, 2 vols. (Milan 1973).

INDEX